FAIRFIELD PORTER

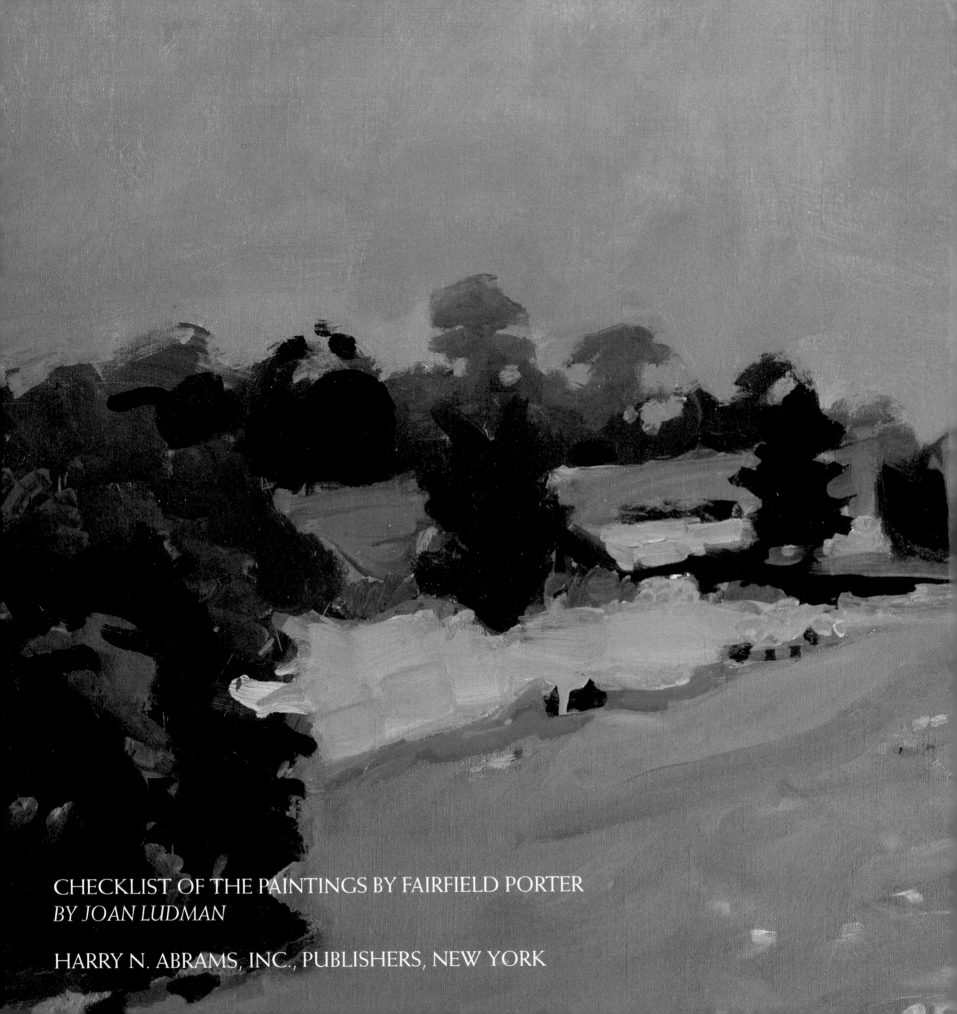

CHECKLIST OF THE PAINTINGS BY FAIRFIELD PORTER
BY JOAN LUDMAN

HARRY N. ABRAMS, INC., PUBLISHERS, NEW YORK

FAIRFIELD PORTER

AN AMERICAN CLASSIC

BY JOHN T. SPIKE

TO NICHOLAS'S GRANDPARENTS

Editor: RUTH A. PELTASON
Copy Editor: EVE SINAIKO
Designer: ANA ROGERS

Pages 2–3: *Children in a Field* (detail). 1960

Library of Congress Cataloging-in-Publication Data

Spike, John T.
Fairfield Porter, an American classic / by John T. Spike;
checklist of the paintings of Fairfield Porter by Joan Ludman.
p. cm.
Includes bibliographical references and index.
ISBN 0-8109-3719-0
1. Porter, Fairfield. 2. Artists—United States—Biography
I. Title.
N6537.P63S65 1992
700'.92—dc20 91-37549
[B] CIP

Printed and bound in Japan

CONTENTS

6 ▪ PREFACE

10 ▪ ACKNOWLEDGMENTS

14 ▪ FAMILY, EDUCATION, EUROPE 1907–1932

44 ▪ THE PORTERS IN NEW YORK AND WINNETKA 1932–1949

88 ▪ SOUTHAMPTON, *ART NEWS*, AND *THE NATION* 1949–1961

158 ▪ THE BEST OF A VERY SMALL NUMBER 1961–1966

206 ▪ THE LAST YEARS 1967–1975

272 ▪ AFTERWORD

274 ▪ NOTES

282 ▪ CHECKLIST OF THE PAINTINGS BY FAIRFIELD PORTER
BY JOAN LUDMAN

310 ▪ SELECT BIBLIOGRAPHY

311 ▪ INDEX

320 ▪ PHOTO CREDITS

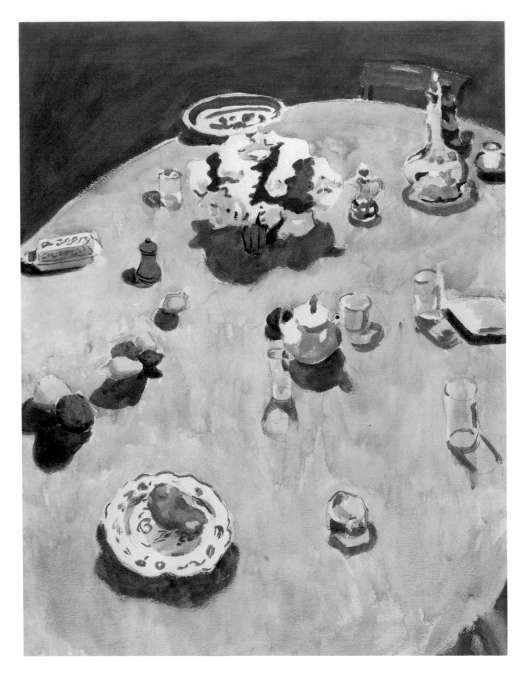

The Table. 1970

PREFACE

I have tried in this book to sketch a profile of Fairfield Porter as an artist and writer whose intellectual formation was not confined to any single period of his life, but was continually shaped and enlarged by the events he witnessed and the people and readings that influenced him from the time of his childhood until his death in 1975: how Porter was raised in affluence in Winnetka, Illinois, the shy,

middle son of distinguished parents; how his parents' interests in classical human-
ities and natural science inspired their children toward careers in art, education,
and literature; how the family summers on rustic Great Spruce Head Island,
Maine, were likewise influential; the classes Porter attended at Harvard College in
the twenties and the reluctance with which he received the prevailing wisdoms;
how Porter made his first decisive step toward an artistic career by enrolling at
the Art Students League, following his graduation; how he went to Florence in
1930, met Bernard Berenson, and studied Italian paintings; how he married Anne
Channing and began his career in New York City, but failed to gain recognition
other than occasional commissions from the Socialist party; how he enjoyed dis-
cussing art and politics with other artists, including Alfred Stieglitz and the poet
John Wheelwright; how the thirties ended with Porter disappointed in his lack of
progress, alternating between the influences of John Marin and José Clemente
Orozco, and how he returned to New York after three inconclusive years in
Winnetka; how Porter learned technical drafting during World War II; how Willem
de Kooning and other New York friends deflected his interests from politics toward
art and literature; what Porter thought of Clement Greenberg and other *Partisan
Review* critics; how he continued to paint figuratively and how Edouard Vuillard
and Pierre Bonnard, whose works he had seen in exhibitions, began to shape his
development in the later forties; how Elaine de Kooning arranged for him to write
reviews for *Art News* in 1951; how Willem de Kooning, Jane Freilicher, and Larry
Rivers persuaded Tibor de Nagy Gallery to show his paintings in 1952; how his poet
friends John Ashbery, Frank O'Hara, Kenneth Koch, and James Schuyler encour-
aged his literary interests beyond criticism to writing poetry; how he achieved his
mature style during the fifties; how his paintings began to sell in the early sixties;
why his reputation suddenly emerged around 1963, leading to a retrospective
exhibition at the Cleveland Museum of Art in 1966; why his reputation then began
to recede once more, despite the constant improvement of his work; the enjoyment
that Porter derived from debating with the faculty at Amherst College during his
year as a visiting artist there; the importance that he attached to lecturing on art
and on conservationist themes; how Porter changed galleries and was encouraged
by his sales at Hirschl & Adler; how he devoted much of his creative energy to li-
thography in the seventies; and how his strength declined, but not his muse, during
the last eighteen months of his life.

 In short, I have compiled here the known facts about the life and works of
Fairfield Porter, who confronted, criticized, and ultimately left his own impress
upon American arts and letters in this century. This biography is the first compre-
hensive treatment of Porter's life, and is based largely upon unpublished materials
that I have found in many different archives and sources. No book on a major
artist can claim to be definitive, but I have deliberately set out to write a Porter
biography that will be considered a primary source in its own right, since its accu-
racy has been attested by Anne Porter, the artist's widow. For this reason, I have
not ventured to read Porter's life in psychoanalytic terms, nor to engage in specula-
tions that no one else could possibly confirm. As far as possible, I have told this
story in Porter's own words. On the other hand, I have also endeavored in this
book to offer the first full-length examination of Porter's artistic formation, devel-

opment, and achievements. My commentary on his paintings necessarily presents my personal interpretations and my own aesthetic judgments.

Porter did not write his autobiography, yet he freely wrote about himself. His hundreds of surviving letters to friends and family are an epistolary chronicle of fifty years, 1924–75. He was heir, moreover, to a family tradition of writing letters that sound as though they were meant to be read aloud. His unpretentious, yet meditated, descriptions of his family's comings and goings, his works in progress, current readings, and views on art and politics are as engaging as they are illuminating. No other American artist of the twentieth century has left a correspondence of comparable range, intelligence, and literary quality. The excerpts quoted in this book are taken from transcriptions kindly provided me by Ted Leigh, who is editing a collected volume of Porter's letters.

Porter's surviving correspondence provides us with a vivid picture of his life and times: the extended interview that he recorded with the art historian and critic Paul Cummings on behalf of the Archives of American Art on 6 June 1968 is another irreplaceable document of Porter's own voice—in this case literally so, since the tape is readily available at the archives. There is of course a vital distinction between evidence that is contemporary to the events being described, such as personal letters, and information taken from interviews and memoirs, in which the same events are seen with the perspective of intervening years. This book attempts to weave together diverse facts without obliterating their individual shadings. Thus Porter's opinions in 1968 are clearly identified as such and do not serve as surrogates for what he may have thought in 1928. This biography abounds in nubby details of correspondents, dates, and places that might have been consigned to notes, but I think history is polyphony, not fugue.

Research into other sources has made it possible to add detail and relief to Porter's firsthand testimony: the private papers donated by the Estate of Fairfield Porter to the Archives of American Art, and now on microfilm, amount to cartons of miscellaneous drafts of articles, reviews, lectures, and poems (interspersed with unidentified poems by others), financial statements and contracts from his dealers, and assorted correspondence received by Porter. This archive would make it possible for another scholar to reconstruct Porter's sales after 1952 in greater detail than I have gone into here. The Porter family still possesses numerous original letters written by his mother, Ruth Porter, as well as two notebooks (cited in notes as APL and APL2), containing extracts from Anne Porter's letters to her mother, Katharine Channing. Finally, I can recommend an overlooked source for information on American artists: their high-school and college transcripts. There is no telling what may turn up in the files preserved in perpetuity in a Registrar's office: Porter's entrance application to Harvard is a time capsule of his state of mind in 1923. Painting ranked low on his list of aspirations.

The two hundred-plus illustrations of Porter's paintings, prints, and drawings in this book are another form of autobiography—precisely so, since Porter's subject was always himself, his family, his friends, the landscapes in his life. He was in awe of Penobscot Bay and its spectacular wildness, but he did not disdain cityscapes in New York or the parking lot behind his Amherst studio. He told Paul Cummings in 1968 that painting was neither emotional nor intellectual. "I think it's

a way of making the connection between yourself and everything." So far as we know, Porter's earliest works after his return from his year in Europe in 1932, and marriage, were portraits of his wife. He never varied from figurative painting nor from his interest in portraiture, notwithstanding insistent opinions at the time that figuration was imperiled and portraiture resoundingly dead.

Porter's paintings are related to autobiography, but not to the family album. De Kooning taught him that his first allegiance was to the canvas. "What I think now is that it doesn't matter much what you paint. What matters is the painting." This deceptively simple belief set him free. As often as Southampton and Great Spruce Head Island, his family and friends appear and reappear as the subjects of his works, yet Fairfield Porter is among the most original of twentieth-century American painters for the simple reason that he does not repeat himself. Porter's portraits and his landscapes are as individual as moments in a life. Looking hard at light and nature gave him the courage to paint his canvases without formulae, patterns, or "signature" motifs. "I found out many, many years later that composition isn't good because something is repeated but because it is not repeated," he said in 1968. "It was just the opposite. If there's something that never occurs again in a painting that's what gives it its unique quality."

Porter did not realize his mature style until the early fifties, perhaps because Harvard and the Art Students League had coached him in alternatives to seeing with his own eyes. Works of the thirties and forties have hitherto been suppressed in considerations of his work, partly because these paintings were immature and partly, I suspect, because little was known about them. They have never previously been illustrated. One of the purposes of this biography is to restore a wholeness to Porter's artistic and intellectual profile by restoring these formative decades to the discussion. The checklist of paintings that Joan Ludman has graciously made available for this book constitutes a chronological outline of Porter's oeuvre that is immensely informative in many ways, not least because of the new light that it casts on his early productions.

The title of this book is borrowed from an influential essay by Hilton Kramer, that appeared in *The New Criterion* in May 1983. After viewing the Porter retrospective at the Museum of Fine Arts, Boston, Kramer predicted that the history of American painting would have to be rewritten to give more importance to Fairfield Porter: "He is going to have to be recognized as one of the classics of our art."

In the aftermath of the Porter retrospective, which was widely and enthusiastically reviewed, it seems a certainty that Porter's name will no longer be omitted from the basic textbooks of this field. Whether future critics will agree that the whole terrain of postwar painting will have to be resurveyed, and traditional boundaries shifted to accommodate Porter, is up to them to decide. This book was written to afford his paintings and writings an opportunity to speak for themselves.

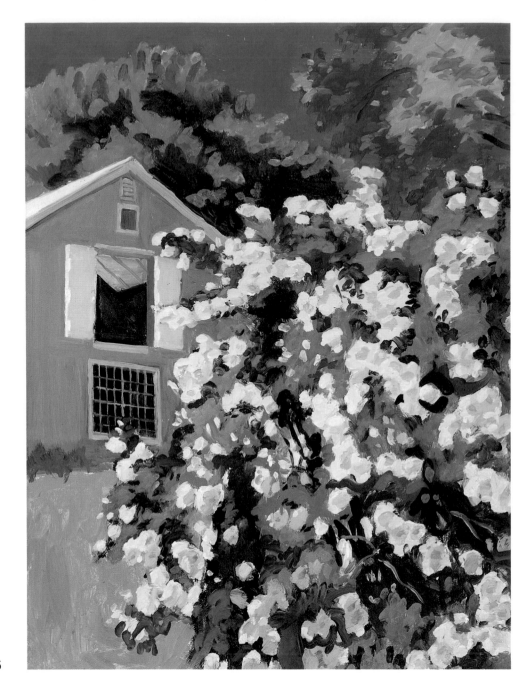

Persian Rose Bush. 1975

ACKNOWLEDGMENTS

I am most grateful to Anne Channing Porter, who honored me with the invitation in the first place to write this book. Furthermore, her authorization of, and assistance to, this undertaking never failed to open doors, wherever my research happened to lead me. My meetings and telephone conferences with her amounted

to many more "interviews" than are formally cited in the notes. Always responsive to my questions and appeals for help, Anne trusted me with the freedom to write this book in my own way. I hope that she is content with it. Anne Porter and Laurence M. Porter, Fairfield's son, both read the completed text in search of errors and provided valuable corrections. In their respective views, the events in this biography are accurately presented. As author, however, I am solely responsible for any errors.

My warm thanks go to all of Fairfield Porter's children for making themselves available and offering encouragement. Fairfield's brothers and their wives permitted me to visit them for interviews: the late Eliot Porter and his wife, Aline, in Santa Fe; John and Trudy Porter in Bronxville, New York. I spoke with Nancy Porter Straus and her daughter, Margaret Straus, on Great Spruce Head Island. I am particularly indebted to Stephen and Marcie Porter, who hosted me in Bellefonte, Pennsylvania: Steve Porter generously shared with me his remarkable knowledge of Porter family genealogy and island history. I am especially grateful to Anina Porter Fuller, who gave me many clippings about Fairfield and guided me around Great Spruce Head Island, but especially for providing me with a spark of inspiration at a moment when the end seemed unattainably distant.

Throughout the preparation of this book I directly benefited from the loyalty and affection with which Fairfield Porter's memory is honored by his friends as well as by his collectors. The painter Rackstraw Downes and the scholar Joan Ludman had previously written important books about Porter, and both authors extended themselves to assist me, solely out of their desire to see this book succeed. Both Downes and Ludman read this book in manuscript and offered important comments, for which I am deeply grateful. Joan Ludman made an immeasurable contribution, moreover, by undertaking and completing the checklist of the paintings in time for me to refer to it, and by permitting its publication here. She has truly collaborated on this book, investing extraordinary amounts of time and expense in transatlantic telefaxes, responding to my pleas for clarifications and information.

I wish also to acknowledge with appreciation the kind assistance of Armistead Leigh, another Porter scholar (in both senses, since Porter advised him while at Amherst), with whom I enjoyed many conversations. Ted Leigh collected and transcribed the original letters on which I have relied so heavily here. I hope that these excerpts will prepare the way for Leigh's forthcoming volume of Porter's collected correspondence.

My warm thanks go to many other Porter friends and contemporaries who granted me interviews and other information: Arthur M. Bullowa, Paul Cummings (who kindly read and commented on some early chapters), Lucien Day, Tibor de Nagy, Jane Freilicher, Dan Hofstadter, Kenneth Koch, John MacWhinnie, Ron Padgett, Casimir Rutkowski, David and Lindsay Shapiro, Susan Shatter, Prescott D. Schutz, John Walker, Neil Welliver. Edith Schloss generously gave me permission to use excerpts from the fascinating memoirs that she has written about her and Rudy Burckhardt's friendship with Porter in the forties and fifties. I hope that other of these friends will compile memoirs of those eventful years. In my research I soon discovered that Porter's friendship had as many different aspects as he had

friends; I have endeavored to let Porter define his own personality through excerpts from his writings.

I cannot omit to thank my friend Paton Miller, who somehow intuited that I would enjoy writing this book and, without telling me, first suggested the idea to Anne Porter.

A special word of thanks goes to Stuart P. Feld and his colleagues Betty Cunningham and Martha Parrish at Hirschl & Adler Galleries in New York, who responded helpfully to all my requests and, indeed, provided me with most of the photographs that I used in my research and have published in this book.

Dominic Madormo greatly facilitated my research at the Archives of American Art in New York, where most of Porter's papers were deposited after his death; without his assistance my work with this material would have been made far more difficult. I wish to acknowledge the efficiency and cooperation of the staffs of the Frick Art Reference Library; The New York Public Library; the library of the Metropolitan Museum of Art; the public libraries of Englewood, Hackensack, and Tenafly, New Jersey; and the registrars and archivists of New Trier Township High School in Winnetka, Milton Academy in Massachusetts, and Harvard College in Cambridge, Massachusetts.

Over the years I have benefited from the help of countless people, often collectors or museum professionals, in the task of locating paintings, obtaining photographs, and other aspects of research; my heartfelt thanks to everyone, including Elizabeth Barrett, Anna Brook, Jean Cadogan, Frances Chaves, Ruth Connell, Robert J. Elowitch, Richard S. Field, Tommaso and Nancy Galdy, John Gruen, Helen A. Harrison, Doris Heimlich, Abol and Fati Helmy, Marion Hirschler, Rachel Kaminsky, Virginia M. Krumholz, William S. Lieberman, Walter Liedtke, Alicia Longwell, Joanne Kahn Miller, Adrian Mnuchin, Mrs. Robert H. Morris, Andre Nasser, Mary O'Neill, Roland F. Pease, Mary Anne Pennington, Elizabeth Pratt, Janet Russak, Marcia Smith, Thurston Smith, Ashby Sutherland, George Tubert, George Wachter, Roger Ward, Kay Williams.

My warm thanks go to Paul Gottlieb, my publisher, who bought this book when it was just an idea; to Gabriele Pantucci, my literary agent; and especially to Ruth Peltason, my editor at Harry N. Abrams, who was patient with me when I was late and then was patient with me when I was in a hurry and, best of all, was sympathetic and helpful to my text.

Finally, I must conclude these acknowledgments with my deepest debt of gratitude to my beloved wife and son, Michele and Nicholas Spike. They have accompanied me and heard me out on every step of this long journey. To them, and for them, I am forever thankful.

John T. Spike
Florence, 1992

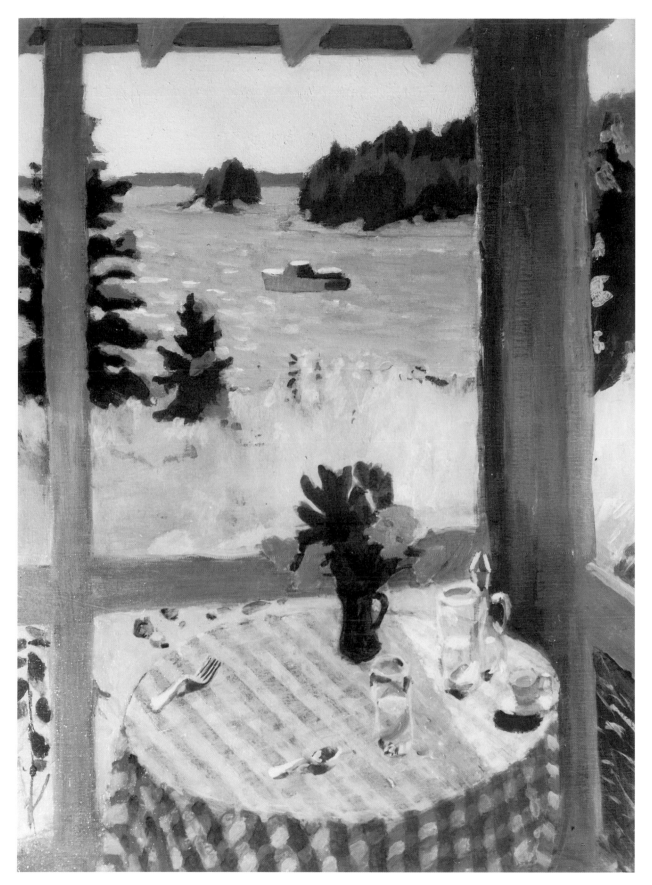

Blue Table. 1971

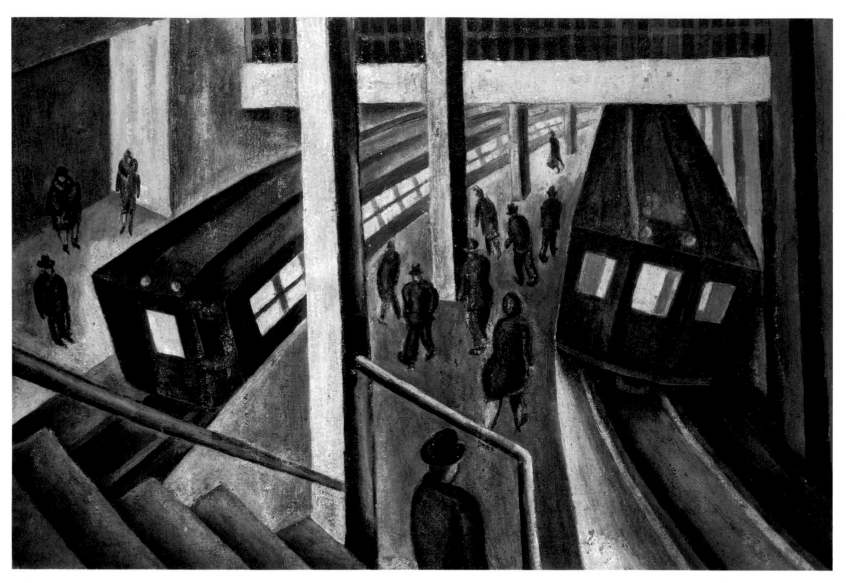

Subway. 1929

FAMILY, EDUCATION, EUROPE | 1907–1932

"I bumped into a fellow I had known at the [Art Students] League in New York. His name is Porter, his first name I've forgotten." An American overseas, Frank Rogers, wrote home in 1932 about his chance encounter in Munich with another young artist, Fairfield Porter, who was then twenty-five.[1]

> *We had been in the same class and admired each other's intelligence . . . We liked Boardman Robinson but not John Sloan as teachers . . . I once went to dinner with Porter and thought him a bit too intellectual. His drawings were good but his paintings a little too intellectual tending toward mannerism.*
>
> *He met me at 5:15 and had to catch a train to Florence, Italy, at 6:45. For several weeks he had not talked much with anyone—much art, that is . . . We were both bubbling over, so that in that hour and a half we tried to cram every new idea we had, both of us talking a mile a minute and interrupting one another. What enthusiasm! We yelled. We laughed. We argued.*
>
> *He told me about glazing (a process of painting). El Greco and Rubens used it he says. We talked about painters and both agreed that Rubens was wonderful, having thought him rotten in America. It was all pell-mell, fast and furious. I loved it . . . He's the only person I know of as enthusiastic on art as I am—the only one. He's rushing all over Europe the same as I want to do. He's already been to Italy once. He's nuts about Rubens and Giotto and Piero della Francesca, same as I am . . . He said to me, "I think I'm just beginning to understand Rembrandt."*
>
> *Now he's on his way to Italy. He says Giotto is swell . . . After he left I asked a German girl what she thought of him. "Typical American," says she. "Yes, all Americans are enthusiastic like that. We in Europe are tired, but Americans are all young, in their prime. They're about to have their day." By God! She's right.*

In 1932 Fairfield Porter had every expectation that his own recognition and fulfillment as a painter lay just ahead of him. His classmate Rogers wondered out loud how far "this fellow Porter" might go: "He's got lots of talent and an appreciation of the old masters. If he doesn't let his intellectual side carry him away, he'll be good."

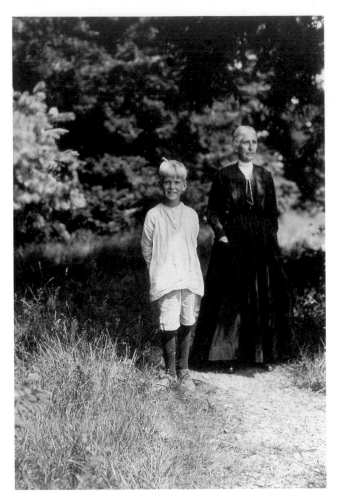

Fairfield Porter with Julia Foster Porter, his maternal grandmother, 1916

But Fairfield Porter without his "intellectual side" would have been a different person, not Fairfield Porter at all. His love of literature and of provocative and intellectual conversation—his love of good talk amounted to a need—were indelibly instilled in all the children of James and Ruth Porter of Hubbard Woods, Illinois. "Our family was a close-knit one," Fairfield's brother Eliot Porter, the photographer, wrote in his memoir, *Summer Island: Penobscot Country,* "in which we children shared more than ordinarily in the intellectual life of our parents and their friends. As a result, we grew up feeling very much a part of adult society and at home in it. We were never pushed aside or left out of discussions if we showed any interest in them."[2]

Fairfield and his four siblings, Nancy, Eliot, and Edward, who were older than he, and John, who was three years his junior, were all born into a family that was privileged in more respects than the word customarily implies. The Porters were certainly well-to-do: Fairfield's paternal grandmother, Julia Foster Porter, had had the good fortune (as Fairfield later described it) to have been born on a farm that was located on the future site of Randolph and Wabash Avenues in the Chicago Loop.[3]

Fairfield's parents, James and Ruth Porter, were descended from four New England families (Foster and Porter; Wadsworth and Furness) that were each distinguished not for wealth but for their literary culture and ethical behavior. Most generations had included clergymen or educators. James was the son of an Episcopalian rector; his mother, after she was widowed, became a broad-minded and generous philanthropist. Among her many charities Julia Porter founded, in 1882, the first children's hospital in Chicago, Maurice Porter Memorial, a large, well-respected hospital that still serves needy children regardless of their ability to pay.

Fairfield's mother, Ruth, was the daughter of Major William Eliot Furness of Philadelphia, who had served in the Civil War as an officer in the Third Regiment, U.S. Colored Troops. He had previously graduated from Harvard University in the class of 1860 (Phi Beta Kappa) and completed Harvard Law School. After the war, William Furness had married Lucy Fairfield Wadsworth, the sister of two of his Harvard classmates, and the young couple had gone to Chicago, where he practiced law. Fairfield Porter was named for his maternal grandmother. Through their mother's family, the Porter children were related to the Greenleafs, Wadsworths, and Eliots, including T. S. Eliot.

The family inheritance that served Fairfield Porter the longest and most truly—outlasting, in fact, the eventual dissolution of the Porter Family Trust in the 1960s—was an almost religious faith in literacy and letters. "My mother read more than anybody in the world. She was constantly reading," his brother Eliot recalled, with no exaggeration intended.[4] She "belonged to the small group of women of her time who attained a college education, and in her years at Bryn Mawr she developed cultivated literary tastes, became an omnivorous reader, and made several lifelong friends who became associated with Jane Addams's Hull House in Chicago. I suspect that it was not only family tradition but also these friendships that encouraged her emotional bias towards a liberal point of view. She supported women's rights, the suffragist movement, racial equality, and other progressive political movements."[5]

In preparatory school, Ruth Porter read Xenophon and Homer and at Bryn Mawr (class of 1896) she read Plato. One of her school friends was struck by Ruth's "peculiar pleasure in the expression of Greek thought."[6] Two years before she died in 1942, Ruth Porter studied Homer again at Northwestern University, where her translations were highly praised. Fairfield Porter often said later that he associated Greek culture with his mother; in 1957 he wrote a poem in sestina form, "The Colors of the Flag of Greece," which was partly intended as an homage to her.[7]

Ruth Porter's personality was unusually sympathetic, and her tolerant spirit and love of fellowship set the tone in the household. Listening to Ruth read aloud was the favorite evening pastime of the Porters, and Fairfield and his wife, Anne, continued the practice throughout their married life and shared it with their own children. When Fairfield's paintings depict people holding books in front of them—*Iced Coffee* of 1966 is one example—in all likelihood they are reading out loud to Porter while he works. A Bryn Mawr classmate once wrote of Fairfield's mother that she "felt in her something fascinating and different from anyone else . . . She had a genius of character and communication in human relations."[8]

Ruth Porter wrote a brief memoir of her mother, Lucy Fairfield Wadsworth, which is revealing about her own upbringing and sense of humor: "I respected unduly people who took the Atlantic Monthly, had current jelly with mutton and Yorkshire pudding with roast beef, and I thought gum chewing not less than indecent. But I am glad that the Unitarian exaltation of the humanity of Jesus [her father was Unitarian], and an Abolition tradition added to my father's military experiences in a colored regiment, made us free of unhappy prejudice against Jews and Negroes, although our beliefs were not much tested by experience."[9]

James Porter and Ruth Furness were married in June 1898, and sailed that summer to Europe on their honeymoon. James had graduated Harvard in 1895, and received his Master's degree the next year. But he had had to give up his main interest, biology, because he felt that his eyesight was too poor for work with a microscope.[10] James changed his field to architecture and was overseas for four months, studying, in the year before his marriage. On their honeymoon the Porters traveled from England to Italy, so that James could study the cathedrals and monuments in York, Durham, Lincoln, Chartres, Lucerne, Venice, Florence, Rome, and Pompeii. James took many photographs during this trip, which are preserved in albums in Eliot Porter's house in Santa Fe. In 1898 and 1899 they lived in New York City, while James attended the Columbia University School of Architecture. Their home at 351 West Forty-fifth Street was decorated with an extensive selection of photographs of Italian Renaissance paintings and other art reproductions.

James Porter was a shy man, which is not to say that he lacked convictions. "To his mind there was a conflict between science and all conventional religion, and while he was by nature tolerant of the opinions of others, his strong feeling of the importance of truth in all fields led him to be a zealous partisan of science as against religion." In this way, the fiftieth anniversary report of the Harvard class of 1895 took due notice of James Porter's adamant atheism. Ruth Porter had inherited agnostic philosophies from her mother; there was therefore no conflict between husband and wife over religion and indeed keen interest in discussing the point among family and friends. Eliot Porter wrote admiringly of his father, "But perhaps

Ruth W. Porter, Fairfield's mother, c. 1898

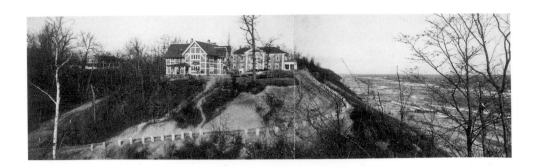

The two Porter houses in Hubbard Woods, Illinois, over-looking Lake Michigan. At right is 1085 Sheridan Road, the Greek Revival house in which Fairfield was born on 10 June 1907. The half-timbered Tudor style building at left was the home of Julia Foster Porter. Fairfield's father, James Porter, was the architect of both houses.

because he had been brought up under the strict guidance of the Episcopalian faith, he retained, if not the religion, certainly its moral precepts. He held to very high standards of conduct. Truth, honesty, and fulfillment of all promises were his guiding principles. He did not lecture us on these ethical matters, it was by example that we learned to honor and live by them."[11] Fairfield and the other Porter children were raised as nonchurch-going atheists, which was quite remarkable in Chicago society before the First World War. In the 1970s, toward the end of his life, Fairfield Porter's views on the existence of God were closer to agnosticism, influenced perhaps by the Roman Catholic faith of his wife, Anne, and their daughters, Katharine and Elizabeth.

At the turn of the century James and Ruth Porter moved back to Chicago, as it became necessary for James to manage his mother's real-estate interests. He was associated for a time with the architectural offices of Burnham & Company and William A. Otis, both of Chicago. Family lore holds that James designed a suburban railroad station and perhaps other small public buildings,[12] but his architectural studies and experience were most notably applied to building his own family's houses at Hubbard Woods, now Winnetka, Illinois, and on Great Spruce Head Island in Penobscot Bay, Maine.

The house where Fairfield Porter was born on 10 June 1907 was, in Eliot Porter's words, "a large brick Greek revival house with Ionic pilasters at its corners, an entrance portico and facade featuring Corinthian columns, and Doric-columned porches on each side of the house."[13] The Porter house at 1085 Sheridan Road had ample, even grand, proportions, but was decorated in response to the needs and tastes of intellectuals. Reproductions of paintings by Italian primitives and Leonardo, Dürer, and Michelangelo hung on every wall; a photograph of Verrocchio's equestrian statue of Colleoni is also visible in an early photograph of the house's interior. Most rooms featured handsome stone fireplaces flanked by classical columns, comfortable-looking armchairs, and oriental carpets. Books were everywhere. On their wide property overlooking Lake Michigan, about two hundred feet away, James also designed and built a house in half-timbered Tudor style for his mother. (Later, in 1936–39, a particularly hard time in his career, Fairfield and Anne and their first two children, John and Laurence, moved back to Chicago and lived in his grandmother's house.)

Eliot Porter was the first child born—in December 1901—to James and Ruth in their new house at Hubbard Woods. He was the second eldest; his sister, Nancy, was then two years old. Fairfield's most faithful playmate as he grew up was his

brother Edward, who was three years older. The youngest son, John, was born in November 1910.

The Porter children had the run of a great high bluff looking out on Lake Michigan, as well as the lakeshore itself and woods and marshland across the ravine that bounded their property. The Porters made close friends with their neighbors in that still-rural part of the North Shore, and it was through family friends that Fairfield, when in college, was first introduced to Anne Channing of Boston, his future wife. Every Sunday James led the children on a nature walk, usually along the lakeside, their conversations touching on all the sciences from geology to astronomy, paleontology to marine biology.

"My father," Eliot recalled in 1987, "at heart a naturalist, instilled in his children, perhaps most profoundly in me, a fascination with the natural world."[14] Eliot Porter acknowledges his father's influence both on his initial choice of a career in science and on his eventual decision to devote himself to nature photography. These Sunday morning nature walks doubtless played their part in arousing Fairfield's interest in landscape painting, not to mention his deeply felt views on conservation and ecology. John Porter was inspired by them to study science; he enjoyed a long and satisfying career as a teacher in the public schools in Bronxville, New York.

Camping trips to the West, to Yellowstone and the Grand Canyon, and especially to the unexplored mountain ranges of the Canadian Rockies, had been James Porter's vacation preference since his college days. As his family grew to include five small children, he was obliged to modify his plans. In 1912 he went east to Maine to look for a summer home for his family; his attention was drawn to, and he immediately purchased, one of the small islands that are scattered like stones in Penobscot Bay. Eliot and his father returned to Great Spruce Head Island in June 1912 in order to lay out the site for their house. Great Spruce Head Island (as distinct from nearby Little Spruce Head) had been farmed off and on and occasionally harvested for timber. Its irregular, rocky outline is basically oval but slightly pinched in the middle. About a mile long and a half-mile wide, the island had no inhabitants and no habitations in 1912. Its northern end is dominated by the spruce-covered rocky knoll from which it takes its name. The southern end of the island is split by a narrow cove, which on the map resembles a vertical crack, where the chilly Maine sea is usually slightly warmer by midsummer and which soon became a favored spot for swimming.

During that winter, the Porters' house on Great Spruce Head Island was constructed according to James Porter's designs. Set atop a slope at the island's north end, the large two-story shingle house had screened-in porches along its two long sides. Weather permitting, the family took their meals on the porch overlooking the bay and the clustered islets known as the Barred Islands. This is the main view off of the island and the seascape that Fairfield Porter later painted most often. The enclosed porch on the opposite side of the house, toward the forest, was eventually adopted by Porter as his summer studio.

The big house, as it was called, was unmistakably a summer place and not merely because its simply hewed wooden planks were never insulated for winter use. It was not James Porter's intention to transport modern comforts into the

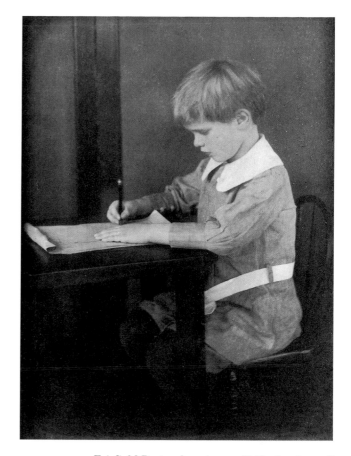

Fairfield Porter drawing, c. 1913, about age 6

The five children of James and Ruth Porter on the dock at Great Spruce Head Island. From left, Eliot (fixing a boat); Edward; Nancy; their nanny, Charlotte; Fairfield; and, front, John, c. 1915

Maine woods. Hot water for most purposes had to be heated on the cast-iron wood-burning kitchen stove. A cranky electric generator produced so little power that the fresh water (which had to be pumped up) and available electricity were hardly enough to heat a bath and have light to read by during the course of the same evening. The children mostly made do with saltwater "baths" in the cove or ocean. Plumbing was primitive and drinking water had always to be conserved.

Yet the big house seemed attractive and comfortable to everybody simply because of its spacious interior and the breathtaking landscapes on every side. In his family houses in Illinois and Maine, James Porter proved to be a domestic architect with a genuine gift for creating congenial spaces for people to gather in and live together. Most of the house is given over to an expansive living room of double height, extending up to the rafters. The hearth at one end was once the main source of heat and light for nighttime reading. The house was decorated, in the Porter style, with plaster casts of the Parthenon frieze (the Elgin Marbles) that James installed over the fireplace mantel. Staircases at either end of the living room lead up to small bedrooms, originally one for each of the children and others for guests, whose comings and goings constituted the most important events of every summer.

James Porter prided himself on a capacity to handle almost any sort of practical problem, and he thought it his duty to inculcate in his children the same spirit of self-reliance. Although in one sense there was nothing to do except read books, play cards, write letters, talk, and occasionally swim, there was an undeniable fascination to life on a wooded island in Penobscot Bay, where every item that could not be grown or gathered from the earth had to be brought over by boat.

An early view looking off of Great Spruce Head Island, Maine. Little Spruce Head Island is in the distance, c. 1916

Eliot Porter's book about the Porters' life on Great Spruce Head Island, *Summer Island,* describes in detail his and Fairfield's childhood on the island. "During our summers in Maine, mother would read to the whole family gathered of an evening in the high-ceilinged living room around the fireplace in which four-foot logs burned . . . Our father explained the names and relationships of all these creatures [mussels, urchins, crabs, starfish, sea anemones, sea cucumbers, limpets] to us, and took an even greater interest than we in this ever-present museum of marine biology."[15] Many years later, Fairfield Porter said that the island always evoked for him his childhood, which he considered his "personal golden age."

As a teenager, Fairfield had the intelligence and the background at home to allow him to enter high school two years early. His academic record at New Trier Township High School in Winnetka was in every way commendable, but from all reports he was painfully shy. Being two years younger than everyone else was probably no help. He graduated high school in 1923 with the nickname "Clam" (which stuck for some years afterward) and the yearbook motto, "Still quietly he works while others play." Because he was only sixteen years old, Porter's parents decided to put off college for a year and to send him in the meantime to Milton Academy, a Massachusetts prep school. Thus an odd situation arose in the spring of 1923, in which Fairfield was admitted both for supplementary studies at Milton Academy and to the freshman class of his father's alma mater, Harvard University. In the fall Porter duly went off to Milton to pass a desultory year that he later felt was largely wasted.

There is little or no evidence from Porter's high-school years or childhood— no works, other than some whimsical drawings—to suggest that he had already decided upon a career in art. On the the other hand, Eliot Porter has recollected that his brother considered himself an artist from his earliest childhood and that their mother encouraged his artistic interests, while James Porter was doubtful that Fairfield had the necessary talent.[16] When Porter was accepted at Milton, Ruth Porter sent an *ex libris* bookplate to Mr. Field, the headmaster, that Fairfield had "made of our island and the Camden Hills when he was in Grammar school."[17] As a boy, Porter had been taken by his mother every now and then to the Art Institute

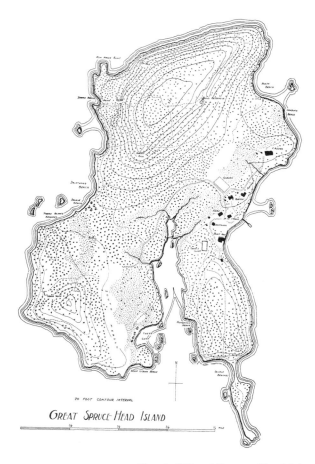

Chart of Great Spruce Head Island

of Chicago; the adult Porter recalled that when he was about fourteen years old he had seen some classical-period ("Egyptian") Picasso paintings, which deeply impressed him. He had thought at the time that if these Picassos represented contemporary art, then painting was a "worthwhile activity."[18] In a 1968 interview he referred to this, and said that he had a faint recollection of taking some painting lessons, just "to give me something to do," during the spring of 1924, when he was home from prep school to attend his sister's wedding.[19]

Porter wrote on his Harvard College application in 1923 that his "Chief Interests" were reading, drawing, and chemistry, and that his "Intended Profession" was architecture. At New Trier Township High School his greatest skills had been in Latin and French; his high-school records do not take note of any penchant for art or drawing.

In Porter's responses on his Harvard application he was characteristically unconcerned to recommend himself or to cut an impressive figure. What is your plan for College life? the document queried. "I am going to take a general course, mainly sciences, but I have no plan as regards College life." Why do you wish to come to Harvard? "I am going to Harvard principally because my father went there and I know more about it than any other university. But I think, from what I have heard, it offers better scientific courses than many colleges; and you can be more independent there than in other universities that I know anything about; for instance, fraternities are relatively unimportant there."

Family travels provided Porter with experiences of European art and architecture that he often mentioned in later life. During the spring of his junior year in high school, James, Ruth, Fairfield, and John Porter (the older children were already at college) sailed to Europe on the SS *George Washington*, landing at Cadiz on 20 February 1922. Their cruise proceeded into the Mediterranean, touching at Algiers, Naples, Athens, Constantinople, Beirut, Alexandria, and Palermo before disembarking in New York on 19 April 1922. Porter later told a friend that his visit to Athens had thrilled him as few other events had in his life. "I was surrounded at home by life size plaster casts of the Parthenon frieze, and impressed by my father's explanations of the excellence of Greek architecture, which did in no way disappoint me."[20]

In July and August 1924 the Porters traveled on the SS *Franconia* to Scandinavia and then England and Scotland. Ruth Porter's letters home to her daughter, Nancy, who had recently married Michael Straus, speak of seventeen-year-old Fairfield's enthusiasm for the "scenery & historic & literary associations & architecture." They had been to Trondheim and Bergen, Norway, and then left their ship at Southampton and traveled inland to see the cathedrals at Winchester and Salisbury. "Fairfield is just enchanted. He is so surprised at the general richness of it all, like very fruity raisin bread. He says: 'Will there be many places like Winchester with so much to see?' & he yearns over every old house, half timbered or thatched, & every buttress & column."[21] Their summer itinerary also took the Porters to Edinburgh, Lincoln, and London. At the National Gallery of Art, Fairfield liked very much Leonardo's *Virgin of the Rocks*, which was familiar to him from photographs at home. He counted as a discovery, however, Titian, Veronese (*The Family of Darius before Alexander*), and Turner, none of whom were in his father's

assortment of art reproductions. "These were my own discoveries. Nobody had told me anything about them except their names, of course."[22]

Porter entered Harvard in September 1924. He requested an advisor in the art department, in line with his intended profession of architect. On his freshman questionnaire he wrote that his "especial interests" were history, science, and art, in that order. One of the identifiable benefits of Porter's time at Milton Academy was the friendship he formed there with Thornton Coolidge. Both had gone on to Cambridge and they were now freshman roommates. During the summer, the Porter and Coolidge parents had met by chance in Edinburgh, which prompted Ruth Porter to comment to her daughter, "Fairfield was so afraid that I'd not like them. In his desire not to mislead with false hopes he has always represented them to me as fearful reactionaries & has made the most of a frightful skeleton in their closet—a remote relationship to the President . . . I was so glad to relieve Fairfield by telling him that I like the Coolidges & thought them quite liberal."[23]

Howard Fisher, a family friend from Hubbard Woods who had preceded him to Harvard, had urged Porter to enroll for classical art with George Henry Chase, but Porter discovered that he was first obliged to take an introductory course. The cornerstone of Harvard's Fine Arts Department during Porter's time, 1924–28, was a course titled "Principles of Drawing and Theory of Design," with Professor Arthur Upham Pope. The art historian John Walker, who also studied at Harvard during these years, remembered Pope with high regard, as "a painter as well as an art historian [who] saw works of art with the eye of an artist, and was . . . able to formulate and communicate the principles of connoisseurship."[24] By contrast, Porter was unimpressed with Pope's approach and the standard Harvard line. He wrote home in early October 1924 that "Howard didn't get me into that course, Professor Chase wouldn't let Freshmen in. Fine Arts 1A which I'm taking instead is all theory about colors and so forth and we do silly little painting exercises like making circles of gray, red, blue, etc., varying in value and intensity. And I had to buy $16.00 worth of apparatus for even that. But I can't take any other Fine Arts course without having had this one."

When in later years Porter reviewed his Harvard education, his impressions were favorable, by and large. He retained a personal regard for Arthur Pope. Yet he also remarked on many occasions that the views enunciated in Pope's introductory course were fundamentally mistaken and had confused him for a long time afterward. "In my first college art appreciation course, Professor Arthur Upham Pope told us that one of the principles of esthetic order was repetition. It took me years to find out that this was not the case; on the contrary, one finds artistic order in diversity, in the realization of the fact that nothing ever repeats."[25]

Porter's freshman courses included French and English; his grades varied from A to D, depending on whether he had bothered to complete the reading assignments. He was able to exempt the German-language requirement because of a proficiency acquired from one of his childhood nannies. Throughout his college years, Porter frequently missed classes and was generally uninterested in earning high marks or in any sort of academic honors. In November he unapologetically wrote his mother that he had missed three French papers in succession. His brother Eliot was a noticeably more serious student. Eliot had earned his

bachelor of science degree from Harvard in June 1924 and was now studying hard at Harvard Medical School.

Fairfield and Eliot saw one another regularly during their overlapping years in Cambridge, although they viewed themselves more as brothers, perhaps, than as friends.[26] Two beloved maiden aunts, Aunt Rebe (Rebecca) and Aunt Laura, sisters of William Eliot Furness, lived on Lyme Street in Boston and often invited their grandnephews to tea. They were always called collectively the Little Aunts. Boston also offered first-rate theater, and the Porter brothers frequently went to plays, sometimes in each other's company. Fairfield saw a production of George Bernard Shaw's *Saint Joan* that he favorably compared to one he had attended in London. Everyone went out or traveled to the Saturday afternoon football games, though Fairfield's involvement was more philosophical than fanatic: "The Princeton game had the distinction of being the worst defeat for Harvard in half a century, so it was very interesting."[27]

During the fall semester of 1924 Porter was reading Chekhov's short stories and preferring them to Katherine Mansfield's. Just before riding the Twentieth Century home for the Thanksgiving holiday, he stayed up all night writing a paper on Marcus Aurelius's *Meditations* for a philosophy course. "It was awfully hard not to say everything I could say in three sentences, but it had to be at least 10 pages long, so I managed to expand each sentence into a paragraph and stretch it all out very thin and transparent over 9 pages."[28]

Porter joined the art department of the Dramatic Club in March 1925, his second semester at Harvard. This is the earliest recorded indication that he considered himself a painter. The immediate club project was to paint posters to advertise a college production of a play by John Dos Passos. Porter liked Dos Passos's own designs for the sets, which he thought were "very expressionistic . . . One scene, in New York, throws all sorts of things at you, skyscrapers, and funnels of boats down below between them. Another scene is Heaven, with many multicolored stars, some very large and near, others small and far off, shooting out rays of light in all directions, that clash and cross. If the posters are like that, too, they ought to be fun to make. But we are allowed to make the poster anyway we want, so long as all the dope about the play is on it."[29] He finished his Dos Passos poster a day late, on 2 April, but in time enough.

"Fine Arts is getting more and more interesting," he wrote,

although Howard [Fisher] says the course I am taking is one of the dullest he took. Professor Pope has been talking to us about modern schools of painting. He says it is wrong to think they are mysterious or un-understandable, because usually they are much easier to understand than older schools. Usually queer modern paintings are merely patterns. He said artists have recently had the idea of making "pure" art as music is "pure," that is, it doesn't imitate or resemble any sound in nature, but of course it is harmonious. He [Pope] criticized Expressionistic art as not expressing anything, the expressionism is almost always accidental. Then he showed us Japanese prints and Chinese paintings that are truly expressionistic. There when the artist wants to represent, for instance, an actor in any

angry mood, he used straight short angular lines in drawing him. And the expressionism in The Cabinet of Dr. Caligari *was truly expressionistic.*

He also told us that at Harvard they have tried to revive the methods of teaching painting that were used in the workshops of the Renaissance masters. He doesn't like the idea of teaching you to paint by merely trying to approximate each individual tone in nature. He wants us to choose our colors first, so that the picture will be harmonious and have more unity.

Dr. Rose of the Harvard Fine Arts department has worked out scientifically a great number of palettes and has painted a few pictures to show how a great deal can be expressed by using few colors.[30]

By early April Porter had duly absorbed and was explaining to his parents the Harvard fine-arts theories on artistic quality. The school's interest in reviving the painting techniques of the Old Masters perhaps contributed to his receptivity to the analogous ideas of Jacques Maroger, with whom he would study in New York after World War II. He also acquired, or was at least encouraged in, an appreciation of oriental art; during his life he owned a variety of Japanese prints. The tolerance for abstract art was probably also healthy for Porter, whose favorite artist at this time was Rockwell Kent, whom he associated with Maine and landscapes.

The idea of selecting a limited number of colors and regulating his palette according to an a priori theory of harmony was directly opposed, however, to Porter's mature style of painting after the mid-1950s. In this same letter home of early April 1925, Porter credulously reported another newly acquired dictum that within two decades would come to seem anathema: "Too much painting from nature cripples your imagination, according to Professor Pope. Holbein never painted his portraits from life; he made a pencil sketch in one sitting and painted the portrait from that."

By the end of his freshman year, Porter was satisfactorily ensconced in the Fine Arts Department and submitted to the college a proposed curriculum for the next three years, including eight more courses in the department; he proposed to fulfill the college distribution requirement for literature with two years of French. After Pope's theoretical class in his first year, Porter elected mostly art-history courses. Very few studio courses were offered, and he later recalled that he was more interested in art history at that time anyway. He particularly enjoyed a course with Arthur Kingsley Porter on pre-Romanesque art.[31]

Porter arrived with his parents and family on Great Spruce Head Island that summer on his birthday, 10 June 1925. His collegiate neglect of his appearance had been the cause of much affectionate ribbing until he betook himself to the barber for a proper haircut. Ruth Porter wrote to Nancy Porter Straus, "Of course he let the barber shave him far too close so that from looking like Paderewski he began to look like an inmate of a penitentiary. But how sweet he is! He was 18 yesterday & expected nothing."[32]

Fairfield Porter's first year at college noticeably developed his interest in art. While Eliot was replacing their father as chief engineer on the island, Fairfield took charge of "the art line." He took down all the black-and-white geodetic surveys that James Porter had tacked up (leaving only some of constant reference)

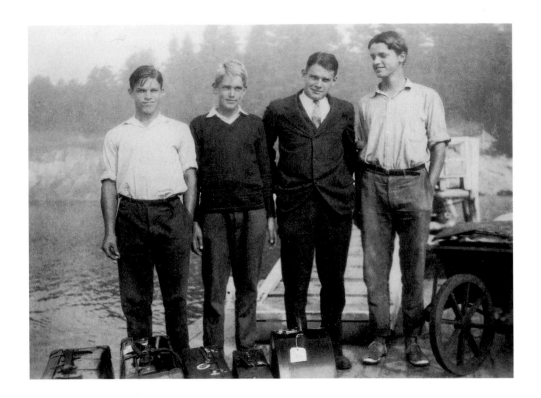

The four Porter brothers on Great Spruce Head Island, 1925. From left: Edward, John, Eliot, and Fairfield. Eliot, in city clothes, was evidently returning to Boston.

and replaced them with posters of Norwich, Lincoln, and York Cathedrals and other photographic souvenirs of the family's voyage to England the summer before.[33]

In July John Porter's tutor in Latin and French, a Mr. Woodberry, visited the island. A cordial, middle-aged man, Woodberry had trained to be a painter in Paris and now taught mechanical drawing at Morristown preparatory school. Fairfield enjoyed sketching with him, and they made plans to buy some paints at the next shopping expedition to Camden, on the mainland, which perhaps can be taken to mean that Fairfield had not often painted on the island before then. Eliot was working hard on constructing a darkroom and so could not participate in the nightly games of bridge. On 9 July Ruth wrote her sister Margaret Furness that Fairfield was "sticking at sketching and sometimes does rather nice things." Indeed, she added, "Mr. Woodberry and Fairfield are growing positively hectic over sketching & Fairfield's room is plastered with his works of art."[34]

Fairfield stayed on Great Spruce Head Island through September, after the autumn rains had arrived, and then returned to Harvard to begin his second year. His letters from college for the first time are chiefly concerned with topics of art and art history, though references to his own paintings are infrequent. He showed some of his island sketches to his Boston aunts, who approved them. "Aunt Rebe said she was afraid she wouldn't like them," he wrote, another sign that he had probably not painted much before that time.[35]

In October 1925 he chose El Greco for an essay topic, writing mainly about the artist's famous portrait *Fray Hortensio Félix Paravicino* in the Museum of Fine Arts, Boston. "The only picture I had to go by was that one, as I hardly know at all the many El Grecos in the Art Institute. I had to read a book on him and look at

photographs of his pictures, and so I have a feeling that what I wrote is largely hot air. I don't entirely believe what I said."[36]

His tutor liked the El Greco essay, though, and assigned him a similar study on Monet, which also turned out well. By November, Porter had decided to write about "contemporary Americans, after I have read up and written on Degas and Manet, to give me a basis for the rest of the French Impressionist school. When you are interested in an artist," he informed his parents, "usually your tutor has you find out all you can about related artists in the same school. After the Christmas vacation I am going to write a criticism of Rockwell Kent. This choice of a contemporary American quite pleased [the tutor] because he likes the Drawings in Wilderness very much too." Porter's tutor had the view that contemporary American art was the only "sincere and good art of all Modern Art."[37]

Modern art was a sore subject at Harvard during the 1920s. Arthur Upham Pope's liberal appreciation of abstraction (which he favorably compared to jazz) and Paul Sachs's of modern French painting were more than matched in vehemence by the reactionary views of Dr. Denman Ross, collector and professor. John Walker has written that Ross was the "leading and most influential opponent of the modern movement" as well as "one of the greatest connoisseurs America has produced, and a collector whose judgement in every field except contemporary art has enriched the Museum of Fine Arts, Boston, and the Fogg [Harvard's art museum] with superb treasures."[38] In early December all the students concentrating in fine arts were invited to Ross's home to view his art collection.

The sobriety of the occasion was possibly lost on Porter, who voiced some skepticism of Ross's presentation:

Denman Ross is a high muck-a-muck in the Painting World . . . He is the man whose theory of color design rules the teaching of painting at Harvard: the theory which in brief advocates painting a picture with colors which make a pleasant combination. But it is more complicated than that, as I hardly understood his terms and some of what he said went over my head. But it appears that he has developed his theory so far beyond his textbook that is used in advanced Harvard courses on design, that it is quite out-of-date.[39]

According to Porter, "Dead silence reigned when Ross ceased talking . . . Going away one boy remarked on the broken antiques and the general mess in his rooms. 'How does that go with his theory of order to design?' he asked."

Shortly before Christmas vacation in his sophomore year Porter wrote to his mother that he had painted a sketch of "the fog rushing over Colts Head and Little Spruce Head as you and I saw it that day on the island. It was quite successful considering it was completely from memory."[40]

Once the second semester had started in January 1926, Porter had to address himself to his essay on Rockwell Kent, which was now a week overdue. His choice of artist struck most of his teachers as peculiar. "I asked Mr. Mower, my drawing teacher if he could tell me anything about Rockwell Kent I could use for a tutorial essay. "Nope. Not a thing," he said. And when I asked Professor Pope, he asked, "Why Rockwell Kent?" He also had never seen any of his drawings of Wilderness or

Voyaging [two illustrated books by Kent] and said he would like to . . . I showed Professor Pope Wilderness and Voyaging and he would say to each drawing that it was great or very swell in an insincere way. But I think he liked them, and merely finds it hard to be enthusiastic when it seems expected."[41]

It may be that Porter's appreciation for Kent, famous mainly as an illustrator, was naive. On the other hand, his regard was not isolated, even if reached independently. Another Harvard undergraduate in 1926, Lincoln Kirstein, who was "disgusted with the mediocrity" of Harvard's literary magazine, decided to start a review that would be an American counterpart to *The Criterion,* edited by T. S. Eliot. Kirstein called his journal *Hound and Horn* and featured contributions by Yeats, Pound, Eliot, Gide. John Walker, who took a part in the new magazine, later recalled, with some chagrin, "the secrecy and excitement involved with selecting the format of the magazine. Lincoln showed me triumphantly the cover design, which he had commissioned from the artist he considered the best graphic designer of our time—Rockwell Kent! Obviously we were not as sophisticated in 1926 as we thought."[42]

On Porter's behalf Arthur Pope telephoned a John T. Spaulding of Boston, whose large collection of paintings included a Rockwell Kent, and asked if he could bring Porter by one afternoon to see it.

> *A butler in a shabby tux let us in. His collection was very nice, mostly French Impressionists and fairly modern French paintings and a Henri and a Bellows. Downstairs Mr. Spaulding and Professor Pope and a friend of Spaulding's in spats talked about pictures and collections and things they would like to buy in much the way people talk about radio sets. He showed us a very excellent Degas he had just bought. The Rockwell Kent was upstairs. I liked it very much; it was a snow scene on Monhegan"* [i.e., a Maine landscape].[43]

The gentlemen were amused, perhaps, at Porter's enthusiasm for Kent and Robert Henri and George Bellows. The Spaulding collection that Porter saw that day also included some of the finest pictures in America by Cézanne, van Gogh, Renoir, and Degas. Since 1948 John T. Spaulding's legacy of nearly one hundred modern French paintings to the Museum of Fine Arts, Boston, has been one of the pillars of that excellent public collection.

For his midterm exams in the spring semester Porter studied harder than ever before. He wrote his mother that he was "disgusted to get exactly the same marks as always: Biology C, Fine Arts (The History of Ancient Art) C+, Drawing B, History C."[44]

During the summer of 1926 Ruth Porter was visited on the island by a classmate whom she had not seen for twenty-eight years. Her college friend had "married a Japanese who did not support her perhaps because poetry does not pay, and she has two children, a boy who is a sculptor in New York and a girl at school there."[45] To support herself, Leonie Gilmour arranged impromptu sales of Japanese embroideries, jewelry, and prints. She had lived and taught English in Japan for fourteen years, during her marriage to the poet Yone Noguchi. Fairfield enjoyed her talk of art and artists and impressed everyone with his knowledge of

Japanese prints. Gilmour's twenty-one-year-old son, the sculptor Isamu Noguchi, was on the threshold of his career and as yet completely unknown.

The Maine house was filled to overflowing that summer; family and guests numbered fifteen. Some significant improvements designed by James Porter had been constructed during the family's winter absence. The caretaker's year-round house, called the farmhouse, had been removed and replaced by a handsome replica of a colonial house that James had seen in Searsport, Maine. The new farmhouse was furnished with a "pump at the sink in the kitchen and a w.c. in the cellar so you can see how grand we are," Ruth wrote to Nancy Porter Straus, on 21 June. But the new bridge over the cove (with improvised function as a diving platform) was a disappointment to James. "Although Japanese in design, it rears itself like the Brooklyn Bridge over the cove at low tide."

In addition to swimming and boating, physical fitness, one of James's abiding concerns, was promoted on the tennis court. Soon after the family's first summer on the island, he had built a concrete tennis court in a clearing in the woods. The unloading of the concrete slabs had given rise to local rumors—it was during the First World War—that the newcomers on Great Spruce Head Island were German spies who were busily constructing a secret gun emplacement.[46] In his habitually serious manner of speaking, James Porter had responded in 1920 to the twenty-fifth anniversary report for his Harvard class of 1895, writing, "Next to climbing mountains my keenest out-of-door pleasure has been tennis. I have found that a cement court is perfectly possible, and does not pound your feet unduly, as I had always supposed it would. Every Saturday afternoon and Sunday morning, the year around, weather permitting, I play tennis."

In the evening discussions, religion and the Creation were favorite topics, as always. In early July Ruth wrote in a letter, "We had an excitement last night at the Bridge table when Fairfield announced that he was not a mechanist. Nor will he admit to the horrid charge of being a vitalist which is all that is left for him according to James. He is a straight agnostic."[47] The Porters' unorthodox views on God usually amazed their acquaintances. When Fairfield was at Milton Academy, his roommates were much surprised and a bit envious that he had never been to church.[48] In October of his sophomore year at Harvard, in 1925, Porter had written home, quoting a friend who had said that "college makes of almost everyone an agnostic or an atheist, but that his parents would be sorry to think he was. So I said proudly that Daddy would be as displeased if I got any religion."

The 1926 summer reading included Joseph Conrad's *Victory*, which Ruth read aloud to Fairfield and John, and then *A Tale of Two Cities*, read to John alone, who was not quite sixteen. Fairfield subscribed to *Time* and read "high-browed periodicals like the Dial, and all the scientific and liberal weeklies that pour in three times a day" (depending upon the comings and goings of guests and provisions).[49] The family followed with interest all the writings by and about their cousin T. S. Eliot that appeared in *The Nation* and *The New Republic*. Fairfield had met Henry Eliot, the poet's brother, at a tea given in March by his Little Aunts in Boston.[50]

Back at Harvard for his junior year, Fairfield enrolled in a philosophy course with Alfred North Whitehead, who he had heard was "the new prophet at Harvard."[51] He later remembered Whitehead the man more clearly than the content of

his course. When as an adult he reread Whitehead's *Science and the Modern World,* he was sufficiently impressed to borrow several of Whitehead's observations for his essays and lectures on the opposition between scientific and artistic perception.

The next summer, in 1927, Fairfield and Edward Porter went abroad for a walking tour of France. In Paris in July they arranged to meet their brother Eliot, who was overseas on his honeymoon. Then Fairfield's travel plans were changed by the remotest of coincidences: one day in Paris, when Eliot and Edward were out on their own, they ran into Arthur Fisher, one of their neighbors from Winnetka. Fisher was stopping in Paris en route to Russia with a group of American journalists, economists, and labor leaders (and even the superintendent of the Winnetka public schools). Eliot ventured that he knew Fairfield would like to see Russia, and it was arranged that he would go along with the group, paying his own way.[52]

Air travel to Eastern Europe was an arduous affair. On 13 August Fairfield informed his mother of his change of plans in a letter mailed from Riga, where he was stopping for a few minutes during the fifteen-hour flight from Berlin to Moscow. The departure had been at three in the morning.

In Moscow Arthur Fisher and most of the people in the group became ill with intestinal disorders, and Porter ended up helping with some of the scheduled interviews on behalf of the American trade delegation. "Moscow when I first arrived seemed like the craziest sort of city you could imagine. The church on the Red Square [St. Basil's Cathedral] that was built under Ivan the Terrible who put out his architect's eyes afterwards, Stuart Chase described as Coney Island gone crazy . . . The people look moderately poor, and there are really only two degrees of wealth. The ordinary populace and the beggars."[53]

The group, including Porter, met with Leon Trotsky. A notebook that Porter had in Europe with him, containing a pencil sketch of Trotsky, is today in the possession of Anne Porter. Porter wrote home afterward from Berlin: "Trotsky was smooth and charming and clever. We spoke directly to Trotsky and he answered through an interpretor, but if the interpretor gave the wrong English word he interrupted with the exact one. The questions were written and the first six, which were about Trotsky's differences with the party, he refused to answer. The most interesting question ran: 'There being no civil liberties in Russia, how can it be said that 85% of the population support the present government?'"[54]

Leningrad, Porter thought, was even shabbier than Moscow. Although Russian literature had predisposed him to Russians, he was not impressed by the Soviets, who he felt had concocted a bogus new religion. "Communists on the whole are impossible to talk to, they quote Marx and Lenin like the Bible. They might as well say: There is no God but Marx, and Lenin—his prophet. They only draw the line at crossing themselves before all the numerous busts and portraits and statues of Lenin . . . I now hope to go back to Russia in maybe 5 years to see how much it will have changed."[55]

In all Porter was about five weeks in the Soviet Union; one of the highlights was a visit in Moscow to the Shchukin and Morozov collections of modern paintings. After Leningrad the American party traveled south to the Crimea, where they stayed in a sanitarium that also served as a vacation spot. Porter drew some

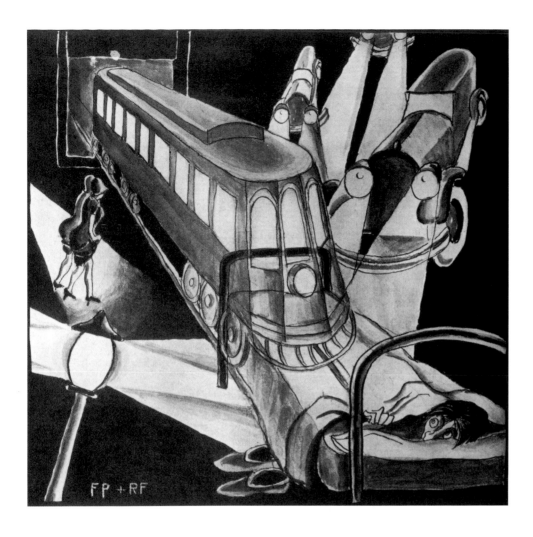

That First Night in Mowrer Hall. 1927. Ink illustration for the *Harvard Lampoon*, 3 November 1927

sketches while he was on the Black Sea, which he used to paint a small picture of an island. *Black Sea* is one of the earliest surviving works by him; if not for its title it could easily be mistaken for a view of one of the Maine islands.

The return from Russia, which he began on 14 September 1927, was even more grueling than the voyage out.

I flew out yesterday with Arthur [Fisher] as far as Konigsburg, the plane didn't go farther because it was raining and there was a head wind. As Arthur says, an airplane trip is pretty severe punishment. We spoke of it in terms of hours the way the Crucifixion is spoken of. The 8 hours from Smolensk to Konigsburg without the usual stop in Kovko, Lithuania, was God awful. You can only sit still in your seat on the verge of airsickness and hope that you won't be really sick.[56]

Registration at Harvard took place on 26 September 1927 without Porter, who was still on board a transatlantic steamship.[57] He was a few days late registering for his senior-year courses in anthropology, European history since 1815, and the history of the Renaissance and Reformation.

That last autumn Porter drew a cartoon about the perils of dormitory life that

was published in the *Harvard Lampoon* of 3 November 1927. Titled *That First Night in Mower Hall, or, That Massachusetts Avenue Bedroom,* the drawing was jointly signed "FP + RF" (perhaps his friend Russell Foster). The modernist style of this drawing is reminiscent of Porter's description of the scenery for the Dos Passos stage production he had worked on in his freshman year. His only existing picture from his Harvard days is a watercolor, *Roofs of Cambridge,* dated 1927. It may possibly be the watercolor that Porter sent to a college art exhibition held in October and November of that year. The straightforward descriptiveness of this simple cityscape is closer to American Scene painting than to the modernist tradition. Porter evidently appreciated the direct, clear vision of this *Roofs of Cambridge;* it was the only pre-1948 picture that he included in his 1974–75 retrospective exhibition at the Heckscher Museum in Huntington, New York, and indeed he discarded most of his pictures from this period of his life.

Senior year at Harvard required more than the usual quota of social rounds, which Porter had never delighted in. After dinner at the Coolidges' one evening, everyone went to see Ethel Barrymore acting in *The Constant Wife.* Porter thought the play "conventional and dull but I always like Ethel Barrymore. I drew a few rotten sketches of her."[58] Another time he faithfully reported home about an afternoon with his relatives: "The tea was like all teas a strain, but not quite as much as those at the Kingsley Porter's [a distinguished art historian on the Harvard faculty] on Sunday afternoons. Mrs. Porter keeps separating you from the person you have just begun to be inane with, saying, 'Now you've talked together long enough.'"[59]

Porter's habitual casualness about class attendance and assignments got him into serious trouble only days before he was due to graduate. A tersely worded notice was sent to him on 15 June 1928: "Dear Mr. Porter, I am sorry to inform you that since you were absent from the final examination in Anthropology 16, it will not be possible for you to receive your degree."[60] Eventually Porter and the registrar reached an agreement allowing him to return to Cambridge in October to make up the final exam, which he had skipped under the mistaken impression that seniors had been exempted from it. When he duly completed the exam, he was retroactively graduated with his class of 1928. He earned a bachelor of science degree at Harvard, meaning that he had not taken the Latin courses required then for a bachelor of arts degree.[61]

While at Harvard, Porter had made occasional trips down to New York City and visited some artist friends who were studying or had studied at the Art Students League there. He liked what he knew about the League: the students were essentially independent and the atmosphere of the place did not strike him as academic. He liked especially that the people who were teaching at the League, Boardman Robinson and Thomas Hart Benton, for example, were professional artists, not just teachers of art.[62]

In autumn 1928 Porter moved to New York and enrolled at the Art Students League. For a young man only twenty-one years old, he had an exceptional grounding in literature and in the history of art; as a painter, he was by comparison a complete beginner. Of his two years at the League, he subsequently remembered only his studies with Robinson and Benton. John Sloan also taught at the League in the 1920s, but Porter said later that he had not worked with him (although his

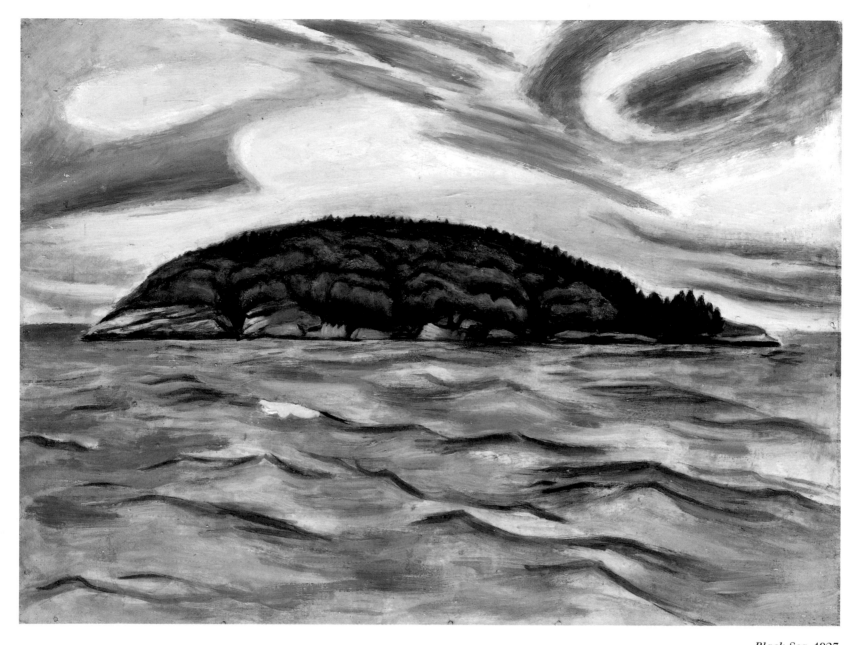

Black Sea. 1927

friend Frank Rogers wrote in 1932 that Porter had been with him in both Robinson's and Sloan's classes). Porter's time at the Art Students League overlapped with the emergence of both Robinson and Benton into the front rank of the American art world. Robinson effectively inaugurated public mural painting in America with his ten murals, *The History of Commerce,* for the Kaufmann Department Store in Pittsburgh. Executed between 1927 and late 1929, nine of the murals were presented at an exhibition in the Art Students League Gallery before their installation in Pittsburgh. Benton was himself on the verge, in 1930, of completing his own cycle of murals for the New School for Social Research (now in the Equitable Building, New York).

Porter recalled that his instruction at the League mainly consisted of life

classes and drawing after models, with little or no attention afforded to painting. He liked Boardman Robinson best, because "he was a teacher, that is he taught *you.* He didn't teach a system. He taught the person he was talking to . . . I listened to his criticisms as he went around the class. There were certain things that he said again and again but there was always something new."[63]

On the other hand, he chafed against both the method and the personal manner of Thomas Hart Benton. "Benton had a system which he could present to you and he presented the same system to everybody. And then you did it or not." In Porter's telling, Benton professed that visual reality could be boiled down to "hollows and bumps."[64] Some awkwardly Bentonesque figure studies in oils on canvas (Parrish Art Museum, Southampton, New York) must have been painted by Porter while at the League. He thought that Benton was intellectually narrow and insincere: "Benton's style as a man was that there was a body of knowledge and it is three feet long and three feet wide and one foot thick, and that's it."[65] The artist was tiresome because "he liked to pretend, he liked to act as though he were completely uneducated and, you know, just the grandson of a crooked politician." It seems somehow paradoxical that Jackson Pollock, who likewise studied at the League in these years, attached himself to Benton and faithfully imitated his mentor's style. Ten years later, Pollock successfully cultivated the myth of his own unruly individuality.

One interesting painting by Porter from the League is known. The subject is appropriately urban and like New York: a small, dark scene, called *Subway,* painted on canvas over a Masonite panel. Porter's name is inscribed on the back of this picture, along with "Benton Class 1930." Neither the style nor the colors are reminiscent of Benton, however. There is a modernist tendency to translate all the forms into lines and curves, but the painting has an unsentimental, even grimy realism at its heart that sets it aside from standard American Scene interpretations. The representation of a subway was precocious at this date; by mid-decade, many other painters, including the young Mark Rothko, had been struck by the societal and technological relevance of the subject.

Many years afterward, Porter's recollections of his classes at the League were at best ambivalent. To be fair, he later concluded that the shortcomings in his preparation were due as much to the generally backward state of American painting in the 1930s as to what the League did or did not offer him. "Nobody taught painting there. I mean you could paint if you wanted to. But they didn't know how to paint. There wasn't anybody in the League who knew how to paint . . . I don't think anybody in America knew how to paint in oils at that time."[66]

In his own way, Porter was referring to the bland and curiously hybrid style of painting that predominated in America between the wars and prior to the revitalizing influence of emigré painters from Europe—principally, in his opinion, Willem de Kooning. With notable exceptions, especially among the painters shown by Alfred Stieglitz at his 291 gallery, American painters of the 1920s and 1930s continued to paint in a socially conscious or anecdotal vein descended from the Ash Can school, combined with various nods and winks at modern art as practiced in Paris. Benton's "hollows and bumps," for example, were the almost unrecognizable offspring of Synchromism.

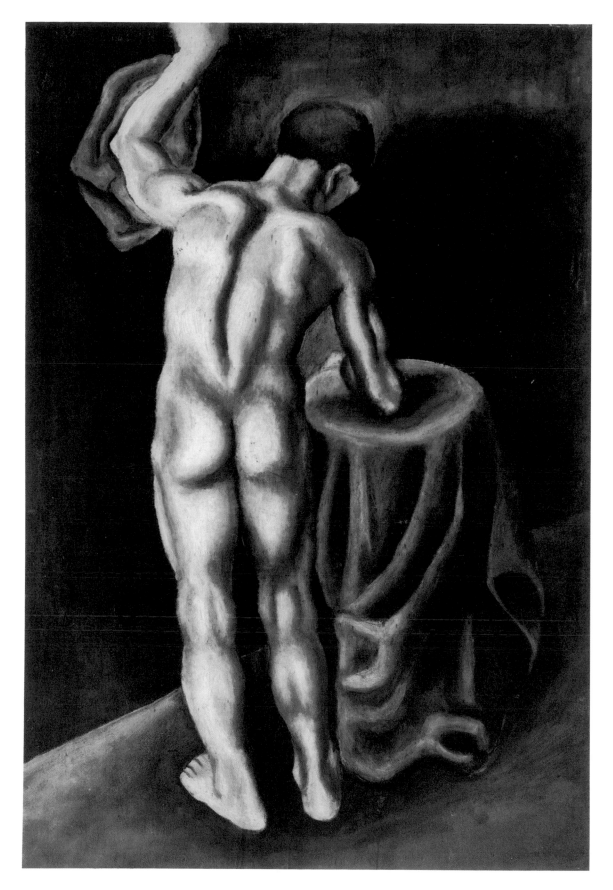

Male Nude. c. 1929

In an interview in 1968 with Paul Cummings, Porter offered some provocative and original interpretations of this epoch in American art. He averred that the celebrated Armory Show of 1913, which first exhibited the post-Impressionists and other moderns in America, "was a complete disaster to American art," because it made painters think that they immediately had to abandon what they had been doing and switch over to a new style that they did not fully understand. "It was a little bit like selling whiskey to the Indians."[67] The only exceptions to this rule as far as Porter was concerned were John Marin and the artists associated with Alfred Stieglitz. Porter agreed with an analysis he had once heard expressed by Virgil Thomson, that intellectual life of America during the 1920s was dominated by journalists and not by artists, as in Paris. As a result, Porter said, American painters between the wars were dependent upon journalism and on cartoonists in radical publications such as *The Masses* and *The New Masses* for their "connection" with the world.[68] Boardman Robinson, for example, was most widely known, prior to his success with *The History of Commerce,* as a political cartoonist. Radical journalism certainly filtered Porter's own viewpoint on art during the Depression.

Porter was a student at the Art Students League until 1930; he was living in a rooming house on Fifteenth Street, together with two nonartist friends: Wendell Reynolds, whom he had known since his year at Milton Academy, and Hans van Neeren. His activities in early 1931 are not known, other than that he and Alex Haberstroh, his best friend from the League, hoped to exhibit their paintings and thus begin their careers. A dealer named Daniels showed some interest in Porter's work, but nothing came of it.[69] A Maine watercolor of the Barred Islands that has always been in the collection of his brother John is datable to about 1930.[70] This early watercolor is reminiscent of Rockwell Kent; its touch is delicate and luminous, but somewhat tentative.

One weekend in May 1931 Porter took the train to Bryn Mawr College, in Pennsylvania, to visit Dorsy Gerhart, a Winnetka friend, and to accompany her to a glee-club concert. Gerhart invited Anne Channing, who was in her sophomore year at Bryn Mawr, to come along on their date. Porter and Anne Channing, of Sherborn, Massachusetts, knew each other slightly because Anne's older sister, Barbara, had been the Bryn Mawr roommate of Marian Brown, Eliot Porter's fiancée. They had also met because of the Channing family's friendship with the Fishers, the Porters' neighbors in Winnetka. Once, during Fairfield's Harvard years, Anne Channing had visited Winnetka and stayed at the Fishers' house. She remembers that something her hosts said about Porter made her feel sympathetic toward him, even before they had met. They told her, "He wants to be a painter—he's only nineteen—but how can you decide to be a painter when you have no talent?"[71] To Anne this young man sounded self-reliant, not foolish. During the summer of 1931, Anne and Barbara Channing were guests of the Porters on the Maine island. After Porter went overseas that autumn, he wrote letters to both sisters.

Two years after the stock-market crash of 1929, America offered few opportunities to fledgling artists and in any case Porter must have considered himself only partially prepared. He decided to accompany his mother to Italy in the summer of 1931 and then to stay in Europe for a year after her departure, in order to improve himself. He wanted to see as many of the world's great paintings as he possibly

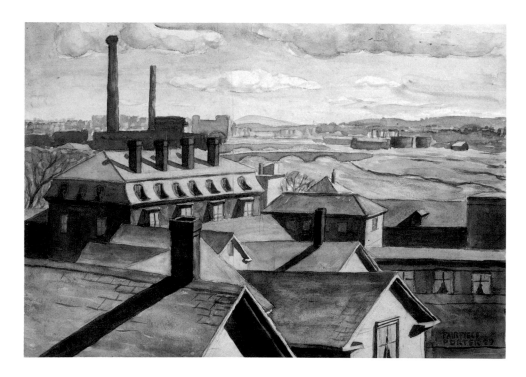

Roofs of Cambridge. 1927

could and he also wanted to study languages. His interest in the Old Masters was no doubt encouraged by conversations he had overheard at the Art Students League. Boardman Robinson said of those years, "Benton and I spent afternoons analyzing the old masters' compositions: El Greco, Rubens, Titian, Tintoretto and Rembrandt. Rubens greatly appealed to Benton: Rembrandt to me."[72]

Porter sailed with his mother, on the SS *Conte Grande* from New York on 11 September 1931 and disembarked in Genoa on the twenty-second, after overnight dockings in Palermo and Naples on the twentieth and twenty-first. While in Milan for several days, the Porters saw Leonardo's *Last Supper;* Fairfield said that Leonardo's masterpiece had "as much pathos as the acropolis."[73] The Porters moved efficiently by train across northern Italy, stopping in Mantua and Verona, where Porter very much liked the primitives in the *pinacoteca.* They arrived in Padua on 2 October and immediately went to see the Giotto frescoes in the Arena Chapel and Mantegna's frescoes of scenes from the lives of Saint James and Saint Christopher in the Church of the Eremitani (the latter were destroyed in 1944). Porter returned to the Arena Chapel on the next day and the next, profoundly impressed. (Afterward, he always kept details of Giotto frescoes tacked up on the walls of his Maine and New York studios.)

On 4 October, the Porters proceeded to Venice. They stayed a full week, energetically touring. Often Ruth Porter rested in the hotel while her son kept up the pace. He commented unexpectedly, even enigmatically, that a Giorgionesque painting of *Apollo and Daphne* that they saw in the Seminario Patriarcale was "like an Arthur Davies—only better." While in Venice Porter wrote a letter to Anne Channing to encourage her on her recent transfer from Bryn Mawr to Radcliffe.

The train from Venice to Ravenna on 12 October was stopped dead on the tracks for five hours near Ferrara; the Porters shared a carriage with some amica-

ble Italians, including a parish priest who was "quite grieved" that they were not Catholics. "'Protestant?' 'Yes,' from me," Ruth wrote in her diary. "Fairfield says that the next time he will say no, Atheist."

From Ravenna, Porter and his mother traveled south into the Marches, passing through Rimini, Pesaro, Urbino, and Arezzo, taking care not to miss any of the paintings by Piero della Francesca. Late on 17 October they reached Florence, where they had reserved rooms at the Hotel Roma in Piazza Santa Maria Novella. A few days later they moved to the Pensione San Giorgio, on the Arno river, because they wanted to establish Fairfield in a suitable place for the winter or longer. Their rooms overlooked a lovely garden and were comfortable, although lacking running water. With Florence as their base, the Porters made day trips into Tuscany, visiting Prato and Pistoia one day, Lucca and Pisa another. Actually, they did not have a moment to go inside the church of Santa Maria Novella until 27 October; there they admired the Duccio altarpiece, *The Madonna Enthroned* (since relocated to the Uffizi Gallery), and the frescoes by Domenico Ghirlandaio, which Ruth Porter especially liked for being "such nice portraits of his contemporaries," a sphere of art in which her son, of course, would one day excel. On 29 October she departed Florence on the afternoon train to Naples, from whence she sailed back to the United States.

Porter's immediate program once he was on his own was to paint copies in the museums. He started at the Palazzo Pitti with a copy in tempera of Raphael's famous portrait *La Donna Gravida*. Within a few days he moved to a different pension, the Casa Bertolini, on the urging of John Walker, whom Porter seems to have encountered by chance. Walker had graduated Harvard in 1930, also in fine arts, but with a brilliant record in his art-historical studies and the highest possible recommendations. In this same autumn of 1931 he had just arrived in Florence with a letter of introduction from Paul Sachs at the Fogg Art Museum and the hope that the art historian and collector Bernard Berenson would take him on as his research assistant at his villa, I Tatti, outside the city.

Walker, with his "charming responsiveness and quick sense of humor," immediately fit into the Berenson circle, which was the epicenter of Italian Old Master scholarship at that time.[74] No connoisseur or historian of Italian painting could rival Berenson's international reputation, or indeed his erudition. Walker was therefore enjoying this autumn a personal triumph, and Porter was genuinely pleased both for his friend's success and for his own good fortune in meeting up with him. Writing home about life in the Casa Bertolini, he noted, "John Walker is very rarely here because he spends weekends with the Berensons and has much social life. He is always gay and kind . . . Through John I have extended my social life and I have had dinner twice in the house of Baron and Baroness Anrep."[75] Baronessa Alda von Anrep was the sister of Nicky Mariano, the indispensable confidante and librarian to Bernard and Mary Berenson.

Through Walker, Porter was introduced to the Berensons, who invited him to I Tatti several times for lunch or tea. In his enthusiastic way, Walker subjected his friend to a steady dose of Berensonian aesthetics, which Porter of course had already encountered at Harvard, Berenson's adoring alma mater. The connoisseur had prescribed for Walker an exhaustive itinerary of altarpiece and fresco studies

like that which Berenson had used to hone his own eye in Italian painting. More often than not, Porter went along with Walker and sometimes other companions in Walker's Ford, traversing central Italy, following in Berenson's footsteps and doing their best to imagine the great man's words and thoughts at every step. Years later, Porter said that he could never afterward look at Florentine painting without recalling Berenson's terminology.[76]

The list of their destinations in November alone is immense (and is doubtless incomplete, at that). Porter wrote his mother from Rome that they had recently gone to "many hill towns: Montepulciano, Cortona, Pienza, and many others whose names I have forgotten. They all have museums and good pictures." Porter's comments on Luca Signorelli's famous frescoes in the Duomo of Orvieto contain a hint of Berensonian stylistic analysis: "The Signorelli's disappointed me rather . . . they're good in drawing and composition of objects and not extraordinary in color or values."

Through Walker, Porter became acquainted with the Anreps, with Count Umberto Morra di Lavriano and Count Guglielmo degli Alberti—in short, with all the leading characters in the Berensons' circle of intimates. Yet, commendably, Porter did not lose himself in the heady social and cultural atmosphere of Bernard Berenson and Villa I Tatti. He was able to observe the Berensons with detachment and with neither envy nor resentment at their considerable attainments. He explained the situation to his family:

> I have the impression that the summit of Italian society is Bernard Berenson. He is certainly the top of a certain intellectual-aristocratic society that includes Americans and Italians. When friends of Berenson's talk about each other, they criticize each other's remarks and conduct, they say so and so doesn't know how to grow old or so and so has been rather stupid of late in her or his remarks at the Berensons', or Berenson says that such and such callow youth whom they all know has more brains than Kenneth Clark, an Englishman who writes on artistic subjects [and who had lately fallen out with Berenson]. But they never criticize Berenson's (or Mrs. Berenson's) remarks. They mention them and then agree or tacitly disagree . . . Alberti calls Miss Mariano, B's secretary, "Custode del luogo sacro."[77]

At the end of November 1931, Porter and Walker drove to Siena and San Gimignano over a weekend for intensive sight-seeing. Despite his pleasure in the exercise, Porter was now aware of distinctions between his approach and his friend's. Without perhaps realizing it in himself, Porter and Walker differed amicably because Porter looked at the mass of art that the two were absorbing as a painter inevitably will: against the backdrop of his own artistic sensibility. "I don't admire Sienese painting very much more than before. John does because his taste is a critic's taste and very catholic. It comes from his Harvard and Berenson training. I do not like the little man on horseback by Simone Martini [the *Guidoriccio* fresco, Palazzo Pubblico, Siena], except in parts. I like the barren landscape. I like the way only what is necessary to tell the story is given and nothing else."[78]

Most days Porter was at his easel, working on his copies. He had a steady

Barred Islands. c. 1930

companion for cold lunch in the copyists' room at the Palazzo Pitti, Elizabeth (Tissie) Nottingham, whom he knew from the Art Students League. After his Raphael copy, he started on a Pesellino in the Uffizi, "doing it badly but learning a good deal," he wrote his mother on 12 December. He had recently drawn the Michelangelo sculptures in the Medici tombs in San Lorenzo.[79]

Meanwhile, Porter was undertaking a project that was perhaps incongruous within the Florentine ambient. He had found someone to give him Russian lessons, and he was working hard on a series of drawn illustrations for *The Possessed*, Dostoyevsky's great novel of 1872. The Porter family had a long-standing admiration for Russian literature, which was often read aloud in Maine. In 1971 Porter said: "Of all the books and poems I have read about places, those that meant most to me in this respect have been Russian novels and poems . . . The 'places' in English literature are not nearly so real to me as those in Russian books . . . It is, as in Russian books, very much the reality of the people for me that makes the place real. A Russian novel at its best is like one's own life: an English novel is literary."[80] In December Porter wrote home that he had prevailed upon his friends to pose for his Dostoyevsky illustrations: "I talk Italian to the Oxford student Arthur Giardelli (a Britisher with an Italian grandfather). He posed for a Kirilov. I also got John Walker to pose for a drawing of Kirilov and Pizoli Stefanovic."

It is reasonable to assume that Porter was aware that his favorite teacher, Boardman Robinson, was coincidentally working on illustrations for an edition of *The Brothers Karamazov* by Dostoyevsky, which was published by Random House in 1933. Robinson's illustrated edition of Dostoyevsky's *The Idiot* was published in 1935. Porter filled a notebook with his analysis of *The Possessed* and carried the project through to the realization of a lithograph, which he had printed in Rome, apparently in early 1932. Although no one could claim to recognize Porter's hand in his Dostoyevsky lithograph, the unpretentious draftsmanship has an undeniable verve and the work is infused with a distinctly thirties period charm.[81]

In January 1932 Porter traveled north of the Alps on a tour of the great picture galleries of Europe, beginning with Vienna. While in Berlin he wrote to Anne

Rome. 1932

Channing, who was studying philosophy with Whitehead at Radcliffe: "I took a course with Whitehead out of which I remember chiefly Whitehead . . . I went to his house a couple of times to listen to him talk." Berlin he thought looked rather like New York. Vienna seemed not unlike Chicago.

Porter managed to see the Old Master collections in Dresden and Munich before exhaustion and winter cold persuaded him to return to Italy. It was just before returning south that he bumped into Frank Rogers, from the Art Students League, in Munich and discussed art with him while waiting for a train. On the previous day, 11 February, Porter had written a letter containing his thoughts on all he had seen and learned in Germany and Austria. Both Rogers's and Porter's letters give the impression that Porter had used this intensive immersion in master

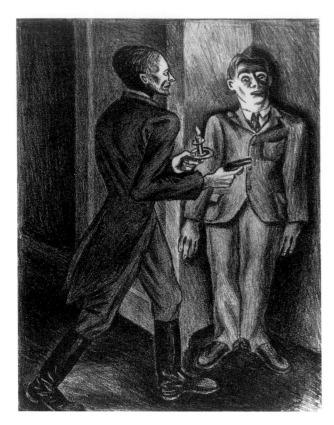

Illustration for *The Possessed* by Fyodor Dostoyevsky. c. 1931–32. Black-and-white lithograph, sheet size: 12⅞ x 9¼"; image size: 11½ x 8⅝". Collection Mrs. Fairfield Porter, Southampton

paintings as a mental laboratory for testing and refining the diverse body of lessons and tastes that he had absorbed at Harvard, the Art Students League, and in Florence. His interest in distinguishing between master and workshop was of course one of Berenson's main concerns.

> *I am getting to be quite an expert on Rubens; I think I can tell what he did himself and what his school partly executed from his designs. One thing that very much interests me is that his paintings done on wood are much brighter than those on canvas . . . I am sure that I know more about painting and am a better judge than any critic; or than any professor or graduate of Harvard who is interested in it. I have learned a tremendous lot since I left Italy; I don't know why or how, maybe from arguments with John [Walker] and lecturing to Barb [Mettler, a Winnetka friend whom Porter saw in Dresden]. Now I can appreciate good Rubens paintings . . . and not just as a painter either . . . I understand what Benton meant when he said once that when people say to him that they don't like Rubens it is as if they should say "I don't like the sky," or "I don't like the ground."*

Porter's letter continues without pause: "I gave Barb a watercolor of Dresden at night that I made there, a good one. My German is now almost fluent. I read columns of German newspapers and understand a quarter; it is a little like James Joyce's work in progress. I have been working on Kirilov and Pyotr Stepanovich again here in Munich and have got a good face for Kirilov."[82]

A watercolor street scene that Porter painted in Rome after his return to Italy is remarkable as an example of American Scene painting transplanted to the Eternal City. The buildings bend and sway according to a personal perspective that has nothing to do with venerable Old Masters but rather much with Boardman Robinson, whose unhistorical opinions on this point Porter must have often heard at the League:

> *Perspective is just a scientific fact. If it disturbs you, design and change it. If you want a man a mile away, in the foreground, put him there. Most of the great art was made before perspective was discovered, anyhow. You have to know about it so you can use it and disobey it.*[83]

By the spring of 1932 Porter was homesick for America and eager to see Anne Channing again. He wrote to her from Genoa that he had decided that he would never want to live outside of America. "It would take so damn long to get adjusted." He had entertained a hope of visiting Russia again, but had given up after waiting for six weeks on the advice of the Russian consulate in Rome for a reply to the "very polite note" he had written requesting a visa, "in which I said I was incapable of doing anything except simple, not too muscular unskilled labor, and that I had read much Doestoyevsky and had fairly good manners and perhaps they had a job waiting for just such a well brought up capitalist."[84] He could never have imagined at the time how fortunate he was that the Soviets did not take him up on his offer.

Spain was Porter's last stopover prior to his return to the United States at the

A page from Porter's Spanish sketchbook: ink drawing of a Madrid street scene, with marginal notes on El Greco, 1932, approx. 4 x 6". Collection Archives of American Art, Smithsonian Institution

beginning of May. He flew first to Barcelona, then traveled to Madrid and environs. His pen-and-ink sketchbook from Spain is preserved; it contains casual but fluent line drawings that resemble snapshots of streets and people. He also made careful notes on paintings such as El Greco's *Saint Peter* at the Escorial and the artist's masterpiece *The Burial of the Count Orgaz* in Toledo.

Once back in New York, Porter was happy to take up painting again in more convenient circumstances; unfortunately, no paintings from immediately after his return are known to exist. He saw Anne Channing several times during May at her family's home in Wareham, Massachusetts, and the couple made plans to go with Anne's older sister, Barbara, and other friends on a canoe trip in Maine over the summer. One probably foreseeable eventuality that arose out of this happy time together was the determination to be married soon—as soon as September, if their parents permitted it.

While waiting for his nuptials, Porter and his friend Alex Haberstroh remained with the Porter family on Great Spruce Head Island. Haberstroh was an outgoing, spontaneous personality who was deeply committed to Socialist Party politics—all qualities that might have disqualified him from the good graces of the head of the family, James Porter. In early September, though, Fairfield was able to write to Anne, "Father almost likes Alex now because he plays bridge well and very zestfully. Alex is quite fresh to him and says, 'Gosh you look depressed' to him."[85] Porter was painting steadily on the island. "My pictures I keep fussing over. Maybe in a day or so they will be O.K. I have more sketches—and more good ones, than I can remember—they keep turning up."

First Avenue. c. 1945

THE PORTERS IN NEW YORK AND WINNETKA | 1932–1949

By "murals for workers" I mean murals that are now in place where anyone can see them, and whose content has immediate meaning and application to the lives of workers. The ideas should be addressed well enough in painting terms so no description can be equivalent to the painting. In other words it should be good enough to require that you go and look at it.

—Fairfield Porter, "Murals for Workers," 1935

Fairfield Porter and Anne Channing were married in the garden of Anne's parents' house in Sherborn, Massachusetts, on 22 September 1932. For their honeymoon, the young couple set off in their two-seater Ford for the South, where Porter had always wanted to see the famous Greek Revival mansions. On the way, they stopped at Martha's Vineyard to call on Thomas Hart Benton and his wife. While motoring through the South, Porter made some pencil sketches of the landscape that are remarkable for their spontaneity and naturalness—closer really to his drawings of two decades later than to the overly calculated style that he had absorbed at the League.[1] Turning north, they went to the Adirondacks for some hiking and to visit Fairfield's friends Arthur and Edna Schwab. On the last leg of their trip, when the Porters were returning to New York City, they had a car accident, but were not seriously injured.

In New York Fairfield and Anne set up housekeeping in a small apartment in Greenwich Village, at 122 Washington Place; the monthly rent was $65. They expected to rely on income from the Porter Trust, which each of the children received.

Porter had endeavored not to lose track of Arthur Giardelli, his Florence friend who had gone back to England, and in an October letter he told Giardelli that he had painted a true fresco. Giardelli wrote back, on 2 November, that he remembered "an argument that you had with Berenson on the subject of modern painting in fresco and I remember how keen you were to do some fresco painting. I am glad you have had your wish and hope the fresco was a success." Giardelli praised a picture that Porter had given him: "I still think the Florence watercolour to be a very good piece of work." Porter probably had not known why Berenson was immovable on the subject of modern frescoes: the scholar's own library at

New York City Kitchen. c. 1932. Pencil on paper, 10 x 14". Fairfield Porter papers. Archives of American Art, Smithsonian Institution

Villa I Tatti had been the scene of a personal disaster in this regard. In 1913, in Berenson's absence, Mary Berenson had commissioned from René Piot an indescribably gaudy series of "Arcadian" frescoes that had had to be covered over immediately.

Porter's "first successful mural commission" (as he described it to Alfred Stieglitz a year later, in July 1933) was executed for his mother- and father-in-law in Sherborn, Massachusetts, in 1932. Several of Porter's pen-and-ink drawings for the Channing fresco are preserved. The fresco was a landscape, in vertical format, with an Irish setter and a horse in the foreground. Free as the drawings are, they give the impression that the animals and the lake in the center of the composition create an effective movement both into depth and across the picture surface.

By December 1932 Fairfield had spoken with a gallery that was apparently willing to show some of his pictures. "Which will be helpful, even if no one buys them," Anne Porter wrote to her mother. "I think the feeling of being recognized will make him more contented about his work."[2] The theme of Porter's dissatisfaction with the progress of his paintings would be a constant one in both his and Anne's letters during the next two decades (and was indeed habitual for Porter throughout his life). In preparation for showing his paintings, he was busy making frames for them on the kitchen floor. He was trying to find a studio, perhaps one he could share with his Russian friend Simon Braguin, since his and Anne's bedroom was overcrowded with beds, bureau, and his easel.

In January 1933 he started work on a portrait of Anne (his favorite sitter during this time), who wrote that it had "lovelier colors than he ever had before, but he has to paint a picture over and over before it satisfies him."[3] He was preparing to paint on aluminum a picture of the "downtown N.Y. El."

During the spring of 1933, the Porters of both generations were in contact with T. S. Eliot, their much-admired relation. Ruth Porter wrote her son the news that Eliot had visited Chicago that month and stayed at the Porters' house in Hubbard Woods. In April Porter wrote to Anne, who was briefly with her family in Sherborn, that he had heard a lecture given in New York by T. S. Eliot; Porter had sat next to Ogden Nash.

The first newspaper notice of Porter's career was published in *The New York Times* on Sunday, 14 May 1933. The review by Howard Devree, art critic for the *Times,* was as follows in its entirety:

> *The first of a series of exhibitions of small groups of paintings, &c. by young American artists has opened at the offices of Theodore A. Kohn & Son, 608 Fifth Avenue. Fairfield Porter and Simeon Braguin share the space. Braguin's cleverness and facility are evident in the present selection. Porter's landscapes reveal a more solid and earnest talent, uneven but promising.*

The exhibition space was in fact a jewelry store on Fifth Avenue and not an art gallery. After talking with Porter, the publicity agent for Kohn's wrote a press release. "She wrote," Anne noted, "that his method in painting abstractions is like T. S. Eliot's in writing poetry: i.e. a classical pattern and a contemporary subject. This applies to the abstraction where the composition is after Tintoretto and the

subject is a trolley and buildings in Dresden."[4]

The "abstraction" that Porter was experimenting with was, from her description, still a form of representational painting. He must not have pursued this "abstract" thread for very long, since there is no other trace of it in any of his surviving letters or pictures. The idea of borrowing a composition from an Old Master was in accord with theories that Porter had heard at the League from Boardman Robinson and possibly others. Robinson had looked for "a system, for an order of procedure," in the making of pictures. "I had never known *method*. The great masters had it," Robinson said.[5] It is clear that Porter was trying to make use of his European experiences, but it is no less evident that his training at Harvard and then at the Art Students League had misdirected him (without malice, but nonetheless effectively) onto a stylistic tangent that was in direct opposition to his mature technique, the unwavering observation of nature.

In 1968, when Paul Cummings asked Porter, "What kind of theory did you find or did you acquire at Harvard?" Porter answered, "Well, they would say, 'Here's the surface of the painting. And this is well-composed.' Composition is the most important thing. And composition means that they analyzed it—I think Professor Pope did too—repetition and sequence and probably another thing, I don't know what—harmony, maybe. And I found out many, many years later that composition isn't good because something is repeated but because it is not repeated. It was just the opposite."[6]

At the end of May 1933 Fairfield and Anne went to a writer's party that was being thrown by the art critic Paul Rosenfeld, whom Porter had known from before his stay in Florence. Anne wrote her parents that she had met a fascinating assortment of people, including the English poet Ronald Bottnall, "whom T. S. Eliot thinks is one of the best living poets. There was also Alfred Kreymbourg, Marianne Moore (a tall Bryn Mawr woman who looks like an abbess and is very cool, collected and intelligent), a novelist who has written a novel called Union Square, a couple of unshaven young communists, etc."[7]

For June, Fairfield and Anne looked forward to taking a cruise with John Walker on his schooner. They went to Great Spruce Head Island that same month, accompanied by their friend Wendell Reynolds; they all enjoyed the "life of outdoor pleasures and rather unkempt domesticity in the big house. Fairfield and I swim and sunbathe a great deal and read aloud."[8] Porter was reading Lincoln Steffens. On rainy days everyone played many, many games of chess.

That summer of 1933 Porter painted Anne's portrait in what she thought her "most disreputable dress," on the grounds that it was her most artistic. By August the painting was complete in black and white. Anne described it in a letter to her mother: "The figure sits in a chair with its hands in its lap (a position a little like Tarbell's portrait of you). It wears an old white tennis dress handed down from K and has bare feet. There is a wall behind it and to one side is a quiet glimpse of islands, clouds and water. Don't you think it sounds like a nice arrangement? I am proud of it because the painting is so firm and has such a flow to it. I think it is quite beautifully painted and Fairfield has made only one portrait before, so it is an achievement."[9] The subject of the previous portrait is not recorded.

For the autumn of 1933 Porter had enrolled in a daily course in anatomy at

Two studies for the Channing fresco. 1933. Pencil on paper, 8 x 12". Fairfield Porter papers. Archives of American Art, Smithsonian Institution

the Cornell Medical School. As an artist, not a doctor, he was not required to do fine dissection, but he often found the going hard. Once, afterward, he said to Anne, "People are so beautiful, just because they're alive."[10] With Anne pregnant and expecting in the spring, the Porters moved to a larger apartment, at a lower rent, at 70 Bank Street.[11]

The debate on public murals and fresco technique was topical and would remain so throughout the decade. Porter had joined a group that called itself the Fresco Painters Guild, comprising "about 10 members, 4 or 5 of whom have ever painted a fresco!"[12] One evening in November he and Anne were having a quiet dinner downtown at the Waverly Inn when they were seen by their artist friends "Mr. and Mrs. Le Brun and Louis Rubenstein, the fresco people . . . who live at 17 Bank Street. We sat with them for a while and Fairfield, Mr. Rubenstein and Mr. Lebrun had a violent discussion of the function of fresco in modern life. I think Mrs. Lebrun and Miss Cohen (who was with them) were positively frightened. After supper we separated, still muttering."[13]

For Christmas 1933 Fairfield gave Anne a typewriter in order to encourage her interest in writing. After the New Year, she mostly stayed at home, quietly resting and preparing for the birth of the Porters' first child, John Fairfield, called Johnny, who was born on 20 February 1934.

During the months that Anne was obliged to stay home, Fairfield entertained her with adventurous stories of his daily activities. "He knows the embalmers at the medical school and the man who makes the skeletons. He describes to me the sea-lions and camels he has seen on the way through [the] Central Park [zoo] and also what the jails are like because he was in one for a very brief time for overtime parking when he had no cash to pay a fine."[14] Porter also entertained her with his knack for making comic caricatures, which he liked to do at inopportune times, for instance, in a restaurant, lampooning "the clubwomen etc" at the other tables. The Art Students League had recommended Porter to sketch quick likenesses at a bazaar—they said he was very good at it—but he declined the offer.[15] A fine portrait drawing of his brother John has survived from this period.

Recognition of the desired sort came to Porter in January 1934, when one of his paintings was accepted for a juried exhibition at the Pennsylvania Academy of the Fine Arts. It was a view that he had painted of the Double Beaches, a spur of land on Great Spruce Head Island. The picture was not for sale, since he had made a present of it to Anne. He thought that he might go down to Philadelphia for the vernissage, because, he said, the painting really needed varnishing.[16]

The Porters invited Alfred Stieglitz and Paul Rosenfeld to a dinner party in late April, together with Ruth Porter, who was visiting New York. Anne had been apprehensive over meeting Stieglitz, whose steely personality was legendary, but she found him quite kind, and admiring of their baby. "He talked all the time," she reported afterward.[17]

Stieglitz was invited to another dinner party the same year which the Porters arranged in order to introduce Fairfield's brother Eliot to him. Eliot was in the sad process of divorcing his first wife, Marian Brown; they had married in 1928 and were the parents of two little boys, Eliot, Jr. and Charles. Eliot had completed Harvard Medical School and had then entered the field of advanced biochemical

36 X IO

Portrait of John Porter. Early 1930s. Pencil on paper, 8 x 12". Fairfield Porter papers. Archives of American Art, Smithsonian Institution

research, but he was dissatisfied with the future such work held for him. More and more he found that his most gratifying hours were devoted to his photography. "About this time," he wrote,

when my married life was in emotional turmoil that ended in divorce, I met Stieglitz through my brother Fairfield, who . . . lived in the Green-wich Village area in New York. Fairfield thought that knowing Stieglitz could have a constructive influence on my photography and invited me to supper with Stieglitz at his apartment. As I remember, there were only four of us at supper: Fairfield, Anne, Stieglitz and I. The conversation was about artists and photographers with whose work I was completely unfa-

Anne Porter. Early 1930s. Pencil on paper, 8 x 12".
Fairfield Porter papers. Archives of American Art,
Smithsonian Institution

miliar. Before the party broke up Stieglitz invited me to come to see him in his gallery An American Place on Madison Avenue. Having heard that Stieglitz had a reputation for devastatingly harsh treatment of any person he felt was imposing on him, I went in trepidation to his gallery some months later with a portfolio of prints. Contrary to my expectation, he was very friendly and looked at them all, without saying anything and then told me that the occupation of a photographer was a demanding one and required very hard work, but he encouraged me to keep working. The next time I came back he said much the same thing again, and in the case of one or two prints he covered an area of the print with his finger, without explanation. He also told me that every part of the photograph must count towards the whole.[18]

With America in the throes of the Depression, political activity and debate were at a fever pitch in New York City, and Fairfield and Anne were active witnesses and participants throughout the decade. Artists and intellectuals felt individually challenged both to understand the causes of the economic disasters that seemed endlessly to be visited on everybody—bank failures, unemployment, bread lines, government-issued scrip (the list is long)—and to adopt political strategies in order to prevent the recurrence of catastrophic depressions in the future. The thirties were a desperately sad decade, yet intellectually exciting in the sense that everyone felt entitled to argue his own political philosophy. The feeling was widespread that capitalism had ceased to be a viable system—after all, the evidence of its failure seemed inescapable. Most American intellectuals at this time believed that the solution probably lay at some point on the wide spectrum of left-wing politics. To accommodate all the individual conceptions of socialism and communism, a bewildering number of splinter groups and committees arose. One aspect of the thirties that any commencement speaker would find extremely difficult to explain to the uncommitted graduates of the class of 1992 was the widespread assumption that educated people were morally obligated to participate in the raging, cacophonic political debate. A great part of Porter's correspondence from this decade is devoted to extended discussions of political terminology and of distinctions between Socialist and Communist philosophies. As one radical has said recently, looking back, "If you lived during the Depression you were either a political creature or you were nothing."[19]

Porter loved the debates and frustrated his various friends, in fact, because he refused to side with any one party or group. (He would be just the same as an art critic.) His artist friends included Socialists and Communists of every stripe: Porter was always prepared to grant to each of them the debating points that he could accept. He was a good listener; in his turn, he would carefully detail the objections that prevented him from joining any party. Porter could not imagine lending his name to a group if he disagreed with any line in their platform. (In 1961, for example, he was asked to sign a petition in support of an artists' strike. Characteristically, he neither signed the petition nor threw it away; instead, he went to the trouble of preparing a series of carefully wrought "conditions" under which he was prepared to sign it.) In a practical political sense, Porter was perhaps naive; in a very

American sense, however, he was an individual who deeply distrusted organizations.

Porter's friend Alex Haberstroh was able to obtain for him some painting projects for the Socialist party. Porter was working on an enormous mural titled *Turn Imperialist War into Civil War;* he had also been hired to make a placard, "Workers, Unite against Fascism," to be carried in the Socialist party parade on May Day, 1934. Anne described these turbulent times to her mother: "Today is the day of the big Socialist and Communist parades, when some of his posters will be carried, but we aren't going. He is going to work on the mural and I don't want to go alone or with Alex to whom I might be rather a burden, in case of a riot especially."[20] Anne was able to see some of the Communist party parade after all, because it passed by the end of Bank Street. "It was exciting because of the intense feeling of all the marchers, though it wasn't at all well arranged; there were too many placards on sticks, demanding anything and everything . . . There was even one placard in Arabic."[21]

The Porters joined Fairfield's family that summer on Great Spruce Head Island. Among invited guests were Alex Haberstroh and Edward Laning, a painter who is best known today for his *History of Printing* and other historical murals in the New York Public Library. "We expect the Lanings (communist) and Alex (socialist) to visit us simultaneously, and I rather tremble at the thought of it. Fairfield and I considered making a rule that politics only be discussed in the open air. That would give a chance for the liberals to escape and also shouting is better out of doors."[22]

Four-month-old Johnny's crying confirmed that summer an idea that was already current on the island, namely, that the different Porter families would be better off having houses of their own, so that their infants "could be naughty without feeling apologetic," as Anne expressed it.[23] This was the first summer that Michael and Nancy Straus had passed in their own house. Eliot had built a small house for himself in the winter of 1928. John and Trudy Porter's house was constructed in the winter of 1938. All of the Porter houses are sited on the same side of the island, atop the incline that overlooks the harbor. Fairfield and Anne, who had the most children, "inherited" the big house.

As part of her early morning routine, Fairfield's mother liked to take a quick dip, unconfined by bathing suit; as the island family increased, the idea caught on. In one of her summer letters to her parents, Anne reported, "The island has become very easily and naturally a nudist colony where swimming is concerned . . . Fairfield has the nicest figure, so I feel very superior." It is not known how Harold Ickes, secretary of the interior, regarded this local custom when he was a guest on Great Spruce Head Island in August. Anne's letter of 15 August continues about Fairfield: "He has made a perfectly beautiful water color from a high rock, of trees close by, a wooded point, rocks and water. It is by far the best he has made, much the most spontaneous too."[24]

Porter's landscape style at this time is not documented by any dated paintings. During the mid-thirties, he painted some Maine landscapes under the influence of John Marin, and it is possible that the spontaneity that Anne admired in this lost watercolor was in part due to Marin's influence supplanting Rockwell Kent's. In

Isle Au Haut. c. 1934

his 1956 overview of Porter's career (which must have been compiled with Porter's help), Thomas Hess published a watercolor with caption, "The Maine scene, a bit like Marin, around 1934."[25]

By November Porter and Haberstroh were finding out that radical politics could support an artistic career if the artist was nimble enough to garner opportunities from rival left-wing factions. "Fairfield is so busy," Anne remarked that autumn. "The socialist organization 'Rebel Arts' is employing him to help decorate Madison Square Garden for a meeting of the International Ladies' Garment Workers Union, Rebel Arts being in turn employed by the Union because they underbid everyone else. He teaches at Rebel Arts too, one night a week, a class in drawing from a model, and I think he must be a very good teacher. He is painting a nice portrait of me and a very good picture, 'Labor and the NRA' for a branch of the John Reed Club. Studying anatomy has strengthened his drawing a good deal and made it more rhythmic."[26]

Perhaps the same portrait of Anne was described by her in a subsequent letter that winter: "Fairfield is painting a portrait of me in the surgical apron with a bureau and alarm clock in the background. It is a very appropriate setting, and a very good picture. He is also doing some work on the magazine [*Arise*]."[27]

In January 1935 Porter wrote to thank his mother for sending him a book, *America and Alfred Stieglitz*. He added some comments about their life-style. "Alex and I finished last week another banner—this time a paltry 18 feet square for another local of the International Ladies' Garment Workers, for a dance. We did it in too short a time and worked late at night so the banner is probably less good than the other one. But Rebel Arts made money out of it . . . Alex came to supper: his girlfriend arrived at 8:30, Alex at 10, we were pretty sore. What I most object to in the Radical Movement is the irregular lives people lead, working until 2 AM and never getting up before 11 or noon. It would get me down if I worked more for them."[28]

Except for the summer months in Maine, though, most of Porter's working hours were taken up, in some way, shape, or form, by projects, often volunteer, associated with the Socialist party or other leftist organizations. In 1986 he offered his own summary of his diverse activities in this wise:

> *Rebel Arts I think was the Socialist club in imitation of the John Reed Club. And I taught drawing to a class of amateurs. And then I became one of the editors of* Arise *which had 4 issues. It was a Socialist imitation of* The New Masses. *And the other editors were Alex Haberstroh . . ., Sam Friedman, who was a real Socialist, an active, full-time Socialist, Gertrude Weil, who was also an active full-time Socialist, a columnist on the then* New Leader *I think, and John Wheelwright from Boston. I wrote one article for them about mural paintings [*Arise, 1935*]. I called it "Murals for Workers" which seems to me now like a very pretentious name. And I wrote about murals that had been made mostly by the WPA; some of them not, because I included Thomas Benton and Orozco.*[29]

Porter's involvement in Socialist politics put a strain on his relations with his father, a fact that both of them regretted at the time, and Porter deeply so after his

father's death in 1939. Ruth Porter wrote in February 1935 to Nancy Straus, "Father persists in being his own physician. I think he broods over Fairfield's treatment of him too. Eliot writes about radical ideas just as much but has an appreciation of his father and knows that he/Eliot is inconsistent. As a matter of fact James is the only consistent one in the family, believing still in the Capitalistic system as a permanent one and the best we could have . . . Barbara Mettler gives dancing lessons to Anne and Fairfield gives painting lessons to her. He has a Jewish gentleman in his class at the 'Rebel Arts' whatever that means, whom he says is the kind of ugly middle aged man I 'fall for' so he sent me his picture, a nice pencil sketch. I am puzzled by this analysis of my tastes."[30]

In January or February 1935 Porter finished his own mural, at present untraced, "the subject of which was: turn the imperialist war into civil war; which also now [1968] seems to be very pretentious. It was in imitation of Orozco, more or less."[31] The social realism of the Mexican muralists, David Alfaro Siqueiros, Diego Rivera, and José Clemente Orozco, was one of the critical influences on American painting during the thirties and forties. Porter stated on several occasions that of this group he much preferred Orozco and did not especially like Rivera's murals.

The commission for this mural for the Queens Borough branch of the Socialist party had been obtained for Porter by Haberstroh.[32] It was part of a "Mural Painters" exhibition organized by Laning, Benton, Hildreth Miere, and Jacob Burk at Grand Central Galleries ("a funny place where they play organ music all the time like a department store").[33] At the opening Porter met the painter William Gropper. "He is very nice: quite open and modest about his work. I liked his Brueghel-like picture of farmers drinking wine and bringing in grapes for a midtown private bar—but he was surprised I liked it. I told him I hadn't liked murals of his at the Modern Muscum three years ago and he said, 'They were terrible! They were so forced.'"[34]

Although supported by his family, and therefore not in need, Porter was beginning to be frustrated in New York by the lack of opportunity to exhibit his paintings, none of which was political in content. Anne gave a dinner party for a group of painters at which Porter brought out his watercolors to show the others. He had not looked at them for a long time and they seemed to him to have real quality. Anne particularly thought it a shame that he had not had any chance to exhibit them.[35] Meanwhile, the Porters found themselves reading advertisements for farms near New York. "Next year," Fairfield wrote, "I think I will (if I can) paint just for myself."

One of Porter's letters to his mother indicates that he did participate in an exhibition in 1935, although where or when is not recorded. He thought it a poor show except for his own work and that of his friend Tissie Nottingham. He exhibited a portrait of Anne and three watercolors; a watercolor of Vinal Haven, Maine, was sold.

His inaugural effort at art criticism, the "Murals for Workers" article in *Arise*, was published in 1935 and created a minor stir, inevitable in the political climate of that time and place. Porter was frustrated to learn that his former teacher Benton had complained about it.

I think I made an enemy of Thomas Benton by my article on mural paint-ing although I showed it to him before it came out and I toned it down somewhat as a result of suggestions he made. That manner of being uneducated that you [Ruth Porter] noticed is getting more and more pro-nounced in all of his official utterances. I think he feels both more and more successful and more and more persecuted. Sam Friedman said I made an enemy of the I.W.W. I don't care about the I.W.W. but I do about Benton because I learned a lot of what I know from him—but I also don't like his attacking Stieglitz because Stieglitz is "mystical" or "talks too much" when it is, after all, a fact that Stieglitz is the only man perhaps in the world who shows pictures and doesn't do so out of a profit motive . . . Stieglitz has not made a cent off Marin or O'Keeffe, but they have made all they have made because of him.[36]

Porter seems sincerely not to have realized that his increasing ambivalence about Benton's style was writ in every line of his analysis of it. Benton could hardly have delighted in the observation, "It is hard to discover an attitude . . . He shows with the same amount of interest strikers being shot down, girls taking their clothes off, people in a subway, a chain gang, a bread line, or the working of a Diesel engine."[37]

In June 1935 Porter's cousin Henry Eliot sat for his portrait. The preliminary drawing for this portrait, Eliot seated in a rocking chair, still exists; the painting itself is lost.[38]

After returning from Maine that summer, Fairfield and Anne rented a house north of New York City, in Croton-on-Hudson, which was then rural and remote. This was seen as a temporary move until they could find a house to buy; they were stymied because houses large enough both for their growing family (Anne was pregnant with their second child) and for Fairfield's studio and storage require-ments were beyond their means.[39]

By December Porter had met and quickly made friends with John Brooks Wheelwright, "a rebel Boston Brahmin and heretical Christian who combined his experimental poetry with Marxist political activities."[40] Porter already knew Wheelwright's poetry, which was gaining wide respect. The year before Wheel-wright had been described in *The Nation* as one of the three leading "revolution-ary" poets. Reviewing Wheelwright's first collection of poems, *Rock and Shell,* in *The New Republic* (16 January 1935), Horace Gregory had called the poet "one of the few matured poets in our time."

In 1974 Porter reminisced about Wheelwright:

I met Wheelwright . . . when we were both editors of Arise, *a Socialist magazine started in competition with the Communist Party* New Masses. *I got on this through Alex Haberstroh, a friend of mine from the Art Stu-dents' League, who was a Socialist party member. I had read in* The Hound & Horn *a long poem by Wheelwright that I admired. So I was thrilled to meet him at an* Arise *editorial meeting and invited him to come out for the week-end to my house in Croton that I had just rented and was awaiting my wife and baby son John in. I remember that that week-end we walked over the fields, while we exchanged views about social prob-*

lems . . . You ask, why didn't he gravitate towards the Communist Party? It was because it was obvious to him that the Communist Party was completely immoral. The Socialist Party was actually democratic, *one could express one's views. You see, he was also a Christian. He used to say to Marxist friends who criticized his devout Episcopalianism, "If I weren't a Christian, I would certainly never be a socialist."*

Wheelwright was quite familiar with the theoretical/polemical issues. I think he may have thought that socialism was a consistent development from American 17th century radicalism . . . When our second child was born [Laurence, in 1936], Wheelwright suggested that we name him Uriel, after, I think, Emerson's rebellious archangel. I know he admired Emerson, but I don't remember his saying anything about Whitman.

According to Porter, the line, "your views and my views" in Wheelwright's sonnet "Mirrors of Venus" was a reference to this first weekend of talks in Croton. "Wheelwright was interested in my wife's poetry and my ideas."[41]

Porter and Wheelwright decided to collaborate on illustrations for *Poems for a Dime* and *Poems for 2 Bits*, two Vanguard Verse magazines that Wheelwright had founded in 1934. Porter was to make linoleum-cut prints of his own designs, based on Wheelwright's and other poets' poems. The fourth number of *Poems for a Dime* was published on 8 January 1936, with a cover linocut by Porter and two illustrations inside, *Donkey and Elephant* and *Three Archers*.[42] This issue was entirely devoted to Wheelwright's verse drama *Masque with Clowns*. "The masque, which describes a national election campaign as though it were a circus, in many ways resembles a play by Bertolt Brecht."[43]

The letters exchanged between Porter and Wheelwright reveal that Porter worked hard on these assignments, but was never completely satisfied with his own efforts. He eventually abandoned a finished drawing of bicycle riders for *Masque with Clowns*, because he concluded that it contributed nothing to the poem.[44] He was probably being too severe with himself; Wheelwright continued to call on him for illustrations for more than a year, even after Porter moved to Illinois in October 1936. In the meantime, Wheelwright sent him Kenneth Whelan's poem, "Murder at Pottsville," for which Porter made two linocuts that were published in the third issue of *Poems for 2 Bits* in June 1936. "Whelan wrote me a very nice note about the proofs," Porter wrote to Wheelwright. "Apparently he likes them!"[45]

Porter's involvement with Wheelwright whetted his appetite for political discourse, although at about this time he confided that his energetic discussions with Haberstroh had made him feel like "a hypocrite because with me it is not so real as with Alex, who is after all a member of a party."[46] The main forum for that winter's debates was the American Artists Congress, which was held in New York between 15 and 17 February 1936, under the banner, "For Peace, for Democracy, for Cultural Progress." Porter was chiefly interested in hearing what Orozco would say to the congress.

Wheelwright, like their common friend Haberstroh, hoped to persuade Porter to accept formal membership in the Socialist party, but he again declined and

Poems for a dime.
number five
10c

Ruins. Illustration for cover of *Poems for a Dime*, no. 5, 25 November 1936. Black-and-white linoleum cut. Image size: 4½ x 3¼". Collection Mrs. Fairfield Porter, Southampton

offered him a lucid statement of his stance regarding art and politics.

> *I suppose I should answer your hope that I have joined the Socialist Party.*
> *I don't yet see joining any radical party, because I don't feel that I could*
> *then continue being a painter, or at least not an honest one. How can one*
> *both believe in revolution strongly enough to want to work for it and at*
> *the same time paint pictures? Pictures aren't useful enough. Alex may*
> *imagine he is serving both art and Socialism by making murals for local*
> *22, but isn't he more likely using his Socialist connection to further his*
> *art? One can be a cartoonist, but I haven't got that kind of talent, maybe.*
> *The Socialist or Communist artists, here I mean painters or sculptors, I*
> *know seem doomed to be only partially truthful. They forbid themselves*
> *from recognizing and standing up for excellence in art that has not got*
> *the class struggle label . . . Gropper, who is a Communist, may be an*
> *exception. One difference I imagine between the Socialist and Communist*
> *parties in this respect is that it is possible for an artist (any kind) to con-*
> *tinue pretty free and unhampered in the S.P. but not, unless you have*
> *Gropper's integrity plus intelligence and profound belief, to do so in the*
> *C.P. You couldn't have published Kenneth Porter's poems about Jesus, for*
> *example [had you been a Communist] . . . As for me, I still feel divided in*
> *my loyalties between painting and Socialism, with painting taking much*
> *the larger piece.*[47]

Porter's home life and nonpolitical artistic interests were sufficiently fulfilling, moreover. The Porters' second son was born on 17 January 1936, making the issue of house hunting all the more immediate. The baby was named Laurence Minot Porter, in honor of Anne's brother. "Fairfield loves him," Anne wrote her mother, "proving that little infants are an acquired taste."[48]

That winter and spring they often saw Barbara Mettler, Porter's childhood friend from Winnetka, who was directing a school of modern dance in New York. He attended some of the rehearsals and made many rapid sketches with ink and brush. "A lovely medium for moving things," Anne observed, adding, though, "I hope he won't overwork the finished painting and lose the flexible look of the sketches, it's easy to do that."[49] Several of these ink studies, Matisse-like in their openness and breadth, still exist.[50] Porter said to Wheelwright at the time, "I am drawing dancers for a dance mural. They are fun to draw. They often look like Picasso's acrobats, calm and classical with nice large feet and hands."[51] The project was left in abeyance when the Porters made the decision to move to the Midwest.

The death of Fairfield's grandmother, Julia Foster Porter, at age 89, was an unforeseen resolution to their search for a permanent home. With the Foster house in Hubbard Woods standing empty and his own parents, especially his father, ailing, it seemed the obvious decision for Fairfield, Anne, John, and Laurence to leave New York and make their home at 1077 Sheridan Road, directly across the lawn from the house where Fairfield had been born.

Porter wrote to Wheelwright from Winnetka in October 1936 to describe his new environs and to announce that his linocut for the cover of the next number of

Poems for a Dime was almost finished. "It was fun driving west. Each state has a different character, and New York has several . . . Winnetka is a more femaleish town than ones in the East. The womenfolk give luncheon parties galore for each other. Almost all the Haute Bourgeosie here, as in Boston, are for Landon [1936 was an election year]. The newspapers are even worse than the Boston papers . . . Even father, who is a Landon supporter, subscribes to the New York Times."[52]

Porter's second cover for *Poems for a Dime* was published soon afterward, in November. It depicts men staggering among the toppled columns of a classical temple. Wheelwright liked the cover but suggested that it was "too European" (a prophetic criticism, and one to which Porter's work was later subject). In fact, as Porter explained with typical frankness, his cover had been inspired by other poems and poets, not by Wheelwright. "I couldn't find one picture from the poems in no. 5 and I kept thinking of T. S. Eliot's "There the eyes are/Sunlight on a broken column" and of a poem by Wallace Stevens in the *Nation* called *The Men That Are Falling*."[53]

Upon his return to Winnetka, Porter set up his studio and painted a self-portrait, since lost. In addition to his painting, he had two immediate concerns: he wanted to make contact with Chicago-area artists and he had promised Wheelwright that he would try to find a group to sponsor a visit and a reading of his poems. The latter plan was unsuccessful, despite many approaches by Fairfield and Anne to local universities and the offices of *Poetry* magazine.

After the intellectual agitation of life in New York City, suburban Chicago took some getting used to. In January 1937 Porter wrote to Anne's mother about some of the differences.

> *My life here is half way between New York and Croton life. Anne's is very different from either, more femalish. I have met the Winnetka painters, who are a little lonely and therefore very friendly, and a few Chicago ones. There are a few good painters here and as they all know each other they seem kinder about each other's work than New York ones. The best one is perhaps Aaron Bohrod, who handles oil paint with more facility than is common with Americans. There are about two art galleries here, and if you stay in a Gallery more than half an hour, the dealer suspects your sanity. I am painting a picture of suburban streets that is mostly signs, and I keep learning more about oil painting. It is the most difficult medium . . . Anne is reading some books about women in order to write an essay on the subject, if she finds that what she thinks she has to say has not been said before.*[54]

Porter made contact with the Socialists in Chicago, and soon found himself in one of the few situations in his life in which he was obliged in short order to repudiate his own views. In his January letter to his mother-in-law, he mentioned that "the editor of the Socialist Appeal in Chicago asked me if I would try to collect some money for Leon Trotsky."[55] At this time Trotsky had been exiled by Stalin and was being persecuted in the Soviet press. During the winter and spring of 1937 (on 13 April Porter published a letter in *The New York Times* calling for a fair trial for Trotsky) he and Anne devoted much spare time in their neighborhood to collecting

donations for Trotsky's legal defense. Within a year, however, Porter came to know Paul Mattick, founder of a group of German Marxists called the Council Communists, who knew much more than he about the actual situation in Stalinist Russia, and who were vehemently opposed to the Soviet Communist party. "Then [in 1938] I met Paul Mattick, and he disillusioned me about Trotsky. I learned that Trotsky really believed in all the Leninist lying and authoritarianism and terror: and in contrast to his [Trotsky's] defender over the Moscow trials, John Dewey, in the doctrine that the ends justify the means. Mattick would say that your means are your ends, that what you are doing are your ends."[56]

In an undated letter to Wheelwright, written after his conversations with Mattick, Porter's change of heart and the pain of his disillusionment are evident. "To me, [Trotsky's] *Dictatorship vs. Democracy* gives as his goal one that I would oppose utterly. I consider it a blueprint for fascism . . . I think that one's goal follows from one's actions, and out of bolshevik actions the goal can not be anything other than a restriction of freedom, and a worse tyranny than has ever before existed . . . I like pessimism, I have the prejudice that pessimists are realistic and optimists romantic . . ."[57]

Porter was basically satisfied with the status of the painting scene in Chicago, and he devoted most of 1937 to attempts to win government-sponsored competitions for public commissions. As far as we know, none of these was successful. On 13 March he wrote to Wheelwright, "I am working on the latest Treasury Department mural competition and the design must be in by April 30 . . . I have met some of the good painters who live here through being a member of the Artist's Congress . . . Here mural painting is in the ascendency in the WPA. It is on the average better than the New York WPA mural painting. The influence here is Orozco, in New York Rivera." Anne informed her mother that Porter was "working on a government mural competition, the subject is national parks."[58]

As Porter himself remarked to Paul Cummings in 1968, the fact that he had an independent income from his family trust effectively disqualified him from WPA projects, which were intended, after all, for the relief of indigent artists. In 1937 he learned that his Porter Trust income for the next year would amount to $6,200, a reduction from his previous total of $7,200. The existence of this trust meant that they did not suffer financial distress, despite Fairfield's inability to support himself as an artist. His annual income sufficed to support him comfortably until his father's death in 1939; thereafter, through lack of proper management, the yield from the Porter Trust steadily declined in relative terms, until finally it was dissolved and divided among the children in the 1960s. (Indeed, by the 1950s, he found himself strapped for funds, and seriously so during the early 1960s. His financial situation began to improve in the mid-1960s, when his paintings began to sell profitably for the first time in his career.)

A Porter landscape of Evanston, Illinois, was accepted and exhibited in March in the Art Institute of Chicago "Annual Exhibition of Painting and Sculpture." Perhaps this was the "picture of suburban streets that is mostly signs" that he had been painting in January. The Artists Congress exhibition in Chicago was to open on 7 April, and Porter debated between sending a portrait of Johnny and one of Anne and Laurence.[59] The latter is possibly the large portrait of Anne and an

infant, rather awkward and Bentonesque, that is now in the Parrish Art Museum.

Porter worked around the clock in April on a government mural, whether a proposal or an actual assignment is not clear. The subject was theatrical and the scene in Winnetka reflected same: Anne wrote, "We have been entertaining actors and professional acrobats at lunch and dinner—they have been posing for Fairfield's mural. The models are nice, the acrobats nicer than the actors . . . The last model who came was a little Cuban man who got very excited telling us how the world was hollow and we and all of the stars are inside of the earth."[60]

By 1937 three-year-old John had started nursery school, where he was "the no. 1 problem child," as Porter described the situation in a letter to Wheelwright. "At school they say he is a year and a quarter behind his age in everything except music in which he is ahead two years."[61] The trace of optimism in this appraisal proved to be unfounded. The Porters' first child had shown behavorial peculiarities since his birth; he had stubbornly refused, for example, to learn to feed himself. From the vantage point of the 1990s it is difficult to imagine how completely ignorant, as recently as fifty years ago, both medical doctors and the public were regarding mental retardation. Family members and friends who knew John Porter believe that he suffered from a condition like that now called autism (which is itself imperfectly understood even today). The confused and conflicting diagnoses and indications that the Porters received from specialist after specialist, psychiatrist after psychiatrist, over the next fifteen years exacerbated and perhaps prolonged the anguish they suffered, as they hopelessly attempted to understand John's disability and struggled to find a cure.

The family did not go up to Maine that summer, but Fairfield and Anne treated themselves to a few days' visit to New York City; they arrived in time to celebrate Fairfield's thirtieth birthday on 10 June. While in the East, they saw Edward Laning and his wife, Dorothy Allen, and Albert Friend.[62]

Home again in Winnetka, the family read aloud in the evenings *The Education of Henry Adams*. Anne's summer letters to her family include references to several of Porter's paintings, none of which can be identified. In July he began a portrait of her; she joked that her summer dress grew dirtier and dirtier as the portrait progressed. She reported in early August, "Fairfield is still working on my portrait and is in the stage of being very discouraged with it." One August day Porter went sketching with Norman MacLeish, one of his Chicago artist friends, the brother of the writer Archibald MacLeish. Another untraced picture from that summer was a view of the Porters' flower garden, high above the lake and full of flowers in a tangle. He also had a commission for a portrait of eleven-year-old Mary Howe, whom Anne described as "the famous little daughter of the two Drs. Straus."[63] That fall he made a linocut, *Irish Harp*, for the cover of the sixth issue of *Poems for a Dime*, the last that Wheelwright published.[64]

Increasingly, through contacts with German expatriates who were arriving in Chicago, the Porters were drawn into the public protests against the Nazis being organized at this time. In May 1937 a local group invited them to hear Paul Hagen speak about the anti-Nazi movement in Germany; they offered their house for the lecture.[65]

"I got to know these Germans," he recalled in the 1960s, "because when

Street Corner. 1939. Black-and-white linoleum cut, sheet size: 6¾ x 7¾"; image size: 4 x 5". Collection Mrs. Fairfield Porter, Southampton

Hitler came to power I used to see advertisements for little publications and I wanted to know what was going on. I wanted to see every point of view. And one thing would advertise another. And through their publication, in which they announced a meeting, I met Paul Mattick and Fritz Henssler, Walter and Ellen Auerbach . . . They seemed to me more intelligent . . . they were among the few people in the world who had really read Marx all the way through; not just a little bit of it. And at the same time they weren't interested in measuring every opinion against Marx."[66] He later wrote, "I learned that there is hardly any difference between the Communists and the Nazi's. I remember Paul Mattick once saying when there was talk of American Fascism, that the closest thing in the United States to a Fascist party was the American Communist Party."[67]

Porter's political thinking was shaped by Mattick and his group, the Council Communists, from this time until World War II. Mattick was an outspoken man of great vitality and imagination and brutal honesty. He had chunky features and was not handsome or tall—he was, indeed, the picture of a working-class man—but his conviction and blunt wit made him a charismatic speaker.[68]

By the end of the thirties, Porter's negative views on Soviet Communism and on Nazism were more mainstream than radical. He wrote a long letter to Wheelwright in 1939, detailing the many respects in which the two friends had come to disagree:

> *As a materialist, I think the method is more important: I agree with Huxley that your ends are implicit in your means, that there is only an ideal and unreal difference between them.*
>
> *I am against also the ends of the Bolsheviks, which are expressed in Trotsky's* Dictatorship vs Democracy, *and in* In Defense of Terrorism. *His declared aims, which the Stalinists do not reject look like those of Goebbels. The worker is to be commanded as if he were a soldier. There is no freedom of choice of occupation at all. I prefer Capitalism to Trotsky's ends . . . I also am opposed to Trotsky because of his actions against the Kronstadt sailors. Trotsky's and Lenin's superiority over Mussolini and Hitler is only that of aristocracy over vulgarity. Trotsky expressed his feeling about Kronstadt recently in the* New International, *in which he defended his order to "shoot them down like pheasants" by saying that the Kronstadt sailors wore bell-bottomed trousers. For me bell-bottomed trousers is not a mark of the class enemy. I would like people in a socialist society to wear what they pleased. There can be no dictatorship over consumption. If this means doing nothing, then I would rather do nothing, because the alternative, whether it is called Bolshevism or Fascism, is more tyrannical than anything that has existed before. I am interested only in helping to free human possibilities, not in the attempt to restrict them.*[69]

At the head of this passage, Porter calls himself a "materialist," a term he used on later occasions as well. To him the word did not mean "consumerist," its usual definition today; rather, it simply meant that he believed that things were what they were. The religious analogue would be atheism, which of course was

Porter's philosophical background.

In early 1938 Porter was painting a view of Chicago from the thirty-sixth floor of a skyscraper. He found the going difficult, but the picture seemed to be emerging as the most successful cityscape he had yet tried. The Christmas holidays had passed without undue stress or disappointment; Johnny had been happily occupied building intricate webs of block structures in the front hall. Laurence, not quite two years old, was "very proud that he now has milk in a glass." Anne was working on a story, "puffing her cheeks out with concentration," Porter noticed affectionately.[70]

Fairfield and Anne were introduced in January to László Moholy-Nagy, artist and director of the prestigious Chicago Bauhaus. Moholy-Nagy told them that one of the first assignments given to Bauhaus students was to draw their own signatures over and over, nine times actual size. (Anne imagined this exercise would drive her crazy.)[71] Porter made use of this anecdote twenty-five years later, in his lectures on art and science, concluding that "this is like trying to prove the unique by repetition . . . The Bauhaus theory of art finds art valid insofar as it can be entirely included within generalizations, in order to be used by industry."[72]

Anne posed for one or two hours every morning in mid-March, while Porter struggled with a portrait of her. Two of his paintings were among the 224 accepted by the Art Institute of Chicago for the "Forty-second Annual Exhibition by Artists of Chicago and Vicinity" that month. Neither picture, *The Annunciation* and *Landscape by the Lake,* is traceable today. The composition of the former is possibly reflected in the linoleum cut, also titled *The Annunciation,* that Porter made this same year for inclusion in the 1939 *Artists' Calendar* published by the Chicago Society of Artists. He had Anne pose for the figure of the Virgin Mary in the print.[73]

At the end of March 1938 Porter went to New York to view an exhibition at Stieglitz's gallery of new paintings by John Marin, whose Maine landscapes he admired. "Stieglitz is on the whole feeling benevolent," he reported to Anne, mentioning too that he had also seen their friend Paul Rosenfeld.[74] While in New York, he participated, with Alex Haberstroh, in the widespread protests against the Nazi annexation of Austria. Of one such march, Anne was assured by Alex that "it would be quite safe, there would be 200 policemen with no nightsticks." The next day she read in the paper: "100 Hurt in Socialist Demonstration."[75]

The Porters contributed in a small but memorable way to the May Day parade in Chicago that year. Anne wrote to her mother, "'Indian Hollow' (our 2nd-hand station wagon) is to be lent to be a 'float' upholding a papier maché statue of what Fairfield describes as 'a woman crushing a swastika' (for the Artists' Union). We can't help feeling that the combination of sculpture and station wagon will be *extremely* quaint."[76]

On 2 May 1938 Porter painted two watercolors of orchards, which seemed to come out successfully. He was preparing for an exhibition in a week's time, to be hung at his old school, New Trier Township High School. Anne thought that his works looked lovely all together: "The first one man show of Fairfield's pictures."[77]

During the May evenings, Porter went to a carpentry workshop in Skokie, near his home, where he was constructing a spiral staircase for a tree house because Johnny Porter was fascinated by spiral stairs.[78] Johnny was susceptible to

Annunciation, second state. 1938. Black-and-white linoleum cut. Sheet size: 8½ x 6¼"; image size: 7⅛ x 5". Collection Mrs. Fairfield Porter, Southampton

inexplicable fixations on things and words and favorite memories. Fairfield spent hours with his eldest son, taking him on walks or to swim in Lake Michigan, in an effort to encourage him toward a more normal pattern of behavior, but he showed no sign of improvement.

The Porters made the journey east to spend the summer of 1938 on Great Spruce Head Island. From there Fairfield and Anne took a canoe trip on their own to Passamogamoc Lake. The island gained a landmark that summer with the beginning of construction of a separate house for the family of Trudy and John Porter, Fairfield's younger brother.

Over the Christmas holidays, from 15 December 1938 to 15 January 1939, the Art Institute of Chicago presented an exhibition of paintings and prints by Pierre Bonnard and Edouard Vuillard, which Porter cited in his 1968 interview with Paul Cummings as one of the turning points in his development as a painter.

> *Another reason I paint the way I do is that in 1938 we were living in Chicago and in the Art Institute in Chicago there was an exhibition of Vuillard and Bonnard, both of them. I had never seen so many Vuillards before or maybe so many Bonnards before. And I looked at the Vuillards and thought—maybe it was just a sort of revelation of the obvious and why does one think of doing anything else when it's so natural to do this.*[79]

Crucial as the Vuillard and Bonnard exhibition was for him, the available evidence suggests that Porter's response was neither so immediate nor so drastic as when Delacroix redid his skies the day that he saw Constable's. The few Porter paintings that survive from the late thirties and early forties (he painted very little during World War II) are not obviously indebted to the precedents of Vuillard and Bonnard, as they began to be after 1947 or so. The portraits that belong to the war years or just before—almost none of them are dated—are realistic, in the style of American Scene painting or of the Mexican muralists. The watercolor *Schooner Dockside,* of circa 1935 that Porter sent in 1941 to an exhibition at the Art Institute, does not contain any hint that he had discovered French painting.

Porter's later comments about an exhibition of his paintings held in April 1939 at the Winnetka Community House reveal that he had not as yet made any discernible break with a style he was finding increasingly unsatisfactory. He could recollect only one painting from this show, *Anne and Laurence,* which seems from his description to be the Bentonesque portrait that he painted one or two years earlier, probably in 1937. Anne's letters mention posing for another portrait in December of that year; in the absence of dated works and with so many paintings from this time lost or destroyed, it is impossible to know for certain which paintings are those cited in the Porters' letters. The Winnetka exhibition, which Porter afterward listed as his first one-man show, was arranged by Ruth Porter, who always strove to assist her son's career.

In 1968 Porter said to Paul Cummings, "I only remember one picture which went into that show which I still have. It's a terrible picture. Except it has one part in it that's nice. And that's my son Laurence, my second son, as a baby, sitting in his mother's lap. And I still like the way he's painted. The other pictures I think I've

destroyed." The interview with Cummings continued:

Paul Cummings: *How did you like seeing all your paintings out of the studio and lined up?*

Fairfield Porter: *Oh, I'm sort of ashamed of them.*

PC: *It didn't do anything for you at that time?*

FP: *Well, it made me see what a lousy painter I was, I guess.*

PC: *It wasn't really an enthusiastic response.*

FP: *No. I mean people were very polite and interested, you know. And even quite a good Chicago painter expressed real interest in it. But that was like an older person seeing ability in somebody younger. I think that was all. That wasn't what I was interested in. I was interested in performance, not promise.*[80]

About the time of his Winnetka exhibition Porter bought a John Marin watercolor from Stieglitz; he traded it for a Marin that he had bought a few years earlier, and paid the balance in installments. A letter he wrote to Stieglitz on 14 April about this transaction describes his high regard for Marin and a few other contemporary artists, including his brother Eliot Porter:

The Marins at the International watercolor show at the Art Institute are the best things there. They are scattered through the show, and they set a standard and show what can be done with the medium. The other good things are Klees and a Max Ernst.

From what you said about Eliot's photographs and still more from the prints themselves, I learned a lot. Something I mean that I can use in painting. From other paintings I seem to learn only techniques—except from Renoir, probably because I am not like him. From Eliot I learned something about the attitude of an artist.[81]

Although we cannot know precisely what Porter meant by "the attitude of an artist," his brother's example surely served as a demonstration of the single-minded dedication and sheer hard work that the artist must invest if his ultimate aim is artistic integrity. Porter's good deed in introducing Eliot to Stieglitz had eventually returned dividends to both photographer and art dealer. After his meetings with Stieglitz in 1934, Eliot had gone to Europe in 1935 and then continued to photograph in Maine and Canada in the following years. "With these latest photographs," he later recalled, "I went again in the fall of 1938 to An American Place. Stieglitz looked at them all very slowly, put them back in the box, and then opened it and looked at them all again, without commenting. I was expecting some severe criticism, but he simply said: 'I want to show these.'"[82]

Eliot Porter's first one-man show of photographs was held at Stieglitz's An American Place gallery between 29 December 1938 and 18 January 1939. *The New York Sun* ran a notably favorable review on 31 December that remains one of the most perceptive critiques Eliot Porter's photography has ever received.

Anne and Laurence. 1937

Fairfield and Anne did not go to Maine in 1939; instead, they drove out to spend three weeks in San Francisco and other California points while Johnny and Laurence were occupied in summer school. The Porters returned to Winnetka only days before Fairfield's father died, on 25 July. Although he had to some extent foreseen his passing, Porter was deeply sorrowed by it.

The loss of his father gave impetus in an undefinable way to Porter's recent resolve to move his family back to the East Coast. By late September, the Porters and their two little sons had already driven across the country and settled into a rented house in Peekskill, New York, in the same Croton area where they had lived before. Having accomplished their move, they now worried at having left Fairfield's mother alone. Anne wrote to her own mother, however, that their general attitude had been strengthened by the change: "It will be strange to begin living in Croton again, where we left off, though not really where we left off. I feel so much stronger, Fairfield's painting has developed so much, as he and other people feel."[84]

Porter stayed in touch with Paul Mattick in Chicago. Their correspondence was not confined to politics (they knew each other's views thoroughly by now); they also discussed the latest literary and art criticism. His letters give the impression, in fact, that after his return to New York in 1939 he increasingly devoted more attention to critical writing, and considerably less to political action.

"I don't care for the art criticism articles in *Partisan Review,*" he had concluded by November. He had been working for some time on a portrait of Mattick and had managed to "put back some of the life that I previously killed, after you did not pose. The Auerbach's liked it. But Dinsmore's portrait is now perhaps even less 'official' than yours." Porter's mood about his work, which was never so bold as to be confident, was at least positively disposed for the time being: "I have learned a good deal from Anne's remarks about writing. I think she is doing good work, but lately she has been interrupted by having no one to work for us and by Laurence being sick again."[85]

Through Paul Mattick the Porters had met the photographers Walter and Ellen Auerbach, who were living now in Elkins Park, near Philadelphia. While Porter was reworking portraits in his rural house, a major Picasso retrospective, "Picasso: Forty Years of His Art," had opened in New York, occupying every gallery in the old Museum of Modern Art. Walter Auerbach wrote on 26 November to urge Porter to see the show as soon as possible, which he rightly regarded as a historic occasion. He thought Picasso's works of the twenties brilliant, while *Guernica* and the related pictures were "the strongest that we have seen for some centuries. We wished so much you were with us and we wanted to congratulate you that you are in the same metier. The *Guernica* work reminded us very much of what you told

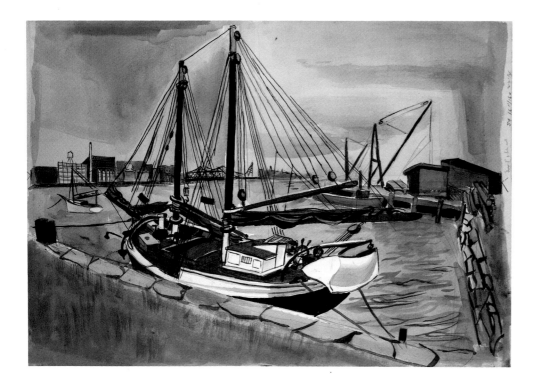

us about your writing and painting, namely that one has to come to that state
where we don't care any more how the things look or sound if they are only right."
When Auerbach added, "And it is very encouraging to see that Picasso succeeded
in a comparatively short period to get rid of all that which had been taught and
that was conventional," one suspects that he was subtly encouraging his friend to
try the same approach.[86] It was precisely the advice that Porter needed and what,
in time, he was to do. He saw the Picasso show in December and by chance met
John Walker and his wife there; Walker now lived in Washington, D.C., and was
working, as director, on the formation and construction of the National Gallery of
Art, which opened in 1941.

The Porters were searching for a more convenient house to buy or rent; they
were situated so remotely in the country that to go into New York by train was
almost too complicated. John and Laurence's school was eight miles away and
their parents had to make three trips there every day. Within a few months the
Porters had rented a different house in Croton-on-Hudson.

In 1940 the Porters were shocked by the death of John Wheelwright, struck
down in Boston by a drunken driver. Anne wrote, "We feel increasingly sad about
it—one seems to think of more and more things one wanted to talk with him
and we took it for granted that there would be so much time."[87]

After his return to the East, Porter began an active correspondence with
Dwight MacDonald, the editor of the New York literary journal *Partisan Review*.
MacDonald had sought out Porter in Chicago two years earlier, because he had
been told that he was worth knowing.[88] Porter's circle of correspondents was so
interwoven that it was sometimes difficult to know with whom a given idea had

originated: in September, for example, he wrote to Mattick, "The editorial by Mac-Donald in *Partisan Review* that you liked had several ideas from me and you, because I recognize my phrases in letters and conversations with him, and my versions of your ideas."[89]

During the summer of 1940 Porter had gone to visit John Marin in Maine and had found him much easier to like there than in New York. He felt that Marin was proud and preening when in the city, "but in Maine in his own house he is sympathetic and serious and a little sad."[90] The Porters saw Marin and his wife that year at a Thanksgiving dinner in New York. Their critic friend Paul Rosenfeld was also there.

The Mexican muralists were very much on Porter's mind this autumn, but he responded with only mild enthusiasm to the major exhibition, "Twenty Centuries of Mexican Art," that the Museum of Modern Art had organized. To Anne's mother, who had sent him a book on Mexican art, he wrote, "The book is more interesting to me than the exhibition was. I am glad they reproduced in color Tamayo's *Pretty Girl,* which is at the moment one of my favorite pictures. I also like the picture of *Fire* by Orozco, which was not at the exhibition, since it is on a wall in Mexico."[91]

The influence of contemporary Mexican painters is detectable in two portraits, *Anne* and *Seated Boy,* which Porter probably painted after his return to New York in 1939. Their earth tones and the unromantic realism they express are hallmarks of the muralists' style; indeed, the heightened naturalism is a welcome indication that Porter had finally cast off every last vestige of Benton's stylizations. But a newfound concern for the texture of the painted surface—it is noticeably more tactile—is especially forward-looking. It is possible that Vuillard and Bonnard were making their presence felt, if only in a whisper. The tiled floor and the patterned rug beneath Anne's chair are French devices also, though treated cautiously still. From his own description to Stieglitz, Porter felt that most of his progress in this period was in painting technique, and he cited Renoir as one of his sources, although in all other respects he thought Renoir a very different artist.[92]

At the end of 1940 Fairfield and Anne were expecting their third child. Six-year-old Johnny's handicap was unimproved and more and more apparent as he grew older. The noisy squabbles between Johnny and Laurence, now four years old and very bright, alarmed their parents. The doctors confidently offered wildly varied prognoses. Now the Porters' hopes were cruelly raised by the latest report, which concluded that "the reason that Johnny can't seem to learn to use buttons, safety pins, and shoe laces, is connected with his repressed aggressiveness" and the fact that he had "too much conscience." With proper therapy, the Porters were told, he could have "a normal life by next year and he and Laurence can go to the same school and the whole family will be on a normal basis."[93] As time passed, this diagnosis fell by the wayside, along with all the others they had received.

Porter invoked Kafka as he described to Mattick one of his parental dilemmas, his hesitation between sympathy and firmness in the matter of discipline. "I like Kafka because for me he expresses in the most detail possible, with humor and with horror and always with great and beautiful tenseness, all the combinations of the relationships between authority and the object of authority—and all

the mystery of perhaps the unsolvable problems connected with it. Authority is bureaucratic and ridiculous, or perhaps reasonable, you can never be sure. And I will never be sure that the authority I pretend to exercise and exercise in spite of myself with my children is ridiculous or capricious, or arbitrary or reasonable."[94]

In the same letter he told Mattick, "I met Clement Greenberg who writes for *Partisan Review* and whose articles I dislike, but I like him. I think I will try to interest him in *Living Marxism* [Mattick's political journal]."

Porter crossed swords with the art critic early and often. By his own testimony, he liked Greenberg personally, but one suspects he most appreciated the man as a forceful and brilliant disputant. In the January–February 1941 issue of *Partisan Review* Porter published a long letter to the editor, detailing what he approved and disapproved about their magazine. The same form of discourse that he had practiced in connection with politics he now applied to art and literary criticism. His letter assumes the journal's interest in his considered opinions, even the negative ones, and that its editors might even modify their stance in response. He delighted in the intellectual give-and-take associated with political arguments and he had enjoyed firm friendships over many years with his favorite discussants, chiefly Haberstroh, Wheelwright, and Mattick. As he shifted his sights from politics to criticism, he characteristically did not pause much to weigh the possibility that the subjects of his discourse might resent his interventions and quite conceivably take personal offense from them.

Porter informed *Partisan Review* that its art criticism was "sectarian and academic" and itemized the faults of George L. K. Morris, the magazine's principal writer on art. "Morris fights the rigidity and narrowness of Official Art with a more breathless rigidity and a more snobbish narrowness than any he opposes. He almost never writes about an artist directly, nor does he analyze the quality of any work . . . He likes Brancusi, so he gossips about where Brancusi spent the summer . . . His comments remind me of a fashion column in *Harpers Bazaar*. I have no sense of his using his eyes before a picture, rather he judges on the basis of talk about it . . . I know what the paintings have not got that Morris admires. But what have they positively, what is their quality? If Morris does not say this, he does not make a beginning even of his criticism."[95]

Porter's comments on Clement Greenberg's articles were comparatively temperate, though not more favorable in their essence. He must have been the first observer to advance in print the accusation that Greenberg used art history to influence art. "Greenberg's recent articles seemed to rationalize the points of view in *Partisan Review*. He seems to say in 'Toward a Newer Laocoon' that History justifies the latest fashion. He confuses the arts of painting and history instead of the arts of painting and fiction. I would say that art exists not for history or for fashion, but for men. Perhaps the unifying attitude of the magazine is that everything exists for History's sake."[96] Porter's objections to Greenberg are an unconscious prediction of his own future as an artist who worked without conforming to the dictates of the Art History then simultaneously being written.

During the same period Porter composed another notable critique of an art critic. This was his letter to *The Kenyon Review* (published September 1941, but written almost a year before), rebutting a hostile article by Wyndham Lewis about

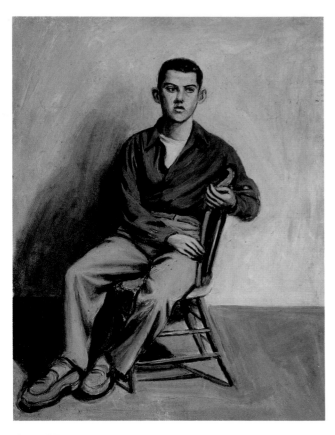

Seated Boy. c. 1938

Picasso. One of the distinctive qualities of Porter's critical prose is his capacity to come directly to the point:

> Sir,
>
> *Your article on Picasso by Wyndham Lewis was very bad. I think that like many literary people you have an indirect understanding of the visual arts, and that since Lewis is both a painter and a writer you thought he must be an art critic.*
>
> *The criticism shows about Lewis, first, that he looks at paintings through the spectacles of words, and without these spectacles would be blind . . . [Lewis] is a manifesto painter. In the end of his article he compares Picasso with his manifesto, and finds Picasso lacking. Picasso is not a manifesto painter, and the end of the article shows that what is at issue is the manifesto by Lewis, nothing else.*[97]

Porter's critiques of the art criticism of George L. K. Morris, Clement Greenberg, and Wyndham Lewis contain the outlines of his personal credo as art critic. This credo is highly individualistic: it is neither commonsensical on its face nor based on attitudes that art critics have customarily employed. In the first place, Porter objected that Morris, Greenberg, and Lewis were, each in his own way, "manifesto critics." Each proceeded from a personal manifesto against which all works of art were compared and thereby approved or found lacking. A respected Cubist painter in his own right, Morris was one of the founders of the influential group American Abstract Artists, and therein lay his manifesto. Greenberg's manifesto, Porter said, was his personal vision of the history of art and its inexorable progress; Greenberg's History-with-a-capital-H either justified or rejected works of art as they suited or did not suit his theory. Lewis was also a painter whom Porter accused of applying the theoretical bases of his own art to others' and thus blinding himself to other qualities.

One could justifiably reply that Porter was criticizing critics for having a point of view, which they have always done. But the second basis of Porter's credo is a response to any such objection. For him, the personal manifesto of the critic was of secondary importance to the integrity and uniqueness of the work of art. In other words, he was arguing that critics must be prepared to test and modify their manifestos when faced with the primary evidence, the work of art. Porter recognized that the critic's preferences and preconceptions cannot but naturally occupy the foreground of his mind. ("I know what the paintings have not got that Morris admires. But what have they positively, what is their quality? If Morris does not say this, he does not make a beginning even of his criticism.") Nevertheless, the critic must attempt to overcome his personal prejudices and not be blind to individual, even opposing qualities. This is the profile of the undogmatic critic that Porter would strive to be. His contribution to art criticism would reside in his sustained effort to avoid manifestos (just when most other critics were sharpening theirs), and to seek the individual qualities in every work of art. To a remarkable extent he was able to write independently of the prevailing vogues and swirling fortunes in the art world of the fifties and sixties.

Porter's favorite art critic at this time was Paul Rosenfeld. *The Kenyon Review*

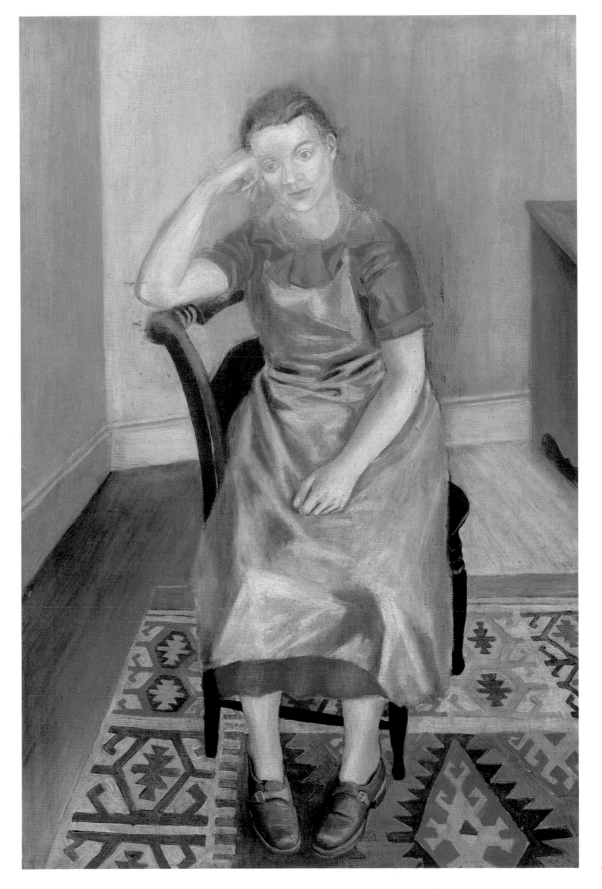

Anne. c. 1939

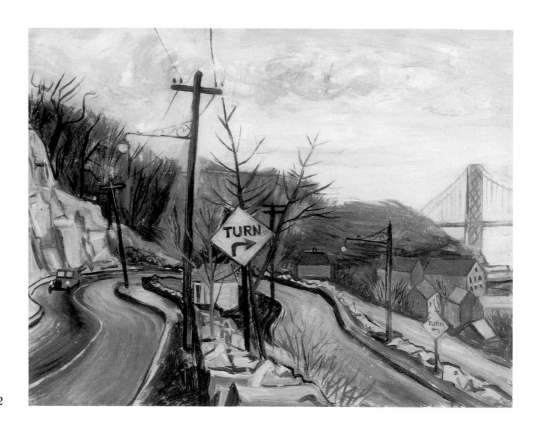

Turn. c. 1942

had slightly abridged Porter's letter about Lewis, not distorting it, but cutting a few lines in praise of him: "But on your own staff there is a man who does see painting directly, who has sensibility, and who can write about art. I refer to Paul Rosenfeld. I am not the only person who thinks he is a good critic; many painters and sculptors whom I know share my opinion."[98] Later, in 1945, Porter and Rosenfeld talked about collaborating on a book about e. e. cummings's paintings and poems.[99]

To Paul Mattick Porter once quoted a dictum of Rosenfeld's that he considered a great truth. "Paul Rosenfeld says that 'art exists for the artist's sake. It is his way of making something of his life,' not for art's or society's sake, and Anne says it is fake if made in any other way." Porter's later statements and lectures on the meaning of art often echoed this maxim.[100]

Over the New Year's holidays, 1941, the Porters were introduced to Rudolph Burckhardt by Walter and Ellen Auerbach. Burckhardt was to become Porter's preferred photographer for his paintings, but he greatly admired his original compositions, which may have encouraged Porter's interest in painting New York cityscapes, notwithstanding their diverse styles. "I like [Burckhardt's] way of seeing New York. His photographs isolate what you see on the street right under your nose, like newsstands or on walls with writing scratched faintly on top, or the junction of two neighboring and dissimilar buildings and the way the sidewalk is warped around it, or hydrants or grills."[101]

The Porter's third child, Jeremy, "Jerry," was born on 18 December 1940. The household was distressingly agitated in those years, with Johnny's future so uncertain and his relationship with his bright younger brother so difficult to gauge. Doc-

tors advised them to be on the watch for Laurence's resentment at being displaced by the new arrival. Porter communicated this latest diagnosis to Mattick, sounding more weary than convinced. "Johnny takes everything more calmly, which is as it should be, for he has had five more years to get used to our betrayal of him."[102]

The Porters were invited to a *Partisan Review* editors' party given by George Morris. Morris had a fine collection of paintings, mostly abstract, by himself, Picasso, and others. The editors attending, Porter wrote to Mattick, were "Dupree, Burnham, Guenther Reimann (wrote the Vampire Economy) and David Schuber (poet) and Clement Greenberg. I like Greenberg because when I see him he smiles most warmly and he does not look around the room for a way to escape. He is the only editor of *Partisan Review* who is not snooty at all. Greenberg and Reimann both expressed great admiration of you and they were both as drunk as I."[103] The Porters also met the poet and critic Paul Goodman at this party.

Many years later, Porter reflected humorously about the *Partisan Review* circle of writers and editors. "One thing that struck me about Mattick, et al., was their very good manners in debates. *Nobody* ever interrupted, no matter how long the speech was. This is hardly ever the case among American debaters, especially radicals. For instance, the editors of Partisan Review were in the habit of interrupting and over-riding the person they disagreed with. Also, once at a PR editorial meeting, I think it was MacDonald who said, 'I think it is time we introduced the American Public to Kierkegaard. Who is Kierkegaard?'"[104]

Porter had to tell Paul Mattick in July 1941 that he could no longer make donations to his journal, *Living Marxism*. "My income is reduced about a third, and our expenses next year will not be correspondingly reduced."[105]

On their way to Maine that year, Porter had another car accident; as before, another driver ran into his car. Fortunately, Anne and the baby had gone ahead by train. Porter was unharmed, but the other occupants of the car were not so lucky this time. Johnny had a cut on his forehead that required stitches; Laurence took a splinter just above his eye, and his other passenger, a young teacher, broke her nose. In 1941 and 1942 this young woman from Berlin, trained to take care of "backward" children, helped the Porters with Johnny. Porter became very attracted to her, but his marriage to Anne weathered this strain, which ended when she moved to Chicago and married.

That summer on Great Spruce Head Island Porter felt he was making progress with his landscapes. He had settled on a method of working he found congenial, although it meant going against everything he had learned in art school. Anne wrote of this, "Fairfield has done three lovely oils already. He sailed to Isle au Haut yesterday with the Powells to stay and paint an oil there. He says it's not the fashion to paint oils from nature any more, not outdoors anyway, but he finds it better."[106]

Porter's move from Chicago to New York had not satisfied his urge to travel and his seeming need to find the perfect house. Since returning to Peekskill the Porters had moved two more times within the Croton area, but the addresses and timing of these moves are not now clear. By November 1941 they had been living for perhaps a year on the Old Post Road in Croton-on-Hudson. But Porter spent most of that fall in California, in a determined effort to find the most appropriate

town and the best school system for his children. While on the West Coast he enjoyed meeting and spending time with Kenneth Rexroth, the poet.[107] He returned to Croton on 31 November, having visited his mother in Winnetka, and was preparing to make a house tour of Connecticut, this time in Anne's company, when all these plans were indefinitely postponed by the events at Pearl Harbor, 7 December 1941.

Anne wrote her mother on 16 December, with an audible sigh of relief, "It was fortunate for me as for Fairfield that his trip is over. I know he would have been worried about me and children as I would about him if we had been separated during these days. He is registered for civilian defense spotting airplanes and repairing houses and has already spent one morning from six to noon, on a farm reporting airplanes."[108] Fairfield commented during this early moment of national mobilization, "The war makes everybody friendly, the way a flood does."[109]

In mid-January 1942 Fairfield and Anne went into town to have lunch with Ellen Auerbach, "and she introduced us," Anne wrote to her mother, "to a poet named [Edwin] Denby (who writes librettos for Aaron Copland, I think) and a painter, a Dutchman named de Kooning."[110] A few days later, in New York, the Porters saw "Fairfield's friend Clement Greenberg and his friend Mrs. Connolly, whom I was never able to meet before." Anne Porter had an interesting perspective on Greenberg at that early date: "Greenberg is a wine taster at the customs house and also a writer, and editor of Partisan Review. We met at the end of a Partisan Review editorial meeting."[111]

Anne Porter's phrasing in her letter is ambiguous, and it does not seem likely that this was the first time Fairfield had met Willem de Kooning. Porter recalled long afterward that the Auerbachs had introduced him into their circle of friends soon after the Porters' return to New York in 1939: "Through Walter Auerbach, I met Edwin Denby, Rudy Burckhardt and Bill de Kooning. They were not politically oriented."[112]

In his 1968 interview with Paul Cummings, Porter recalled an early episode when Greenberg encouraged him to write about de Kooning; by the end of the decade, Greenberg was openly discouraging de Kooning, according to Porter and other witnesses. The dates mentioned by Porter are imprecise, since he did not remember that his letter to *The Kenyon Review* was published in September 1941.

In the thirties we lived outside of New York; I met Clement Greenberg of Partisan Review. *And he asked me then to write something about Bill de Kooning for* Partisan Review. *That was in 1938 or 1939. And I did write something. He was the art editor of* Partisan Review. *He and MacDonald liked it but the other editors didn't like it. It came back, although Greenberg said, "It's very good; it's better than I could do." He was polite. So I sent it to* Kenyon Review. *I guess I had written to* Kenyon Review—*they had printed something by Wyndham Lewis, anti-Picasso, and I wrote a long letter arguing with Wyndham Lewis. And they printed this letter of mine [1941] and wrote to me that they hoped I would write something of my own sometime. So I sent them this thing about de Kooning in 1939 [sic]. And they sent it back and said, "It's very interesting but he's an*

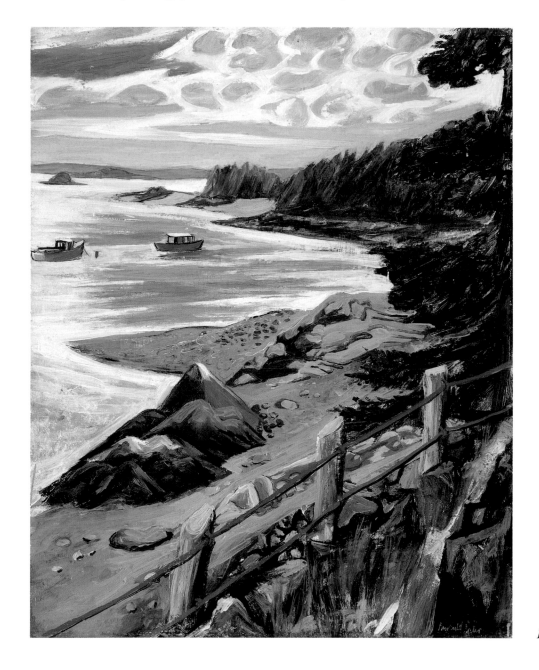

Red Cables. c. 1943

*unknown painter, and you haven't sent us any photographs so we can see
what his work really looks like so we can't accept it."*

Porter's unpublished article on de Kooning is not known in any form today;
there are indications to suggest that he wrote it in mid-1942, or thereabouts. In
March Walter Auerbach regretted Porter's absence at "a party of Bill's where
Elaine's two brothers were present. Later we went to my room and finished your
whiskey with the best wishes."[113] Anne mentioned in a family letter of 2 April 1942
that Porter, besides being asked to be an assistant blackout warden and chief war-
den for their block, had heard that *The Kenyon Review*, "which is very good, wants
more writing from Fairfield since his letter on Picasso."[114]

Over the summer Porter lived by himself in a room at 141 East Fifty-third Street, in New York, except for the month of July when Anne was there. His mood was at one of the lowest points in his life. According to a recent recollection by Anne Porter, he was deeply discouraged about the lack of progress of his painting. Anne had already noted to her mother in April, "Fairfield needs a rest so much . . . I sometimes wonder whether the problems of Johnny are too acute for Fairfield and Laurence."[115] The death in May of Porter's mother was also an emotional setback. During the mid-1940s Fairfield and Anne felt under stress from many different directions and contemplated separation. In the end, they never separated and the uncertainties in their relationship had been resolved by 1949, when their daughter Katharine was born.

In the summer of 1942 Porter wrote a letter to Anne in which his friendship with de Kooning appears to be his sole spark of inspiration, although this situation was also subject to complications.

> *I am getting to enjoy my room, it feels like home, though all I do here is loll on the couch and day dream, or read Karen Horney,* New Ways in Psychoanalysis *(I finished* The Neurotic Personality*) or play chess, or try to think about painting . . . Bill de Kooning has painted some surpassingly beautiful abstractions—one in pink and yellow, with a blue window, which expresses my delight in June at the island—the blue for the sky and water, the yellow for the Indian paintbrushes and the pink for the way you feel at the seacoast. But de Kooning, himself, though I like him, makes me feel uneasy, perhaps envious, perhaps guilty that I don't paint. Also I feel I am interrupting him, and that he is poor and I am rich.*[116]

In August 1942 Porter bought a house for his family at 312 East Fifty-second Street in New York, paying $13,250.[117] An appraisal of the contents of this house was drawn up in March 1943; this interesting document records that Porter had three paintings on view in his dining room, two of them his own copies after Pesellino and El Greco, the third an oil painting on panel by "William de Kooning, contemporary, 'Composition of Three Classical Female Figures; one with Pitcher Vase.'" Curiously, all three of these pictures were valued equally, at $100. The living room upstairs held Porter's most valuable work of art, *Vigil,* a small, abstract oil on canvas by Orozco, appraised at $300. In the same room was the Marin watercolor he had bought from Stieglitz, *Movement—Cape Split, Maine,* valued at $100. Nearby stood an "African Primitive Carved Wood Statuette of a Female" worth $45.[118]

Porter's library and photographs were more valuable than his art collection. He valued his photographs of "famous master paintings in the Museums of Italy" at $100. He owned about fifty art books, with titles on "Raphael, Leonardo da Vinci, El Greco, other old master and moderns—Picasso, Cézanne, Renoir, etc." Their value was estimated at $200. On the other hand, Porter's five hundred books of "poetry, travel, classics, history, etc." were valued at $500. The Porters owned various oriental rugs, the most valuable being an Afghan Bokhara worth $250. This was perhaps the rug that Porter painted in his portrait of Anne of around 1939.[119]

The fourth floor at 312 East Fifty-second Street was used by Porter as a studio (for a while he also painted in a room on West Twenty-third Street, near to Rudy Burckhardt's).[120] It contained a large wall mirror and two painter's easels. The fourth-floor studio was filled, moreover, with the most valuable items in the house, an "assortment of paints, brushes, unframed oil paintings, watercolors"—in short, the bulk of his works since his return to New York, which were appraised at $1,000.

In a 1942 letter to Anne, Porter mentioned an idea that he did not pursue (something he blamed on his own "puritanism"): "Maybe what I will paint next will be nudes from nature." This would have been a natural response by any painter who had admired the Bonnards exhibited in Chicago in 1938, and perhaps this is a sign that Bonnard was on Porter's mind.

Probably Porter's best picture from the war years is a New York *Street Scene,* which is imbued with a certain European intimacy that recalls Bonnard's famous lithographs, *Quelques aspects de la vie de Paris.* At right, an appealing young woman who looks like Anne Porter steps lightly off the curb. There were ample possibilities in New York for Porter to see pictures by Vuillard and Bonnard even during the war. In March 1942, in fact, there was an important exhibition of Bonnard drawings, watercolors, and prints at the Weyhe Gallery, which he presumably visited. Paintings by Vuillard and Bonnard were also shown at the Rosenberg Gallery in New York, in July 1943. Bonnard was seventy-five in 1942, and John Rewald dedicated a long homage to him in the October issue of *Art News.* The opportunities for Porter to refresh himself at this particular fountain were plentiful; for the time being, though, he did not drink deeply.

During World War II Porter worked for the U.S. Navy in the office of an industrial designer who had navy contracts. Much of his work was strictly secret; for example, he worked on a new shell-case ejector design for a shipboard cannon. He found the work boring, but his contributions were appreciated. In affidavits dated 13 and 14 March 1944 his employers successfully appealed to keep Porter on their staff and exempt from the draft.

> *This is to certify that Fairfield Porter is a draftsman on the staff of Walter Dorwin Teague, 444 Madison Avenue. Ht. 6'1". Wt. 150 lbs. Brown hair & eyes.*
>
> *Fairfield Porter, now employed on a confidential job for the Bureau of Ordnance, Navy Department, is doing essential work in a position which is extremely difficult to fill. There were four other individuals who worked on this particular project for many months without results. Mr. Porter has not only familiarized himself with the intricate problem, but has also produced designs which are advantageous and useful. He has shown the distinct ability to invent, devise, and design the particular class of mechanisms such as are required on the confidential Navy project on which he is employed. It would be most disastrous to this project if Mr. Porter were removed from the work in question.[121]*

The war, of course, did not leave space for summer vacations in distant

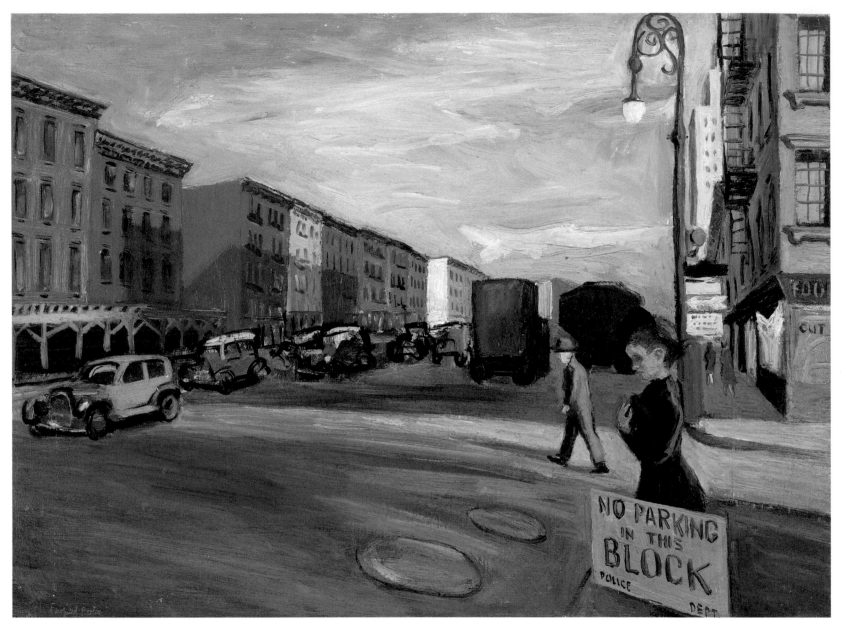

Street Scene. c. 1943

Maine. Anne and the children went out to Sayville, Long Island, to be near the beach during the summers of 1943 and 1944, and Porter took off as much time as he was allowed to be with them. During August 1944, while the family was away, Porter was able to paint occasionally during the evenings. He was reading E. M. Forster at the urging of Albert Friend, who was staying at the Porters' house while working on a critical study of Forster. Anne recorded that Sunday would be Porter's chief painting day, provided he could find some place outside of the house to work.[122]

Just before the war's end, he was happy to be transferred to the model shop of Walter Dorwin Teague, "which is more real and satisfying than just drawing guns." As soon as possible after V-J Day Porter quit his job at Teague; in retrospect, he said, it was "a valuable experience for me to work for this industrial designer,

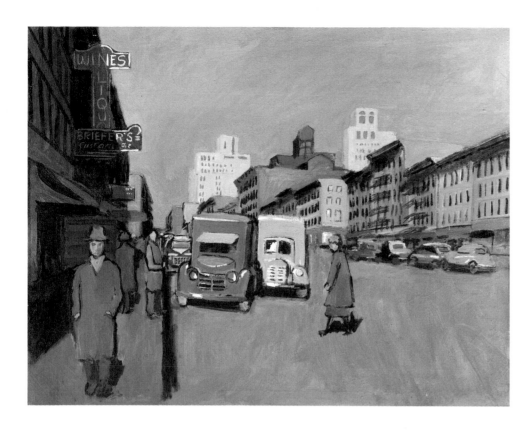

Wines and Liquors No. 2. c. 1945

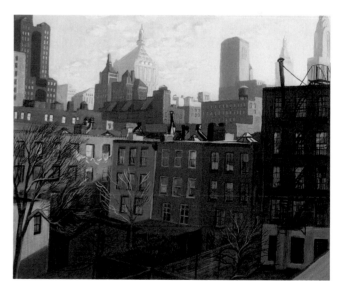

Cityscape. c. 1942

because when the war began to peter out they would give me [work] that had to do with peacetime activity. And I would read in the *New York Times,* 'There is a significant artistic effort in this country's industrial design and it is Walter Dorwin Teague.' . . . I had always felt a little guilty about being an artist, so to speak, and having no connection with the real world. And I saw, working for this person who was considered to have a connection with the real world and engaged in a really useful activity, that his activity was no more socially significant than if he'd owned, say, a one thousand foot yacht and employed one hundred people to run it around. It was just his own entertainment . . . He would re-design things that usually were perfectly well designed already."[123]

By March 1945 Porter was attending a painting class taught by "old Maroger, who has the good oil medium of boiled black oil or whatever it is," as Anne explained it at the time. Edward Laning had told Porter about Jacques Maroger, a war exile who had formerly been an art restorer at the Louvre. Maroger taught classes in technique at Parsons School of Design (and, later, at Baltimore, before returning to France). Porter recalled, "I had a feeling that I didn't know how to paint . . . I mean, I had never learned it. And it was very difficult . . . Then, when I did study with him he showed me this medium. It seemed to be so easy, natural, that I stayed with it only for that reason."[124]

Maroger's Medium, used as an additive to oil paints, became an important element in Porter's work. It is now available commercially, but he always preferred to make his own. It combines one part beeswax and one part lead carbonate (or oxide) with ten parts raw linseed oil. This brew is cooked until it is as black as pitch and dismal-smelling. The medium turns out slightly differently for everyone

who makes it, no matter how closely the recipe is followed. The painter then mixes a little bit of the medium with his tube oil paints. If he prefers, he can prime the canvas with the medium and then paint into it. Paints mixed with Maroger's Medium are very fluid and can be freely, quickly brushed; the beeswax component insures that they will hold their place; they are liquid, yet they do not run or stain. The medium is also very slow drying, which allows the painter great flexibility in changing his mind. It is a simple matter to scrape away painted areas that the artist doesn't care to keep. The paint surrounding is not disturbed and the reworked section of the canvas still has a smooth surface for painting again.[125]

Maroger claimed that he had rediscovered the medium of the Old Masters; most authorities on technique have expressed doubts. The history of Maroger's Medium was less important to Porter than the fact that this medium gave his paintings a richly textured surface comparable to that of the best Europeans, including Vuillard and Bonnard. Porter wanted to paint broadly, with a gestured brushstroke, but by temperament he also wanted to describe carefully. He also wanted to be able to return to a passage until he had got it right. Maroger's Medium allowed him to work in this way. He did not always use it, but many years later he commented, remarkably, "Sometimes I don't, and if I don't use it, the fact that I have studied it somehow helps me in painting just with ordinary turpentine. I don't know what it is, but something comes through so that the ease that I get from [the medium] passes over, even when I don't use it."[126]

To Porter, Jacques Maroger was essentially a technician; Maroger's classes taught him what to paint with, not how to paint. "What I got from him was just the medium. He didn't interest me otherwise . . . He measured everything by what he called 'the Medium.' And if you spoke of Goya he would say, 'Well, he didn't have the Medium.' And that was all he'd have to say about Goya. The last [i.e., the latest] person he was interested in was Fragonard, because he did have the Medium."[127]

In 1945 Porter was thirty-eight years old. He had worked independently as an artist for more than a decade, yet he still felt the need to begin at the beginning. In October he went to the Metropolitan Museum of Art, set up his easel, and devoted a month to copying a work by Tiepolo. Anne tried to cheer him up by quoting Hokusai, who had said, "Not till I was seventy did I begin to understand the forms of animals, birds, and plants."[128]

Porter often got into conversations with the passers-by who stopped to stare at the canvas on his easel. One of them was a "Frenchman with a Dutch name, van Hooten [Houten], who said that he had known Degas, Renoir, Bonnard, and Vuillard.

> *I was copying a Tiepolo at the Metropolitan Museum. I was using the Maroger Medium. And a little man with very, very bad breath came up and spoke to me and said, "You have light in your pictures. Most of these copyists don't have any light in them." I don't know what I said about that. Then he said, "I have never copied." And I said, "Really? But I thought Renoir copied and so on." I mentioned all the Impressionist painters. He said, "No, none of them copied. I knew them all.[129]*

Fairfield and Anne became friendly with van Houten and his wife. Van Houten

gave Porter a few lessons, perhaps three, "in which he told me what I needed to have told me, though I already knew it in a way. But I needed to have somebody say it.[130] His advice was to keep on seeing light in everything, to see light even in shadows, and above all to see light rather than pigment in paint."[131]

Porter's description of his lessons with van Houten gives the impression that the older, more experienced Belgian was able to offer him some much-needed confidence in his native abilities. Van Houten's message was that it makes a difference whether something is done the right way or not, and that he could see Porter understood the distinction. This seems to have been immensely helpful to the younger man. Porter later said of van Houten's advice about paint and light, "I got things like that from de Kooning, too."[132]

The Porters saw a show of Marsden Hartley's work at the Museum of Modern Art in December 1945; Anne liked many of the paintings, while Fairfield and Edward Laning found them mostly too "literary."[133] Porter's views on Hartley had changed since 1936, when he had defended Hartley's works to John Wheelwright. "I admire his pictures," Porter had written then. "He is hard to talk to because of his deafness, and because he is bitter and contemptuous, so that he turns your remarks into something absurd and silly . . . He is a reactionary . . . However, he is a real artist, who deserves better treatment from the world." Wheelwright must not have been convinced by this, since Porter had later pressed the point: "I don't agree about Hartley—it is paradoxical to say [he is] a good though lifeless painter: and Hartley's still lifes have more life than for instance Grant Wood's people, even more Humanity."[134]

Christmas 1945 was notably successful, even if Porter found the year-end holidays exhausting, as he always did. "For some reason I hate Christmas. Johnny is much improved: he listens to me and I can now talk to him in the way that I talk to Jerry and Laurence, which gives a lot of pleasure to us both."[135] Johnny Porter now attended Devereaux School for troubled children, in Paoli, Pennsylvania, and, being relieved of the pressure to behave according to rules that he could not understand, was much happier. He came home for holidays and for the summer. Five-year-old Jerry was especially attached to his father, always asking him to draw pictures for him and greatly enjoying carpentry together. One day Jerry brought his mother a piece of wood with pegs in it and told her proudly, "Daddy and I together made this solemn toy."[136]

Porter was more optimistic about his painting than he had been in years. "My painting is much better than it was in the summer. I think I learned much this fall."[137] This appraisal came on the heels of his meetings with van Houten and classes with Maroger in the spring and fall of 1945.

Only a scattering of notices are known from early 1946: in March they gave a party for the painter Isabel Bishop; during the spring the Porters traveled outside of the city, looking at "farms and things" because Porter longed for the country, at least for weekends if not longer;[138] Porter was reading Jane Austen, "cover to cover."[139]

With three sons now, they returned to Great Spruce Head Island that summer for the first time in five years. Fairfield's mother had died in 1942, so that this was their first island vacation without either of his parents. He took consolation from

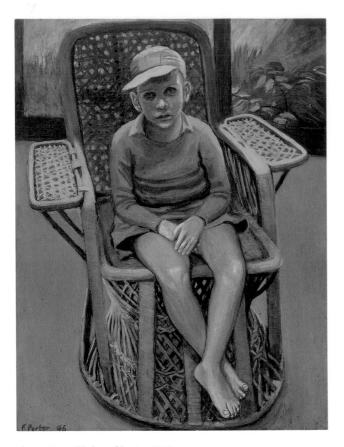

Jerry in a Wicker Chair. 1946

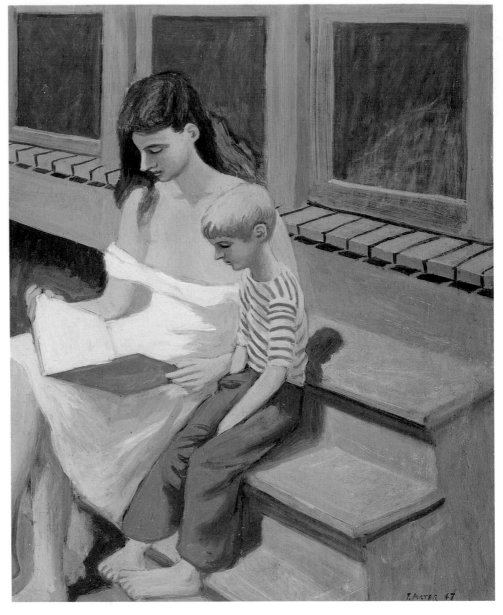

Anne Reading to Laurence. 1947

the innocence and energy of his own children. At the same time, he was sensible that the responsibility to provide them with their own "golden age" now rested upon his shoulders. "Fairfield paints and takes little boys on walks and I think feels happy in spite of the sadness he must feel in this house sometimes . . . It's hard for Fairfield to talk about things, which makes them hurt more. Otherwise we're having quite a lovely time." Anne concluded a summer letter on her habitually positive note.

Despite sadnesses—and in July there was the shock of learning that their friend Paul Rosenfeld had suddenly died—Porter painted rapidly and well this summer. Between July and August he painted what Anne called a "sweet Jerry-like portrait of Jerry,"[140] probably *Jerry in a Wicker Chair,* a picture that reveals the fluency imparted by Maroger's Medium. It is a shame that none of Porter's other

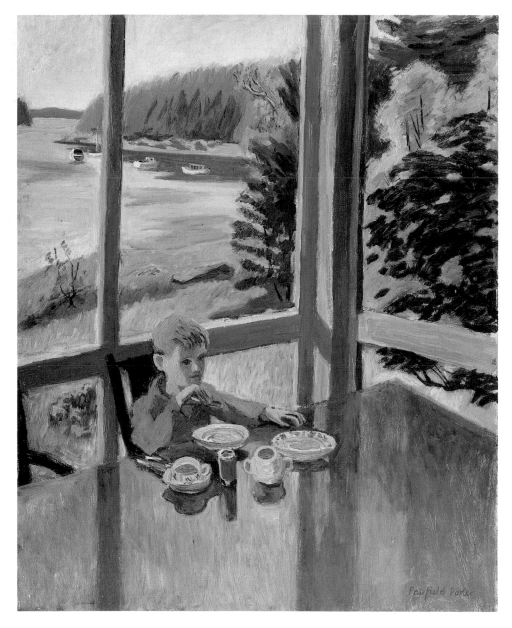

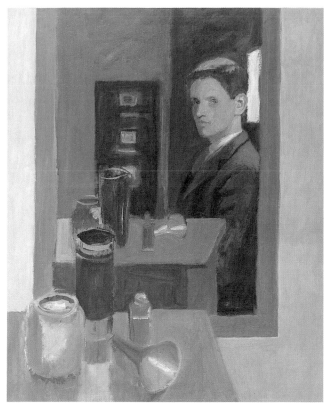

Self-Portrait. 1948

Boy at the Breakfast Table. c. 1948

paintings from this summer can be identified: he painted at least three landscapes, a still life, and portraits of his friends Jimmy Straus and George Jefferson.[141]

The Porters saw Bill and Elaine de Kooning especially often during the autumn of 1946. Porter and Elaine had hatched a plot to make money by painting portraits on commission; Anne agreed to pose for them, "looking as society as I can manage." Around Thanksgiving time the de Koonings drove down to visit the Porters at Sand Brook, on the Jersey shore. "The arguments were, should architecture be functional, and do modern artists need a new metaphysics."[142] Their various opinions are not recorded.

If we compared Porter's development as a painter to an ocean-going ship, we could say that during the winter of 1946–47 his ship finally rounded the cape and headed toward home. For the first time, he felt that he understood both what he

City Window. c. 1947

wanted to do with his painting and what he felt a painting should be. Not a word of what he thought was in agreement with what he had been told at Harvard or the Art Students League. "I have been painting more pictures of New York disguised as Venice, with the pinkish and yellowish buildings of 8th Avenue, and I have discovered how to paint a picture in one day. Also I discovered that what Mr. Van Houten was trying to teach me I had been doing inarticulately in watercolor, but not in oil which I thought was something special, and [in] which I made the mistake of thinking that I could do everything later instead of at the beginning, which is the only way."[143]

Both Fairfield and Anne felt that his work was improving almost from painting to painting. It was an exhilarating time for them, and increasingly so, when they saw that his progress did not slow or break. In December Anne first noticed, "Fairfield's painting begins to show more and more what he has put into it since he left the draftsman job. It has got beyond the point where he just gains in technical proficiency. Now some of the freshness and mystery that he had in watercolor is coming into his oil paintings too and they are softer, less literal and more alive, and they express him better."[144]

Porter's comments about painting New York disguised as Venice were penned in February 1947. A month later he was still enjoying the sensation of painting very quickly and sometimes finishing his pictures in one day.[145] Years later Porter never failed to credit de Kooning for a crucial influence on his development at this time, although of course Porter never imitated his style. Critics have even wondered whether, in effect, Porter gave credit where credit was not due. Perhaps, however, it was the idea of painting quickly, which translates also into painting fearlessly, that Porter took from de Kooning. The Porters and the de Koonings were particularly close during the late 1940s, precisely in the years when Porter cast off the idealistic inhibitions of his early training. On this question he said in 1968, "In aesthetics [my Harvard education] was weak. The weakness came from the fact that there wasn't any relation to practice . . . It was all theory and the theory didn't go very deep. It was superficial theory. And I found that out much, much later, when I met de Kooning. First I thought I had found it out when I studied with Benton. He seemed to go further. But then, when I met de Kooning, I thought Benton too was not too deep. It didn't, with Benton, come out of not enough practice. It came [out of the sense that] the idea comes first and you apply it."[146]

Porter was also deeply impressed by de Kooning's contributions to discussions held at Studio 35 and the Eighth Street Club in New York City. After the war a group of artists used to meet in Washington Square at night, after work, and then continue their talk at Stewart's Cafeteria on Manhattan's West Side, or the Waldorf Cafeteria in Greenwich Village.[147] By the end of 1949 they made these meetings more official and organized what came to be called "The Club." De Kooning was one of the charter founders and he invited Porter to come when he wanted to. Almost all the other artists were abstractionists. In 1949 de Kooning read a paper in which, among many observations, he declared, "In Genesis, it is said that in the beginning was the void and God acted upon it. For an artist that is clear enough"; and, "In art, one idea is as good as another"; and, "Style is a fraud."[148] De Kooning's dicta might seem so encompassing as to reduce art to manufacture; their actual

effect was to reject most American prewar painting. For Porter, his words were a wrecking ball that smashed the way into the light and air.

De Kooning confirmed for Porter that an artist need not apologize for being an artist. He liked to recall the time when de Kooning had spoken at the Museum of Modern Art and a member of the audience raised his hand to ask, "Mr. de Kooning, how can we persuade the American public that they need art?" and de Kooning had answered, "They don't need art. What the artist should do is to assert himself." Another time, de Kooning recounted seeing a man at the circus, off in a corner by himself, doing a handstand on one finger. The point was, "No one asked him to do this."[149]

In April 1947 Anne posed for a picture that was probably *Anne at 312 E. 52nd Street,* which is known in two versions. "Fairfield is painting an interior—the living room with me in it. The colors are lovely. I look very alert and mischievous in the picture, which Fairfield says he has now 'spoiled.' But he always says that."[150]

Although no one commented on it at the time, it is evident in *Anne at 312 E. 52nd Street* that Porter has ceased to paint in the style of the American Scene. His goals in this atmospheric interior are principally pictorial: he uses his brush and colors first of all to make a painting, something worth looking at. He no longer gives a thought to anecdote or to social comment. He has completely transformed his palette as well, if we compare it with the earth tones in the portrait of Anne seated of circa 1939. The inky shadows and greenish lamplight in the later painting are reminiscent of France, of Vuillard especially.

Porter's transitional paintings of the late 1940s are mostly unidentified or lost. He had a lifelong habit of destroying his unsatisfactory pictures and most of his paintings prior to 1950 perished in the incinerator after he hit his stride as a painter. It is regrettable, if understandable, that he discarded these works. At his best, even during his immature decades, his paintings invariably offer satisfactions, if, admittedly, in part as portents of greater things.

As the winter came to an end in New York Porter was able to work out of doors. In May 1947 he painted a spacious city view, *5th Avenue at 84th Street* (location unknown), which Anne and all his friends considered his best New York picture to date, and which he himself liked. Anne said the colors were "very mild and delicate" and predicted that he would have a good painting summer, "with the landscapes he loves and his new picture technique" (a reference to Maroger's Medium).[151]

Before going up to Maine in 1947 the Porters attended a lecture by Simone de Beauvoir—"'The' woman existentialist," as Anne called her. "She is a beautiful looking woman with level eyes and a perfectly smooth forehead. I somehow associate that look of devastating calmness with intellectual French ladies."[152]

The three painting summers of 1947, 1948, and 1949 confirmed for Porter that the drought was indeed behind him. It was still true, of course, that he found no occasion to exhibit any paintings. But his satisfaction with his new, broader approach remained constant. His resultant good humor spilled over into a family life that was regaining its equilibrium. By 28 June 1947, on the island, Anne noted that "Fairfield has already painted four lovely pictures full of color, and has taught Laurence to play two handed bridge and Johnny to split kindling wood . . . he is

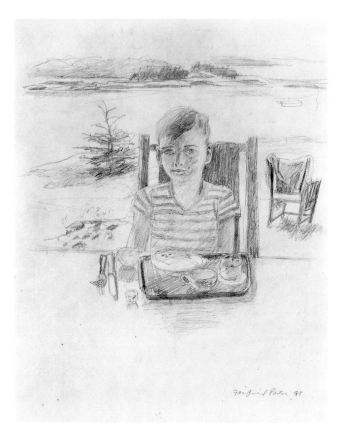

Breakfast in Maine I. 1948. Pencil. 19⅞ x 14⅞". Private collection

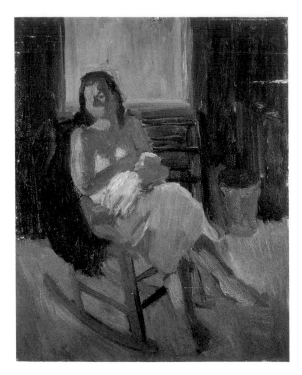

Mother and Baby. 1949

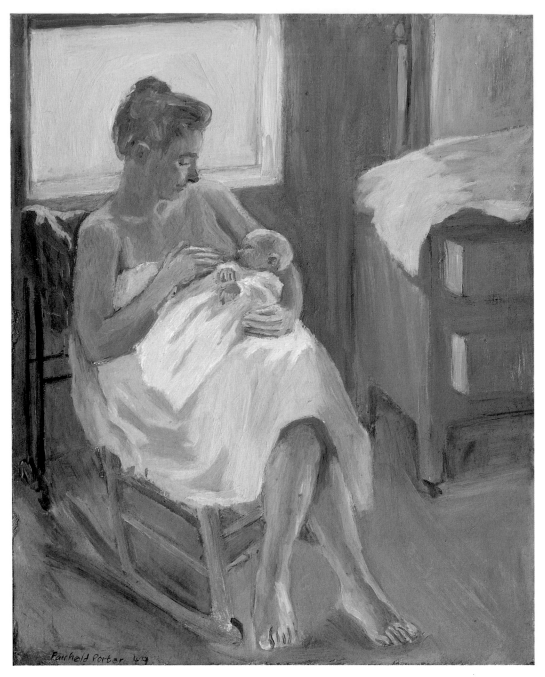

Anne and Katie. 1949

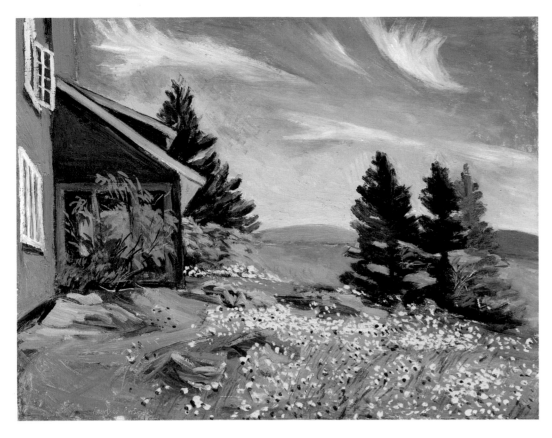

Big House with Hawkweed. c. 1948

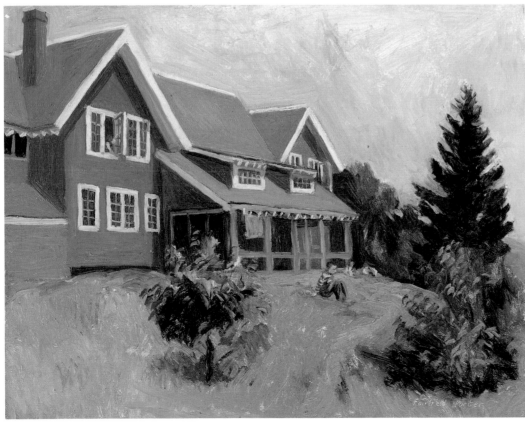

House, Great Spruce Head Island. c. 1948

much happier here than in the city."[153]

All that summer the Porters talked of moving out of the city to the country somewhere. In these conversations was the germination of their eventual move to Southampton, Long Island, two years later. Anne said, "I still think it would be good to get Fairfield and the little naturalists [the children] into the country and that we will make a little money when we leave New York because our house, which wasn't expensive, is now in the United Nations area. Fairfield doesn't mind because he loves looking for houses—or would, if I didn't always insist so stubbornly on good schools."[154]

After returning to New York in the autumn of 1948, Porter found that his summer paintings were as good as he thought they were, to judge from the favorable responses of his friends. This saved him some frustration because plumbing repairs at the house on East Fifty-second Street prevented him from getting much painting done. For the sake of the boys he put up a new fence in their backyard, but afterward realized that he had probably built it too high. "The yard looks like a compound for captured elephants," Anne commented, "and when Fairfield looked out at it he said pensively to himself, 'Bongo Gongo I don't want to leave the Congo.'"[155]

Over the winter of 1947–48, Laurence and Jerry passed personal milestones appropriate to their respective ages, twelve and seven. In October Porter explained to Laurence about the French language "and made it interesting, as he did with arithmetic."[156] (French language and literature have been the lifelong study of Laurence, who grew up to be a professor of French.) Jerry was promoted to adult entertainment and for the first time the whole family went to the movies together; Jerry sat seriously through the show, his arms folded in imitation of his father.[157] In March 1948 Fairfield painted—notwithstanding the distractions of school vacations—two small interiors of the house with figures of Laurence and Anne.

Shortly before they went off to Maine, a major Pierre Bonnard retrospective opened at the Museum of Modern Art on 11 May 1948.[158] Porter's canvas from that summer, *Boy at the Breakfast Table,* represents his deliberate response to the stimulus of this exhibition. The use of a table in the foreground, the larger figure, and its mise-en-scène are recognizable quotations. In the ten years since he had first been so impressed by Vuillard and Bonnard in 1938 Porter had laboriously covered a lot of ground to gain a closer vantage point. By the time of the 1948 Bonnard retrospective he was far better equipped to assimilate what he wanted from these masters.

Porter was most drawn to the later phases of Vuillard and Bonnard's careers, to the paintings that were contemporary with his own time. It is easy to forget, especially if we rely too much on textbooks, that Vuillard lived and painted actively until 1940; Bonnard until 1947. Porter's response to them was therefore a response to the best contemporary figurative painting in France; he was not proposing a nostalgic return to Art Nouveau. This is also why Porter's paintings have nothing in common with the lingering shades of post-Impressionism, which never went out of fashion in the twentieth century, but never rose above the mediocre, either. Porter's admiration for contemporary paintings by masters of the

rank of Vuillard and Bonnard was fully as insightful, canny, and promising in its implications as was, say, de Kooning's reliance on the later Picasso.

On 20 May 1949 Katharine Minot Porter, Fairfield and Anne's first daughter, was born. Porter painted two oil sketches of Anne nursing; the intimacy of the theme and format of the paintings contrasts with the breadth of the handling. Again, the stylistic referent is French, perhaps more Vuillard than Bonnard, in these little sketches.

Katie Porter's addition to the family imparted some urgency to the pending plan to move out of the city. They looked at houses near to Anne's family in Sherborn, Massachusetts. "Fairfield thinks really so much more about the schools and the children's needs than a beautiful house, though he has such a feeling for architecture," Anne had written in April.[159] But no decision was reached before they traveled north to Great Spruce Head Island for a long summer, extended into September. Four-month-old Katie was especially bright and animated: "Fairfield says she smiles at him condescendingly as if she thought: 'This man has really been very kind. One should smile at him.'"[160]

The Maine summer of 1949 was the fourth in a row in which Porter felt that he made steady progress in the direction he wanted for his paintings. As more and more time passed and the results continued to be good, he grew confident that he could sustain his momentum. This summer, a transitional yet encouraging phase of Porter's development, was summed up by Anne: "Fairfield has really tossed off a great many paintings, which have an increasing lightness and freshness, and I think soon he will begin to feel that in his paintings he has gone through Leah to Rachel which is how it seems to me."[161] Porter had decided, probably under Bonnard's influence, that he wanted to "paint people more and more, rather than landscapes." In the event, Porter would strike a fine balance during the fifties and thereafter among portraits, landscapes, and figures in landscapes.

Before the end of September the Porters had followed a lead suggested to them by their friend Eliot Atkinson and had gone to look at houses in Southampton, a rural community with a colonial heritage on the East End of Long Island. The town had splendid broad beaches on the Atlantic, but Southampton was not yet known as a summer resort. The chief occupation of the year-round residents was potato farming. Porter found and bought a large Georgian frame house, built in 1836, on South Main Street. The house stands in an ample yard, with a barn behind it, in a residential neighborhood that is only two minutes' walk from the central crossroads of Main Street and Job's Lane. By mid-October Porter had already entered community life: he duly went off in the evening to hear the guidance counselor explain the programs in the Southampton schools.[162]

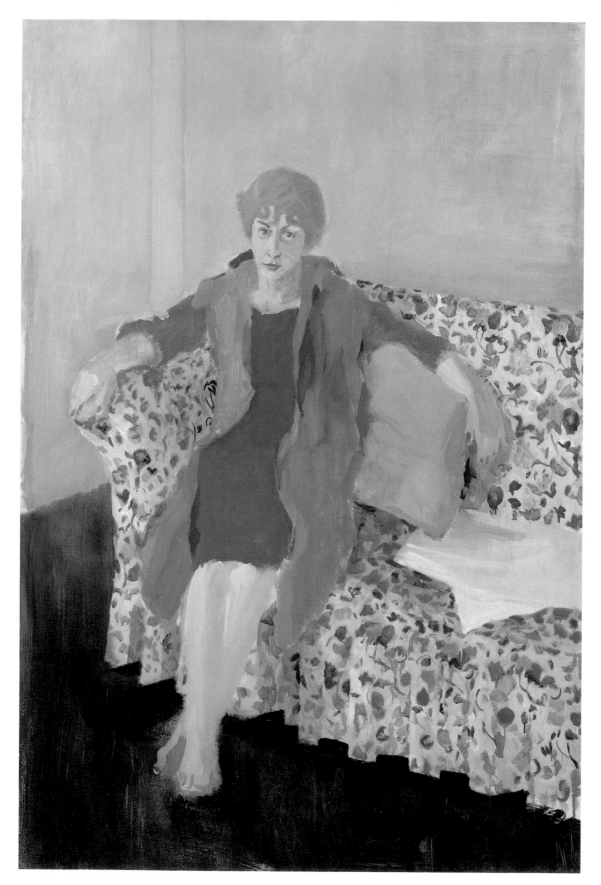

Elaine de Kooning. 1957

SOUTHAMPTON, ART NEWS, AND *THE NATION* | 1949–1961

We moved here because I wanted to be in connection with New York as a painter. It seemed a place that, if we couldn't afford to keep on going to Maine would be a place where in the summer one could swim in the ocean. If you try to make something of our living in Southampton rather than in another place, you won't find much real material.
— Fairfield Porter, letter to Claire White, 13 April 1972

When the Porters settled in Southampton in October 1949, they had been talking for more than two years about selling their house on Fifty-second Street and moving to the country. Most of their house hunting had been in Massachusetts, where Anne's family, the Channings, still lived, but they had also looked at a big house in Westport, Connecticut, where they had heard the schools were good. When Fairfield and Anne found Southampton, they were looking for a quiet life near to nature; the area had not yet become an artists' colony. Jackson Pollock and Lee Krasner had moved to nearby East Hampton three years before, but Pollock and Porter were temperamentally poles apart. (Once, for instance, Porter saw some new paintings in Pollock's studio that he warmly complimented. Pollock looked, and said tersely, "Those are my wife's.")[1] Other artists followed Pollock and Porter, and quite unexpectedly the Hamptons turned into a haunt of artists, especially during the summer.[2]

Porter did not manage any pictures during the first autumn at 49 South Main Street. The large house needed extensive repairs, including proper insulation. He painted all its woodwork and sanded and varnished all the floors. He planned to convert a small barn (more like a two-story tool shed) in the back of the property into his studio. By January 1950 he had installed a studio window, but no insulation, so that the building was too cold to use.

The transfer to Southampton—new schools, new friends—affected each of the children differently. Laurence found the local schools inferior, when compared to Dalton School in the city, where he had been doing college-level English work in the eighth grade. On the other hand, eight-year-old Jerry said that his school in Southampton was "the least unpleasant" of any he had been in. Johnny got along wonderfully with Katie, who liked him especially. He was still enrolled in his special school near Philadelphia, and his parents wanted now to find a quieter locale for him. After more than a year spent in interviews and visits, they at

Painting Materials. c. 1949

last learned of a family in Vermont, the Odetts, who provided a farm life to disturbed children. Over the coming years, the farm in Vermont provided John with a supportive atmosphere in which he was able to accept responsibilities and take other steps toward personal growth.

The emotional shoals and reefs of Christmastide were successfully negotiated that first Southampton Christmas of 1949. Porter sent Anne's parents the gift of a book about Vuillard. With his customary thoroughness he wrote to them explaining the deficiencies of the illustrations, though presumably they were less concerned about this than he. "I asked Mr. Weyhe [the bookseller] to take special care to see that it was a good copy, because I know that they vary a lot from copy to copy."[3] The book must have been one of the two most recent monographs on Vuillard, either Andre Chastel's (in French) or Claude Roger-Marx's (in English translation), both published in 1946.

Two of Porter's works were included in a group show in January 1950 at the Artists' Gallery in New York: a small painting of Anne and Katie in their room in Wareham, Massachusetts (done during a visit to Anne's family) and an unfinished "and consequently fresh" landscape of New York with the Queensboro Bridge in the background. Porter was pleased to see that the colors in these two pictures were "not too gray," and although he was not completely satisfied with them, he preferred them to any of the other pictures in the show. "I haven't before thought my paintings as good as the best that they were with," he remarked.[4]

The gray tonality that Porter mentions was presumably similar to the varied grays in his painting *The Dining Room*. This wintry-hued still life must have been one of his first pictures done in the new house (and was occasioned, in a way, because the studio was not ready). The walls and furnishings in the room have a just-moved-in or perhaps a Wet Paint bareness. In another 1950 interior of 49 South Main, the seasonal light outside is notably brighter, even white, as it filters through the window and illumines the rose-pink walls of his bedroom. The clock on the dresser says that it is three o'clock in the afternoon.

These paintings from 1950 are significant. Only nuances of handling separate them from Porter's mature style, which he had certainly attained by 1953. The brushwork is already broad; all that essentially remains is for Porter to organize more effectively the interlocking shapes on his canvas, that is, to bring background passages into equilibrium with foreground subjects. Dated pictures from this period are important, since these were the canvases that he would show some two years later to the painters Larry Rivers and Jane Freilicher, and subsequently to John Bernard Myers of the Tibor de Nagy Gallery.

On Great Spruce Head Island in the summer of 1950 Porter experimented with a casein paint that could be applied to canvas with much the ease of watercolor. He was happy with the luminous effect of some of his landscapes in this new technique. His summer's reading included Hawthorne's *House of Seven Gables*. By August Fairfield and Laurence had finished together nearly a year's course of Latin.[5]

Porter's activities in the fall and winter of 1950 are not much documented. In January 1951 he wrote a letter to the Metropolitan Museum of Art, protesting

the results of certain recent restorations. His complaint was instigated by the bulletin of the museum, which that month illustrated *The Adoration of the Magi* by Hieronymus Bosch on its cover. "I think you clean off not only dirt but layers of paint that are an integral part of the paintings."[6] He also objected to the recent treatment of *View of Toledo* by El Greco, which had emerged from restoration looking disturbingly different from the El Greco paintings he had seen at the Escorial in 1932. His was not the only accusation of overcleaning at the Metropolitan raised in these years. Porter's concluding remarks addressed the very real (and still current) problem of painting restoration in America in terms that reflect his personal frustrations of the previous two decades.

> *I think the trouble with restoration that is "bad" comes from an incomplete training in the art of painting. In this country drawing is taught, and "composition," and Art Theory, and Aesthetics, and everyone knows what is Artistic, but no one learns how to paint. We train Artists but not a single painter . . . We learn color systems, and chemistry of pigments, and what we do with it has no flavor. Therefore our trained technicians do not see and do not respect the quality in the masters, the subtle difference between a master's painting and a pupil's. I remember in Harvard Prof. Pope showing us the difference between a Master's drawing and a School drawing, but we were never shown this difference in* painting. *There is a difference. I maintain that the Bosch* Adoration *has been transformed by you from a masterpiece to a schoolpiece.*
>
> *I am sorry to say all this because I like and respect the Metropolitan. But the pictures count too.*[7]

Studio Interior of 1951—the room still looking half empty—was perhaps the most accomplished painting that Porter had made to that date.[8] It is a difficult picture to describe because it does not draw on any of Porter's usual sources or indeed look like the work of any other painter than himself. We do not know how this picture seemed to the artist; he would have been the first to recognize that it represented a natural outgrowth of his development in painting during the previous three years. In *Studio Interior* his ability to craft a picture has arrived at an unprecedented subtlety and control. Wedges of tone, which seem almost stained into the canvas, fit together or, elsewhere, seem to glide together or even sometimes to knock into each other, creating a sustained interplay that gives interest to every corner of the painting. Certain passages—for example, where the color of the metallic heating stove slashes through neighboring slabs of ocher and olive-gray tone—call to mind contemporary paintings by Nicolas de Staël although Porter's painting is more ambitious. The game of the picture within a picture—in this case, an unfinished painting on an easel that could be an abstraction, for all that Porter describes it—is managed with complete aplomb. Besides being the best painting in his career to that date, *Studio Interior* was, in fact, one of the best paintings by anyone that year.

Porter's little daughter Katharine became his favorite model for a time, not least because she was in the house all day. He painted portraits of her in March and again over the summer in Maine. For every hour that she posed she was duly

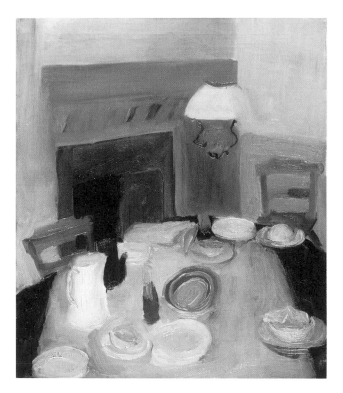

The Dining Room. 1950

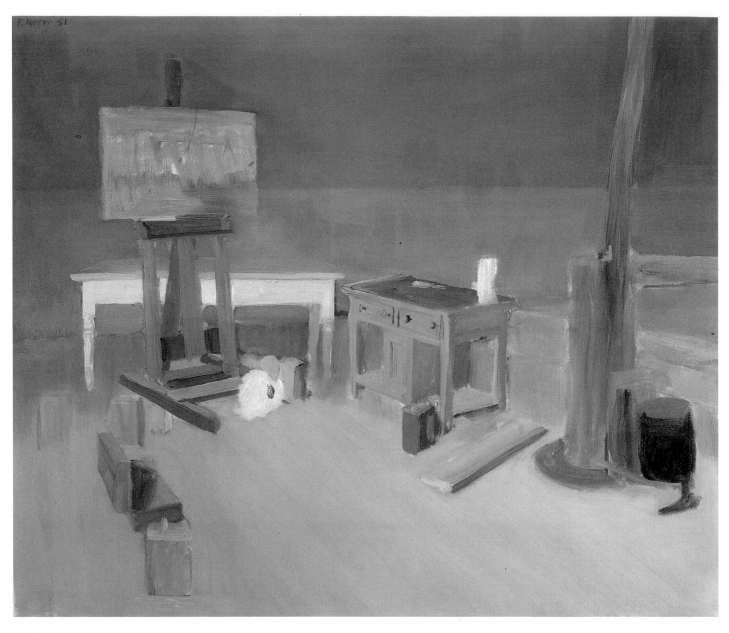

Studio Interior. 1951

remunerated with a metal washer, which she delightedly called a "washer-woman."[9] In August Porter again took up his 1948 idea of a Bonnardesque-scene of a boy seated at a table, with a background of bay and islands. An interesting footnote to his works of 1951 is a small panel of Anne at the oval dining-room table in Southampton in lamplight. The composition was planned in a preparatory drawing. Every element, including the panel support (which Porter almost never used), seems calculated in affectionate homage to the intimate pictures of the early Nabi Vuillard.

The relocation to Southampton did not distance Porter from the New York art world; on the contrary, 1951 and 1952 were the pivotal years in his career. Without any warning, so to speak, he received his first recognition as an art critic in 1951, and a year later his paintings were taken on by Tibor de Nagy, the

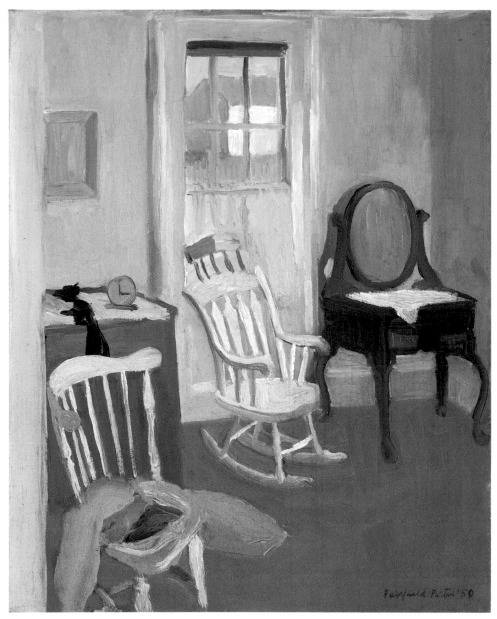

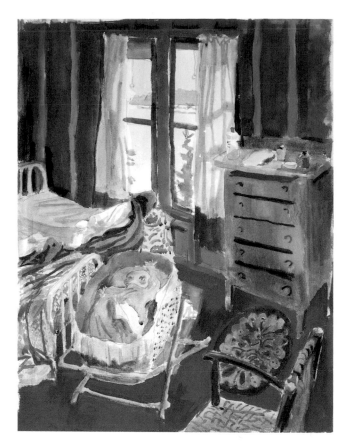

Katie in Crib. c. 1949–50

Interior with White Rocking Chair. 1950

gallery of his choice. His first one-man exhibition in New York City opened there in October 1952, the first of fifteen such shows that the gallery gave him between 1952 and 1970. As Porter was always quick to acknowledge, his chance to prove himself both as a writer and as a painter was the direct result of the unselfish support of many friends, especially his old friends, Walter Auerbach and Willem and Elaine de Kooning.

The first break to come his way was the assignment to write monthly exhibition reviews for *Art News*, which was then edited by Alfred Frankfurter, with Thomas B. Hess. Porter's appointment was the unexpected outcome of his visit with Elaine de Kooning to an Arshile Gorky retrospective at the Whitney Museum in January 1951. "She talked to me about how good [Gorky's paintings] were. And I talked to her about how bad they were. We had a complete, thorough dis-

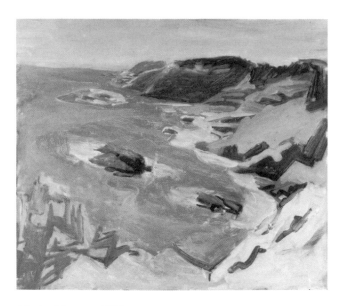

Isle Au Haut. c. 1950

agreement about them," he recalled. But he expressed himself very well. She was just then deciding to leave off writing reviews for *Art News*, where she had been on staff as editorial associate in 1948–49. Hess asked her if she could think of anybody to replace her and she recommended Porter. "I jumped at the chance," Porter remembered, "because I had always thought that I would be good at this, better than anybody . . . And they liked me right away at *Art News*." "When I started," he noted on another occasion, "Frankfurter said to Elaine who had recommended me, 'He's too intense, I give him six months.'"[10] But Porter wrote monthly for *Art News* until September 1959.

He was thrilled to have a regular venue for his critical voice and in the back of his mind he hoped to find a gallery for his own paintings while he did the rounds for his reviews. He threw heart and soul into his *Art News* pieces, working intensely, which meant that he spent one or two weeks out of every month in the city. He stayed in Walter Auerbach's apartment at 500 East Eleventh Street, an arrangement that was particularly convenient the following year, when Auerbach went to Rome on a G.I. scholarship.[11] In addition to seeing all the New York exhibitions, Porter, by the end of 1951, was writing feature articles on individual artists and their working methods as part of the *Art News* series, "——Paints a Picture." These articles were based on interviews and repeated visits to each featured artist's studio, and took him weeks to write to his satisfaction. "Evergood Paints a Picture" was written at the end of November 1951 and published the following January. In Southampton Porter devoted still more days to crafting and polishing his pieces in the monthly "Reviews and Previews" section of the magazine. In September 1951 Anne observed, "There is a real joie de vivre in his short reviews—which are full of wit and sympathy and much knowledge acquired in solitude."[12]

Porter came to *Art News* fully formed as a writer. His critical style held a steady course throughout the years of his monthly reviews for the journal and, later, for *The Nation*. He had a remarkable ability to advance his personal point of view without focusing attention on himself. In one of his first pieces, he commented about a young painter, "He solves the problem of the oil medium in the usual Anglosaxon way—he avoids it." This was of course precisely how Porter felt about American painting after so many years of his own struggles. Yet who else but Porter would have written at the height of Abstract Expressionism that American painters had yet to master the oil medium?

Porter's independence and honesty exempted his criticism from unfairness, however personal it inevitably was. His open-mindedness chiefly rested on his efforts at accurate description: "I would try as much as possible when looking at something that I had to review to cease to be myself and simply identify with it so that I could say something about it." This approach was encouraged, even urged, by Porter's editors. "Frankfurter said that the best criticism is simply the best description. And I think that is true."[13]

Accurate descriptions of all the gallery offerings Porter saw in the course of a month would have added up, though, to tiresome reading (as tiresome as the gallery going), if not for his strong opinions and remarkable literacy. His knowledge of art history was unusually strong of course. And perhaps he benefited

also from the fact that he did not begin to write reviews until he was in his forties. On most questions his mind was made up and it was too late anyway to try to gauge the popular pulse—whatever that was. Porter typically feels free to turn a brilliant aperçu—"Claude intoxicates, Turner is drunk"[14]—without a moment's concern that not one of his readers could have possibly agreed with him, if they stopped to think about it. When Porter was of a mind, he was happy to twit the art world in ways no one could miss. Reviewing a de Kooning show in 1959, he blithely proposed a personal rewriting of the most overwritten epoch of modern art history: "The phrase 'abstract-expressionist' is now seen to mean 'paintings of the school of de Kooning' who stands out from them as Giotto stood out from his contemporary realists."

Porter's lines are often witty, but always to the point: "Lindner like a Balthus corsetted by cubism, has the strength of his European training." In one of his first *Art News* reviews, he summed up Art Brut and Jean Dubuffet as appreciatively as anyone ever has: "By throwing quality away, quality is what he attains." He could draw fine distinctions and find new meanings in artists we thought we understood: "Ensor was terrified by calmness before cruelty; by the fact that the scream makes no impression." Always, he showed his prejudices without apology or dissimulation: "In Moholy-Nagy there is no quality except the quality of order—the picked up desk."

Porter's criticism reads freshly thirty years later because it expresses his individual voice and his individual sensibility. It was not his ambition to use his reviews as a platform to spar with critics Clement Greenberg and Harold Rosenberg; as a result, of course, his columns never attracted as much attention as theirs. Porter was difficult for the art world to categorize because he made no effort to pick the "winners" among new artists or to stick labels on emerging styles: "I do not much believe in criticism of contemporaries that estimates importance, because although some things are better than others, as Shakespeare is better than Shaw, this has too much to do with restricting, either morally, like a minister, or pseudo-scientifically like a social worker." His opinions on art and the extent and achievement of his criticism were not generally recognized until a collection of his reviews and essays was published posthumously, under the title, *Fairfield Porter: Art in Its Own Terms*.

Porter's writings on art deserve to be read in their entirety, for excerpts tend to distort his arguments, rather than convey them, and they merit more extended examination than is possible in this biography. Reviewing *Art in Its Own Terms*, Hilton Kramer wrote:

> *This is an extraordinary book, one that places Porter among the most important critics of his time. What once seemed fragmentary and somewhat unfocused (owing perhaps to its original mode of publication) now turns out to have been the most consistently sensitive and thoughtful writing on new art, and on the art of the recent past, that any critic of the time gave us.*[15]

As a result of his writing Porter found himself spending more time in the company of other painters in New York than he had while he had lived there.

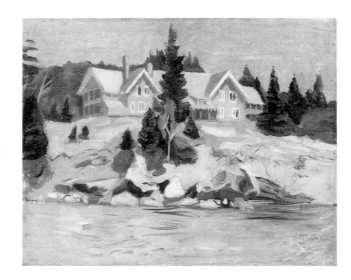

The Maine House. c. 1950

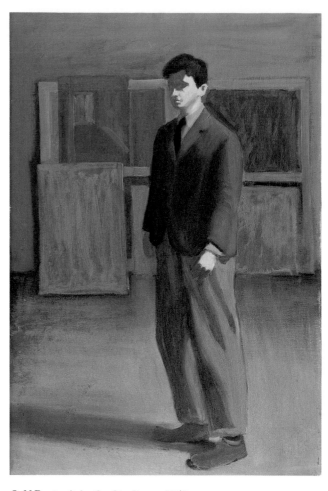

Self-Portrait in the Studio. c. 1950

Between visiting galleries and studios and going to the Eighth Street Club, where the Abstract Expressionists held forth, and the Cedar Tavern, where they drank all night, Porter's circle of New York friends expanded dramatically in 1951. He had of course met all the leading artists of his own generation, but he was not close to any of them, except de Kooning. In fact, most of the abstract painters struck Porter as standoffish, or even condescending.[16] Almost all had survived the Depression thanks to their meager earnings from the WPA: thus, William Baziotes, James Brooks, de Kooning, Adolph Gottlieb, Philip Guston, Pollock, Rothko, Clyfford Still, and others were effectively members in a fraternity to which Porter did not belong. (Barnett Newman, too, claimed that he was never taken seriously during the thirties because he was not in the WPA.) Most of the friends Porter now made were artists a full generation younger than himself. For the rest of his career, in fact, he always showed extraordinary sympathy to young artists. Years later, his Amherst student Ted Leigh said of him, "He took me more seriously than I did myself."

Two lasting friendships Porter forged at this time were with Larry Rivers and Jane Freilicher, born in 1923 and 1924, respectively. Porter's 1951 portrait, *Larry Rivers,* is the earliest record of their acquaintance. The painting has an uncalculated naturalness that is deceptive, to say the least. It presents itself as if neither Porter nor Rivers had any suspicion that portrait painting had been declared completely dead outside the National Academy of Design. When Porter suggested to Rivers, who was visiting his studio, that he sit to have his portrait taken, and when Rivers did so without striking a self-conscious pose, the two of them were combining forces to make a manifesto for figurative painting, and they knew it very well.

Rivers and Freilicher were both young painters for whom abstraction was neither a crusade nor a cause, but an option they respectfully declined. They had studied together at Hans Hofmann's school in New York in 1947. With Hofmann they had benefited from a European outlook on art and on the finely crafted work of art, without feeling compelled to imitate their teacher's abstract style. The 1948 Bonnard exhibition at the Museum of Modern Art had had a crucial influence on the development of both, just as it had helped to confirm Porter in his own. The two younger artists had both been impressed, further, by an exhibition of Henri Matisse's postwar works, shown at the Pierre Matisse Gallery in New York in February 1949.

Matisse's portraiture comes to mind as a possible source for the pose and format of Porter's *Larry Rivers,* although there is no other hint of his influence. (Porter's basic indifference to Matisse is interesting in itself.) The frontal position of the head, the prominent eyes, owe something to de Kooning's figure paintings of the early forties. The tan, red, and yellow hues are also found in early de Kooning works, but could as well derive from the late Vuillards that Porter so loved. The relaxed expression of the body and, above all, the artist's concentration on painting first, description second, are distinctively Porter.

There are anomalies sometimes in Porter's portraits that raise hard questions about the anatomy lessons offered at Cornell Medical School. Rivers's right arm, bending across his leg, is not the most compelling or beautiful arm that

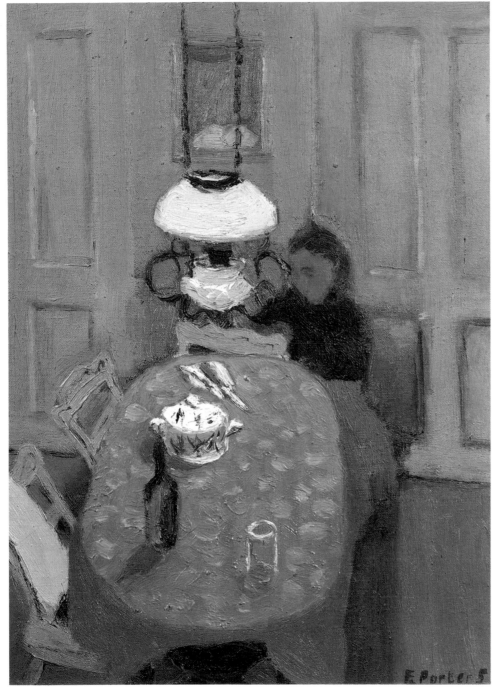

Interior. 1951

Study for *Interior.* 1951. Ink, 11 x 8½". Private collection

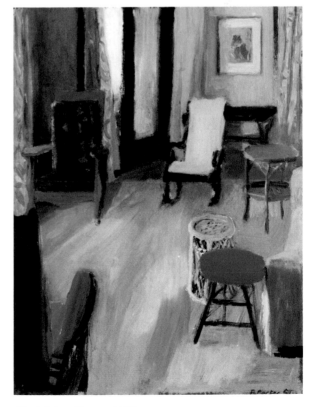

The Living Room. 1951

Porter ever painted. The bicep seems too long, or perhaps the forearm is not long enough. Yet Porter offered a justification of "mistakes" like this in his review, just a year later, of Freilicher's first solo show. One of his criticisms of Freilicher was an apt self-criticism: "When she has to choose between the life of the painting and rules of construction, she decides to let the rules go. The articulation of some of the figures is impossible and awkward, and though this is a fault, it is a smaller fault than murder."[17]

Porter wrote a favorable review of Freilicher's first show at Tibor de Nagy Gallery in the May 1952 *Art News*. Soon afterward, Freilicher and Rivers went out to Southampton to see Porter's pictures. The two liked his paintings and recommended him to John Bernard Myers, director of the Tibor de Nagy Gallery. Porter was a kind of discovery, it seems: a painter who had been working independently for years, stubbornly sticking with the figure, painting beautiful pictures that nobody knew about.

"I think Larry knew Fairfield before I did," Jane Freilicher recalled in an interview in 1989. "I met Fairfield at the first show I was going to have at Tibor de Nagy: Fairfield came to review it for *Art News* and that's how we met. We felt a kind of kinship, or an affinity, and we became friendly. Larry said he had met Fairfield, and he liked him. I think I went out there with Larry first and we looked at Fairfield's paintings, which he didn't really bother to show to anybody. He'd never shown at that time. We both were enthusiastic about them and actually I think it was our bringing them to John Myers, as well as Bill de Kooning and Elaine—Elaine was always a good friend of Fairfield's—that convinced Myers to look at them."[18]

Freilicher and Rivers's visit to Porter's studio took place over Memorial Day weekend, 1952. Porter described it to his painter friend Lawrence Campbell, who also reviewed for *Art News*. "It was most strenuous. Larry Rivers was like a tactful anthropologist visiting natives of an alien culture whose mores must be formally respected. It is clear that they are not his mores. He thought that we would find him strange (that we are not used to people like him) which made it strenuous all around." Notwithstanding the generation gap, they discovered a mutual sympathy, and the outcome of the day was, as Porter recognized, that "Larry and Jane seemed to like my paintings (which is something that always surprises me) and maybe I will as a result get an exhibition at Tibor de Nagy. I want to paint some pictures worthy of it."[19]

On 7 October 1952, Porter's show opened at Tibor de Nagy Gallery, on East Fifty-third Street.[20] John Bernard Myers, director of the year-old gallery, recalled that it was de Kooning who had originally drawn his attention to Porter; that, in fact, de Kooning had paid him a visit specifically for the purpose of doing his friend a favor. According to Myers, de Kooning had pulled up a chair and said, "I've got a really good artist for you . . . Someone who knows how to paint really good—Fairfield Porter." When pressed, he had admitted, "Yes, he is a friend, but I'm telling you Porter is really good. He knows what he's doing!" On the strength of this urging, Porter was signed on at Tibor de Nagy, sight unseen. "A few weeks later, Porter showed up with a half-dozen canvases, which, to my bewilderment, were neither abstract nor Expressionist. What he had brought were naturalistic still lifes and landscapes, rather dark in color and not very alluring. I felt uneasy, but I had given my word. A few months later we installed Porter's first show. I feared I had made a stupid mistake, but after about a week of being with the pictures and looking at them daily, I found that Fairfield Porter was exactly the artist de Kooning had praised as 'really good.'"[21]

Porter's own explanation of the events that led to his first show at Tibor de Nagy gives some credit to his reviewing and some credit to his friends' recom-

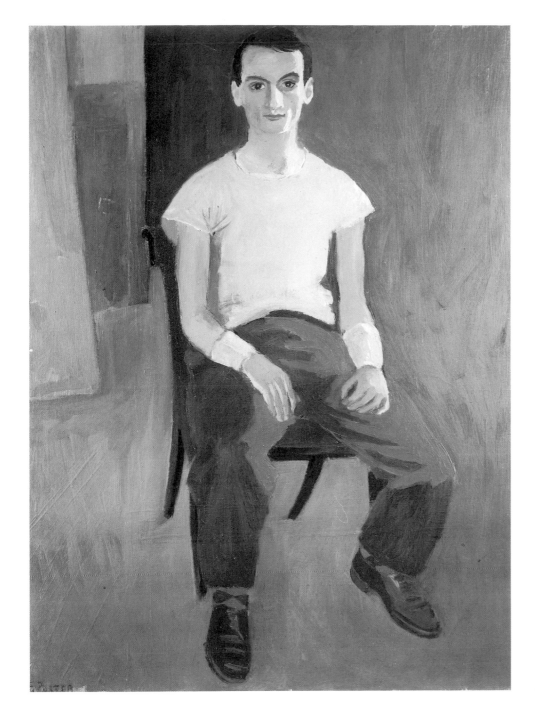

Larry Rivers. 1951

mendations, but does not suggest that the gallery took him on sight unseen. In December he wrote to Aline Porter, his brother Eliot's wife, "My show was a success, except financially. Also I got into the Gallery in New York that I prefer to all others. I got to know about them by reviewing, that is galleries, and this one seemed the one that took chances, and the chances worked. I did not think I had a chance, but they liked my reviews of their shows (both the favorable and unfavorable ones) and Walter [Auerbach] told them about me, and I showed them some pictures, and Bill and Elaine de Kooning also recommended me, and I

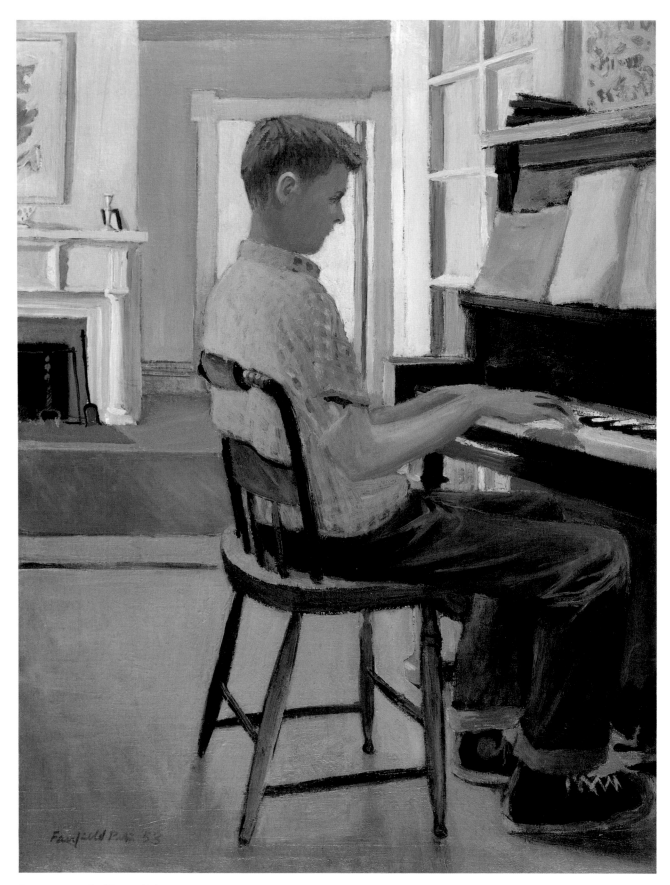

Laurence at the Piano. 1953

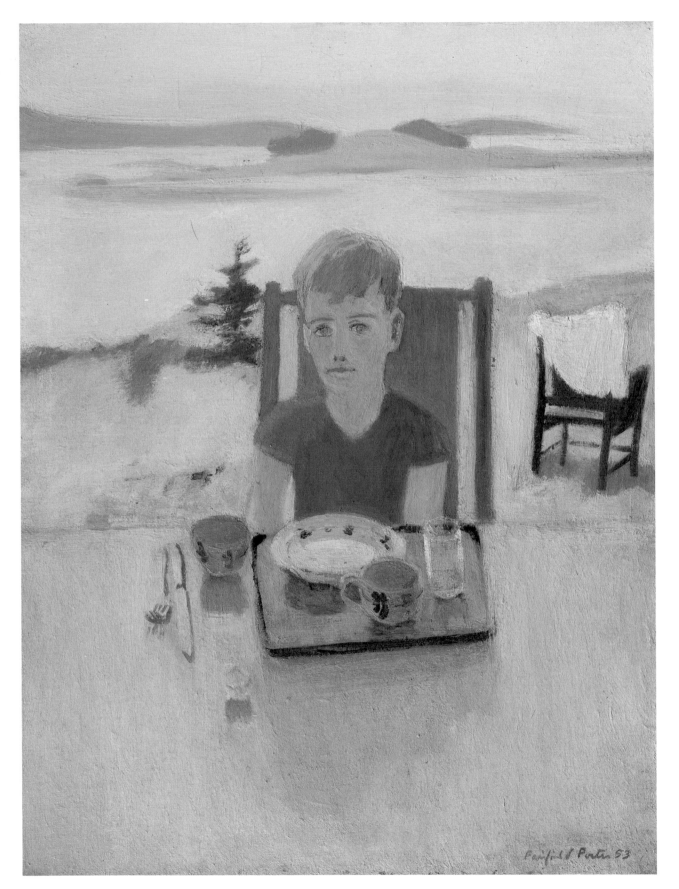

Laurence at the Breakfast Table No. 4. 1953

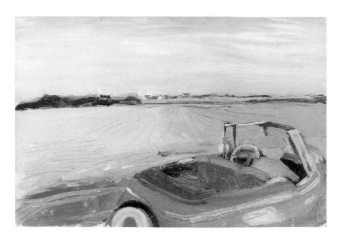

Red Car. c. 1951

could not tell whether they liked my pictures because they said to everyone that showed pictures, 'they are beautiful,' so as to hurt no feelings, and then two artists [Rivers and Freilicher] who were there also liked my pictures, and put pressure on for me, and I told them that I preferred them to all the other galleries, which did no harm, and so they took a chance with my pictures, which was a chance that my pictures would look academic. It has given me a big boost."[22]

The Tibor de Nagy Gallery had been founded in November 1950 as an improbable partnership between de Nagy, a Hungarian refugee, and Myers, formerly the managing editor of *View* magazine. Neither had any money; the gallery was run on shoestring backing provided by Dwight Ripley. The original core of artists included Helen Frankenthaler, Rivers, Freilicher, Grace Hartigan, Harry Jackson, Robert Goodnough, and Alfred Leslie. Myers had conferred with Clement Greenberg about new talents, and it is ironic, perhaps, that Porter became associated with a gallery that, initially at least, had been influenced by a champion of abstraction. In addition to reviewing their shows, Porter had had an opportunity to learn about this gallery in depth at the Eighth Street Club. On 7 March 1952 Myers had moderated an open discussion among the de Nagy artists Freilicher, Hartigan, Leslie, Joan Mitchell, and Rivers. The poet Frank O'Hara had also taken part.

Porter's agreement with Tibor de Nagy stipulated that the dealer would receive a one-third commission on the net sale price. Nowadays art dealers take higher commissions, but pay more of the concomitant expenses. Porter was personally responsible for the expense of framing his pictures and transporting them to and from the gallery. The artist had to pay the cost of printing invitations to the opening and the catalogue, if any.

Six days before the show opened, Anne described their excited preparations for it: "Fairfield had to buy a trailer—it was cheaper than the cost of trucking the pictures to the city. He framed all the pictures very simply with thin strips of wood. The director of the gallery John Myers, a warm-hearted Irishman, chose *all* pictures of the children and the house and one of the sycamore tree—it's a sort of family album. I hope to get to the opening for an hour. Fairfield will drive me back here. On top of all that he has been asked to be membership chairman of the PTA . . ."[23]

The prices in Porter's exhibition ranged from $50 to $1,000 (the lower must have been for a drawing). In the event, no paintings are known to have been sold. His being on staff at *Art News* paid a notable dividend, in that Porter's show was illustrated in the magazine with a photograph and reviewed by a personal friend, Lawrence Campbell—favoritism, to be sure, but Campbell's comments were perceptive and just.

Fairfield Porter . . . Long Island painter and critic who is F. P. in these pages, demonstrates in his first show that the glass of realism is not spent . . . There is no nostalgia. There is something very hard-headed and unsentimental about Porter's work, an honest appraisal of what the eye sees. Nature is analyzed and offered as patches of paint which fit

together. There are no tricks, no obvious patterns, no composing by the line, yet everything holds together. The children are never alone because the furniture lives, too. Sometimes his acute appraisal seems to extend to the thoughts of the subjects. Katy, though a little girl having break-fast, is thinking about being a fish or a bird. The stove in The Big Studio *is not displeased at being cast in the role of prima-donna.*[24]

Campbell's comments ring so true as to suggest that he and Porter conferred before the review was published. "Nature is analyzed and offered as patches of paint which fit together. There are no tricks, no obvious patterns, no composing by the line, yet everything holds together"—is word-for-word a perfect summary of Porter's method. And there is more than a hint of Porter's own thoughts in the suggestion that "the furniture lives, too."

This first show was also reviewed by Stuart Preston in the Sunday *New York Times,* 12 October 1952, and by James Fitzsimmons in *The Art Digest,* 1 November 1952. Preston was unreservedly favorable; he characterized Porter's style as simultaneously "intimate, tranquil and thoughtful" and made a telling point about his approach: "Facts are not distorted nor are they allowed to interfere with the pictorial orderliness." Fitzsimmons, on the other hand, was polite but completely unmoved. His review offered a most informative analysis of Porter's sources in Vuillard and Bonnard, but ultimately complained that Porter was not an Expressionist—that he was not even Balthus.

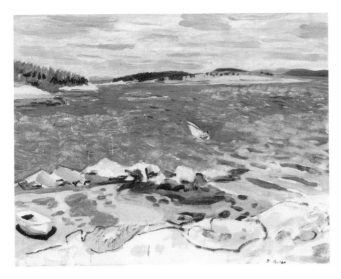

Penobscot Bay. c. 1952

Porter has none of Balthus' fever, his hint of perversity. Rather his mood is one of civilized restraint and serenity. In this respect he is much closer to Vuillard and, despite the relative austerity of his colors, to Bonnard. Harmony, order, balance—the classic aristocratic virtues characterize his work . . . But there is perhaps too much taste and charm here—qualities one does not look for in expressionism—and also a slickness, a suggestion of the magazine illustration. The artist is at his best in Studio Interior *where, with light and color, he achieves a curious hushed intensity.*[25]

Fitzsimmons's critique serves double duty as a review and as a high-precision barometer of the prevailing critical sensibilities of the early 1950s. It is fascinating to read these peremptory dismissals of civilized restraint, serenity, harmony, order, taste, and charm. The only fitting subject of art, it seems, was angst.

Porter had feared that his paintings might be dismissed as academic, and the review by Fitzsimmons did indeed apply the innuendo "magazine illustration." In sum, though, he could be justifiably encouraged by the reviews of his first New York show. No one knew better than he (except perhaps John Bernard Myers and Tibor de Nagy) the strength of the contrary tides he was venturing against. He emerged unbattered; his pictures understood even by a largely unsympathetic critic.

Edward Laning, Porter's old friend from his radical days, wrote a congratulatory note about the show that was characteristically leavened with politics: "I enjoyed your show extremely. Your painting . . . has steadily become more inte-

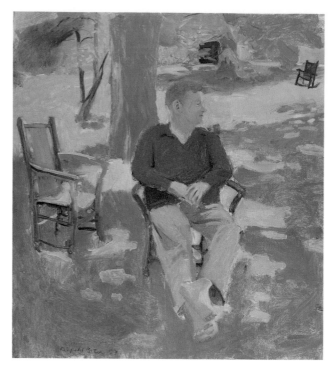

John Myers. 1953

grated, personal and skilful. It's made me very happy to read 'good reviews' of the exhibition. I talked to Isabel Bishop the day after your show opened and she was very enthusiastic . . . I'm sorry Senator McCarthy interrupted the art festival this evening, though he was very entertaining, too. I find it difficult to trace the influences of Inness and de Kooning in your work—a little like the subtle entanglements which bind [Adlai] Stevenson to the Communist conspiracy, maybe. Too subtle for me."[26]

Porter also kept a kind note sent to him by Philip Evergood, the painter whom he had profiled in *Art News:* "I was very pleased and thrilled by what I saw . . . The one of your wife stood out with great simplicity of design and human quality as did the splendid large studio interior, and some of the small ones looked very fresh & lively to me. All in all it was an unusually cheerful & healthy and *honest* exhibition on a high esthetic level—not straining a gut to be 'out of this world,' 'in a test tube' or designing linoleum of a most highly valuable estheticness to go with the Viennese cocktail glasses and the Directoire Commode which contains the dial phone—so much of this we see everywhere."[27]

Porter's friends were politely enthusiastic; if they inwardly harbored doubts about his importance, they prudently kept these quiet. Edith Schloss, an artist friend who was married to Rudy Burckhardt, remembers her mixed response to the exhibition. Her descriptions of the pictures are especially valuable because no catalogue or checklist was printed.

> *I think most of us, including Bill de Kooning, as loyal friends tried to believe in this show but it was not easy. It was not that it was figurative when most work in those years was abstract, but that much of it was still awkward. Here was a brown fourposter bed in a pink room; a robe thrown over a victorian chair; Anne nursing a baby; a reading lamp with green shade over an open book and vase of flowers; traffic on Third Avenue; and of course the island views—all in muted color.*
>
> *There was something blunt and brooding about these paintings, but most of all, something too rare in those times, they were very honest. In a show years later, when Fairfield's work was in full bloom—when it was clear he could perceive a scene and put it down and paint it all in one fluent whole—Bill and I were remembering that first show. We agreed it had been much better than we had secretly thought at the time. True, then there had been something tentative and inhibited, a sort of stumble between perception and execution. But thinking of the old pictures in the light of the new ones we realized they already carried everything. Fairfield's determined directness and clear sight were always there. It was us who had not seen this.*[28]

Myers and the painters at the Tibor de Nagy Gallery included many young poets in their circle of friends. On 14 May 1952, Larry Rivers chaired a session at the Eighth Street Club on "New Poets," introducing John Ashbery, Frank O'Hara, and James Schuyler. Together with Kenneth Koch (who was then in France on a Fulbright grant), these poets became known as the New York school. It was probably through Rivers and Freilicher that Porter met them, although years

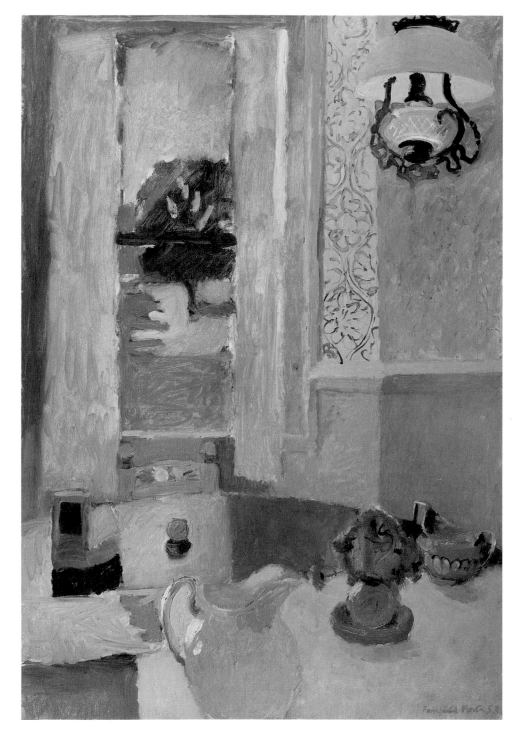

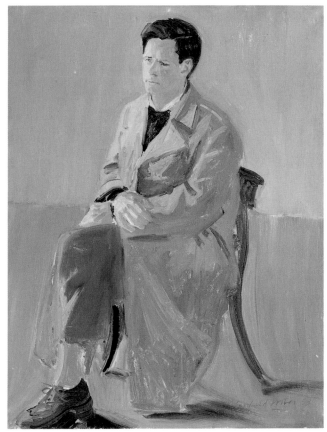

Frank Wallace. 1953

Still Life with Yellow Tablecloth. 1953

later no one could precisely remember the sequence of introductions. Except for Porter, the group had known each other since 1949, when Freilicher had lived upstairs from Koch on Sixteenth Street.[29] It was Porter's recollection that he had first read an Ashbery poem in 1949, and had met the poet in person two or three years later, at the Cedar Tavern. The young poets of the New York school became Porter's closest friends during the fifties and stayed thus for the rest of his life.

"The Tibor de Nagy Gallery also publishes avant garde poetry, very good," Porter explained to Aline Porter in a December letter. "If Anne would write they would publish her. I like the poets whom I meet, whom Anne refers to as the de Nagy children, because they are all under thirty. I think I am the oldest person whom they [the gallery] sponsor. For feeling way out of things for years and years, I suddenly feel on the inside. It is naturally a good feeling."[30]

Literary culture flourished in New York during the 1950s and Porter enjoyed being part of it. (He said once, "I am somewhat in awe of any writer of poetry."[31]) French literature and the Symbolist poets, especially Stéphane Mallarmé, were the reigning favorites. A distinctive attribute of postwar culture was the understanding that painters and poets should be well-read, at least in contemporary literature and the nineteenth-century classics. Under the influence of his poet friends Ashbery, Koch, O'Hara, and Schuyler, Porter began to write poetry.

"I started to write poetry because I met all those poets who were published by the Tibor de Nagy Gallery and they used to meet at the Cedar Bar and pull something out of their coat pocket and show them to each other. And I envied that very much."[32] Some of his first poems were biographical, about the painter Leon Hartl, whom Porter profiled in the May 1953 *Art News*. He explained to Hartl, "I am not a professional poet, but I enjoy writing more than going to the movies. It is a very satisfactory way of spending the time when you cannot paint, which you cannot do all the time."[33] He took part in a panel discussion, "The Artist as Writer," at the club on Eighth Street on 6 June 1953.

Porter's son Laurence, now seventeen, was preparing to go to college in 1953. He had a natural gift for the piano, and his father painted a portrait of him, *Laurence at the Piano,* in the young man's most characteristic pose at home. The piano was located in the front hall in Southampton and the view in the painting extends into the living room. Over the fireplace, only partly visible, hangs a John James Audubon print of a *Raven,* sketched in gray and white. *Laurence at the Piano* is representative of Porter's fully mature style and is the earliest painting that can be considered to be such. The passages of color and light that comprise it are for the first time defined not only in terms of shape but also in terms of weight and density. Of course, the desire to endow figure and furniture with three-dimensional solidity is as traditional as the Old Masters. Porter's modernity resides in the three-dimensionality and density of his paint: the red band of color in the very middle of the painting (a carpet) is as solid and as tactile as the chair legs or the window panes—in short, as any other passage of painting on the canvas.

The heightened contrast between his light and dark colors is another hallmark of Porter's maturity. *Laurence at the Piano* is painted in a higher key of brightness than he had used previously. In later years he said that Freilicher had influenced his shift to a brighter palette; she does not now recall any specific conversations with him on this subject. At this point in his development, he was able to observe and learn from other artists, without losing sight of his own objectives, and he made some revealing remarks about artistic influences in a 1952 letter to Lawrence Campbell: "I am painting now under the influence of [Herman] Rose. Last winter I painted under your influence, then one picture

under the influence of Jane Freilicher. A year ago it was Bill de Kooning. They would probably all look the same to you."[34]

Larry Rivers moved to Southampton in May 1953 and lived in a house with his two sons and his mother-in-law, Berdie. With Rivers living only a few streets away, Porter was now involved with his young circle of friends in Southampton as well as in the city. An endless succession of house guests was the norm, which was fine with Fairfield and Anne. A joke was going around in the city about "Porter's Rest Home for Broken-down New Yorkers."[35] In June Porter started his *Art News* article, "Larry Rivers Paints a Picture," which he was still writing during August. It was published in the January 1954 issue; Rivers's painting was a de Kooningesque portrait of Berdie, his favorite subject in those years.

Of course Rivers's idiosyncratic personality and quicksilver imagination were not the usual makings of an ideal neighbor. Some of the flavor of his wit and of the strains upon his friendship with Porter, even when it was at its closest, can be discerned from two of their letters of 1952 and 1953.

Rivers to Porter:

Not alone but somehow I have managed to decode your last note. Tact has never been a virtue of mine. I'm sorry to have had it upset you . . . Lately I feel as if I've been stitching hours together hoping it resembles a heroic life . . . Frank O'Hara has a touch of pneumonia and this has given me something else to do. . . . When we pass away it is like burning the books that should be written about us. But we must work very hard for that plump chunk of perpetuation. Frank says he wants to be thrown into the sea. This horrifies me. He says no stone dares take the place of himself . . . I envision evenings of poetry in South Hampton: Fairfield reading his latest works at the dinner table slightly disappointed in the boys faces who are too aware of its importance to the man who reads them . . . The mythical group passeth away like all other things. Only a party joins us with those we think we like. John Ashberry was very drunk and cried like a baby. He was so cute and verging on chubbiness. He loves everyone and remembered something that passed between us many years ago that was amazing. This event that I couldn't even recall he says set the tone of our relationship. Big tears and a hug. I preferred him to someone else. How could I have. Kenneth has joined hands with those parts of society that by their very nature make him my enemy . . . My mind is a serpent my actions a stray lamb.

Porter to Rivers:

I am getting very fed up with caring for Tristy [Rivers's dog] and wish you would take him back . . . I think my attitude toward all animals is really dislike. I tolerate (but barely) a strict minimum for the children's sake, but Tristy is too big to be a minimum. I resent the care he really requires. He has diarrhea now and a vet is coming this morning to say if he has worms.[36]

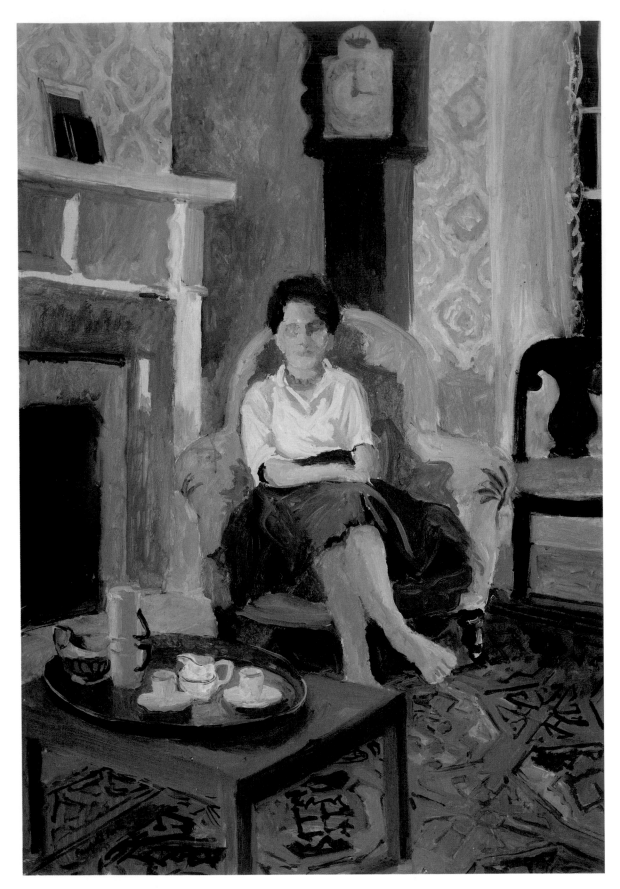

Edith Schloss. 1953

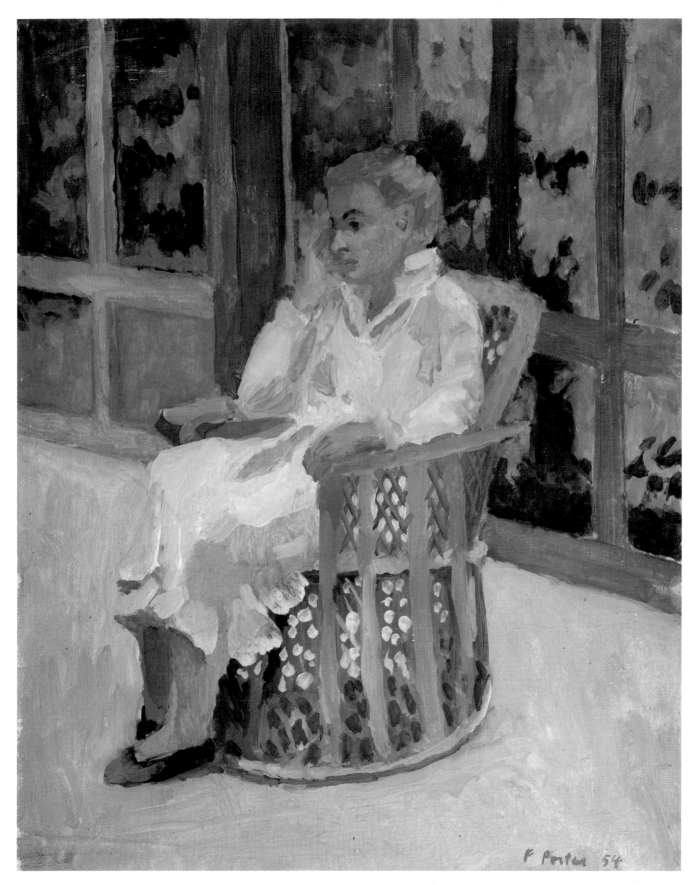

Portrait of the Artist's Wife. 1954

The Porters did not go to Maine in the summer of 1953; rather, they had their hands full entertaining New Yorkers on vacation in Southampton. By July home life had settled down to a regular pattern of continuous improvisation. Anne wrote, "Everyone eats at different times and there are lots of beaux arts going on here, literature (Edith) cinema (Rudy) art and art-criticism (Fairfield) music (Laurence) culinary (me)."[37] Edith Schloss was writing "a sort of a novel" and Rudy Burckhardt was planning to make a movie at the house in which Anne would play the part of a cleaning woman. In August they had a lively weekend that lasted until the following Wednesday, entertaining at various times "5 painters 4 poets 2 concert pianists, an interior decorator, a dancer from Trinidad, a former archduke from Russia (or so he says), a very nice man who runs a skirt factory, a doctor and his family."[38]

By the end of August Fairfield and Anne went out of town in search of peace and quiet. First they drove to the Catskills to visit the painter Nicholas Vasilieff and his wife. Porter had published an admiring article, "Vasilieff Paints a Picture" in the October 1952 *Art News*.[39]

Anne wrote, "The Vasilieffs have a little old house in a small village. They furnished it sparsely from local auctions and it's very pretty. Mrs. Vasilieff cooks wonderful Russian food and says, 'Eat! Eat! Russians big eaters!' She used to sing Russian songs in a café long ago. She seems very sensible and warm hearted. Mr. Vasilieff had painted many bright and beautiful pictures like a cross between Matisse and Grandma Moses with a dash of something else. After that we drove to Nyack to see Jane Freilicher a young painter who is living in an awful rented house with a neglected garden that reminded me of Westchester at its worst—ambitious landscaping gone to seed and a house full of horrible little whims like a bar in the kitchen and a mantelpiece 7 feet high, but full also of young and intelligent company . . . We got home Thursday night and saw the Kleig lights blazing so we knew Rudi Burckhardt was filming some of the 'Day in the Life of a Cleaning-Woman.'"[40]

Burckhardt's film was a modern-day fairy tale, a spoof of the Horatio Alger ethic of Hollywood, in which goodness and hard work are invariably rewarded. The script was written by Anne with assistance from Edith Schloss. Anne was also cast in the leading role of Mrs. Rocker, a cleaning woman who works for the haughty Russian Countess de Caviar (Schloss), who does not treat her well. One day a bum (Larry Rivers) comes by the house, carrying a little suitcase full of wares. Mrs. Rocker buys with her own savings a little dish mop, which lo! works like magic. Whatever Mrs. Rocker touches with the mop instantaneously cleans itself and puts itself away. Burckhardt spent a day shooting a time-lapse sequence of stacks and stacks of dishes scooting across the floor and flying into the closet. Before winding up happily, the plot of the film enjoys several unexpected turns, as when the bum is discovered to be the Count de Caviar, the long-lost brother of the mean countess. (Thus Rivers was given the chance to act across the whole spectrum of emotions.) In the meantime, Farmer Turnip (Porter) has been courting Mrs. Rocker; she at last accepts his engagement ring. The cast was completed by two frolicking children, Katie Porter and Jacob

Burckhardt. Directed, photographed, and produced by Rudolph Burckhardt, *A Day in the Life of a Cleaning Woman* was shot entirely on location at the Porters' house in Southampton.[41]

With so many distractions, Porter found it difficult to accomplish very much painting that summer. In early September, after their return from visiting the Vasilieffs and Jane Freilicher and Joseph Hazan (her new husband), he painted two landscapes "so nice he almost likes them himself," as Anne said.[42] Ten years later Porter memorialized their excursion to Nyack in a large canvas, *Nyack*, 1966–67, which he based on earlier sketches. In November the Channings sent the Porters a gift of a pretty tablecloth that Anne predicted would "probably crop up in many still lifes."[43]

For much of that winter, the critic and poet Frank O'Hara was living in Southampton at Rivers's, and Porter saw them both frequently. Porter and O'Hara were interested in Mallarmé, and in comparing their translations of Mallarmé's poems. Porter drew a nude study of O'Hara wearing army boots that must have been made at Rivers's studio during the time when O'Hara was posing for Rivers's nude portrait of him.[44] Besides being one of the rare nudes in Porter's oeuvre, this drawing is a fine example of his taut, incisive powers of description. The painting by Rivers appears bland by comparison.

Porter's second exhibition at Tibor de Nagy Gallery was scheduled for the end of February 1954, but was postponed, to his relief, until 13 April. In February, Porter estimated that he had gone to twenty-five galleries in connection with his *Art News* exhibition reviews.

The paintings in Porter's second show, 13 April–1 May 1954, signaled the inception of a painterly phase of working, one that he sustained for the next several years. In his canvases of the mid-fifties, the pigments are much diluted and seem to stain the canvas, rather than cover it. This more liquid paint, which sometimes evokes watercolor, emphasizes the to-and-fro gestures of his brushwork. It is possible that Rivers and O'Hara encouraged his development in this direction, and it should also be pointed out that Porter's and Freilicher's Long Island landscapes from the fifties are often remarkably similar. Rivers seems to have inspired Porter's decision to paint more thinly in these years; O'Hara, who was striving to make his name as an art critic, preferred Porter's works where they tended toward abstraction. Such was the thrust of O'Hara's laudatory review in the April *Art News:* Porter "in his second one man show has moved beyond the earlier felicity of sentiment (which linked him to certain pictures of Vuillard) to a more abstract concern for the verity of painting itself."

Dore Ashton reviewed Porter's second show for *The Art Digest* (1 May 1954) in terms that were more descriptive and less prescriptive than O'Hara's. Ashton was satisfied with Porter as she found him. "His interiors, spacious New England landscapes, and figure studies are filled with a hushed dignity which comes from Porter's unfailing taste and controlled technique . . . Porter is a refined, mature painter who takes us into the chamber of his well-resolved esthetic soul, permitting us to enjoy the peace and order of it."

The review in *The New York Times* (15 April 1954) was written by Howard

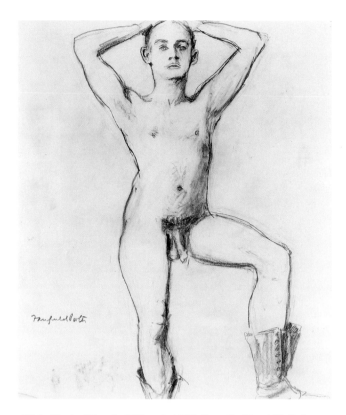

Male Nude [Frank O'Hara]. 1954. Pencil, 22 x 17". Private collection

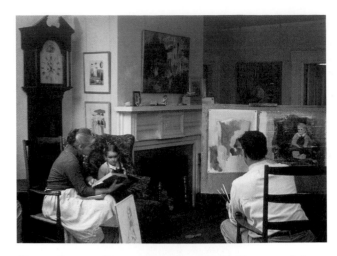

"Porter Paints a Picture," *Art News*, 1955. Photograph by Rudy Burckhardt

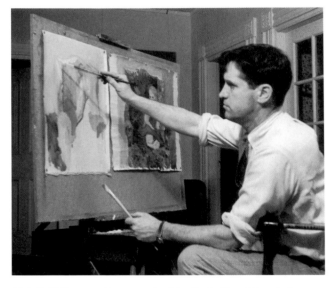

Fairfield Porter photographed by Rudy Burckhardt for "Porter Paints a Picture," *Art News*, 1955

Devree, the same critic who twenty years earlier had called Porter "promising" at the time of his two-man show with Simon Braguin at the jewelry store on Fifth Avenue. Not recalling that prehistory, Devree nevertheless maintained his positive opinion, now finding that Porter showed "real feeling for landscape in his cool, personal and yet somewhat detached statements."

O'Hara's reviews and writings about Porter, as favorable as he always intended them to be, were ultimately more illustrative of O'Hara than of Porter, or so the latter thought. Under O'Hara's watchful gaze and friendly banter he began, in mid-April 1954, the portrait of his five-year-old daughter, *Katie in an Armchair*, which was to be the focus of O'Hara's *Art News* profile, "Porter Paints a Picture." When this article came out the following January Porter wrote him a note of thanks: "I have read of course your article about me and in this second version I find it most complimentary, flattering, humorous and fun to read. I shall now have to paint in the way I seem to have told you I did, and I had better make something good, too."[45] Anne remembers that Porter joked with O'Hara that the frequent references to Henry James in "Porter Paints a Picture" were more reflective of the reviewer's current reading than of Porter's own interests; O'Hara acknowledged the truth of this, replying, "Well, when the cow's been in the garlic . . . "[46]

The Porters resumed their summers in Maine in 1954. Among the recorded visitors that year were Joe Hazan and Jane Freilicher, and Rudy Burckhardt and Edith Schloss.[47] "How do you get to Great Spruce Head Island?" Edith had stopped a fisherman in Rockland, Maine, to ask directions, having hitchhiked with Rudy from New Hampshire to the shore of the bay. The fisherman took his pipe out of his mouth and looked her right in the eye. "Lady," he said, "if you was Jesus Christ you'd walk straight out there," and with the stem of his pipe he pointed to a spread of islands on the horizon. Porter had told them about a boat service from Rockland that his parents' guests had used in the twenties, but now they learned that this had long been discontinued. The Burckhardts spent the better part of the day in car and bus rides all around Penobscot Bay, until they reached Sunset township, a sleepy place with a handful of trim white houses standing around a church. A little weathered hut of a store was set apart in tall grass; the storekeeper also ran the mail boat that carried both post and passengers out to the island.

Nobody was home when the Burckhardts finally stepped on the dock at Great Spruce Head Island. They had no way of knowing that everybody had gone over to Camden, on the mainland, for an outing and to collect the week's provisions. The place was eerily deserted. Receiving no replies to their shy calls, they climbed up the well-worn path toward the big white house, which they found completely open. The interior was a strange assemblage of summer cottage odds and ends intermingled with artifacts from a time and place hard to pin down precisely.

We stood in a enormous shadowy cavern. When our eyes got used to the gloom, we saw rafters above, and balconies all around from which led

Katie. 1954. Pencil, 16⅞ x 14". Private collection

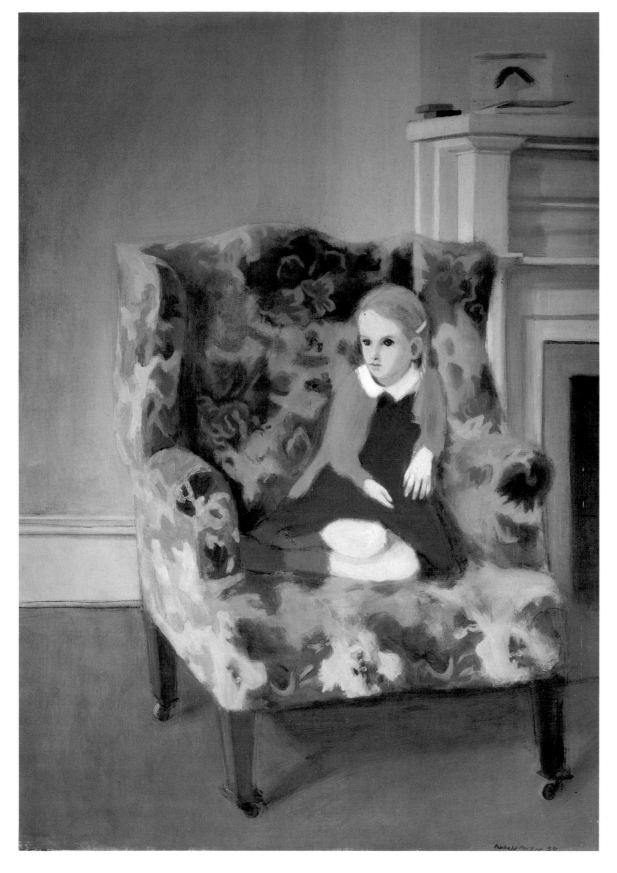

Katie in an Armchair. 1954

many doors, probably to upstairs rooms. In the hall below all around us, tables, chairs and settees were hung with Afghans. Indian berrying baskets, books, chess boards and children's clothes were scattered about. A frayed sneaker or two peeked out from under a chair. There was a large fireplace. On its mantel stood a ship's model and on the brick wall above hung a plaster relief of a warrior on his horse, a copy of the Parthenon frieze. Over us floated large silky chinese lanterns and all around, under the upper balconies ran a frieze of deep yellow gold over which long red dragons were uncurling . . .

Working against the spell we began to look for light switches, for food. We bumbled around. Then we stopped. There were motor sounds, then shouts and a confusion of voices. They grew louder and gradually came closer and in the end a bunch of sunburnt children and grown ups laden with shopping bags burst in.[48]

Island guests were expected to entertain themselves. Depending upon the weather—some summers the fog came in and refused to lift for days and days—visitors went exploring, rowed, swam or collected wildflowers all day, but always the household ate on the front porch, in hot weather or damp, in plain view of the surrounding islands. On shut-in days, people read, wrote letters, or played games of chess (no longer bridge, as in the days of Fairfield's parents). On many nights, the children induced the guests to make up parlor games in front of the fireplace.

Porter established a productive working pattern that summer of 1954. He was notorious for always being the first to go off to bed at night, which was logical, since he liked to get up hours before everybody else (sometimes as early as 5:30 A.M.) and start painting in his back-porch studio. This summer studio was half-immersed in the woods. The bristling branches of spruce trees pressed against its screens. The door opened onto a path lined with ferns and the occasional orange flower known as devil's paintbrush. The porch was bare, except for painting supplies lying about and a table, a chair or two, and maybe a book open on the floor and a spray of wildflowers in a glass of water, the fruit of somebody's morning walk. It was a place through which people were allowed to pass, but they did so with respect for the work that went on there.

In the fall of 1954, once more at his home in Southampton, Porter painted more large portraits than he had previously, including *Frank O'Hara, Jane Freilicher and Anne Porter,* and another version of *Laurence at the Piano.* The year stands out, though, for gathering signs that Tibor de Nagy Gallery might begin to be able to sell his paintings. The publicity from O'Hara's article was no doubt a help. In Porter's account book the earliest reference to funds received from Tibor de Nagy for the sale of a picture dates from June of this year. He received $75, his share for an unidentified picture sold to Don Schrader. Although this trickle of success did not soon swell into a torrent, his prospects were undeniably looking up. In February 1955, at his third one-man show at the gallery, four paintings were sold.[49]

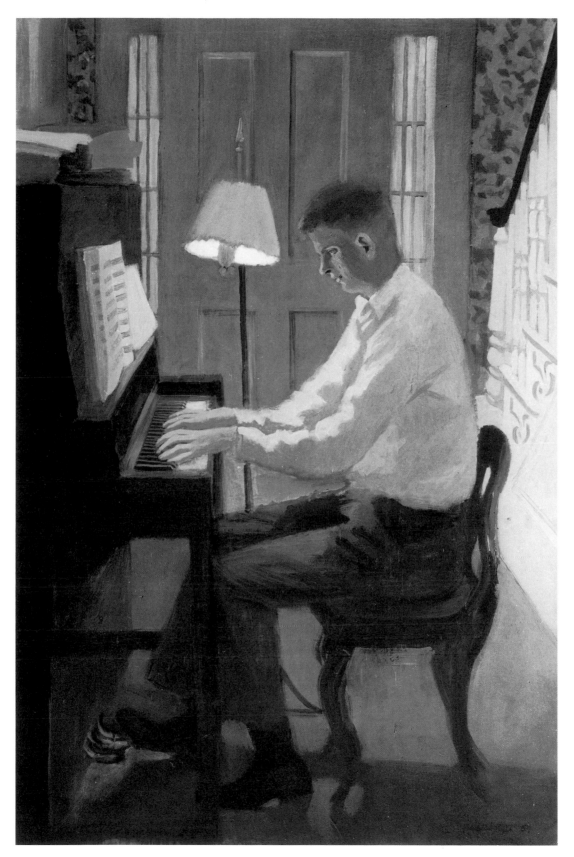

Laurence at the Piano. 1954

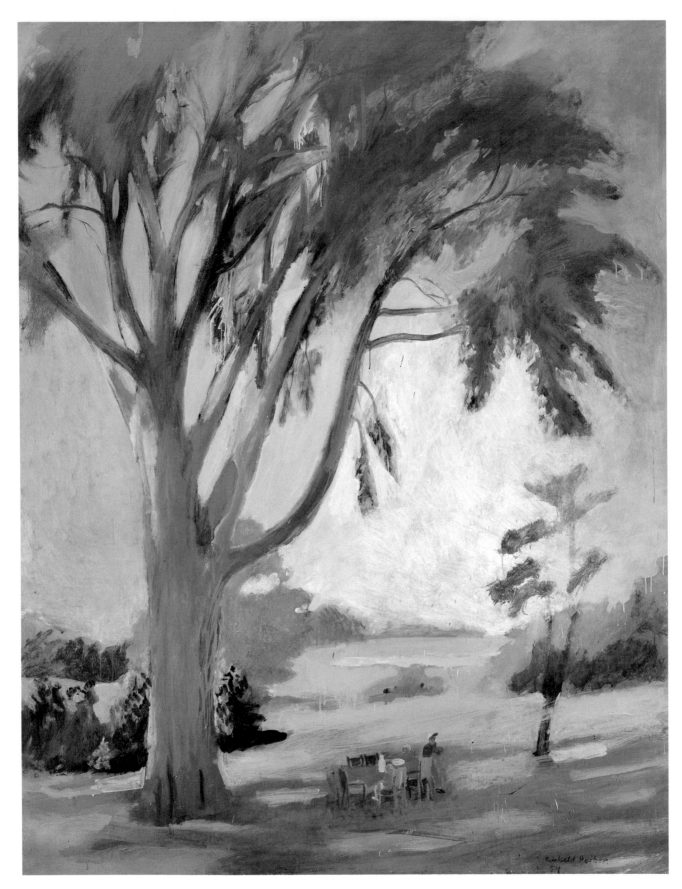

Lunch under the Elm Tree. 1954

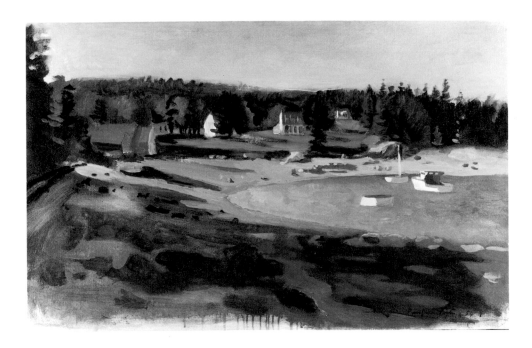

Harbor Scene, Maine. 1954

Apart from his profile on Rivers, which appeared in *Art News* in January, Porter did not publish any feature articles in 1954. Nonetheless, it had been his most active year of writing short reviews for the magazine. In most months he was paid $84 for what amounted to two weeks' full-time work. In January 1955 his writings were recognized from two different directions. Creighton Gilbert wrote to inform him that the College Art Association had voted him one of two honorable mentions in its survey of the best magazine art criticism of 1954. He also learned this month that three of his poems had been accepted by *Poetry* magazine. As Anne put it, he had now to consider himself a professional poet.[50]

Anne wrote proudly of him in March 1955, "Fairfield's poems are published and I'm impressed all over again with how well made, fresh and real they are, with no affectations!" She continued, "Poetry, a magazine of verses, seems to have struck oil since the depression when I remember my first paycheck for $9 for five poems. Fairfield got $68 for three poems, and I tell him I feel that a mink coat is only a few sonnets away (only I don't like mink, too bad)."[51]

The poet James Schuyler wrote him a complimentary note too, pointing out that the same issue of *Poetry* had involved in one way or another Porter, Ashbery (subject of Porter's poem), O'Hara, and Koch. Buoyed by this publication of his work, Porter devoted serious effort to poetry and constantly exchanged letters and poems with Ashbery, Koch, O'Hara, and Schuyler. His activity as a poet mostly fell between 1953 and 1958; after this success of 1955, he did not publish any other poems, except in private printings. Porter once said of his poetry to Kenneth Koch, "I would like to be as realistic as you."[52] Inspired by Koch, he found the archaic form of the sestina curiously sympathetic, perhaps because of its affinities to prose, or perhaps because he felt most comfortable within its constraints. He kept a faithful correspondence with all his poet friends, often including poems.

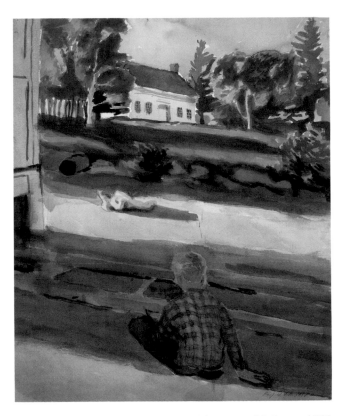

Afternoon, Maine. c. 1955

Letter to Kenneth Koch: A Sestina

Dear Janice and Kenneth, because I am not so vers-
atile as Kenneth, at least in verse, I prefer to stick compulsive-
ly to the same unvarying sestina form.
I am glad you learned how to spell Laurence and I am sorry
that you have not learned how to spell Anne,
for without the final e she feels like someone else.

This time I prefer to do something else
than write about you: I will tell you that three vers-
es of mine were accepted by Poetry, making Anne
say that I am now a professional. Will it make me compulsive
about language as Jerry is? from whom I am not sorry
to hear sentences issue in the most elaborate form.

Partly because he speaks in such a form
because he knows it amuses me or else
when I say he sounds like Shakespeare he is not sorry
to know that unlike the bourgeois gentilhomme he speaks in verse.
At fourteen he begins to lose some of that compulsive
roughness, becoming a sweeter companion for Anne

and Kitty and me, and it is true as Anne
observed that adolescence gives a form
more civilized and gentle, and though he is less compulsive
about his muscles he still likes to fight with Laurence in order
* to get beat up, or else*
with Johnny or Frank or me, and even tolerant of verse
and of Kitty to whom he sometimes says that he is sorry.

Speaking of sorrow, I am truly sorry
that I am unable to persuade Anne
to send you samples of the extremely witty verse
that stimulated by our example she now writes in a form
that as Kenneth or Frank once said could be written by no one else
without a trace in it of anything compulsive.

As for Kitty, she is gradually losing her compulsive
attachment to Frank for which I both am and am not sorry.
I cannot think of very much else:
Johnny talks constantly to Anne
and Laurence in his dignity and inform-
al gravity is interested in and sympathetic towards your and my verse.

In my versatility I write this in the studio, sticking compulsive-
ly by the stove, a necessary form to observe in this snowy winter
* for which I am not sorry*
and neither is Anne. As for painting, well, that is something else.[53]

Southampton. 1955. Pencil, 15 x 20". Private collection

In the spring 1955 issue of *Partisan Review,* Clement Greenberg published one of the major articles of his career, "'American-Type' Painting," in which he recapitulated the history of Abstract Expressionism and identified the primary personalities. In his view these were Gorky, de Kooning, Hofmann, Gottlieb, Robert Motherwell, Pollock, Mark Tobey, Franz Kline, Still, Newman, and Rothko. By this time, the philosophical differences between Greenberg and Porter had spilled over into personal animosity. Porter wrote a lengthy reply to Greenberg's article, taking him to task for his use of the term "value," but seeming most annoyed by the latter's high-handed and dismissive tone of voice: "But Greenberg does not describe 'American type' painting. He evaluates it too easily in a favorable light. He is very ready to tell painters what they may or may not do, without understanding of what they have done or are doing. Sometimes he says 'we' when 'I' would be more accurate." Greenberg replied to Porter's letter, defending his use of "value" and himself from some of Porter's criticisms. This exchange of letters also marked the first appearance in print of Porter's accusation that Greenberg had vocally doubted the "validity" of figure painting; in his reply, Greenberg denied that he had an "*ad hoc* judgement" against figure painting.

Later that year Porter voiced other misgivings about Greenberg and about most contemporary art criticism in general to Thomas Hess. "I think that almost all discussion in New York of painting that is by writers like Greenberg or Rosenberg, or by painters or sculptors at the Club is influenced by writing, and especially by sociologists and critics who think of themselves as sociologists or as anthropologists, and that they therefore miss what each art is about . . . What each art is about is at least partly . . . about itself: as Forster said, to insist that art exists for its own sake is not to say that life exists for the sake of art."[54]

The success of his February show at Tibor de Nagy gave Porter the confidence, in mid-April, to attempt an ambitious composition on a large canvas,

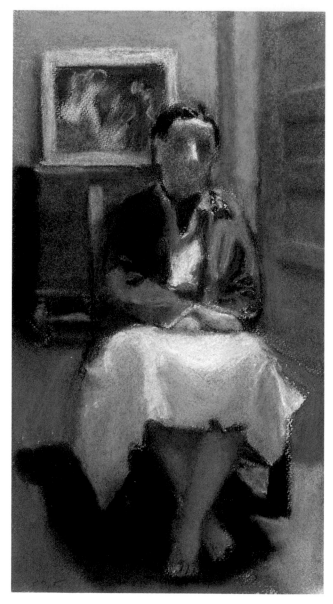

Jane Freilicher. c. 1955.

Katie and Anne. Katie is represented seated on the living-room rug; Anne, at left, is sitting on a sofa and reading aloud to her to relieve the boredom of posing. This portrait of a little girl in a pretty dress, who sits quietly on the floor, must have put Porter in mind of John Singer Sargent's famous group portrait, *The Daughters of Edward D. Boit,* in the Museum of Fine Arts, Boston. Sargent's great picture was itself a quiet homage to Velázquez's *Las Meninas,* as Porter realized. In *Katie and Anne,* though, Vuillard, not Velázquez, was Porter's basic point of departure for both the vivid colors and the impressionistic brushwork.[55]

The painting season—as Porter termed his summers on the island—was again productive in 1955 as it had been the year before. John Button, a painter whose work Porter very much admired, visited them in June and, undeterred by cold weather, painted three oils and more than twenty watercolors. Anne had not yet come up to Maine and everybody more or less subsisted on a great pot of potato soup that Porter kept cooking on the wood stove. One day Porter, Button, and Jerry rowed a small boat over to Eagle Island, where he and Button painted landscapes. "Our canvases like sails dragged against the wind. The row each way was a two hour effort, full of despair."[56] In early July Porter finished a still life of hawkweed, a wildflower "which shuts up around six in the evening, though it is still light, like a good child that goes to bed when it is told."[57]

James Schuyler succeeded John Button as an island guest and stayed on as the company enlarged in early August, with the arrival of Richard Stankiewicz, Joe Hazan, and Jane Freilicher, whose portrait Porter probably painted around this time. It was a disappointment when Frank O'Hara didn't show up on the mail boat with the Hazans, despite laborious instructions. Schuyler was writing a new novel that summer; "Sometimes I hear him typing," Porter wrote O'Hara, "and often I hear a woodpecker and think it is he. He loves to canoe, and has been in the water, swimming slowly around for a time with a smile on his face, and remarking very gently after a bit, 'Why Fairfield. It's the coldest thing I ever felt.'"[58] Even Porter had to admit some reservations about the swimming in Penobscot Bay: "Swimming here one is aware of the bottom, especially at low tide, when oozy things reach up from the bottom that stop me dead in my tracks with pounding heart. It turns out to be kelp."[59]

Two of Porter's best efforts in this productive summer were a portrait of Schuyler, who kept him company as he painted, and a tonal rendition, *Armchair on Porch.* The latter is unusual in that it reaches for an evocation of loneliness—which it attains without sentimentality. In a July letter to O'Hara, Porter seemed to apologize for not painting to O'Hara's particular taste: "I swim every day, and paint one academic picture after another, just as though it were worth doing. I seem absorbed by some slightly new method of painting."[60] His new method appears to have included a preference for a diluted palette of umber and green and also an attraction to an aesthetic of "unfinished" or sketchlike painting. The artist's changes of mind and random traces of underdrawing are allowed to show here and there. An "unfinished" aesthetic was as old as Delacroix (or even Rubens) and was at the heart of Larry Rivers's style, which Porter had lately observed in many visits to the latter's studio.

In November Porter went to Boston to review a John Singer Sargent retro-

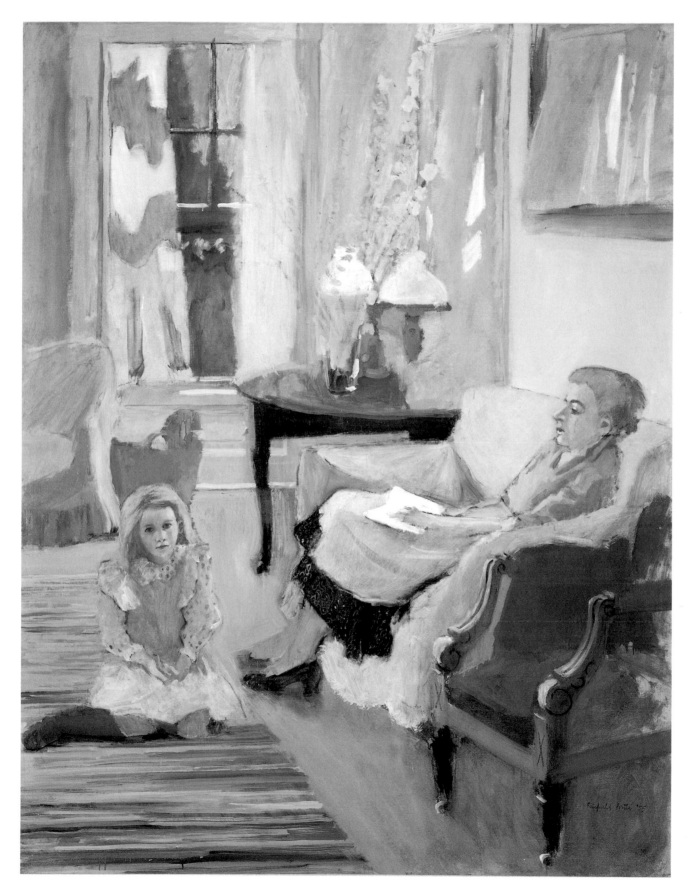

Katie and Anne. 1955

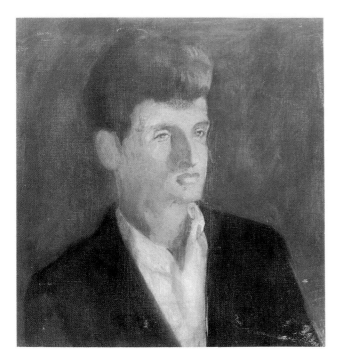

Head of a Young Man. c. 1955

spective for *Art News.* He took advantage of the trip north from New York to have Thanksgiving dinner with Jerry, who was now fourteen and going to Putney boarding school in Massachusetts, and to visit Laurence at Harvard. Porter's article on Sargent, which appeared in January 1956, proved to be one of the major statements of his critical corpus. As almost no one had ever done before, he assessed Sargent as a serious painter, not a social lion, and, writing from a perspective that would only occur to another painter, assigned Sargent an important role in the later development of American painting—a view that most twentieth-century artists themselves have not accepted, but that demands to be considered. "A passage of drapery in a Sargent portrait or a scratched background in a Sargent watercolor relates to certain American abstract painting more closely than do Cézanne, Picasso or even Monet," he argued.[61] The Sargent review was difficult for Porter to write; he mentioned it in a December letter to Kenneth Koch, who was overseas in Florence: "Now I must write my review. I was in danger of making it a symbol of all kinds of things that my sense of proportion, such as it is, tells me would be inappropriate for this review, and should be saved for some other article, or a letter to Kenneth."[62]

None of Porter's correspondence from 1955 makes any mention of the most important event that took place in his family that year, his wife's conversion to Roman Catholicism. Anne had taken this step following twenty years of study and reflection. Although Porter has not left us any statements of his reaction to her decision, he must have felt profoundly challenged intellectually by it, given the conflict between his atheistic upbringing and his deep respect for her intelligence.[63]

In the autumn of 1955 the Porters learned that Anne was expecting another child. A few months later, in November, they went to a party in a cold-water flat in the Village, where Frank O'Hara played the piano and, as Anne recorded, "a young friend Naomi Weinstein, a singer, sang most beautifully. The guests were mostly poets (including W. H. Auden, the only guest as old as ourselves and some young composers) and I had a wonderful time simply because I was made much of because of the baby— the last thing I expected! I think it's because our young friends are fond of our children and think it would be fun if there were more of them. (Poor Fairfield is known in art circles as the Man with 8 Children.)"[64]

The year 1956 was active and rewarding for Porter, but afforded him very little time for painting. Hess included him in a widely read and influential article in the *Art News Annual* for that year. Titled "U.S. Painting: Some Recent Directions," the piece singled out twenty-one painters for biographical profiles and two or three reproductions. The new faces identified by Hess included Elaine de Kooning, Helen Frankenthaler, Wolf Kahn, Robert Rauschenberg, and Larry Rivers. Porter was ten years older than any other artist cited.

He lost some painting time early in the year, while he was on jury duty for several weeks; he passed the hours contentedly reading *The Necessary Angel* by Wallace Stevens. He was particularly struck by Stevens's description of Verrocchio's equestrian statue of *Bartolomeo Colleoni,* which had been one of James Porter's favorite works of art. Porter's annual exhibition at Tibor de Nagy Gallery was scheduled for 3 April, which meant that he had to choose his pictures,

mount them on stretchers, and frame them during the same weeks that he was struggling with the annual frustration of his income-tax forms.

Porter wrote frequently to Laurence in Cambridge, informing him in March that O'Hara had left the staff of *Art News* and Schuyler had taken his place. Meanwhile Porter had started to write a feature article about Jane Freilicher painting a picture, "which promises to be a lot of fun because Jane's remarks are so humorous. It could be for this reason the best of the lot. She is painting a portrait of Arnold Weinstein, and she said that she enjoys having us all (Rudy, Arnold, and me) around while she paints because it seems friendly."[65]

The sculptor David Smith wrote him an appreciative postcard about the Sargent review: "Back in January I meant to tell you that I enjoyed your comment and contemporary analysis of Sargent—I just reread it, so herewith send you thanks." He signed it, "Fraternally, David Smith."[66] In May, Porter was invited by Raphael Soyer to join a group called Reality, a small circle of figurative artists who met to discuss art and, presumably, to offer each other moral support. Since Reginald Marsh and Yasuo Kuniyoshi had died, Soyer wrote, the group had felt a need to add "new faces, fresh voices."[67] Porter did not participate, however, perhaps for reasons connected with comments he made in 1968: "Some of the Abstract Expressionist painters accept me [among them, de Kooning and Tworkov]. In a way, I feel more at home with them than I do with people who aggressively call themselves realists. I don't feel at home either with people who aggressively call themselves abstract—you know, like the American Abstract Artists."[68]

As his sons grew older, Porter took deep satisfaction from Laurence and Jerry's accomplishments and interest in literature. Of the two, Jerry's personality was the more introspective and difficult to reach—Porter often worried to Laurence about the silence emanating from Putney. He tried to encourage Jerry's interest in writing poetry: "I sent Jerry a copy of Elizabeth Bishop's new poems, which are like his, in a way. She has such a relaxed line, without ever being at all boring. I tried to write a sestina about Kitty in this manner."[69] He enjoyed Laurence's letters and exchanged opinions with him about art and books:

I think Matthieu is, well, an at best energetic faker, and I dislike Sartre for his hasty Communism . . . of Faulkner I have only read The Sound and the Fury, *when I was hardly older than you, and then it impressed me much, though later, in retrospect, I have had my doubts. I am more and more aware how uneducated I am, and it in no way displeases that I find you fill for me (more than fill) the gaps, which are larger than the, whatever it is that is not a gap, between my knowledges, slender as they are . . . I think that the younger people I know, especially in literature, keep me alert, and you are now one of them, as Frank, Kenneth, John Ashbery, and Jimmy have been and continue to be. In painting, among painters, I do not find the same stimulus, because painters for some reason are inarticulate, perhaps even stupid (but not critics, when they are of the mental caliber of Tom Hess) . . . I do not think my stimulus from younger writers is just a matter of their age. I think it is a matter of their*

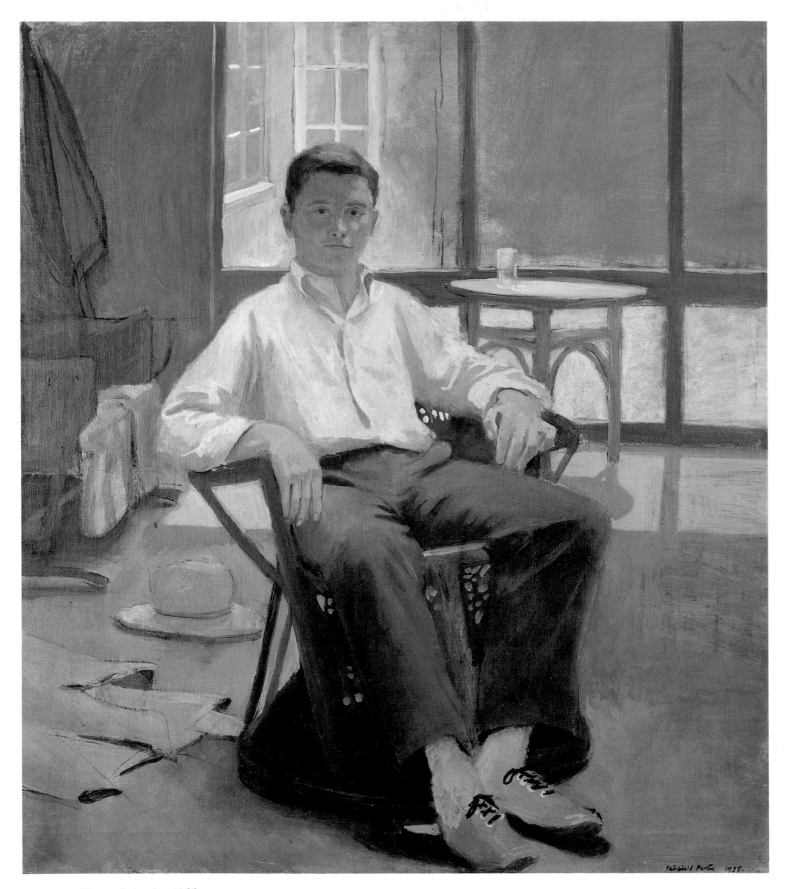

Portrait of James Schuyler. 1955

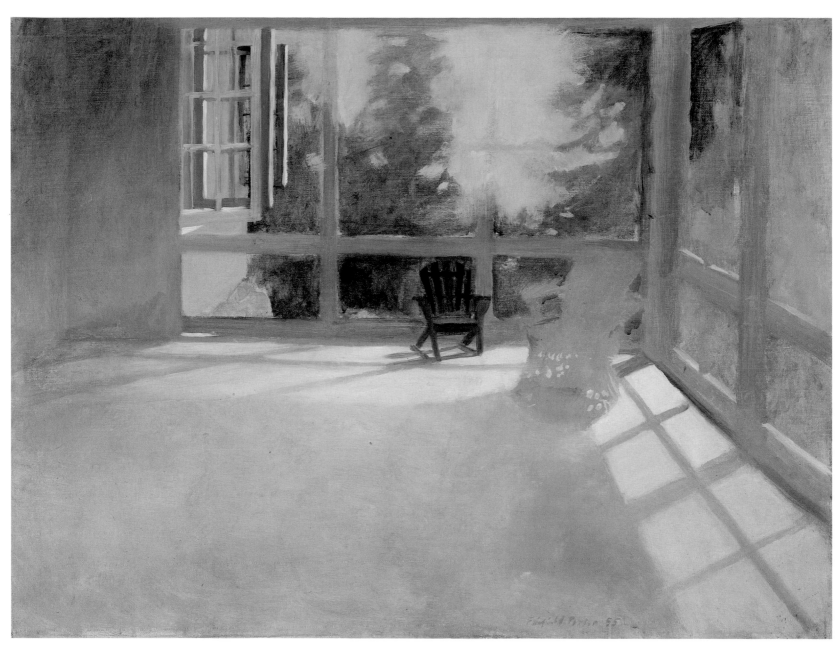

Armchair on Porch. 1955

Cover photograph from *The Party's Over Now*, by John Gruen. *Back row, left to right*: Lisa de Kooning, Frank Perry, Eleanor Perry, John Myers, Anne Porter, Fairfield Porter, Angelo Torricini, Arthur Gold, Jane Wilson, Kenward Elmslie, Paul Brach, Jerry Porter (behind Brach), Nancy Ward, Katharine Porter, friend of J. Porter; second row, left to right: Joe Hazan, Clarice Rivers, Kenneth Koch, Larry Rivers; seated on couch: Miriam Shapiro, Robert Fizdale, Jane Freilicher, Joan Ward, John Kacere, Sylvia Maizell; front row: Stephen Rivers, William Berkson, Frank O'Hara, Herbert Machiz; kneeling on the right, front to back: Jim Tommaney, Willem de Kooning, Alvin Novak (Water Mill, 1961)

point of view, which is more sympathetic to mine than my own genera-tion's—than that . . . of the complacent and conceited painters at the Club, who still repeat the ideas which are not painterly ideas (always excepting Bill de Kooning) that no longer (if they ever did) nourish me.[70]

Elizabeth, the Porters' fifth child, was born on 1 April 1956. A pretty, sweet-tempered girl, she patiently (if a little reluctantly) posed for her father's portraits throughout her youth.

As if in happy augury, Liz Porter's arrival preceded by two days the opening of Porter's show at Tibor de Nagy, which was well received. Always excepting the opinions of Clement Greenberg and Harold Rosenberg, it is clear that Porter's work was attracting a favorable critical consensus, which was steadily growing. A review in *The New York Herald Tribune* compared *Katie and Anne* to Renoir's *Mme. Charpentier and Her Children*—appropriate, considering Porter's sources in French painting. The painting *Armchair on Porch* was illustrated in *The New York Times*.

Porter finished his article "Jane Freilicher Paints a Picture" before going up to Great Spruce Head Island in June. The 1956 painting season was ruined, though, when he became ill with mononucleosis. He returned to New York in the autumn with fewer pictures than he had ever done in a season. The idea of giv-ing up his strenuous program for *Art News* occurred to him, but he stayed on because the magazine decided just then to raise its rate of pay.[71] Between doc-tors and schools, in a family that now numbered seven, Porter's family-trust income was stretched to the limit. He did not yet earn any regular or significant income from his paintings. But in December Tibor de Nagy made a sale that boded well for the future. Mrs. John D. Rockefeller had taken home a portrait of Jerry Porter, but had decided to return it because the colors were "too soft for the decor in her house." While the painting was out on approval, another woman contacted the gallery, saying that she wanted the same picture. Told that Mrs.

Rockefeller had taken it, the woman announced that she too was a Rockefeller, and she bought it.[72]

Work was interrupted in February and March 1957 when the roof of Porter's studio was partly burnt in a fire caused by sparks escaping from the corroded pipe of the heating stove. The basic structure of the barn was not damaged and no paintings were lost. Two interiors of the living room in Maine, including *Maine Interior with Ship Models*, which Porter had started in 1952 and finished the previous summer, and a portrait of Jerry were slightly creased. Porter took the occasion of the repairs to install an oil furnace on the ground floor and to put white asphalt shingles on the new roof, so that it would not be too hot in summer. He wrote to Laurence, "I look forward to summer here using this new studio . . . I have not been painting, but with taxes out of the way, I have ideas for some that I hope to be different, I want to make things stony and simple, and not like Larry's paintings, but perhaps like some early de Kooning's."[73]

The repairs and painting of the studio were not completed until the end of May. He painted a portrait of the painter Jane Wilson in March, in her apartment on East Eighteenth Street. Wearing pearls and primly seated on an Indian print, Wilson in this first portrait seems self-conscious, as though the subject were a socialite and not an artist and friend. In April, in order to do some painting in Southampton, Porter set up his easel in the house. "A huge canvas stands in the living room," Anne wrote her mother, "which is going to be an interior with Kitty and me. Kitty posed for 4 hours today. When offered pay she asked for 1¢ an hour and was quite overwhelmed when Fairfield said she may have 5¢ an hour."[74] This picture is untraced; it was apparently a first attempt at a large interior like that which Porter produced so quickly and successfully the year after .

The Porters did not go to Maine in 1956, with the result that Porter for once participated—and even played a starring role—in the Hamptons summer artists' colony. He was pleasantly surprised at his unexpected social *savoir faire* and described at length to Laurence (away on military service) an epic party that he and the Gruens (Jane Wilson and her husband) had thrown at 49 South Main Street.

When mother was away I had a night party to which 55 people came. The hosts were me and the Gruens, she is a painter who missed out on the television contest that ran with Larry's ["The $64,000 Question"]— hers about Renaissance art—and he is a composer. They had wanted to have a party while renting the Hazan's (Jane Freilicher and Joe Hazan's) house in Watermill, to celebrate her expected $64,000 victory, and so asked to share a party with me. I made about three or four telephone calls, and wrote three postcards, and realized that I had already asked thirty people. John Gruen made two calls bringing about six out of twelve people he invited. It was very expensive costing for two cases of liquor, five bags of ice cubes and two cases of soda and quinine water more than $150 (shared with the Gruens). I don't know very much about the party, because in order not to look too worried about everyone, I decided to act like a guest. Larry said it was the best party of the

Katie and Dorothy E. 1957

year. There was much very wild dancing in the living room, and many people said over and over to me that it was a wonderful party. The dining room was a swamp of melting ice cubes and 72 glasses (bought for the occasion) quickly disappeared from the sideboard. But there was only one broken glass afterwards. I remember Frank and Mrs. Harold Rosenberg dancing, and telling me that it was a wonderful party, at which I embraced them both: "I'm so glad!" which made them both giggle.[75]

The painting season of 1957 was thus in Southampton, not on Great Spruce Head Island. During the summer Porter was keenly aware that he had to use the time off from his *Art News* reviews (most galleries were closed in July and August) to paint enough pictures for his spring exhibition at Tibor de Nagy. He was happy with his freshly painted studio and inaugurated a series of full-length portraits of friends who posed for him. Usually they sat on the sofa, which Porter was fond of because it had been brought from Winnetka and had a floral pattern that he enjoyed painting.

Jane Wilson sat to him a second time, looking considerably more at ease by the open studio window than she had in her city apartment. She later wrote a careful description of how Porter worked and what it was like to pose for him.

Because Fairfield was not happy with this first painting, he wanted to do another. In August of the same year, we began again in his Southampton studio. He put a straight-backed chair for me near the

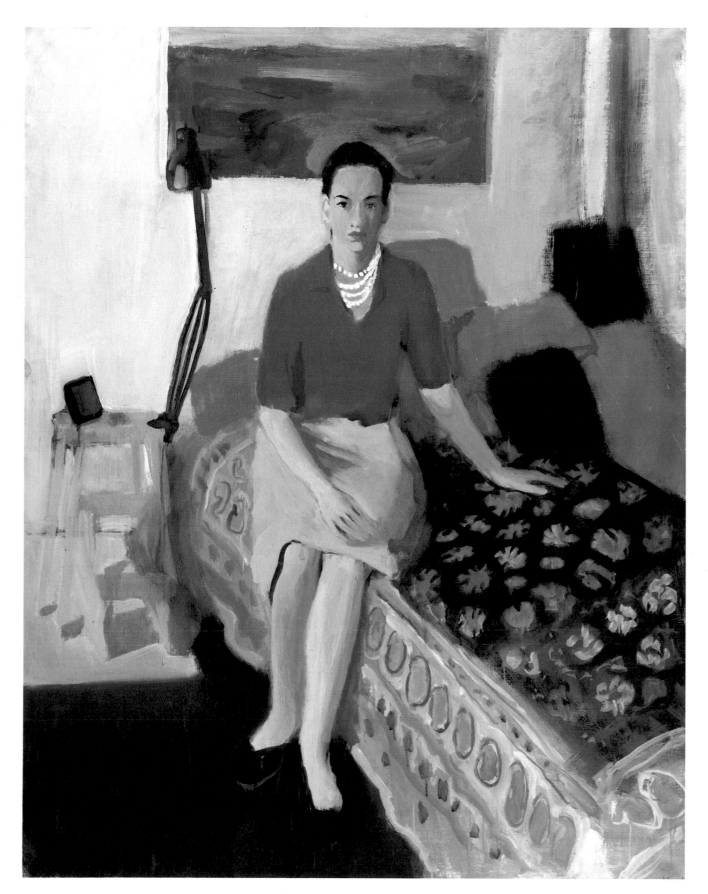

Jane Wilson in Red. 1957

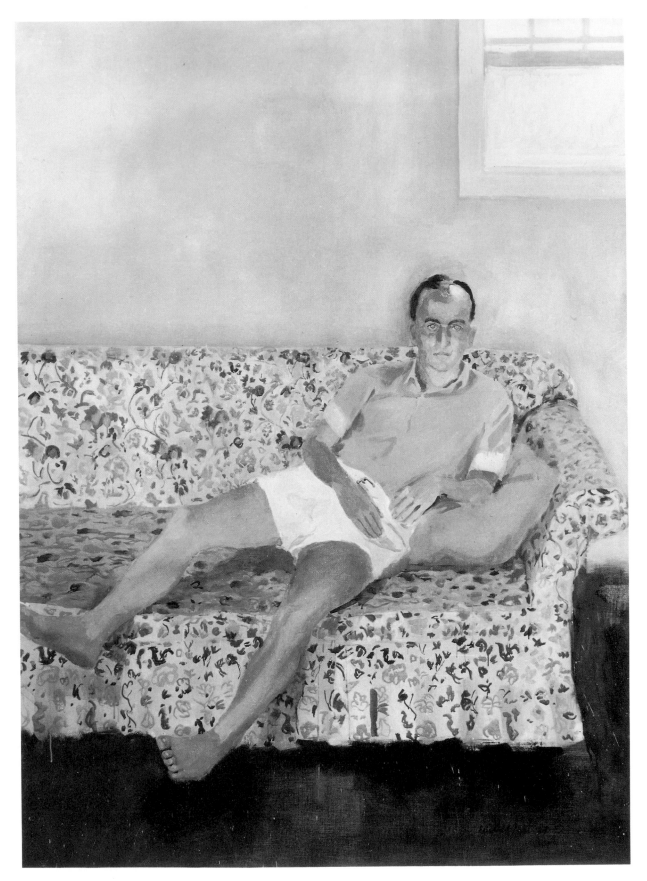

Frank O'Hara. 1957

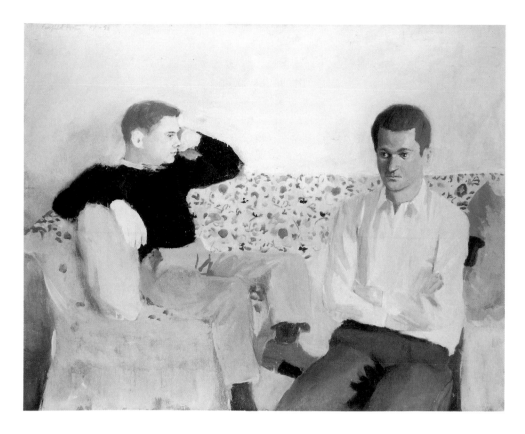

Jimmy and John. 1957–58

open hayloft door. The sunny afternoon light was reflected back into the pinkish studio. In a period when no one's studio could be white enough, Fairfield had his walls painted a very pale, pearly pink. He disliked the color qualities that white walls create.

Unlike the cramped painting conditions of the first portrait, here the space permitted ample and instinctual freedom of movement. Fairfield chose a vantage point six to ten feet from the canvas. He moved back and forth from that point to the easel. He was not a painter who remained at arm's length from his work. In short, his vantage place and his painting place for a portrait were two different locations.

At the Southampton studio, I could watch Fairfield at work, carefully preparing his colors for spontaneity. He set out a great glop of homemade [Maroger's] wax medium on the glass palette, then mixed it up with impressive amounts of five or six no-color colors. The blocking-in was done with big brushes, with large forceful, rather abrupt gestures. Small brushes came in only when nothing else would do. When an area became finicky, stiff or isolated, out came a housepainter's brush, sometimes clean, sometimes loaded, that he swept through the offending passage to re-establish the breadth of the image.

I sat three times for Fairfield for this second portrait. We talked only at rest breaks—and then, not about the work in progress.[76]

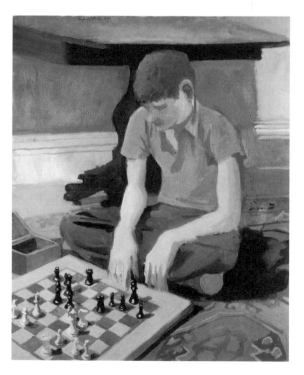

Laurence Playing Chess. 1957

By late August Porter reckoned the summer's painting to have gone well. "I am painting my show, and working goes surprisingly quicker and quicker," he

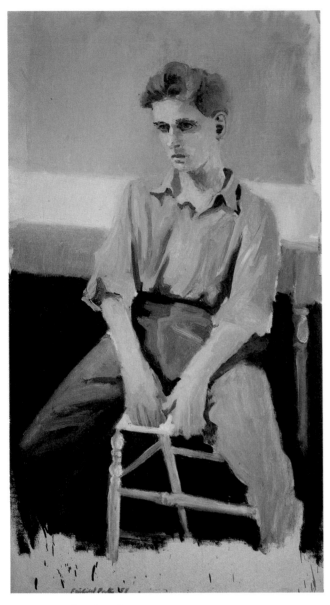

Jerry on a Stool. 1957

wrote. "I can paint a five by four oil in three hours now, as if it were as many inches large. I believe that for me painting should aspire to the condition of watercolor (or even gouache). I want my paintings to be ever so light; then they are, and I want them to be heavy, which then they become . . . Helen Frankenthaler, for some unknown reason, seems to like my paintings, at least she says so."[77] One of this series of summer portraits represented Frank O'Hara semirecumbent on the floral sofa, like an odalisque in shorts. Porter also painted Elaine de Kooning seated in his studio. "It is perhaps my best portrait to date. Also many pictures of the Plane tree from the studio and a portrait of Mrs. Fizdale. I have been giving Arthur Weinstein painting lessons."[78] Porter was friendly with the piano duo Arthur Gold and Robert Fizdale and painted their portrait while they practiced. That summer the poet Elizabeth Bishop, whose work he greatly respected, was staying at their place, which gave Porter the chance to meet her.[79]

At year's end Porter was moved—stunned even—to hear a voice from his past: Arthur Giardelli, his Oxford student friend from Florence, sent him a Christmas card. Porter had been hurt when Giardelli allowed their correspondence to lapse. He wrote to him immediately. "It was awfully nice of you to send me the Christmas card . . . Did you get a long letter from me about twenty years ago, that you did not answer?" In this letter Porter summed up the intervening two (almost three) decades of his life:

I have not been abroad since the time I saw you in Florence, and in England, which makes as real and vivid a memory to me as the memories from Florence . . .

I now have five children: three sons, 23, 21, and seventeen; and two daughters 8 and almost two . . . John was sick from birth with a mysterious illness that was never quite understood . . . He seems simpleminded—he remains childish and can't take care of himself quite, so he lives on a farm in Vermont where his foster parents keep schizophrenics and suchlike (meaning Johnny) free from any responsibilities. It wasn't until seven years ago that we arrived at this solution. No psychiatrists or doctors seemed to know anything definite about him, and the result on me was that I really did nothing for about the first ten years of his life but try to somehow help him. This was a most frustrating experience, because I was trying to solve something for which there was no solution. Then it was only after that, that is after deciding, on advice from a psychiatrist, to send him to a foster home, that I began to have a career or life of my own. This started by my getting a job on Art News, *from which followed the possibilities of exhibitions for me, and at last a recognition for me as a painter. It wasn't until after the war that I could concentrate on painting, that means paint without thinking about my supposed failure as a father in this one case. The next boy, Laurence, is very mature and sweet: He finished Harvard last spring, having majored in French: this Christmas he finished his military training requirements . . . He is trying to get a teaching job. Of*

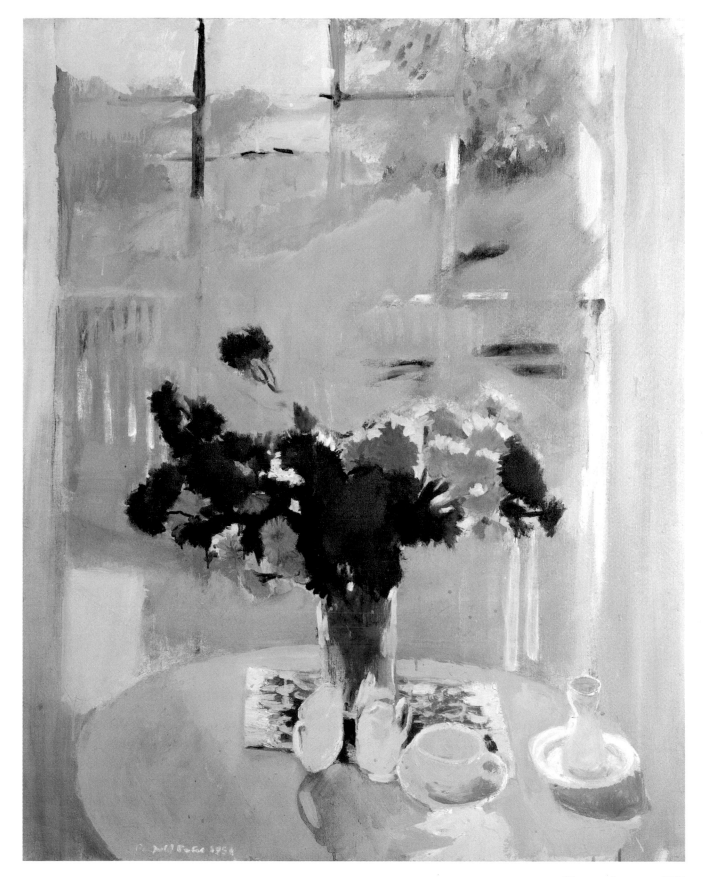

Chrysanthemums. 1958

necessity he became in effect the oldest. He seems to me to be older than me and Anne. Jerry goes to a school in Vermont, and Katy to the public schools here. Katharine is artistic too: she is always making something. Elizabeth has a round face like the rising moon; she is very sensitive. Katy is the one who resembles me most in appearance.

I write for Art News, *which takes about half the time, and I paint the rest. I will have an exhibition in April . . . I have also published some poetry, which I started writing five years ago.*

I live about 100 miles from New York (city) where I go and stay a few days every week for reviewing. I do most of my painting here, but I do some there also. I have what is called a "cold water flat" meaning in this case that there is hot running water but not heating in the building. It is in the slums, the address is 500 East 11th St. Many of my friends live in similar places.[80]

Porter's next exhibition, his fifth at Tibor de Nagy, was scheduled for 29 April through 29 May 1958; he had not had a show in 1957. With stretching and framing preparations, the forthcoming show was already on his mind by early March, and he wrote about it in his newly revived correspondence with Giardelli. "*Art News* will give me a reproduction of a painting—that much they do for their contributing editors—and so in the May issue there will be a small photograph." This would permit Giardelli to see one of his recent works. "It would be nice to get a review by one of my friends on the magazine, too. But I might not, if Hess thinks some one else (that is someone who does not particularly like what I do) would write a more interesting review. I have been assigned to review shows by his friends only because he thought I would not praise them (in an intelligent way)."[81]

The April show at Tibor de Nagy included the two portraits of Jane Wilson, *Frank O'Hara* (which was illustrated in *Art News*), and Southampton landscapes and interiors. His friend Robert Dash, reviewing for the June issue of *Arts,* had numerous reservations about Porter's work, including his technique:

The effect is as if Mr. Porter were making specific, private, perhaps contemporary comments on the surfaces of his conventionally conceived, Impressionistic canvases. Or perhaps his thoughts were elsewhere, for his paper-thin brush often does not completely cover his studies, stopping a good distance above the base as if he were in a hurry to begin afresh in an attempt to be more exact.

Yet Porter's 1958 show was without doubt his strongest to date. His confident mood, his willingness to take chances, was everywhere apparent and not only on the level of the paint surface. Although he never considered himself a pioneer—indeed, the opposite—a certain kind of nerve was nonetheless required to fill an exhibition with life-size portraits of well-known people; nobody else was doing it in 1958 and nobody else had done it in decades. On 3 May 1958, Anne Porter wrote to her family, "Yesterday I went to Fairfield's exhibition. I felt happy the minute I walked into the gallery, the pictures look so bright and buoyant, and

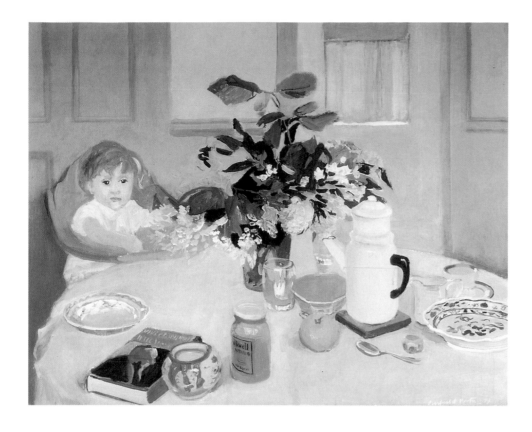

Lizzie at the Table. 1958

there are a lot of portraits, which people like to look at more than landscape. Most people liked it better than any of Fairfield's shows before. Fairfield says that one or two pictures are sold already and he has a portrait commission (though not a very highly paid one)."[82]

By the end of May Porter had sold three pictures out of twenty-two, "which is as well as I usually do," he wrote to Giardelli. "The review in *Art News* was by a friend on the staff—he really likes my paintings, but also he knows what I have been influenced by, and so it is, in a way, more accurate than other reviews. I do not like the painting they reproduced: it is the weakest in the show, to my way of thinking: it is a portrait of the man who wrote the 'Porter paints a Picture' article that you saw. I do not like the article very much, because it embarrasses me. Frank O'Hara is very imaginative and really writes his own ideas, and he is not accurate, nor interested in being so."[83]

James Schuyler's review in the May *Art News* boldly suggested that his friend Porter was doing something important, calling him "one of the few modern American painters who transforms genre into high art." Schuyler's analysis of Porter's influences was offered in connection with some landscapes with sycamore trees: "One in particular has the swathed and simplifying notation of form he has derived from Vuillard (and de Kooning: the washing out of the upper branches, the masking in of sky to gain a distinct but equal value)."

In only two days in June 1958 Porter completed the splendid, life-size canvas of Anne holding Elizabeth, with Katie seated with them, titled, *Anne, Lizzie and Katie.*[84] By contrast, many sittings had been required before Porter was satis-

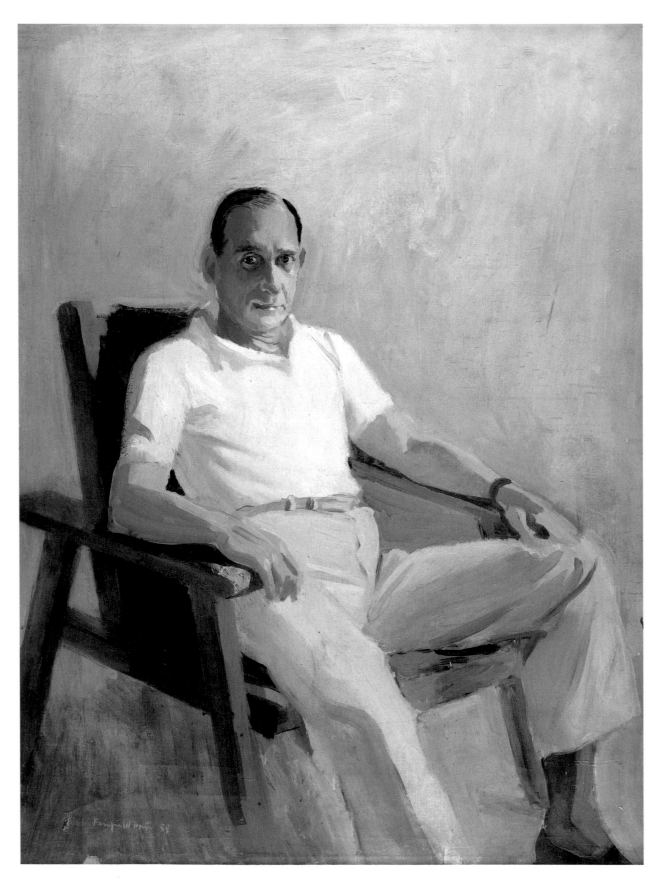

Tibor de Nagy. 1958

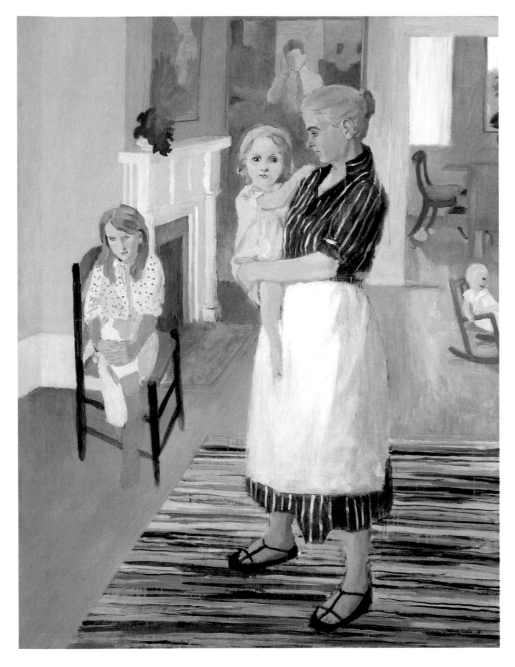

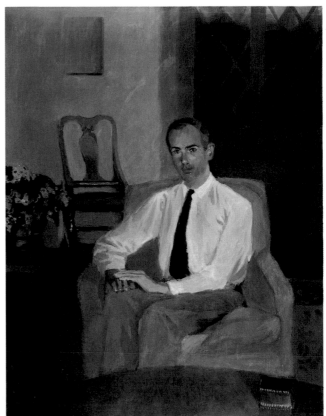

Roland Pease. 1958

Anne, Lizzie and Katie. 1958

fied with his portrait of Tibor de Nagy, which was intended as a graduation present for de Nagy's daughter. De Nagy complained that the portrait did not convey any sense of his wiry figure. Porter painted a second version of his de Nagy portrait, but neither sitter nor artist liked it as much as the first.[85]

The brighter colors and high-key contrasts that had first appeared in the summertime studio portraits of the year before were maintained in *Anne, Lizzie and Katie* and another major picture of 1958, *Lizzie at the Table*. Porter painted the former in a dilute medium, making particular use of drips and runs to give texture to the carpet. *Lizzie at the Table,* one of his best-known pictures, anticipates Porter's development in the sixties, with its denser pigment and more

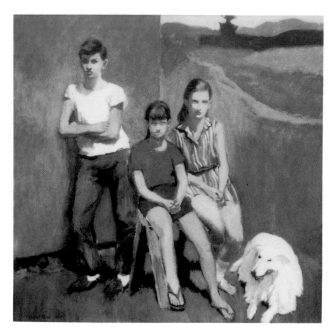

Chris, Sarah, Felicity. 1959

emphatic, weightier modeling. The picture was painted after breakfast, with Lizzie still in her high chair. Porter had been reading Wallace Stevens at the table; the white enamel coffee pot belonged to the Porters' Aga stove (a massive apparatus for heating and cooking imported from Scandinavia). A bunch of flowers and dark foliage from a copper beech had been collected by Laurence's girlfriend, Betsy.[86]

For the second summer in a row, the Porters did not go on vacation to Maine; nor did they go in the following two years. They could not afford the added expenses of island life. By the late 1950s and early 1960s the declining income from the family trust was sorely stretched to support the Porters, their children, Johnny's special care, and Laurence and Jerry's college tuition. The trust had greatly decreased in value and in a few years would be dissolved. Having escaped the deprivations of the Depression, the Porters ironically suffered straitened circumstances during the postwar boom. They lived modestly, without calling attention to their difficulties, and very few people outside of the family were aware of how drastically their means had been reduced.

Portrait commissions seemed to promise the best hope for a regular income from painting. Porter's best year so far had been 1958: he had sold $2,900 worth of paintings, from which the gallery deducted its share, $666. All but $750 of his total sales was earned from five portraits. This was the period of his portraits of Roland Pease and of an unidentified woman with the initials A. K. J., and a group portrait of Lucien Day's three children. "I would like to get some portrait commissions," he wrote to his mother-in-law about this time, "and I took some photographs and a painting in to Portraits Inc., but I haven't heard whether they are interested. I mean to telephone them soon."[87]

Porter's paintings from 1958 were shown the following spring, 17 March to 4 April 1959, his sixth show at Tibor de Nagy. This time, reviewing for *Arts*, Robert Dash reported that the work had cast off its "winter chill." *Lizzie at the Table* was especially praised: "The canvas reminds you of Vuillard, but the tone is Yankee and personal." The painting was sold for $600 to Arthur M. Bullowa, an attorney who had been at Harvard during Porter's time there, and who began at this time to form an important collection of his works, invariably chosen with care. A Southampton summer landscape, *Plane Tree,* illustrated Dash's review and was subsequently selected for the 1959 Annual at the Whitney Museum of American Art.

This was the first year that Porter had made it into the Whitney Annual; he was regularly represented in the Annuals after this breakthrough. Other signs of forward progress in his career this year were an exhibition of his paintings at the Rhode Island School of Design, Providence, and the acquisition of one of his Southampton landscapes by Hallmark International. William Lieberman at the Museum of Modern Art also did Porter a good turn. Asked by Sumner Winebaum, a collector, to suggest an artist to paint a portrait of his wife and himself, Lieberman replied, "Do you want a good portrait or do you want a good painting?" Naturally, Winebaum wanted the latter; Lieberman recommended Fairfield Porter.[88]

"I seem to keep on slowly selling pictures, though nothing so sensational as

the little painting of the Wareham dining room of last summer [1959; painted during a visit to Anne's parents in Massachusetts] getting $750. I painted another portrait of two friends, for $400, and I sold a painting in Texas for $600, and two more here. All this is gross, meaning, that what I get is two thirds of that."[89]

Early in 1959 the publisher George Braziller had announced a series of short monographs on American painters. Thomas Hess was to write about de Kooning, Frank O'Hara about Pollock; Porter was assigned Thomas Eakins, more or less by default. "Eakins was what there was," he later explained. "I was told that it would be this much money—$750. So I thought, I need the money so I'll do it. I remember I didn't like Eakins very much. I think I like him better now. But anyway it was just a potboiler."[90] A sculptor friend of Porter's remarked, "Why that's just chickenfeed," when he heard that Porter had agreed to write a book for $750. To which Elaine de Kooning replied, "Well, Fairfield has chickens to feed."[91]

Porter spent most of February at the Frick Art Reference Library, reading about Eakins and looking at photographs of his work. He was frustrated that he did not have the time to go to Philadelphia to study the original paintings, which he had not seen for many years. To make matters worse, the publisher praised his book as profound, original, and brilliant, and then proceeded to rewrite it in a "horrible way."[92]

By October 1959 the first six volumes in the Great American Artists Series were already out and being reviewed. The haste and negligence with which most of the authors had fulfilled their charge was obvious to perceptive critics. (In their defense, only $750 worth of their time and attention had been commissioned.) Hilton Kramer, in *Arts*, summed up the series:

> *Mr. Goodrich's monograph on Albert P. Ryder . . . is modest in tone, the most scrupulous in scholarship, and the most definitive of its subject. Two of the others, Mr. Porter's* Thomas Eakins *and Mr. Goodrich's* Winslow Homer, *are straightforward and reasonable, but they leave their subjects confused and undefined. The remaining volumes—Mr. Goossen's on Stuart Davis, Mr. Hess's on De Kooning, and Mr. O'Hara's on Pollock—are simply insults to the intelligence.*[93]

In the 12 December issue of *The Nation* Lincoln Kirstein reviewed the same six books more tolerantly than had Kramer, except for O'Hara's *Pollock*, which he likewise deplored. Porter and Hess were singled out for praise: "Porter is himself an able painter, an admirable critic with an eye and mind as candid, penetrating and exact as his subject."[94]

Porter's book on Eakins is an interpretive, critical essay on the artist, very unlike a standard art-history text. It makes for most interesting reading when the author gives free rein to his intuitions: "His clients did not want art to express their lives, any more than they wanted religion to do so: art and religion were for the uninhabited spare room and spare day, for the parlor, for Sunday."[95] Porter took Walt Whitman's appraisal of Eakins—"Eakins is not a painter, he is a force"—as his basic premise, which led him to an unorthodox deemphasis of Eakins's realism.

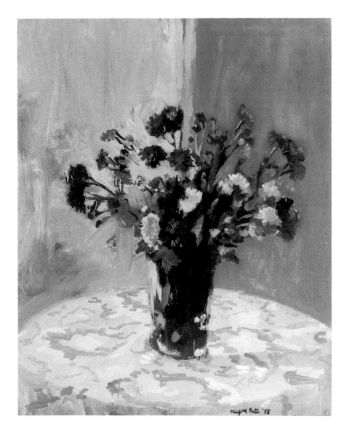

Still Life. 1958

Trumpet Vines. 1958

Claire White. 1960

Robert Dash. 1960

In the eyes of his sitters there is a defeated look that goes beyond objective realism. This is not only the weariness of holding still, it is partly the tribute paid to his conscience for the enjoyment of painting. Because his father's money enabled him not to have to work for a living, he had to convince his conscience that painting was work.[96]

It seems valid to read a measure of autobiography into this description.

Porter left *Art News* in autumn 1959. He simply could not afford the time the reviewing required (which he estimated as at least fifteen weeks a year) for the pay received. Fortunately, a better offer came his way, permitting him to continue writing. *The Nation* took him on as art critic for a monthly column, thanks to Lincoln Kirstein's recommendation, or so he suspected. "Again I jumped at the chance. I thought I'd really be on my own." At *The Nation* Porter was given complete freedom to choose his topics, the opportunity to write more expansively, and a salary about twice that he had received at *Art News*. Robert Hatch, the cultural editor, did not rewrite his columns "behind his back," which for Porter was probably the best aspect of the new assignment.[97]

In his first review for *The Nation* (6 June 1959) he took the opportunity to write his definitive appraisal of Willem de Kooning. He began with the proposi-

tion that "a painting by de Kooning has a certain superiority to one by any other painter," and confronted contemporary criticism head on: "The phrase 'abstract-expressionist' is now seen to mean 'paintings of the school of de Kooning.'"[98]

Porter's article caused a variety of favorable repercussions. "De Kooning liked my review of him: he said (aside from my praise, which I suppose pleased him) that I understand what he is doing very well, that I get his intention, and he went around to the *Nation* to get a copy for himself." The de Kooning article also brought in a cash prize from the Longview Foundation, based on the recommendations, Porter believed, of Thomas Hess and Harold Rosenberg.[99]

In October 1959 Porter sent to his sister-in-law Aline interesting and genuinely happy tidings of de Kooning's recent success. "He sold $125,000 worth at his last show—it was sold out—which means that he got about $80,000. He is rich now for the first time in his life. He went to Italy, which he likes—he might stay there this year. He had never been abroad since he came here from the Netherlands and then he had only been to Belgium and I think Paris."[100]

Porter next used his platform in *The Nation* to publish a major piece, on "American Non-Objective Painting," the term he preferred to use in place of "Abstract Expressionism." The article presented an eloquent case for the superiority of postwar American painting to the French, Italian, German, or Russian. It is fascinating for the light it throws on Porter's way of thinking about figurative and nonobjective painting, which he did not perceive as diametrically opposed. He praises and defines the American brand of abstract painting in terms that could equally apply to his own best work: "The Impressionists taught us to look at nature very carefully; the Americans teach us to look very carefully at the painting. Paint is as real as nature and the means of a painting can contain its end." Another of his observations, namely that "Art is measured by an interior intensity," is at least as true of Michelangelo or van Gogh as it is of Kline or de Kooning. Typically, Porter made his points about contemporary painting without naming names or ranking the contenders. In his very first paragraph he slipped in a deceptively simple aphorism that encapsulates his radically independent approach to art criticism: "It does not matter who influenced who, or who came first; quality is what counts. Arthur Dove and Kandinsky may have made the first abstract paintings in 1908 or whenever, but Picasso's and Braque's Cubism has more authority."[101] According to O'Hara, who sent Porter a postcard with his congratulations, the article was "one of the most important criticisms in years and should be sent everywhere."[102]

While Porter's critical writing thrived in the sympathetic forum of *The Nation*, the autumn and winter of 1959–60 were comparatively slack for his painting. "I am very dissatisfied with my own painting now," he wrote in October, "which does not however mean at all that I am depressed by it, it just isn't up to what I hope for, but I am quite absorbed in it whenever I do it. In group shows (there was one in East Hampton) my paintings surprise me because they stand out from the others, in a way I would not have suspected, if I didn't see it. But that is not enough, it is nice to be relatively good, but I want them to be good even when there is no other thing to compare them to."[103]

During that winter Fairfield's brother Eliot organized a series of museum exhibitions of his photographic essay, *The Seasons*. Porter devoted his January

Katie on Sofa. 1959

Farmland. c. 1959

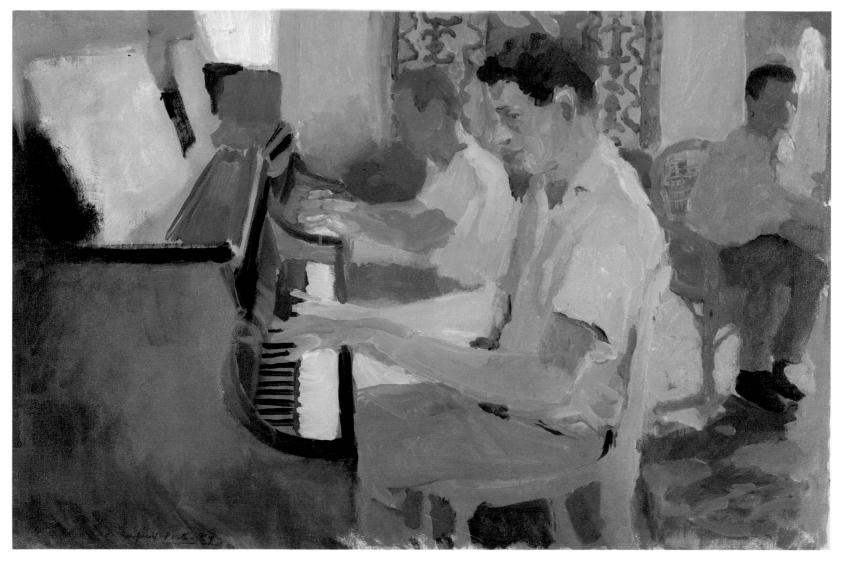

Piano Duet. 1959

column in *The Nation* to an extensive appreciation of Eliot's photography, which he praised in terms that identify at least one connection between the brothers' artistic visions: "Photography is nature, and so critics have thought it was not art. But if these photographs did not show you what they did, you would never have been able to discover it." Porter often defended his paintings after nature on these same grounds.

In the late 1950s Porter made friends with two painters, Robert Dash and Alex Katz, who mostly worked in landscape, although Katz soon evolved into a portraitist. Dash had also reviewed some of Porter's exhibitions and for a time they shared a studio space in New York City. Porter liked Katz's work, especially his brighter palette. Katz's early landscapes, pre-1960, are executed in a painterly style that sometimes recalls Milton Avery, sometimes Porter. The three friends compared notes and observations, with frequent cross-exchanges, as, for instance, when Porter commented to Dash: "Alex painted a double portrait of

Backyards with Wheelbarrow. 1959

The First of May. 1960

Bob Rauschenberg, one rather pinch-faced and cross or withdrawn; the other with a special expression that he wipes on often enough (I have seen it), an expression of such ingenuous sincerity that ice wouldn't melt in his mouth."

Porter celebrated the spring thaw and the return of longer days in Southampton with a major canvas, *The First of May.* He described the work in progress to Dash in a voice unmistakably that of one painter to another.

I started a huge landscape all spring colors, blue greens and green blues, of grass and sky, with thin leaves and transparency of all the branches, and little robbins, and a vast wide world curving up and away, and children far away on the grass, and possibly Jimmy [Schuyler] sitting on wicker chairs, and much sky and the difference between earth and sky ever so slight but nonetheless very very distinct; just a few accents of the darks in the bark of the plane tree; a laundry post and the orange frame of the swings, and the pear tree in new pale leaf. Then I want to make a third version of the Maine interior with Katie reading on the dark leather sofa.[104]

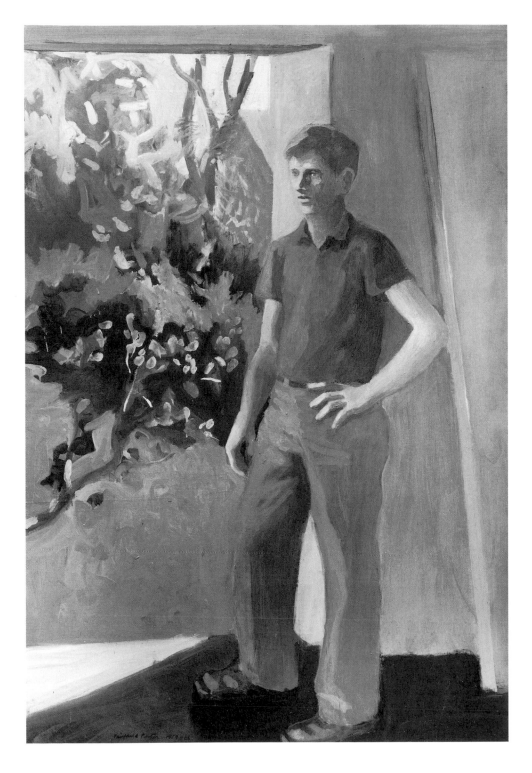

Young Man in a Doorway. 1959–60

Porter had not been able to go to Maine for fully four years, since 1956; his disappointment over this enforced hiatus must have been the cause of his uncharacteristic decision to paint a Maine subject from memory.

Porter's next exhibition at Tibor de Nagy was scheduled for October 1960, and all his efforts, beginning in June, were directed toward making the strongest

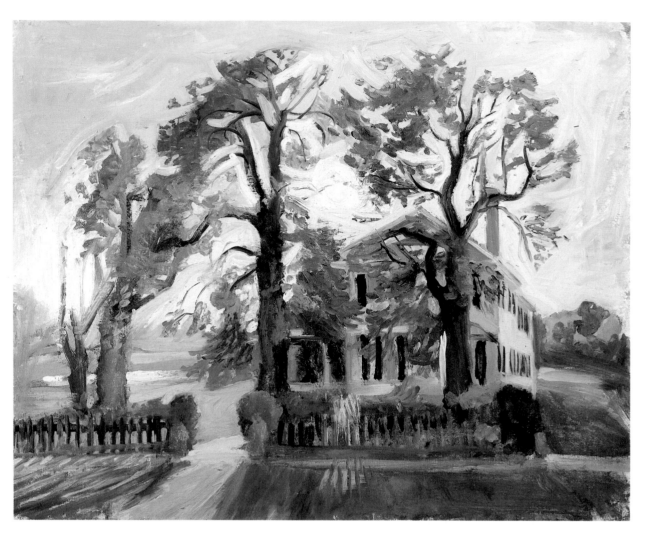

Forty-nine South Main Street.
n.d. [1950s]

South Main Street, Spring.
c. 1960

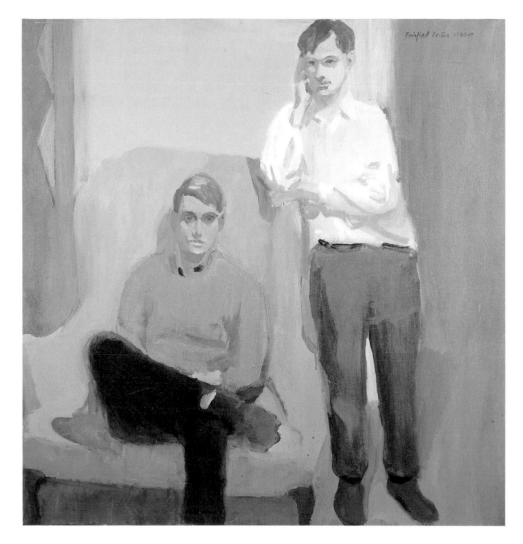

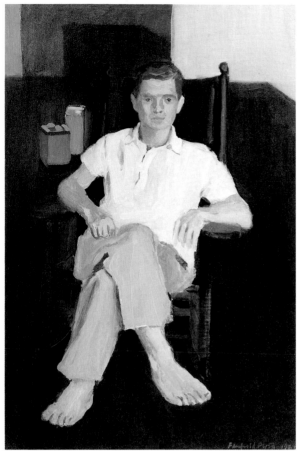

Jimmy in a Black Rocker. 1960

Portrait of Ted Carey and Andy Warhol. 1960

possible showing. "I want many paintings to choose from, and almost everything I have shown you discontents me," he wrote to the poet Howard Griffin, who was thinking of buying a picture.

> *Another new painting is a nude (painted in the city) which I think I like as well as the painting of Kate. I will have it in my show. Then here, a large landscape to be called "The First of May" with almost the whole plane tree, the pear, the pond, and Jimmy and Katie and Lizzie in the middle distance on the new lawn. The painting is all blue green and green blue. I am not sure about it: last night it looked a little stiff. And I am painting a number of very small paintings, 10 by 8 inches, from nature, still lifes and landscapes so far, of the progressing seasons.*[105]

The *Nude* is now in the Parrish Art Museum; Porter was reasonably satisfied with it, and de Kooning told him that he had caught the soul of Ruth, the model, but the figure is too ungainly to be considered a success. The painting of Katharine Porter has not yet been identified; Porter further described it to Griffin as "a large (6 x 5 feet) painting of Katie standing in the [Southampton] living

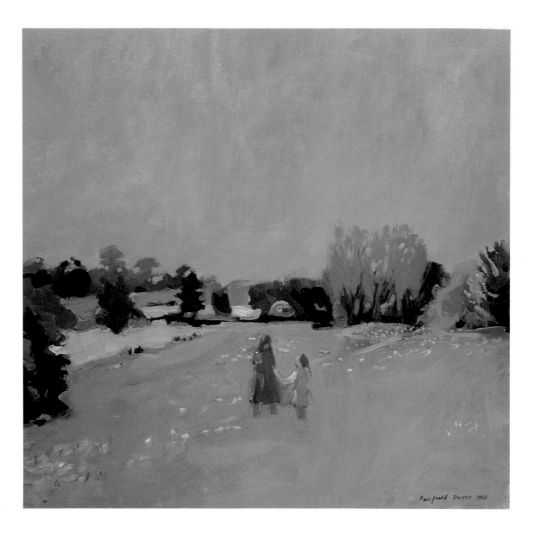

Children in a Field. 1960

room before the windows, in a posture like Velázquez's infantas. It has more glow than I usually, or perhaps have ever, got."

In July he reported to Tibor de Nagy on his summer's progress. "I am painting very hard for my show: so far I have four new paintings (since May) and I have from last year, that is, since my last show about seven paintings that I would like to show: one the interior that John [Myers] sold last fall as soon as I brought it into the gallery, one a portrait commission already executed and delivered [and] possibly the [Lucien] Day portrait. The museum still life, and about four or five other paintings, two of which you have not seen . . . If I can paint fifteen *GOOD* paintings in the next six weeks, I will have a show ready for October 11."[106] The commissioned portrait was the double portrait of Ted Carey and Andy Warhol. In the spring, his friend Arthur Bullowa did him a favor and donated to the Museum of Modern Art a still life, *Schwenk* (the title being taken from the name on the milk carton depicted on the table).

Porter was excited over the prospect of having his show in the new, larger

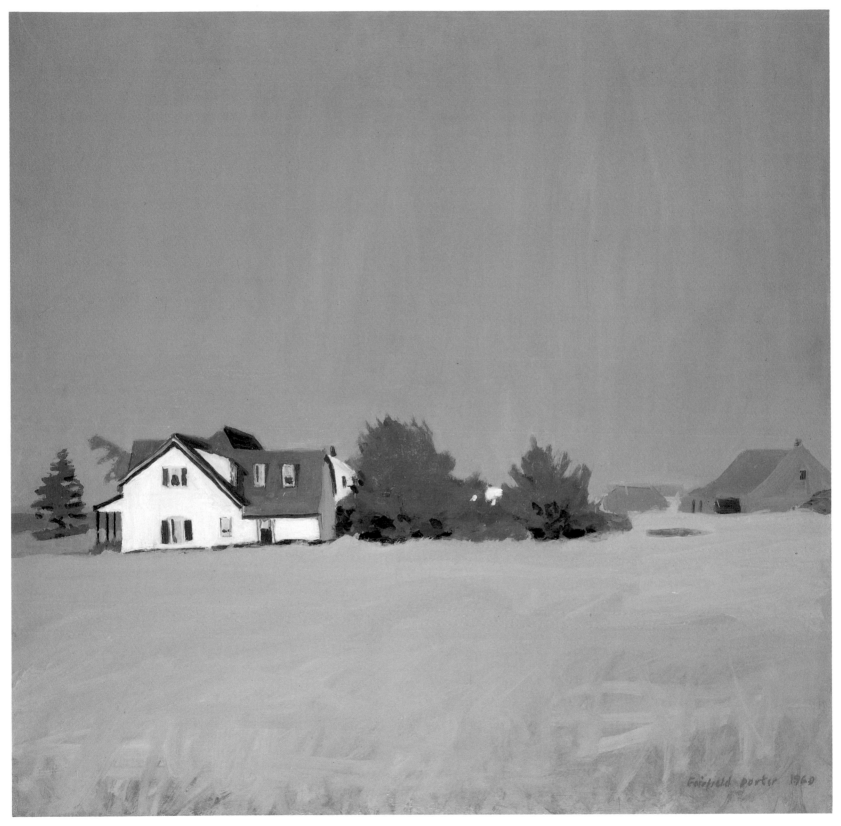

Wheat. 1960

Interior with Bust. c. 1960–61. Black-and-white offset lithograph, sheet size: 14 x 10"; image size: 13 x 8". Private collection

quarters that the Tibor de Nagy Gallery had taken at 149 East Seventy-second Street. One practical advantage of the new gallery was an "enormous storage space, which I bitterly imagine will in a couple of weeks be completely filled with still larger, in fact too large, Hartigans and Riverses."[107] Porter's gripe to Howard Griffin was based more on economics than on aesthetics: paintings that could not be stored at the gallery had to be carted in and out of the city at Porter's expense, whenever an opportunity for a sale arose or fell through.

Early in the summer of 1960 the Porters made some short excursions for family affairs. Their son Laurence was married in Baltimore on 9 June. Porter drove the family down for the ceremony. He found that the exhaustion he usually experienced after long drives was alleviated somewhat by *latihan,* a form of Subud transcendental meditation that he was practicing at this time. "Laurence's wedding was something I took with the proper choking back of tears, that I understand now as a feeling of being touched by the sweetness of the couple, more than regrets at their growing up (and my own growing older)."[108] Laurence and his wife, Betsy Hart, a Radcliffe graduate in architecture, had no honeymoon; they could not afford it. For a present Porter gave them the proceeds from his Hallmark sale.

At the end of June, or perhaps in early July, the Porters drove up to Wareham, Massachusetts, for a few days' visit with Anne's parents. "Wareham was delightful," Porter wrote to Dash. "All pale purple, soft and hot, with a landward or sea breeze, that even more than [Southampton] makes you want to take a nap right after breakfast. And there are no cars near, no exhaust, no noise . . . I tried out magma paints of Bocour there, which work like gouache. I do not know whether I like them. Maybe I prefer casein."

He was concentrating on landscapes this Southampton summer, probably influenced by the pressure of time. In June he wrote to Dash, "I have thirteen to go and they must all be GOOD, damn it."[109] Porter liked the countryside near the house the pianists Gold and Fizdale had rented in Watermill, next door to Joe Hazan and Jane Freilicher. He painted two pictures there in July. "I just made a landscape of a neighbor's yard (Gold and Fizdale) which, when it was almost done, I realized might have this kind of pouring, like wet cement, as though that were the way summer weather is. But all this is about potentialities, not what I have ever done."[110]

Using a squarish canvas, uncharacteristically, Porter painted *Wheat,* a landscape divided between blocks of field and sky, with a farmhouse compressed between them on the horizon. *Wheat* is unusual in its near geometry—it has overtones (probably accidental) of Rothko—yet its simplicity and control anticipate Porter's best works in the coming decade.

Under the pressure of his forthcoming show Porter mostly withdrew from the summer social life, without feeling he was sacrificing much. He found that he liked to paint in the evening light; his *Sunset and Lilies,* of this period, is a twilight scene. He developed the habit of going to the Bridgehampton beach in the early morning, so that he could swim naked (as in Maine), and he was usually gone before the Hazans, the Riverses, de Kooning, and Ruth Kligman arrived.[111]

His annual exhibition at the Tibor de Nagy Gallery ran from 1 to 26 Novem-

East 11th Street. c. 1960

Landscape. c. 1960

ber 1960. Robert Dash threw a party for him after the opening. As Porter had intuited, it was a watershed show for him. Of almost thirty paintings, eighteen were sold, including *Wheat* to the gallery owner Betty Parsons ($650). Mrs. John D. Rockefeller III bought *In the Middle of Summer* ($1,000) and *Golden Rod* ($800). Evidently the consistently good exhibitions and favorable reviews of the decade preceding had finally led to an increase in recognition among collectors that now made itself felt for the first time. A photograph of *In the Middle of Summer* was published in *The New York Times* over Stuart Preston's favorable review. Preston praised the canvases for their "motionless tranquility" and "high summery color," an indirect way of noting Porter's sensitivity to the high-key light of summertime in the Hamptons.

The Museum of Modern Art's still life *Schwenk* was in the show, and Alfred H. Barr and Dorothy Miller from the museum had called Porter to the attention of various members of the Rockefeller family, its primary patrons. Early in the new year, John Walker, director of the National Gallery, brought Jacqueline Kennedy, the first lady, to the gallery. Kennedy liked a picture that had been reserved for David Rockefeller. Tibor de Nagy telephoned Porter to ask if it wasn't possible for her to have it. Porter responded unhesitatingly, "No, if it's promised, it's promised."[112]

Fairfield and Anne were invited by the Museum of Modern Art in December 1960 to meet four Russian writers and critics. The other American artists present were Mark Rothko, Philip Guston, Ben Shahn, and Richard Lippold, the sculptor. "The Russians were exactly the way they are always said to be: with the usual clichés," Porter recounted. "One of them assured Anne that she knew that the department stores that are doing so much business now are closed the rest of the year: only before Christmas have they got things to sell. Anne told me this in the taxi going home, and the driver put in, 'Sure, we make so much money in the four weeks before Christmas that the rest of the year we take a vacation.'" At dinner Porter sat with the one woman who spoke English, whom he succeeded in disconcerting with his knowledge of the inconsistencies of Soviet thought. "As I later was told by Alfred Barr that she is a communist, and the one who keeps her eye on the others, I was not sorry I did . . . I tried to attack in ways that would take her off guard, and I somewhat succeeded; for instance I asked, was there a working class in Russia? and are they paid wages? and that since she assured me that the answer was yes, then in Russia the social situation was capitalism, since the wage system, according to Marx, is the essential symptom of Capitalism. Then when she asked if I had read Marx, I said, that since Marx described reality, it is not necessary to have read him, all one needs to do is to observe the reality he described."[113]

This was a winter of blizzards, beginning in mid-December. By January 1961 Porter had given over whole days to shoveling snow, strenuous exercise for a man fifty-three years old. "This is a beautiful and exhausting winter with endless cold weather and snow that lasts and lasts, and remains fresh and white at least."[114] Porter made some black-and-white offset lithographs, resembling drawings, of South Main Street under snow and of the inside of the house, which

was considerably warmer than his drafty studio. He did six in all, as part of a project organized by Reginald Pollack and Jules Sherman.[115] *Interior with Bust* (the bust is of Frank O'Hara, by Larry Rivers) is perhaps the most interesting of the series, very like a Vuillard drawing. He also did a scene of a New York street near his small city studio at Broadway and Twentieth Street.

The sales promised at his November show had been paid by January, which permitted Porter to hope to Arthur Giardelli that the family might go to the island in Maine that summer. "My success with my painting would make it possible. I miss the island very much, we haven't been there for several years. And certainly it will be changed. My brother no longer keeps a farmer so we have no cows, though I think we still have a vegetable garden."[116]

To his chagrin, Porter now realized that the time he spent writing reviews for *The Nation* was no less than that he had given to *Art News,* even though he could do more work at home. He felt himself "twenty books behind, because of the snow." For the 11 March issue of *The Nation,* he had undertaken to review a battery of new scholarship on ancient sculpture, mostly Greek. "Each book takes me an uninterrupted week to absorb," he lamented in a letter to the poet Carl Morse.[117] By May 1961 he had made up his mind: "I am not going to review in the *Nation*, or anywhere after June, but concentrate on painting, which I haven't been able to do for some time, because criticism seems to take more and more time, for possibly less and less lines. I guess it is my resentment at writing about paintings and sculpture instead of doing it, that makes it go so slowly."[118]

Notwithstanding this resolution, Porter had to devote two weeks in May to writing a review of a Tibor de Nagy Gallery (Tiber Press) publication in four volumes of poems by Frank O'Hara, Kenneth Koch, James Schuyler, and John Ashbery, illustrated with color screenprints by Michael Goldberg, Alfred Leslie, Grace Hartigan, and Joan Mitchell. "It was the most difficult writing I ever did: it took me two weeks to write 5 pages (300 words each) with a page of quotations."[119] The essay, titled "Poets and Painters in Collaboration," was published in *The Evergreen Review* some months later. "I like the poems better than the painters," he confided to Howard Griffin.

> *But the whole business looks awfully good, though it is almost as big and heavy as the Times Atlas, and four times as expensive. I don't know what I think about illustrations for poems anyway. I still think that Edwin Denby's and Rudy Burckhardt's collaboration in* Mediterranean Cities *works better. In the Tiber press thing there is some air of competition between poet and painter, as to who can make the most splash—or rather competition by the painters, which is countered by the publisher as advocate of the poets—though the total effort is the publisher's idea. It is Richard Miller who seems to say, in effect, these are the poets and artists whom I especially value, and therefore they are put together.*[120]

At the end of June 1961 the Porters returned to Great Spruce Head Island for their first summer since 1956. To his friend Griffin Porter revealed some of his reflections a week before their departure from Southampton. "Going to Maine

Lizzie with Wild Roses. 1960

always excites me as much as going to Europe. It has all kinds of emotions attached to it for me: the island stands for my personal golden age (my childhood) and in addition it is very beautiful, so this is not just a cropping out of the Oedipus complex. The melancholy feelings are partly personal and partly a response to something actually melancholy and beautiful, a gain and a loss at once."[121]

Elizabeth in a Red Chair. 1961

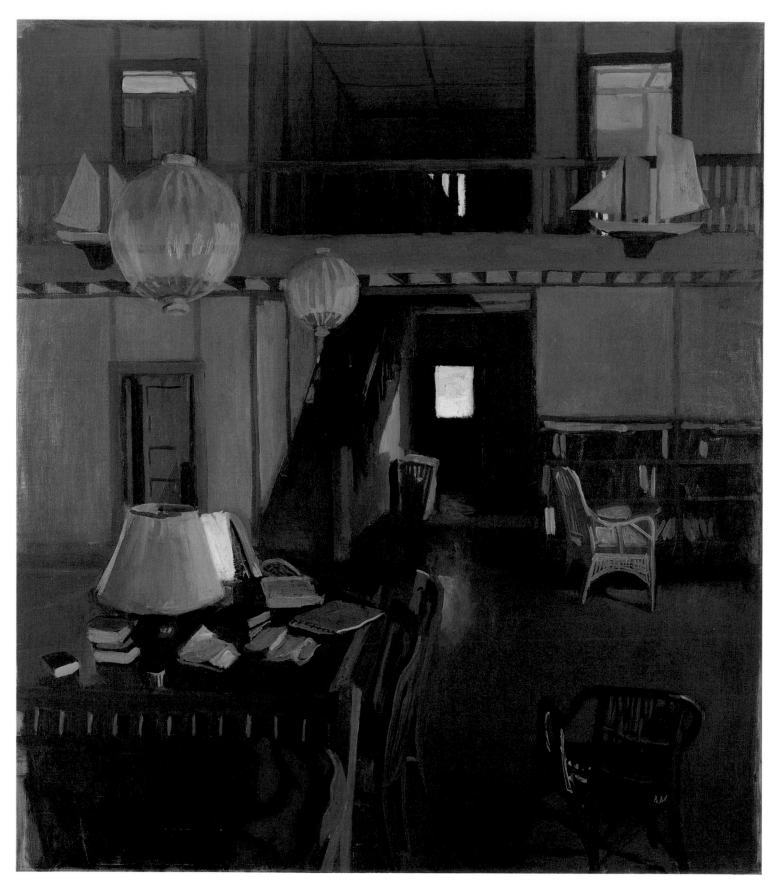

Yellow Room. 1961

We are back here this summer, I made enough money from my show to be able to afford it again, and I am very glad to do so, because this is the one place in the world where I have a sense of connection with my own past.

—Fairfield Porter, letter to Leon Hartl, Great Spruce Head Island,
11 July 1961

Porter's recent success—having sold more than half of the paintings in his November 1960 show—enabled him to resume his summer painting seasons on Great Spruce Head Island. He was entitled to feel good, since there were gathering signs that his work might receive more critical attention, now that the fifties were over. In 1960 his work was included in "The Figure in Contemporary American Painting," organized by the American Federation of Arts, one of several exhibitions around that time dedicated to the proposition that the hegemony of Abstract Expressionism had ended.

His positive outlook for the summer of 1961 was somewhat tempered by the difficult decision to leave *The Nation* after two years and to give up writing criticism. He wrote in mid-July to Leon Hartl, "I have been painting a good deal, but not too successfully as yet. I have to get my hand in again—I have quit writing criticism, and want to paint instead, which was becoming less and less possible with the requirements of criticism, which, the more independent I got, that is, the more independent of bosses, the more work it took, because when I am not assigned, I have to see everything, and then assign myself according to what I think is important."[1] Porter's use of the present tense to describe his reviewing was an unconscious acknowledgment, perhaps, that he would not abandon criticism altogether. After this date he never accepted a regular assignment with any journal, but frequently lectured and published many articles and reviews on contemporary art in art magazines and in *The New Republic*.

James Schuyler was on the island that summer, recuperating from the effects of a "rush psychological cure," involving medication, that he had undergone in a New Haven hospital that May.[2] By the end of June, Schuyler was "all well, cheerful, fat," as Porter described him to Howard Griffin. In the aftermath of this medical crisis, Schuyler came to live more or less full-time with the Porters, both in Southampton and on the island each summer. "Jimmy came for a visit and stayed

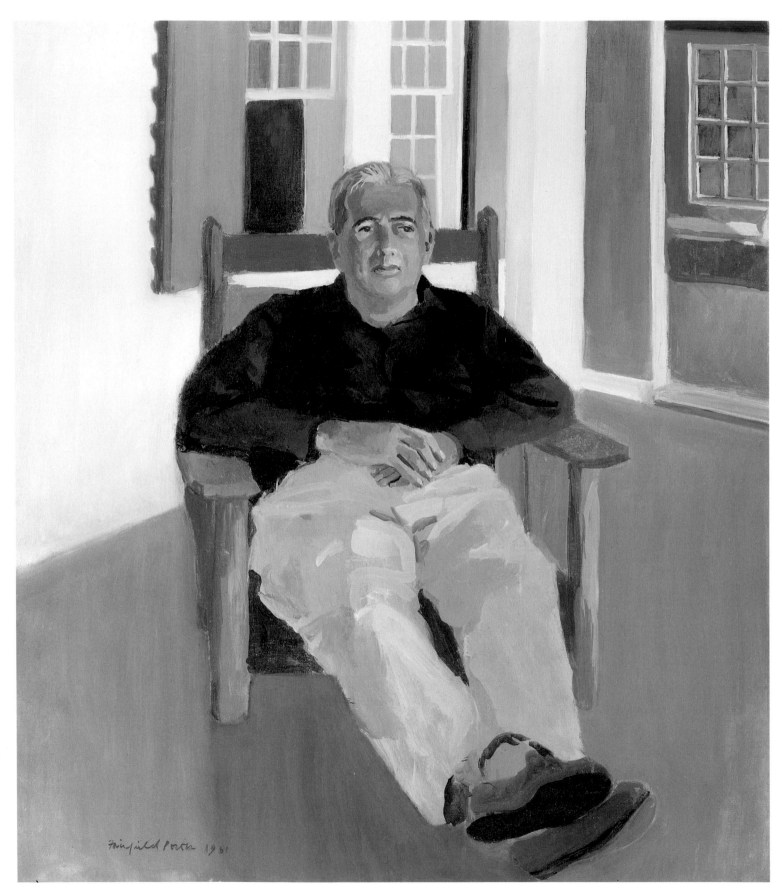

Michael W. Straus. 1961

eleven years," Anne Porter said in retrospect.[3]

A major poetic talent, a brilliant literary mind, and an outspoken advocate of a homosexual lifestyle, Schuyler was a distinctive addition to the Porter household. His personality was kindhearted and helpful, but also mercurial: he was susceptible to depressions and sometimes behaved irresponsibly. The familial love and support that the Porters offered mostly kept him on an even keel, however. Schuyler's poems constantly draw upon his recollections of the Southampton house and of life on the summer island, suggesting that his time with the family, which lasted until 1972, amounted to a "golden age" of his own.

Porter appreciated Schuyler's poetic muse, as well as the intellectual stimulus of his conversation. Having him in the family was like having a resident philosopher—one who was always willing, besides, to have his portrait painted or to lend his figure to a landscape or interior scene. Schuyler often read aloud to Porter while he painted, which the painter enjoyed and did not find distracting.[4] Porter's many still lifes of flowers from the sixties are another kind of witness to Schuyler's presence, since the garden was his special domain. He was a talented and an educated gardener, constantly bringing cuttings and flowers from the yard in Southampton into the house, or wildflowers that he gathered on Great Spruce Head Island.

The long-awaited return to Maine in early July 1961 did not occur as planned, because Anne and the girls were called to Massachusetts to comfort her mother during her final illness. The island was unusually quiet the whole month: Schuyler came up at first, and then went back to New Haven for another checkup. For most of July Porter's only companions were his family in their nearby houses: Nancy and Michael Straus—he painted his brother-in-law's portrait—and John and Trudy Porter, whose children, Ebby and Anina, were both interested in art, as Porter noted in a letter to Robert Dash.

The absence of children's voices perhaps inspired the solemn emptiness of *Yellow Room,* another rendition of the interior of the big house. Porter was sitting in the main room as he wrote to Robert Dash on 27 July, "It is lonely without my immediate family in the house, though I now like rather being completely alone . . . I finished another painting of this room (like the many in the Southampton studio) and each painting when I do it, and, if it is successful, fills me with loathing, that never, never again will I do this one again. But there are just too damn many subjects that I want to do, and as a result, I feel constantly impatient—impatient with people for wanting to talk to me—it wastes too much time—the weather might change."[5]

Porter's impatience with chitchat was a character trait—he was famous for walking off in mid-conversation, having said his piece. His dealer, John Bernard Myers, wrote in his diary,

> *There is a sense in which Fairfield is never quite* with *one. He engages in discussion with intensity, says what he has to say with animation, is suddenly silent, looking elsewhere, or, from time to time, stares piercingly at the person to whom he is speaking. It's put up or shut up . . . Why in the world is it that Fairfield never says good-by when he visits the gallery? Suddenly, there he is, and just as suddenly, he's gone!*[6]

Calm Morning. 1961

Porter habitually expressed himself with a frankness that was often disarming even to his closest friends. Anyone who asked his views could expect to have his unvarnished opinion. Kenneth Koch remembers asking him once whether he had seen one of Koch's poems in a recent magazine. "Yes—I didn't like it."[7]

Rackstraw Downes, the English painter and critic, first met Porter in late 1963 or early 1964, while Downes was studying painting at Yale University. "He came to the school twice and the second time he gave a talk (which eventually appeared, much revised, in *Art News* as 'Art and Knowledge'). I was extremely interested and impressed." During the question time, Downes recalls, someone stood up and started to speak long-windedly on Porter's behalf: "I think what Fairfield is trying to say . . ." Porter leaned back in his chair, folded his arms, and closed his eyes. Finally, Downes stood up in the audience and interrupted. "Could we please hear what Mr. Porter has to say to the issue?" Porter looked up to see who had spoken. As everybody was filing out afterward, he walked over to Downes and shook his hand without saying a word.[8]

Porter's July letter to Robert Dash contains a capsule description of island life. "Maine is like this: each day is a different weather, and it is so intense, that by breakfast, you think that the weather has always been whatever it is that morning.

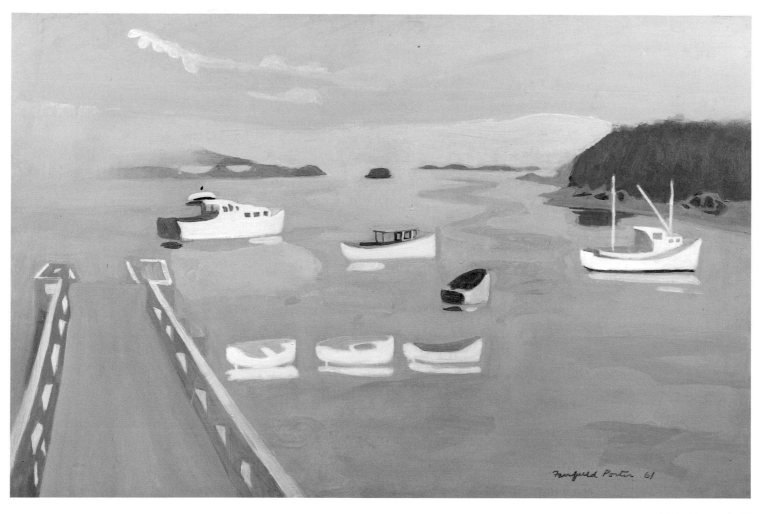

White Boats. 1961

One only remembers the other days of similar weather. And it is most changeable. The water is still icy, but once or twice it is bearable in the cove. We eat many lobsters, which I cook only until red, which is a little underdone, though for fish that is better than the opposite . . . We are in the beginning of the pea festival, which overlaps with the bean festival, the lettuce, zucchini and spinach festivals. It is most convenient that I don't eat cream or butter, as it makes me almost able to live off the land or sea. At night I am exhausted, after morning and afternoon paintings, plus cooking, plus getting ice from the ice house."[9]

By mid-August, the population of Great Spruce Head Island had been completely transformed by new arrivals, especially in the under-twenty category. Since Anne was still needed in Massachusetts, Porter carried on in the kitchen, directing a cadre of willing, if inexperienced, assistants. In Anne's absence, island life took on an improvisational quality. The kitchen in the big house was paneled in wood and its shelves were graced by an immense set of flowered English china, which no amount of breakage seemed ever to reduce. Over the forbiddingly huge cast-iron wood-burning stove hung crusted black cooking utensils of every invention. The icebox on the kitchen porch held blocks of ice, saved from the winter under pine branches in the subterranean icehouse in the woods.[10]

Porter summed up recent events, in a sort of stream of consciousness, to Robert Dash on 10 August:

Since I wrote you, first Anne's two nieces, Ruth, 15 and Anne, 12, and Katie, and a music student named Virginia Kneisel arrived, with solemn instructions to do everything that I wanted, in order to make it possible for me to paint. But Ginny, and of course the others, know nothing about a wood stove, nor anything about cooking either, beyond opening cans, so it meant my doing the cooking, while they watched with polite scepticism, and eating what I made, or not eating it, all without comment, but making their feelings known in the quality of silence. But they also did much cleaning and picking of flowers, to brighten things up, and finally they are also doing most of the cooking. I just start the stove and start breakfast every morning, because I get up earlier than anyone. Then Jerry and [his girlfriend] Suzanne and Jimmy and Adele arrived, and there was a most inorganic and entertaining household, rather like a house party in a novel. Suzanne was full of good natured demands and criticism, but when I suggested she do something about it, she did, and most successfully . . .

Wolf and Emily Kahn came over from Sunset on the mail boat one day, and today Jerry and Suzanne have gone to visit them, if they can put them up. Also Adele has left. I bought something like $180 of groceries day before yesterday in Camden, which should last until Anne comes which will be next week. Her mother died Wednesday, and she will come up with Lizzie.[11]

Anne's nieces left in mid-August, at about the same time that Laurence and Betsy Porter, who were both in graduate school at Harvard University, arrived for a visit. Laurence was studying for his Ph.D. in Romance languages and literatures; Betsy was enrolled in the school of design, studying for a master's degree in architecture.

Fortunately, Porter's unaccustomed role as majordomo did not interfere with his painting. On the contrary, he reported to Dash that his work had thrived that summer: "I have been painting more than ever: five paintings 40 x 45", four 36" sq. and about four or five others, that I like. It could be an island show. One was my brother-in-law, which turned out so that he likes it, as well as me . . . One of my paintings is of Katie and Annie on a trail on the woods, another is spruce trunks with hawkweed blooming between them, very Teutonic, but then Jimmy says Maine is teutonic. Also details of specific flowers—wild primroses, and I plan one of Queen Anne's Lace. The weather is just beginning to get warm, and swimming is now possible . . . When the weather is the way it is today, I like it here very much. It would be nice to have a winterized house and stay indefinitely, just painting, and of course reading."[12] Two weeks later, he estimated to Larry Campbell that he had painted about thirty-nine paintings since July 4, "many of which are as good as I am capable of. But this is not good enough."[13]

Although Porter never ceased to be self-critical, during the early sixties his work attracted more and more attention. In the autumn of 1961 he was again

invited to exhibit in the Whitney Museum Annual: he sent the large *Yellow Room*, the picture that had caused him to lament his fixation with the subject.

Porter's "island show" at Tibor de Nagy did not open during the autumn, as in previous years, but was scheduled instead for January 1962. Stuart Preston commented auspiciously in *The New York Times* on 14 January that "each of Fairfield Porter's exhibitions increases his sober authority as a landscapist." There were a fair number of sales. Arthur Bullowa added two more canvases to his collection; one, *Calm Morning* is striking for its notably quick and broken brushwork, perhaps intentionally reminiscent of de Kooning's painterliness of these years. Two important American collectors, Joseph Hirshhorn and Roy Neuberger, bought Porters from this same show. Hirshhorn's interest in Porter resulted in numerous other acquisitions in ensuing years. Neuberger chose *Blue Harbor*, a very fine, very painterly example of Porter's work. In 1968 he commented that he had previously thought of Porter as not too adventurous, but over time had observed how the artist's stature had consistently grown. *Blue Harbor* had reminded him of Albert Marquet—a reasonable comparison—but he had come to regard the composition of Porter's picture as more daring.[14]

Selling more than seven paintings from his January show, Porter realized not quite $5,000. The most expensive paintings, among them *Blue Harbor*, were priced at only $1,300. Hirshhorn, a notorious bargainer, paid less than that for *Edge in the Morning*. In early June 1962 Porter took his earnings and bought a Chevrolet minibus to replace the Volkswagen van that had become too cramped to carry his large family up to Maine. The island and the paintings he hoped to do over the summer were very much on his mind. The "yuma yellow" Chevrolet bus was the first car that he had ever bought new.[15] "I am thrilled with it," he reported. "It is most capacious. Nine passenger—like the VW—but nine fat people instead of nine thin ones. Also I transported an easel and a huge roll of canvas with much baggage."[16]

Once in Maine he had still to sort through and solve with Tibor de Nagy the customary wrangles with collectors over the reserves, prices, and sales of his paintings. Porter deeply resented the relentless commercialism of contemporary art collectors, and did everything he could to discourage or prevent them from speculating on his paintings. This was his reason for stipulating in his will that an estate should be created upon his death for the purpose of donating his paintings as gifts to interested public museums.[17] He resented, too, the discounts and other blandishments that galleries use to court reluctant clients. He once wrote about this to John Myers, "I like to sell to private people . . . To make a concession in a sale to a company is like selling a daughter cheaply to a whore house. I would rather give her away to someone who cares for her."[18]

The main problem in June 1962 involved the collector Ben Heller and *The Pear Tree*, a Southampton garden landscape that Porter had painted that spring. The picture had been sent, unpriced, to a summer exhibition at Guild Hall, East Hampton, because Porter was under the impression that Tibor de Nagy had bought the painting from him outright. Porter wrote to de Nagy from Maine on 29 June, having heard in the meantime that de Nagy had regarded *The Pear Tree* as reserved, not sold to him, at $1,500.

White Tree Stump. 1961

Under the Elm Tree. 1962

Forsythia Hedge. 1962

Mid-day. 1961

When I agreed to sell the new painting to you for $1,500 . . . I understood that you would buy it immediately . . . I did not mean to reserve The Pear Tree *for you until you had been able to sell it. Now, Ben Heller does not like the new painting. Does this mean that you cannot pay me for it? If so, our deal is off: I did not agree to reserve it for you at $1500. I would ask $3600 at Guild Hall for it, which would mean that I would get $2400 for it . . . Since you haven't yet sent me the $1500, I suppose it is because there is some difficulty from Ben Heller.*

Some time ago, when I was in financial difficulties, I sold a de Kooning to him for $7000.[19] I had asked $8000: he made me the smaller offer, because, I later found out, Eugene Thaw had offered him $8000. In other words, Ben Heller was not, as I thought, buying the de Kooning for himself, but in order to make a quick $1000. What he did was use my distress as an opportunity to make money. And now from what you tell me, he seems to be a man who is in the habit of engaging in shark practices. Therefore, I want to let you know right off that I will never agree to give Ben Heller any discounts. If I have a special price for him, it will be a specially high one. I am not impressed by any of the arguments that run like

A Short Walk. 1963

this: Ben Heller is an "important" collector. I do not want to be in "good" with him . . . So, if your purchase depends on Ben Heller, please let me know, and I can write Enez Whipple at Guild hall not to reserve the painting after all, and that it will be for sale, and at $3600. Ben Heller's opinion of the painting is just one opinion and other people who have seen it think it the best painting I have done; or, at least, not inferior to other paintings. From what I know of Ben Heller, I suspect that his opinion is just his way of bargaining. I neither trust nor like him, and the less I have to do with him, the better.[20]

As if to prove his point about the picture, a year later Porter sent *The Pear Tree* to represent him in the 1963 Annual at the Whitney Museum of American Art. *The Pear Tree* was also one of four paintings by Porter exhibited in the American pavilion in the 1968 Biennale in Venice, Italy.

During this summer of 1962 Porter felt his painting was slow in getting started. The weather was no help. "The summer here has been cold, as my sister says, a meeting point between spring and fall."[21] The work went more slowly than it had the summer before, when he had painted his "island show." "I do not know whether my painting has merit or not," he wrote to Carl Morse. "My results have not particularly thrilled me, though painting itself is always more absorbing. I am trying to paint more people."[22] He elaborated on his difficulties to Robert Dash. "I do not know about the quality of my paintings, but it is more consistently ambitious than ever before. I seem to know what in general I want to do differently, which is mostly in reference to color, but I do not know as well as last year what I want to do specifically, when I went from spontaneity to spontaneity."[23]

By the end of July Porter had finished several pictures, including a triple portrait of Laurence and Betsy Porter seated together with Anne on a green bench, *Night,* showing "Jimmy and Katie by electric light,"[24] and "one dreadful large painting, that is really nastily sentimental, of the caretaker's little girl mounting her bicycle on the garden road, all perfumed, tight, and artificial, which however I rather like."[25] *The Garden Road,* which portrays Rose Ann Shepard, the youngest daughter of the island's year-round caretaker, is indeed a good picture. "A rapport grew up between me and Rose Ann (8) who is very bright for her age, she got to understand what I liked and didn't like in painting."[26]

Porter's major work from this summer, *Summer Studio,* was also finished before the end of July. "I painted Lizzie one rainy day among turpentine and coffee cans, rags and a ladder, with an expression on her face that Anne says says 'When I grow up, I'm going to change all this.'"[27] The little girl's face shows that she was exasperated about something. Porter described this same painting to Lucien Day: "I have made a complex portrait of Lizzie in my studio porch, with flowers, turpentine cans, and the landscape through the screen, rags and litter. She earned one dollar, which she proudly tells everyone about."[28] Lying idly at Lizzie's feet is the straw hat that Porter wore for protection against the sun when the weather was conducive to painting out-of-doors.

Porter experimented this season with a water-soluble medium made by Liquitex, which was quick-drying and therefore solved the chronic problem of how to transport still-wet canvases at summer's end. With oils, it had usually been neces-

Night. 1962

sary for Porter to leave wet paintings in Maine to dry for another month and then to make a special trip back up to the island to collect them. "[Liquitex] is a water medium," he reported, "with all the brightness of watercolor, and as much dryness as one can wish, which can be done on oil prepared canvas, or any other surface, and which unlike casein, can be rolled forever afterwards, and never changes color, and becomes waterproof even to soap. The palette after painting looks per-

The Rocking Horse. 1962

A Day Indoors. 1962

fectly brilliant, all glowing with violet and caramel colors. I got it for the paintings at the end of the summer, when oils do not dry fast enough to take away."[29] Although similar to oil pigments in many respects, the Liquitex paints, like acrylics generally, are noticeably more brilliant, fluid, but also more opaque, not lending themselves to translucent overlappings or glazes. Porter was quite taken with these new paints during the early sixties, and many of his works from these years are incorrectly described as "oil on canvas." He wrote to Robert Dash, "I have started using liquitex, which has all that casein had for me, and then some, that is an intensity and luminosity that I never knew of before. Also it smells strangely—I recognize the smell from most New York galleries."[30]

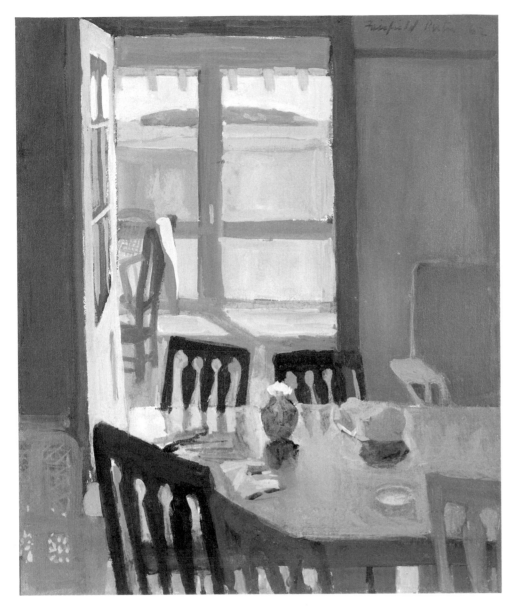

Interior. 1962

Stephen and Kathy. 1963

By the end of August the summer was over and the sun had only come out on four days during the entire month. Porter was satisfied with, but not elated over, his accomplishments during this subdued painting season. Although his health was good, he felt his age for the first time. "This year I took canvases over to the neighboring islands, and find that I no longer have as much physical energy as say twenty years ago; it tires me to row a couple of miles and carry paints a mile, with a couple of hours of painting in between. However, twenty years ago I was less ambitious than I am now, and did much less, at least effectively."[31] *Scragg Island* is one of the canvases Porter painted after rowing to another island in Penobscot Bay—certainly a strenuous activity for a man over fifty years of age, as Porter now was.

Although life on the island depended upon visitors to vary the discourse—especially on shut-in days and in the evenings—Porter was beginning to feel worn out by company, "even though I do not do anything for them."[32] He was usually too

View of Studio with Elm Trunk. 1962

tired to participate in the evening rounds of "dramatic switchboard" and other parlor games that Schuyler and Katie Porter enjoyed organizing—an island tradition that was very much alive. "I don't do much except paint, including on neighboring islands, to which I row . . . Jimmy says he and I have opposite records; he for getting up late, and I for going to bed early."[35] Four of Laurence Porter's in-laws were houseguests in August. After they departed, Carl Morse came to stay a few days, and then Alex Katz and his family. Once, while Porter was stretching and sizing some big canvases to paint, Katz observed that "large canvases are a sympton of ambition, and small ones of ego." Porter told him, "I have plenty of both sizes."[34] On 20 August, Fairfield and Anne risked a stormy sea to go to Camden on the mainland for lunch with Edwin Denby, an old friend whom they had met just before the war, when they had first returned to New York from Winnetka.[35]

As in 1962, Porter's 1963 show at Tibor de Nagy Gallery was scheduled for January and February. The announcements were illustrated with a Maine landscape, *Low Tide.* Hilton Kramer wrote a studied analysis of this painting in his end-of-the-season review in the June issue of *Art in America.* Kramer attributed considerable importance to Porter's work, but thought that the artist's attempts to reconcile his "dual commitments" to both abstract and realist loyalties were sometimes strained to the breaking point. In *Low Tide,* he observed, the painting divides horizontally across the middle, where the broadly abstracted beach meets the more precisely rendered seascape. "Yet Porter remains an interesting artist, gifted in intellect and sensibility as well as accomplished in craft, and *Low Tide* remains a memorable picture."[36]

Favorable responses to Porter's show included an interview with Jack Kroll in *Newsweek* on 11 February 1963. Porter's first exposure to the national press only embarrassed him, however. "I hated the interview in Newsweek," he confided to Lawrence Campbell. "It made me want to hide. I think I was rather silly in my remarks, all from a feeling that it was all up to me to say many things, to be talkative. If I am interviewed again, I will think more carefully before speaking and not be led by the interviewer's ideas or interests, like the rubbish about Calvinism, which Jack Kroll wanted to hear, I think because of something I had written about Wyeth."[37]

The sales from this show were again encouraging, if unspectacular. The Chase Manhattan Bank bought the 1961 *Sycamore in September.* Prior to the opening of the show, the Wadsworth Atheneum in Hartford, Connecticut, acquired the 1958 *Chrysanthemums* for its permanent collection. While the exhibition was still on, the Art in Embassies Project of the U.S. State Department approached Tibor de Nagy Gallery with a request to borrow some of Porter's works to hang in American embassies overseas. To this, as to all other such promotional schemes, Porter's response was characteristically emphatic: "I am not at all interested in selling pictures to hotels, even less to hotels abroad, and still less in lending paintings to embassies. I don't want to advertise the American government abroad: I get nothing from such a program except a reputation for passivity and indifference."[38] Presumably he was referring to his opposition to the Vietnam War.

Although Porter's paintings sold steadily, his earnings from them were modest, since most of his pictures were priced at less than $2,000. Yet he needed every

possible sale in order to support his family; by this time the value of his stock shares and annual income from the Porter Family Trust had drastically declined. Porter spelled out his fragile financial circumstances in a 1963 letter to his dealers. He calculated that his annual income was less than $6,000 (his friend de Kooning received more for every picture he sold). Porter's letter also documents his arrangement with his gallery: the exhibition announcements and postage were paid for by his dealers, while Porter was still responsible for framing expenses (he always preferred simple wood strips or baguette moldings).

Fairfield Porter with *The Garden Road*. Photograph taken at Tibor de Nagy Gallery, 1963

> *February 15, 1963*
> *Southampton, New York*
>
> *Dear John and Tibor:*
>
> *On Tuesday I had a talk with John [Myers] about how much I had received this year, from you. This year means since September, when I got a check for $566.66.*
>
> *In January and February I have received the following:*
>
> | *Wadsworth Atheneum* | *$ 900.00* |
> | *Dorothy Seiberling* | *366.66* |
> | *William Bloedel* | *1,600.00* |
> | *Commerce Clearing House in Chicago* | *1,080.00* |
> | | *$3,946.66* |
> | *less cost of baguettes* | *64.75* |
> | | *$3,881.91* |
>
> *This is my income from paintings in 1963, so far. My other income, from dividends and interest, was, in the same time $326.45. In the course of a year I can expect from this about $2000.00.*
>
> *Therefore, I would very much appreciate anything else you may have got since then.*
>
> *The printer gave me no envelopes, which I discovered too late when I opened the package of announcements at home. I spent on envelopes and stamps the following (I bought the only envelopes I could get, and all there were in this town):*
>
> | *100 envelopes (manila mailing envelopes)* | *$ 7.50* |
> | *154 5 cent stamps* | *7.70* |
> | | *$ 15.20* |
>
> *All announcements that I sent without envelopes, I fastened together with little pieces of scotch tape. They seem to have arrived safely.*
>
> *Will you please add this $15.20 on to your next check?*
>
> *The above should give you an idea of my income for 1963, which is the total income of me, Anne, Johnny, Katie, Elizabeth, Jerry, and Jimmy Schuyler.*[39]
>
> *Fairfield*

The Garden Road. 1962

Flagpole. 1962

In response to Porter's need to earn more from his painting, Myers and de Nagy tried to obtain portrait commissions for him, but not many were forthcoming. Nor was he always successful at them, to tell the truth. By late March he had painted a portrait of Mr. and Mrs. Henry Mayer, married lawyers whose thirty-five-year association with the Building Maintenance Employees Association was to be commemorated. "I am afraid that the Mayer picture will get me no jobs: it is too stiff in the way it is painted," he admitted in a September letter to Myers. He considered that his best portraits to date had been those of Tibor de Nagy, Don Schrader, "and the one of Katie standing before the windows . . . The painting of Katie has a certain traditional formality, I should think." He recommended these as likely to attract commissions.[40]

Porter's low prices and his modest earnings are more distressing to us now than they were in fact for him. After all, as Anne Porter has pointed out, he had embarked on his career during the Depression, when it was understood that painters were poor.[41] Most artists lived in cold-water walk-ups. This was certainly

Low Tide. 1962

true in the forties, as well. The Porter Family Trust, while it lasted, had spared Fairfield and Anne from serious deprivation, as they were well aware. By nature none of them was much preoccupied with material wealth. Although the bright colors and serene expression in Porter's paintings cast an undeniably benevolent light on both nature and family, the artist's optimism was certainly not a reflection of an affluent style of life, as some critics have mistakenly assumed. The Porters were artists and intellectuals, not social climbers. Great Spruce Head Island was not a country club; it was, and still is, a wilderness with an outpost.

Porter's gallery show for 1964 was scheduled for the spring, 17 March to 11 April. Framing and other preparations were already under way in early January. Tibor de Nagy thought that Porter might sell more paintings if they were framed more impressively. Porter declined to make this investment, and his next letter to Myers and de Nagy addresses once again the ongoing conflict of interest between the gallery's efforts to cultivate clients and his sense of his personal integrity.

> *I have Tibor's letter about the frame. When I put strips around pictures, and the customer doesn't like them, if that will stop him from buying the painting, then please don't sell to him. I do not want to pay for frames. I*

Long Island Landscape with Red Building. c. 1962

Scragg Island. 1962

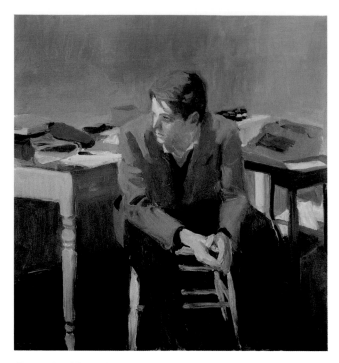

Portrait of Donald Schrader. 1962

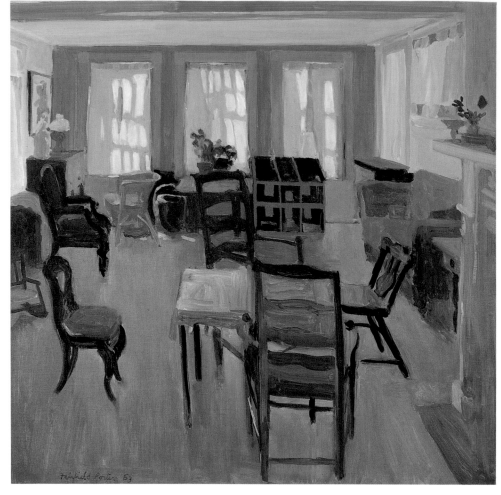

Interior with a Doll's House. 1963

am in a position where I have to count pennies, and anything for a frame is too much. And if I buy a frame, I want to add the cost of the frame to the price of the paintings.

There [are] a few other thing[s] I would like to put down here, for the record. Please do not send away to any exhibition any paintings that could otherwise be in my current show. If anyone wants a painting, let them take it away after the show. Please do not let the Museum of Modern Art or any other museum borrow a new painting for one of their purposes, no matter how worthy. I do not want my show that is coming up raided by the International Council, or Dorothy Miller, or Alfred Barr, or Mrs. Kennedy, or his Holiness the Pope, not even by the most important and arrogant collector on Manhattan Island . . . May I have something to say about the catalogue? I did not like the one last year, so I don't want this year's to look like it.[42]

Porter was naturally concerned to make his strongest possible showing. One difference in the 1964 show was that the most important pictures had been painted not in Maine, but in Southampton. The previous summer painting season in Maine had been necessarily shortened by Anne's illness in June and July. One of the few

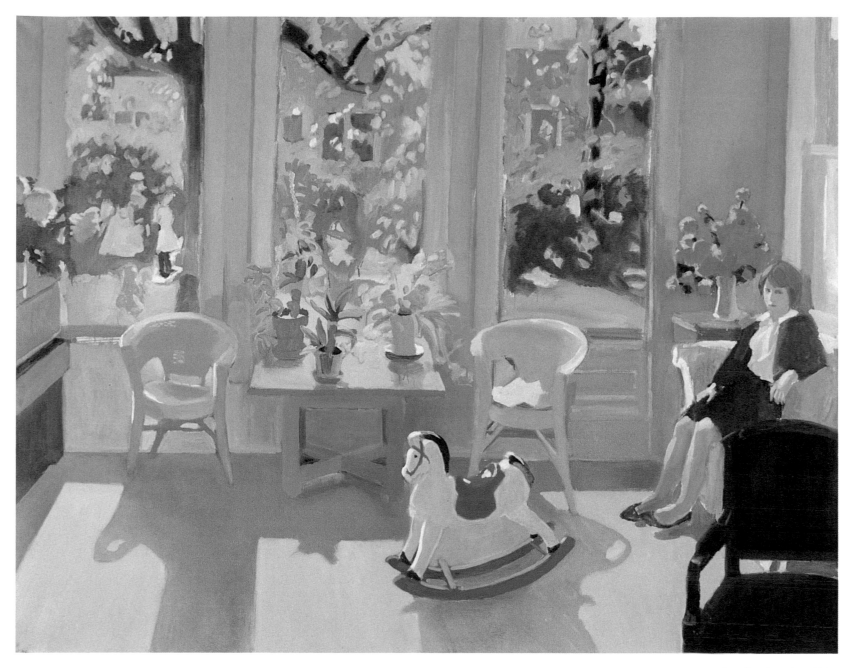

October Interior. 1963

Maine pictures from August 1963 is a double portrait, *Stephen and Kathy*, representing young Stephen Porter, Eliot's son, and his wife. The two major pictures for the 1964 show, of equally large size and with curiously symmetrical titles, *July Interior* and *October Interior*, had both been painted at 49 South Main Street.

July Interior is a portrait of Anne lying in bed, her face unnaturally smooth and white. "The picture should really be called 'Hepatitis,'" she once said jokingly.[45] "I was terribly sick and I had to stay quiet for a month." *July Interior* is therefore a document of Fairfield sitting with Anne during her recuperation. It is undoubtedly the most brightly colored sickroom painting in the history of art, an observation that sounds trivial, but is in fact suggestive. Porter loathed sentimental

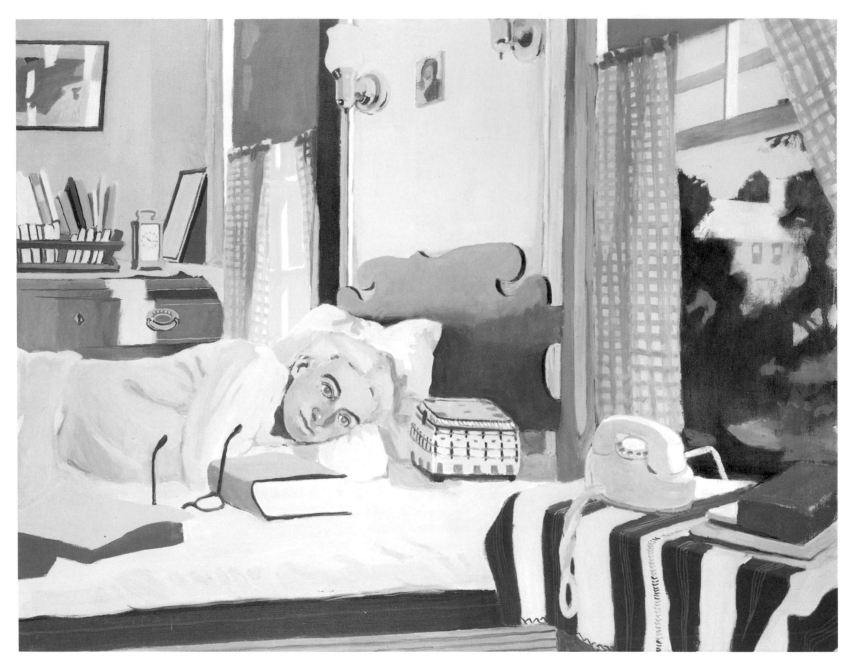

July Interior. 1964

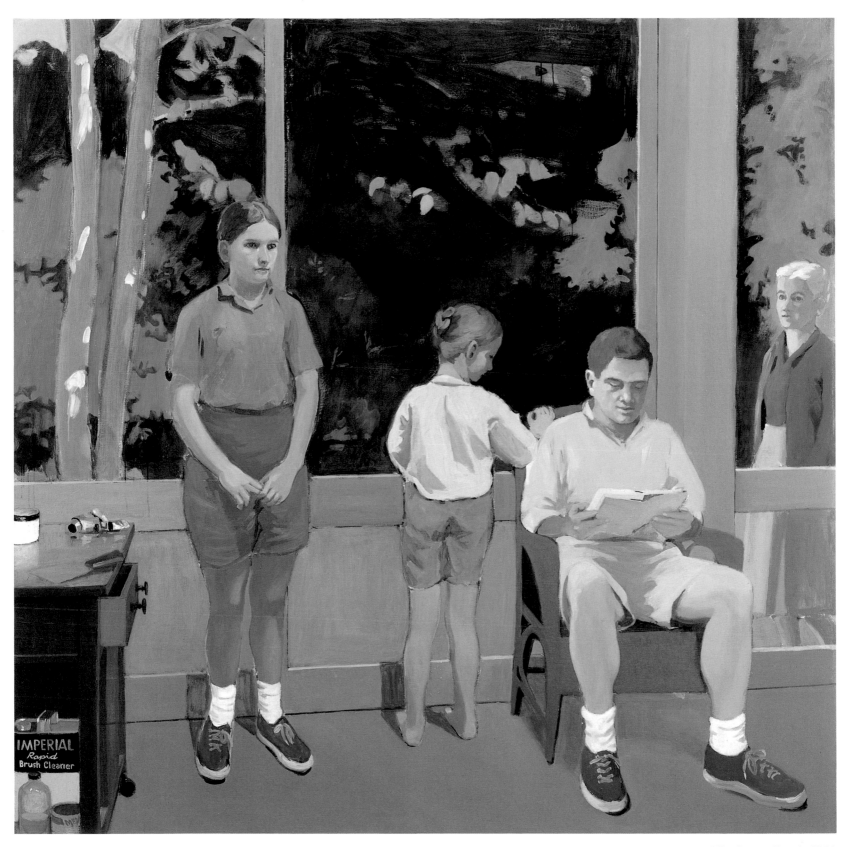

The Screen Porch. 1964

The Bay. 1964

art. His method of concentrating on particulars of light, time, and place was not only an approach to painting; it was a technique that he used to filter out emotional rhetoric or any kind of playacting.

Another fine picture in the show was a portrait of his youngest daughter, *Elizabeth Thinking.* When it was praised by the critic Michael Benedikt, Porter complained, "I worked too much over the expression there; it's not quite right. To paint a portrait of a person you have to be clear of your complexes about him."[44] This is problematic advice, though, and most other portraitists, from Rembrandt to Picasso, would reject it. One wonders whether it is truly feasible, in fact. Isn't every choice that the artist makes, every pictorial influence that he admits, an expression of his emotions toward the sitter?

Quotations from other artists—and he acknowledged his borrowings from Velázquez's *Las Meninas,* in particular—represent a category of content in Porter that is not visual only. The pose of *Elizabeth Thinking* disguisedly evokes English Renaissance precedents and thereby makes a play on Lizzie's monarchial name.[45] It is important to bear in mind, however, that none of Porter's critical writings nor the writings about him suggest that he wanted his paintings to be interpreted in this way. The lessons that Porter had from van Houten and the advice that he gave

Woods and Rocks. 1964

to young painters were Impressionist at heart.

The famous dictum about Monet, "He is nothing but an eye, but what an eye!" does not suffice for Porter. As a painter and in terms of his literary culture, Porter is most comparable to Bonnard, not Monet. In recent years it has come to be recognized that Bonnard's emotions and responses to the world around him can be discerned from his paintings. This is the kind of discovery that does not surprise. The artist's choices of composition, technique, motif are all intuitive decisions that grant us insights into the meaning of his work of art.

With Fairfield Porter, any search for hidden meanings takes us onto very thin ice, yet there are certain signs that seem to show the way. This is not, of course, a question of traditional symbolism, which would have seemed contrived to him, like Surrealist painting. By the same token, his paintings are filled with people, places, and things that had particular associations—strong associations—for him, and the memories and emotions that he attached to his subjects clearly influenced his creative process. While Porter's views on how to paint and how to see ("visual-

Spruce and Birch. 1964

ness interests me very much") were published, transcribed, and paraphrased throughout his adult life, he almost never addressed the question of meaning in his art. The following exchange from his 1968 interview with Paul Cummings is therefore of exceptional importance.

> Paul Cummings: *In one show you had a number of interiors painted around the house. Do you paint the house a lot? I mean you seem very involved with the environment that you live in.*

> Fairfield Porter: *Well, that's mostly the house in Maine. I paint that perhaps a little more than I do this one. And I think that's because it was built by my father. It's an example of his architecture. And so in a sense if I paint that house in Maine I'm also painting a portrait of my father or something like that. And this picture, this photograph, this color photograph of [Adlai] Stevenson, I like the color photograph on* Life. *[Porter painted Stevenson's portrait from this photograph.] The landscape is Illinois, obviously, to me. Stevenson is a symbol of Illinois. So what there is, it's a return to my native country. It has that meaning to me.*

> PC: *Yes . . . I mean it would be very hard for someone to figure that out by looking at that picture unless they had biographical information—it would be an assumption on their part, anyway. You know, your colors seem to have gotten brighter or clearer in the last few years.*

> FP: *Well, that is because I've tried to do that. I've worked in that direction.*[46]

And then the conversation shifts. We have to agree with Cummings's immediate response: the kinds of meaning that Porter described are inaccessible to the viewer. As Cummings said at the time, if we came to Porter's work armed with his biographical background, we might try to hazard a guess, but we would always only be speculating.

In the same interview, Porter made another statement that bears directly on his personal understanding of his paintings, as well as on the process through which paintings are viewed.

> PC: *Do you think that painting is more of an emotional thing than an intellectual thing?*

> FP: *No, I don't think it's more emotional or more intellectual. I think it's a way of making the connection between yourself and everything.*

> PC: *How do you mean "and everything"?*

> FP: *Well, I mean "and reality," which is everything. In other words, you connect yourself to everything, which includes yourself.*

> PC: *Through the painting?*

> FP: *Yes, through the process of painting. And the person who looks at it gets it vicariously. If you follow music you vicariously live the composer's efforts.*

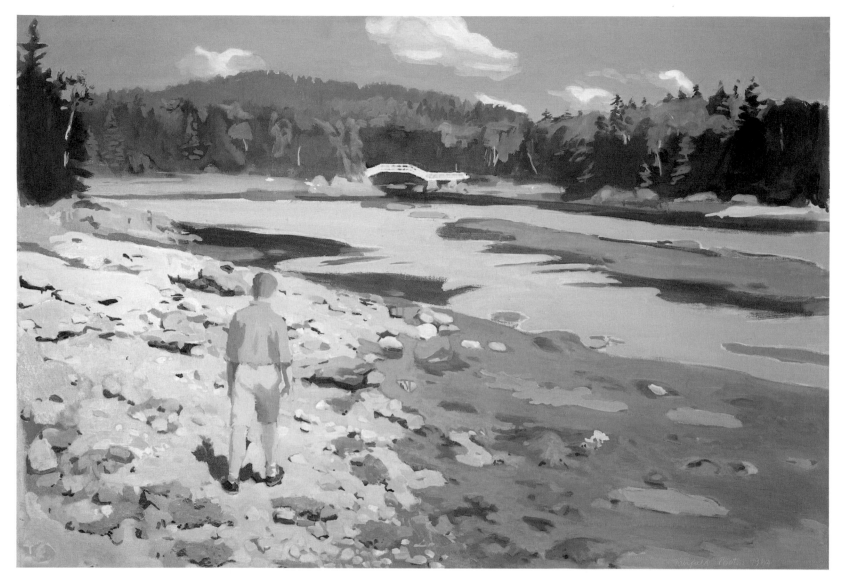

PC: *But don't you think the person who looks at a painting has an entirely different relationship to it than the person who has painted it?*

FP: *Well, for one thing they see something that is hard for the person who's painted it to see. I mean they see the person who has painted it and they see his emotions, which he maybe doesn't see.*

Porter's comments justify our efforts to understand the personal meanings of his paintings, although the explanations he provides do not inspire much confidence that we will get them right. It is clear at least from his statements that he freely associated with the persons, objects, places, and possessions he painted, and that it is elucidating for his art to know as much as possible about his subjects.

July Interior merits reconsideration as a case in point. The painting is a portrait of Anne resting, ill in bed—though no one could surmise this from its title. While Porter has not painted anything that was not in fact in the room, he has com-

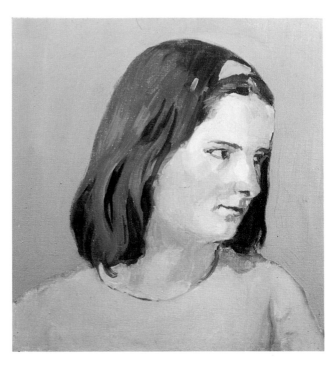

Katie. 1964

posed his picture to comprise a host of fascinating items, none of them self-evident. High over the head of her bed hangs a little reproduction of a Russian icon. Framed and leaning next to the clock on the bureau in the background is an original letter by Emily Dickinson, which Anne had been given, at age sixteen, by the daughter of Colonel Higginson, Dickinson's editor and confidant. The icon and the letter are no more prominent in the painting than the sewing basket on the bed or the telephone on the table (indeed, they are less so); yet they are tangible signs of Anne's religious and literary culture—her identity is bound up with them. At upper left, on the back wall, is a photograph by Eliot Porter of the islands in Maine. To Anne's right, the window opens out on the side yard in Southampton, toward the house of their neighbors, the Diefenbachs, visible through trees.

Do these fragmentary bits of evidence add up to anything at all? Perhaps Porter was disappointed that, as a result of Anne's illness, this was the first "July interior" in several years that he had had to paint in Southampton, rather than Maine. But among many possible interpretations, none can be considered definitive.[47]

Porter's *July Interior* is dated 1964, which means that he must have finished it over the winter, as he sometimes did with summer canvases. The other major picture in the March show, *October Interior,* is described in a letter: "I am also painting with varying success, one large interior with Katy at one end, the October suburban landscape and plants and flowers and in the windows—also Lizzie on the swing framed in the left window."[48] In the center of the painting, like a bridge between the two daughters, is a red-and-white rocking horse, which Kenneth and Janice Koch had given to Katie when she was a little girl. If we consider Porter's emotional associations with both the sitters and the still life in *October Interior,* it seems likely that the painting held meaning for him beyond that of a domestic interior.

For Porter's reputation, his 1964 show at Tibor de Nagy Gallery was the culmination of a favorable trajectory that had begun with his first great success in November 1960. This show of new paintings was treated in the press as an event of first-rank importance. Michael Benedikt's review, "Fairfield Porter: Minimum of Melodrama," was the cover article of *Art News* in March. Porter was profiled, along with Wayne Thiebaud and George Segal, in *Time,* in an article titled, "They Paint; You Recognize." For the April issue of *Arts,* Jerrold Lanes began "Fairfield Porter's Recent Work," a long and mostly negative review, by stating, "I think most people would agree by now that Fairfield Porter is the best of a very small number of good representational painters." Lanes ranked Porter over Richard Diebenkorn (who was then still working in a representational mode) and Philip Pearlstein. Brian O'Doherty, reviewing for *The New York Times,* credited Porter as the "father of some new developments in landscape and figure painting."

As a direct result of a general consensus that Abstract Expressionist painting was "finished," Porter found himself transformed overnight from odd man out to hero. An exhibition that the Museum of Modern Art mounted in 1959, "New Images of Man," had been influential in this process, since it had underscored the vitality of figurative painting. The emphasis had been on Expressionism, though, and only three New York school painters, Willem de Kooning, Jan Müller, and Jackson Pollock, had been included. In 1960 Porter was represented in "The Figure in Contemporary American Painting," a traveling exhibition organized by the

American Federation of Arts. The Museum of Modern Art sponsored "Recent Painting USA: The Figure," a more general exhibition of figurative painting in May 1962. Porter was not invited to this second exhibition either, but he, Elaine de Kooning, Alex Katz, and Larry Rivers took part in "The Figure," a show of New York artists that had been organized at Kornblee Gallery in opposition to "Recent Painting USA," and that opened on the same night.

Porter reviewed "Recent Painting USA" for *Art in America.* The climate had shifted so drastically toward figurative painting since he had first exhibited ten years before that he allowed himself to correct a popular misconception.

> *The exhibition opening at the Museum of Modern Art in May has the pur-*
> *pose of "exploring recent directions in one aspect of American painting:*
> *the renewed interest in the human figure." Since painters have never*
> *stopped painting the figure, [the exhibition] could be said to represent a*
> *renewed interest in the figure on the part of critics and the audience*
> *rather than among painters.*[49]

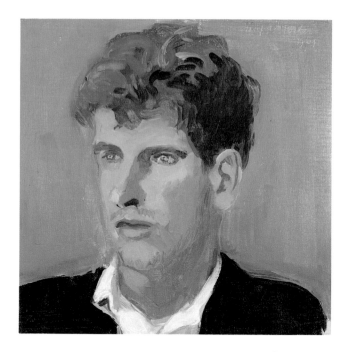

Jerry. 1964

The review of Porter's work by Michael Benedikt in *Art News* was unreservedly approving and Porter later said that it reflected his views accurately.[50] Benedikt wrote that the twin rules of Porter's aesthetic were "great efficacy combined with a considerable invisibility." In essence, Porter worked hard to make his paintings look easy, and this quality was praised. In Benedikt's analysis, "Porter's renderings of individuals tend to make those by most other painters—even those others who approach painting in a cool way—seem exaggeratedly Expressionistic." The article concluded by claiming that "Porter's identification of painting with a way of seeking emotional as well as plastic simplicity is perhaps his most distinctive philosophical contribution to American painting today." Although the phraseology sounds disconcertingly Minimalist—a style that Porter detested—Benedikt's article, evidently written with Porter's cooperation, defended his "happy" subject matter and emphasized the painterly objectives of his art.

Jerrold Lanes, in *Arts,* recognized Porter's leadership among contemporary figurative painters and professed to admire his work. Lanes's complaints, however, were delivered with rather more relish than his praises. He condemned Porter as "academic," though he used the word in an unorthodox sense. "This line of painting stems chiefly from Corot, and it has always kept two qualities that Corot's art had pre-eminently: it is progressive but not revolutionary, and it is eclectic." Unlike Pollock, Lanes explained, "Porter has no apparent interest in painting 'important' pictures except as good pictures."[51]

Although the general line of his argument is difficult to follow, Lanes also offered some specific criticisms that were valid, or at least arguable. He pointed out that in recent years Porter had noticeably whitened his colors, leading to a generalizing effect in his palette that "neutralizes his sense of particulars, which is one of Porter's finest gifts." It is true that Porter's paintings, beginning in the later fifties, from *Lizzie at the Table* on, became markedly brighter—which in itself was a positive development. But Lanes rightly saw that in certain pictures the dominance of white accents or highlights risked being a cure-all means of unifying the painting, and sometimes even a mannerism. Lanes singled out the double portrait

Stephen and Kathy, an acrylic painting that is almost entirely painted in white and sky blue, too much like the icing on a Thiebaud cake.

Lanes's critique of Porter's compositions ("a real inability to think or feel profoundly in compositional terms") was less warranted, however. Porter belongs to the very first rank of American painters precisely because he painted an impressive number of memorable compositions. When Lanes set out to attack his compositions, it rather seems that his real quarrel was with Porter's subjects, and his real purpose invective.

> *I should say in general that Porter's strength of mind has never been properly reflected in his painting. In fact my only reason for knowing he has it is that I have read some of his criticism, and I cannot understand why someone with such a powerful critical intelligence should paint pictures that in composition are so banal.*

An ensuing exchange of letters between Porter and Lanes in *Arts* was more comic than consequential.[52] Lanes had seen a sandy beach where Porter had painted a meadow with stubby brown grass. Porter showed his true feelings about the review in an April letter to John Myers; his response was characteristically honest. "I read the article in *Arts,* which depresses me more than I like it. I think his criticism is justified, especially about the paintings he chooses to talk about and reproduce, which are not my favorites. I feel about his criticism, that it is about perhaps the greatest number of my paintings, but that those that I like, not fitting into his categories, are ones that he doesn't write about. They are also what I want to do more of. I want to paint in the way that those paintings are done which this man as well as Michael Fried (is that the man?) ignore."[53]

Fried, a young academic, had made his reputation by championing Morris Louis and Color Field painting, and could therefore not be counted on for support. Porter was prepared to accept Lanes's remarks about the flaws in his weaker paintings. Even under attack he retained his capacity for self-criticism; he freely admitted that he saw faults in most of his paintings. But his main rejoinder was irrefutable: Lanes's review flagrantly omitted the artist's best work. Neither *July Interior* nor *October Interior* was illustrated or even mentioned. The latter was chosen for illustration in *The New York Times.* Porter was photographed in *Newsweek* standing next to *July Interior,* which was bought by Joseph Hirshhorn for $4,000, the highest price that he had ever received.

Hirshhorn bought three paintings from this show; his purchases amounted to $6,600, of which Porter received $4,400 (the gallery retained a one-third commission on all sales). His support was extremely critical at this time, since Porter's initial receipts from his 1964 show totaled less than $10,000.[54]

In February, before the show opened, Porter had accepted an invitation to lecture at the University of Alabama in Tuscaloosa. He described his preparations to his son Laurence, who was now teaching French and comparative literature at Michigan State University in East Lansing. "At Alabama I read a lecture that I had taken almost a month to prepare. I tried to memorize it; I spent many days declaiming it in the studio to fix it in my mind, which finally helped, but I did not know it all by heart. And since then I have altered it a little, and will use it in

Milwaukee."[55] In April he was to give a lecture at the University of Wisconsin. Since retiring from active reviewing, he had channeled most of his literary energy toward drafting a treatise on his artistic theory. One of his abiding concerns, which was connected with his stance on ecological conservation, was to demonstrate that science and art were two different systems of apprehension and that scientific observations were not necessarily more precise or more dependable than artistic ones.

Porter's essays are invariably so thick with meaning, and his use of language so particular—so peculiarly concentrated—that it is preferable to offer excerpts, rather than attempt a synopsis:

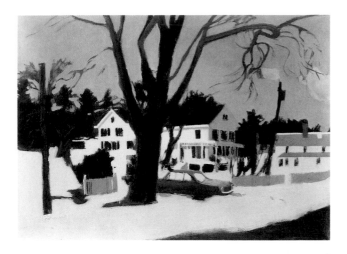

The Doering House. 1965

> *Science predicts the highest probability . . . The ultimate reality of death is assumed by those of us who are so much impressed by the prestige of science as to think there is no certainty outside of it. The anthropologist Jaime de Angulo once lived among some California Indians who traveled through the woods in old cars, which they skillfully kept in running condition. At his remarking on this one of them answered, "You white people think everything is dead . . . "*
>
> *There is another attitude toward existence, namely, respect. The scientist resembles the Platonic social theorist. If you make order important in a Platonic way, you have to close your mind to disorder, as Plato closed the Republic to the poets. There is a nervousness about the uncontained.*[56]
>
> *Art, being about specific things, is accurate. A specific is not valued by its closeness to a standard. A specific has integrity, which one knows in the same way that you know the hotness of your coffee, directly. And in this sense art is about one's direct connection with the material world: there is no translation into standards.*[57]

Porter discovered that he enjoyed speaking to university students and during the next several years tested his theoretical writings in front of many of these farflung audiences. His basic lecture, of which Rackstraw Downes had heard the original version at Yale in 1963 or 1964, went under different titles, including "What is Art" and "Can Art Be Taught" and was finally published in *Art News* in February 1966 as "Art and Knowledge."[58]

From Tuscaloosa, Porter went on to Carbondale, Illinois, to "look over the situation." He had been approached by Southern Illinois University concerning an appointment as artist in residence, either for three months or for the whole of 1965. "The latter seemed most practical with the family to consider," he told Laurence. "They would pay me $12,000 for a nine months year. Now they are considering me. It would help me next year, when everything is unsettled as usual, though I might do well on my show, which opens March 17th."[59] Porter liked the people he met in Carbondale, but when he returned home, he said to Anne that he did not want to take the post because "there was nothing to paint and there was too much chlorine in the water."[60] The sales from his show made it possible for him to decline this invitation.

After the abbreviated summer of the previous year, Porter and Schuyler went up to Maine in the first week of June 1964, a little earlier than usual. When Anne

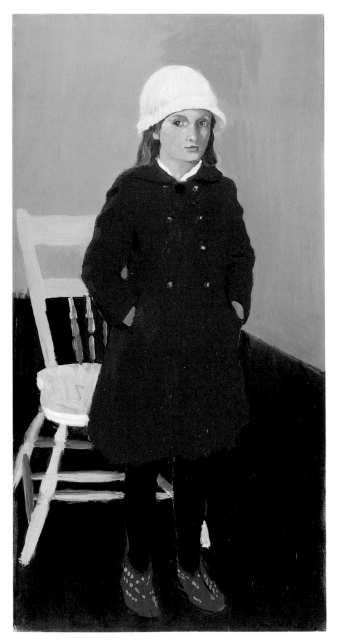

Elizabeth. 1965

and the girls arrived about two weeks later, Porter painted the assembled company—Katie, Lizzie, Jimmy, and Anne—at one end of his painting porch in the big house. The group portrait, *The Screen Porch*, is one of Porter's best-known works because it has often been exhibited. A family secret is that the painting was always called "Four Ugly People," a nickname given it by Anne. *The Screen Porch* was Porter's largest canvas to date, 79½ x 79½", and was the first of a series of ambitious works in square format and life-size scale. The other paintings in this same format are *Morning Landscape* (1965), *Iced Coffee* (1966), *Columbus Day* (1966), and *Island Farmhouse* (1969). Porter is not known to have commented about the purposes or inspiration that led him to a square canvas, which is unusual for a figurative painting. It is probably pertinent that Anne's figure in *The Screen Porch*, where she stands outside the porch, isolated in the doorway, is quoted from the background of Velázquez's *Las Meninas.* The Velázquez is not square, but nearly so (125⅛ x 108⅝").

Porter was a visiting artist at the Skowhegan School of Painting and Sculpture in Maine over the weekend of 21 and 22 July. Susan Shatter, one of the young painters there, remembers that on Friday evening "he read a paper on Art and Science to the students and faculty . . . The paper was prophetic in predicting the extent to which technology has provided an illusion of man's control over nature. Artistic perception was a way to stay in touch with nature's diversity and chaos." The next day Porter made visits to the studios of the artists in residence. He warmly praised Shatter's plein-air landscape paintings. "I was elated after his visit," she recalls, "and continued to work directly from nature. In 1964, this approach to painting was rare." On Saturday night, Fairfield and Anne went to the Skowhegan School beaux-arts ball "as self-portraits from one of his paintings."[61]

Porter's next gallery show opened on 16 February 1965. In *The New York Times* review, Stuart Preston thought he detected a new direction in Porter's latest pictures. Preston too was tempted to find thematic meanings similar in kind to those that were proposed for *July Interior* and *October Interior.*

> *These perfectly representational paintings, involving a fresh and spontaneous response to subject matter rather than the employment of an artistic convention, relate not so much to things seen as to the meaning and significance they hold for him. Theirs is a spirit of stoical sadness. Their very charm implies that the passage of time changes everything, that the sun will set over Penobscot Bay, the children grow up, and the trees cast longer and longer shadows.*

James Schuyler wrote a long review for *Art News*, which of course was laudatory. He took a telling thrust at the critics who thought Porter's paintings were inexpressive: "This portrait accepts the expression a person posing wears as just as personal as any other, an uninsistent perception that one can scarcely not be oneself."

Schuyler's observation is a fundamental one. Porter's figures are not expressionless: they mostly look like people who have been asked to pose and are doing so as patiently as possible. Although Porter said to Michael Benedikt that he always tried to suppress his emotions toward his sitters, he could not compel his

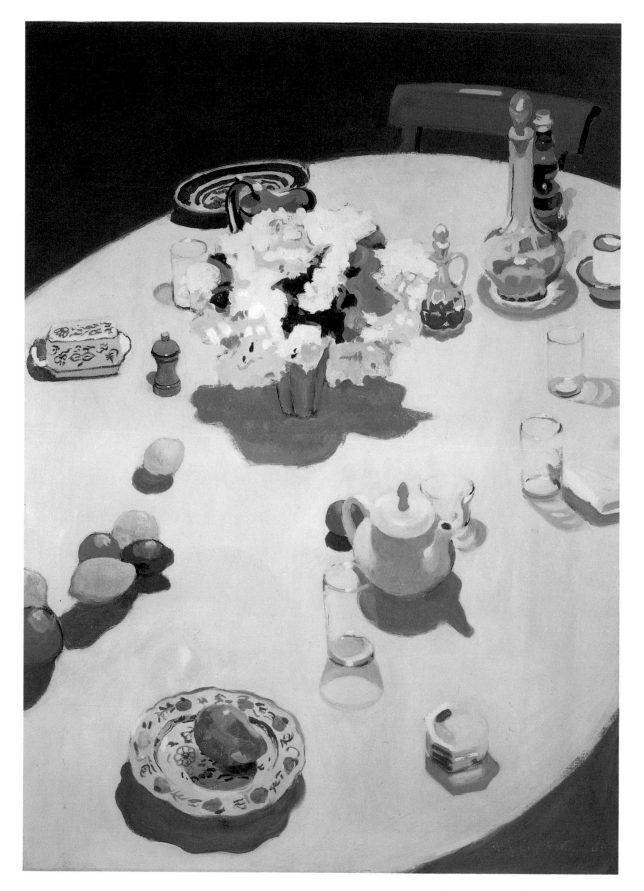

Table at Night (first version). 1965

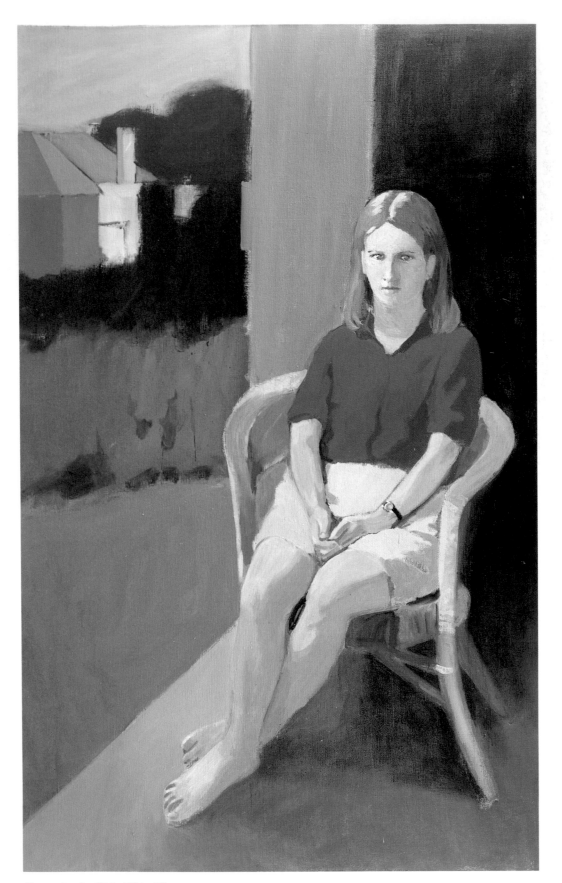

Portrait of a Girl. 1964–65

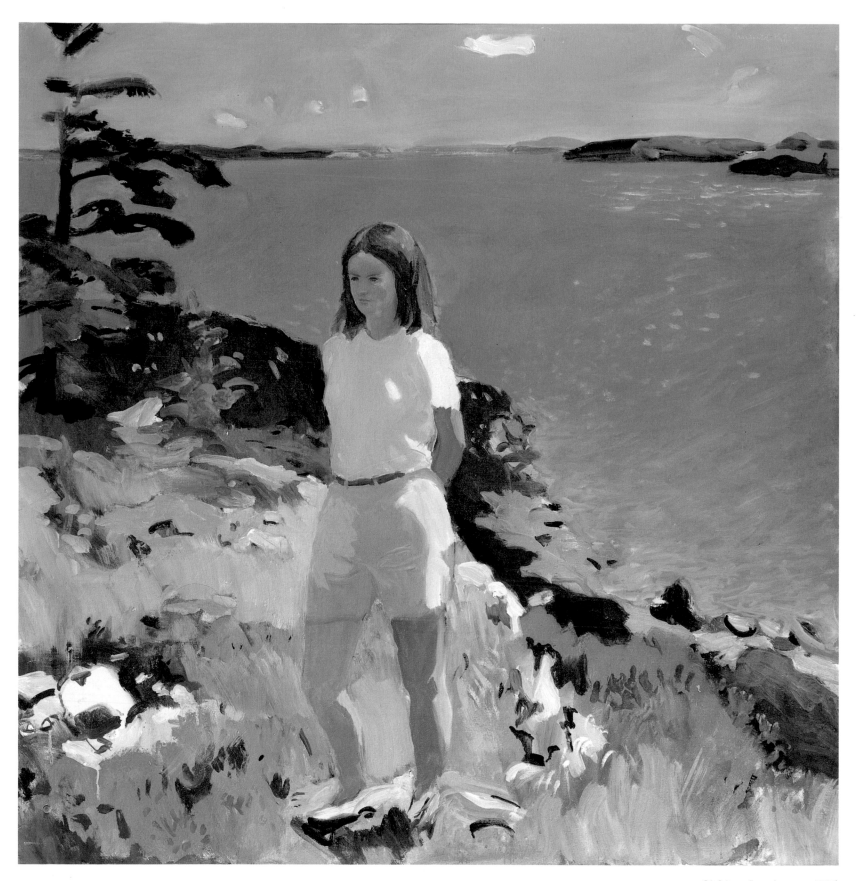

Girl in a Landscape. 1965

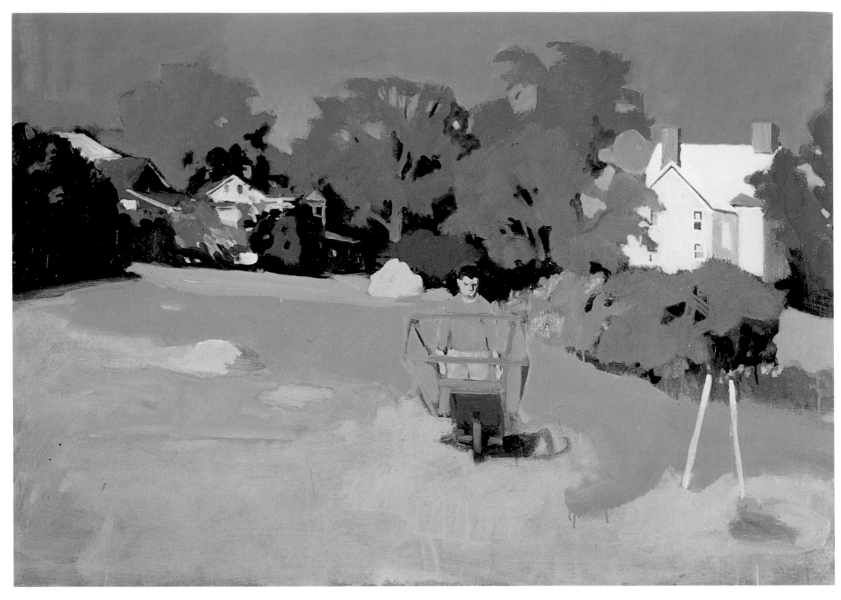

Jimmy and Leaf Cart. c. 1965

sitters to ignore him. Porter's paintings stand apart in the sixties precisely because every one of them evokes his physical presence and his identity. No wonder he liked *Las Meninas* so much. It is a picture that shows us the artist reflected in his subjects' eyes.

One always senses that the primary audience of Porter's paintings is Porter himself. By contrast, the contemporary works by Andy Warhol, Ellsworth Kelly, Donald Judd, Alex Katz, Jasper Johns, Philip Pearlstein, George Segal, and numerous other protagonists of the sixties are always directed toward a hypothetical viewer, a global eye. Like the commercial art they emulated, they addressed themselves to a mass audience.

Porter was isolated in the 1960s by virtue of his disinterest in creating an imagery of archetypes. This was now the divisive issue, not abstract vs. represen-

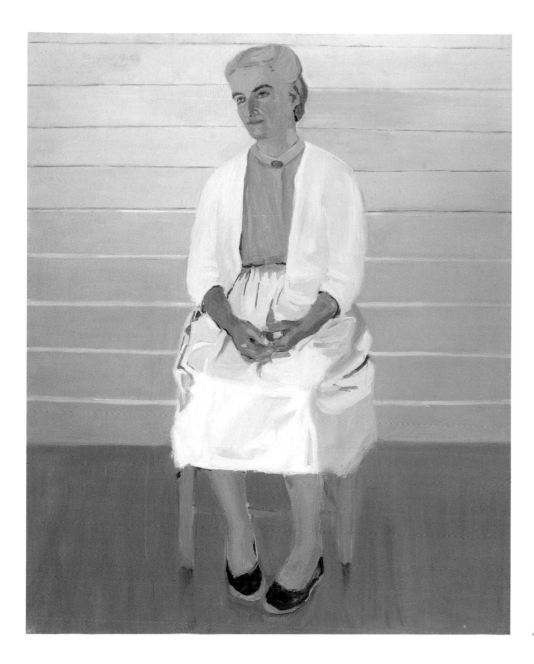

Anne. 1965

tational. Jasper Johns painted symbols; Kenneth Noland, targets; Kelly, the primary colors. Pearlstein depersonalized his models into bodies by omitting their heads. Katz's portraits represent individuals generalized into billboards. But Porter's subjects, as Schuyler said, remain always themselves.

The publicity fanfare that accompanied Porter's show in 1964 evidently attracted new clients to the Tibor de Nagy Gallery rolls. For the first time, the Statement of Payments Received that Porter was sent by the gallery ran to a second page. The most important pictures, such as *The Screen Porch* and *The Living Room,* now had prices close to $5,000, though neither of them was sold right away. Almost all the other pictures were sold at prices that brought Porter less than $1,000 each, after deduction of the gallery's commission. But there were sufficient sales to bring his total earnings to $11,000.

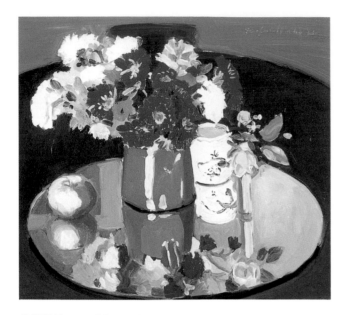

Still Life on a Mirror. 1966

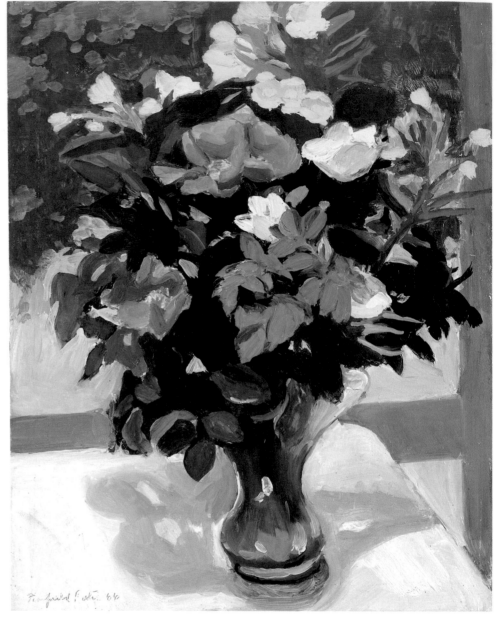

Rosa Rugosa. 1966

In June 1965 Porter was almost killed in an automobile accident. This was the third, and by far worst, crash that he had experienced, but he did not seem daunted by it when he wrote a few months later to Howard Griffin in England.

'65 was a good year for me—does that mean the worse is yet to come? On June 8, I ran into and was run into by a Long Island railroad train at Scuttlehole Road [Southampton]. The car was, as they say, completely demolished, though at the time it did not look at all so to me; though I was upside down, when I got out, which, as it seemed to me, I did simply by opening the door and stepping out. As I looked back at it, I thought that all it needed was to be righted and towed away and started again.

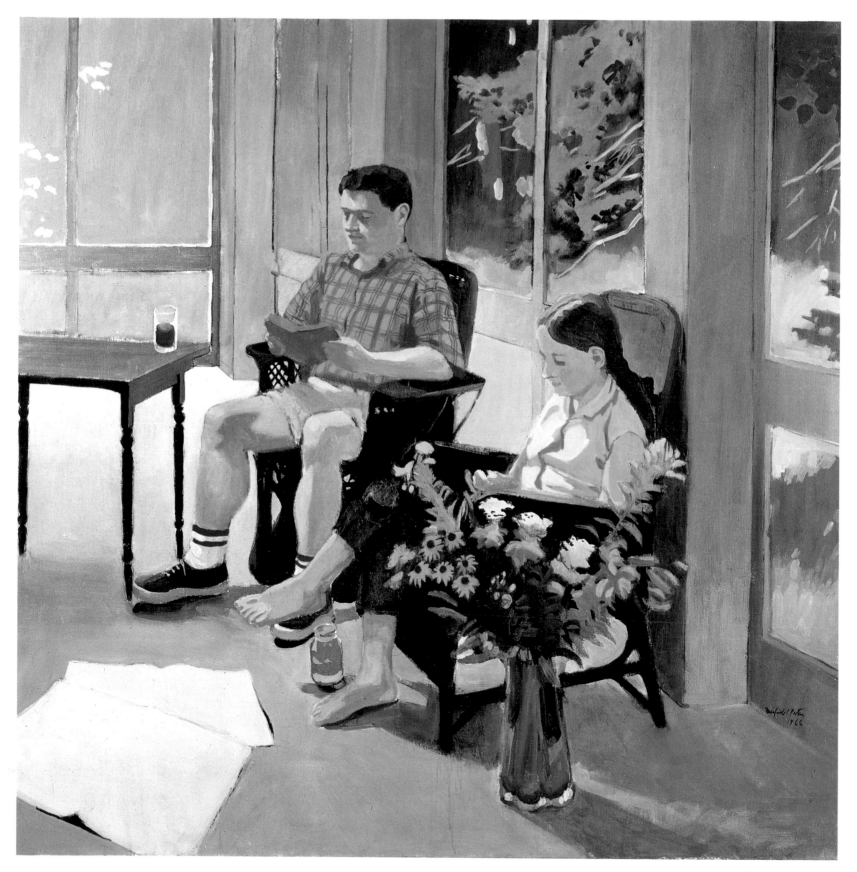

Iced Coffee. 1966

Early Morning. 1966

But the engine had sheared off the rear end. I saw that the train had stopped, so I thought I should show them that I was all right, which so alarmed the conductor or engineer or whoever, that he ran towards me and put me in a waiting car, whose driver, a woman, felt too sick, at the sight of me all bloodly [sic], to drive, and took me to the hospital. No bones were broken, I only sustained cuts and bruises, which required a few days in the hospital for the principal cut to heal enough so that I could bend my knee and go home.

Paul Georges, who visited me in the hospital the same day, told me that this was the most interesting thing I had ever done in my life—which I suppose is true.[62]

Compared to his personal survival, Porter's other good news pales, perhaps, but was nevertheless of great importance to him alive. The Cleveland Museum of

Art was to give him a one-man show in the spring of 1966 (it was eventually sched-
uled for August). Porter had had shows in university galleries, the latest being this
same year at Reed College in Portland, Oregon, but Cleveland would be his first
exhibition in a major museum. Another good tiding was the realization that his
following had increased to the point where the gallery was able to sell his pictures
throughout the year, and not just at the time of his shows. Collectors were begin-
ning to buy his older paintings from the gallery's stock, encouraged, no doubt,
because the prices on the older pictures had never been adjusted. During the
autumn of 1965, Paul Roebling, who had been collecting Porter for several years,
paid $1,500 for *October Interior*. In 1966 Porter's earnings from sales came to thirty
thousand dollars, which put him on decidedly firmer financial footing.

Porter worked on various writing assignments during the autumn of 1965. He
enjoyed the work, but regretted the commitment that it required. "[It] takes so
much time and energy to write, particularly criticism, and I should rather be
painting. My painting is bad enough to warrant constant practice. I am also teach-
ing this year, at Southampton College (which is only three years old) and this, too,
I think was a mistake . . . The students have no background and are such babies
that my job is rather like being a nurse. That is a waste of time too." His principal
writing project was to decide upon a final version of his treatise "Art and Knowl-
edge," which had been accepted for publication. "I have been working for almost
two years on a paper (not long) on aesthetic theory, I suppose, which I have been
giving as a lecture at colleges and now will be printed in a condensed and much
more coherent form in *Art News* in February. I no longer know whether it is good
or bad—I am tired of it."[63]

Porter was also agonizing over an article about Joseph Cornell, who was well
known for disliking everything written about him. This article, published in the
spring of 1966, is one of the most impressive examples of his critical style; every
sentence in it seems the distillation of a book, or perhaps a life—for example:
"Nineteenth century civilization, more than that of any previous century, was dom-
inated by the written word."[64] Cornell's uniqueness, his sources, his powers, his
meanings are beautifully evoked in Porter's review, which, incidentally, is no less
effective for not giving the impression of having come easily.

Cornell wrote a letter to Porter "to comment at long last, upon the fine piece
that you did in 'Art & Literature.' The passage about 'content having something
that has not been seen in works of visual art since the Renaissance' really had me
by the ears, and a vein that I have been hoping to work again . . . Please feel free to
come by any time and investigate over some tea and panetone. In deepest grati-
tude for your piece, and the magnificent tome of your brother's images."[65]

In January 1966 Porter did something that he had not done in years, or even in
memory: he bought a painting. He paid $1,500 to Tibor de Nagy Gallery for a 1965
oil by Jane Freilicher, the friend who had helped him get his start. Porter did not
accept the 10 percent discount to which gallery artists were entitled.[66]

By the time of Porter's next one-man show, 15 February to 5 March 1966,
Tibor de Nagy had moved to 29 West Fifty-seventh Street. "It doesn't have as good
exhibition space," he wrote to Laurence at Michigan State, "but it does have very

Forsythia Trees in Bud. 1966

Red Wheelbarrow. 1965. Ink, 12 x 18". Private collection

Columbus Day. 1966

much more storage space, so they won't constantly be sending paintings back here, and then demanding them again in a couple of weeks as they used to do."[67]

The gallery announcement of Porter's show now included four photographs of paintings, instead of one. Three of these had been done in Maine during the previous summer. The fourth was a still life, *Table at Night;* Porter liked the composition so much that he painted a second version of it, something he almost never did. *Morning Landscape,* 1965, was also reproduced; this was Porter's second effort with a large square canvas, 80 x 80".

"I have one very large [painting], the same size as the one last year that mother called 'the four ugly people' which has Lizzie sitting on the front porch in Maine with all the morning harbor view behind her, all in pink, cerulean, pale orange and grey. Lizzie is in scarlet. And on the left of her are pink and purple canterbury bells and foxglove planted the preceding year by Jimmy. The island was very, very dry and the grass turned the color of the rock. And the weather has been correspondingly good. I have to paint a lot more than usual because in May or June I am having a big show at the Cleveland Museum, so it is as though I were to have two exhibitions this year."[68]

Porter's 1966 show inspired a major review by Hilton Kramer in *The New York*

Bear Island. 1966

Towards Bear Island. 1966

Times on 20 February. This was the first extensive statement on Porter by the critic who over the years would prove to be his most influential advocate. The show was not reviewed, however, in *Time* or *Newsweek,* an omission that was more significant than anyone realized at the time. None of Porter's shows after 1964 received national attention, even as his paintings became stronger and more ambitious with every year. What had happened between 1964 and 1966? Although the return of figurative painting into critical fashion had momentarily buoyed him in the eyes of critics, it seems that his stylistic independence—he could not be categorized with any school—qualified him to those same critics as a major representative of a very small niche.

In his Joseph Cornell article Porter offered a persuasive explanation of why modern painters preferred to run in packs: "It is literary criticism that led to the development of schools in modern art. It is the economic pressure on scholarship exerted by the universities that leads to the naming of movements in the arts, and once a movement is named, it is justified by words, and the literature around it gives it critical validity."[69]

One scholar, Judith E. Stein, has recently observed that no major museums organized comprehensive exhibitions such as *The Figure* after 1962, noting that on the rare occasions afterward when "museums thought about the figure in relation to the New York School, it was solely in terms of the prototypes and embodiment of pop art."[70] The most extreme example of the phenomenon Stein describes was the exhibition *New York Painting and Sculpture: 1940–1970* that Henry Geldzahler organized in 1970 at the Metropolitan Museum of Art. Porter was not included, even though he had been one of the ten artists selected to represent the United States at the Venice Biennale in 1968.

In numerous reviews of Porter's gallery shows during his lifetime, and in a pivotal article, "Fairfield Porter: An American Classic," in *The New Criterion* in 1983, Hilton Kramer has never wavered in his belief in Porter's work. In 1966 Kramer compared Porter's independence to Giorgio Morandi's and aptly noted that Bonnard had long been viewed as "a latter-day Impressionist, a painter who had somehow not kept abreast of the most important new developments. This judgement now strikes us as ludicrous." In Porter's defense, he wrote:

> *If we really value such works, we must always be a little skeptical about historical categories that seem to exclude them . . . The pictures in Mr. Porter's latest exhibition include some of the best work the artist has ever produced. They are pictures that could only have been painted by an artist who had remained especially alert to the central artistic issues of his time, yet the pictures themselves exist at a considerable distance from those issues . . . They are accomplishments of mind and craft that only a very independent, very confident, and very capable artist could envision, and then bring to realization in the face of all the countervailing movements of the current scene.*[71]

Kramer could have added as well that it was in no way unlikely or inconsistent for Porter to admire Bonnard and Vuillard, both of whom were still working

View from Upstairs. 1966

when Porter came of age. In the end, the notion of quality outside of trendiness was too subtle for most critics, historians, and curators. For years Porter's name could not be found in any of the innumerable picture books and college textbooks that have been published about American painting of the twentieth century; only recently has this omission begun to be corrected.

There is no evidence that Porter rued or even noticed the shifting sands of his critical fortunes. His son Laurence remembers that he was proud that he was able to support his family from his earnings, which continued to be sufficient until the time of his death in 1975.[72]

In the spring of 1966 Porter painted *The Mirror,* one of the major pictures of his career. It is a portrait of his daughter Lizzie, sitting on a stool in Porter's Southampton studio. Porter himself appears large in the picture, reflected in a big,

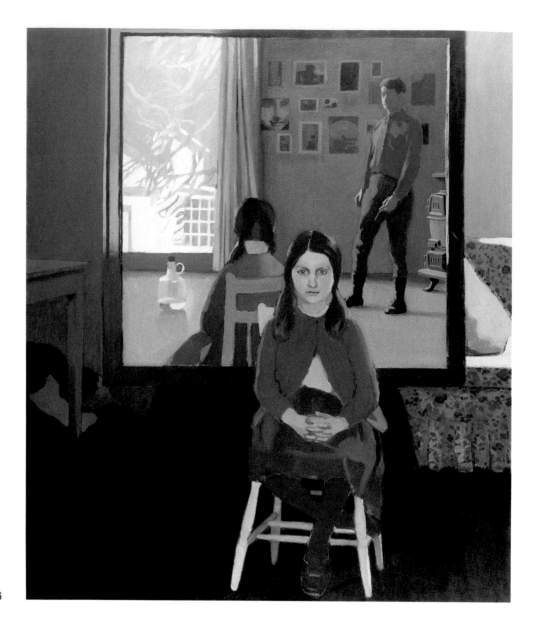

The Mirror. 1966

square mirror just behind her. An exciting painting from a visual standpoint—in addition to the figures, the mirror reflects the studio interior and a luminous window opposite—*The Mirror* is fascinating as well for the insights it offers into Porter's views of the creative process. The painting quotes liberally from *Las Meninas,* as all critics have observed. Even the vertical format is close to the proportions of Velázquez's masterpiece, which is not precisely square. Porter is the principal audience of *The Mirror* because he is the sole observer of the scene as he paints it. In painting, Liz poses good-naturedly and looks directly outward, at her father. If the great mirror leaning up behind her were real, not painted, it would logically reflect the viewer. The viewer who appears in it, of course, is Porter.

The Fairfield Porter exhibition at the Cleveland Museum of Art opened that summer and was on view for only a month, from 10 August to 11 September 1966.

Since Porter was on Great Spruce Head Island for most of this period, it seems doubtful that he ever saw his own exhibition. (The year before he had gone briefly to Cleveland in May to sit on the jury for the museum's annual invitational show of local painters.) The retrospective was hardly comprehensive, no doubt following his own wishes. Of the twenty paintings in the show, only six were earlier than 1960. The 1948 *Self-Portrait* was the only picture painted prior to his first show with the Tibor de Nagy Gallery in 1952. Although few people could have seen it, Porter's show at the Cleveland Museum must have been extremely impressive, since the selection included many major works: *Katie and Anne* (1955); *The Garden Road* (1962); *The Living Room* (1964); *Morning Landscape* (1965); and *The Mirror* (1966).

The title of the exhibition, "The Genre Art of Fairfield Porter," must have been suggested by Edward Henning, the curator, presumably with Porter's approval. Porter never actually discussed his own work as genre, and in fact landscape does not come under the term. The catalogue essay by Henning was evidently based on Kramer's essay in February, but defended Porter in terms that implied that his work was marginal. He was departing from a flawed premise, namely, that Bonnard and Vuillard had also missed the mainstream boat.

> *Bonnard's art lies outside the mainstreams of development of the late nineteenth and early twentieth centuries; so does Vuillard's; and so today does Fairfield Porter's. Such painters do not lead the art of their time in new directions. They demonstrate a regard for tradition and for the appearance of the world, yet they paint so well that they command the respect of all serious artists and critics.*[73]

Porter's surviving letters do not contain any reference to this retrospective; he probably did not afford it particular importance because it was not seen by anyone outside of Cleveland. In the summer of 1966 he took a break from painting until the middle of July, and then painted mostly smaller pictures, landscapes that were less strenuous, after a year of intensive painting for his shows. The weather was very hot and he was slightly troubled by arthritis in his knee.[74] The island was quieter than usual, because Katie had gone to Europe that summer with Laurence and Betsy Porter. While she was away, her parents received the news that she had been accepted to Manhattanville College, skipping her senior year in high school. In August they were visited by Kenneth and Janice Koch and their daughter Katherine, who was a good friend of Lizzie Porter.

Perhaps the travels of his children—Laurence went often to France—inspired Porter in an unexpected direction. He made up his mind to take the family to Europe the following summer, after a lapse of more than thirty years. For six months at least he calculated and adjusted their itinerary, making notes and lists, until it gradually dawned on him that there would never be enough time for all the places they wanted to see.

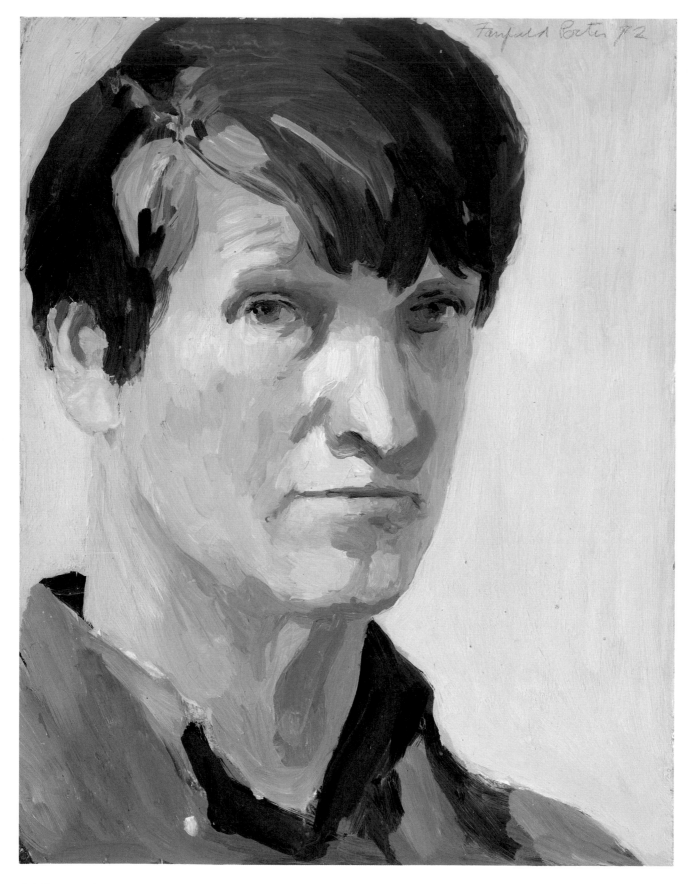

Self-Portrait. 1972

THE LAST YEARS | 1967–1975

Fairfield wanted to take Katie and Liz to Europe on a boat so they'd know how far it is. He thought that on a plane you never really get a sense of it.

 —Anne Porter, interview, Southampton, 1988

The idea of going to Europe brought back childhood memories for Porter. He wrote to Laurence, "I am looking forward to this trip with as much excitement as I did the very first time I went abroad with Uncle John and your grandparents when I was fourteen."[1] Before the end of December 1966, Porter had booked passage for Anne and himself, Katie and Liz, on the *Michelangelo,* to sail 5 June 1967 from New York for Naples. They were scheduled to come home on 12 August aboard the *France,* sailing from Southampton, England. Porter decided to leave some flexibility in their plans and not to make any hotel reservations except for the first few and last few nights of their trip.

The intervening six months of winter and spring 1967 were thus filled with anticipation. There were many prior commitments, of course. In mid February, Porter participated as one of the principal speakers in the 1967 Creative Arts Festival at Kent State University in Ohio. "The topic of the festival will be: The Arts Today: A Symptom of a Sick Society?" he told Laurence. "This stimulates me in opposition. I think that when people say this it means not that they are worried because of original sin, but that they do not like modern art at all—that they wish it looked like the art of some previous society, which because they like the art, they imagine to have been a well society. For instance, the Greeks, who practiced genocide against the other Greek states, if they had the power to get away with it."[2]

Porter's lecture at Kent State was still another version of his treatise, "Art and Knowledge." He also wrote a brief statement about his paintings for publication in the festival program. His views on interpretation were akin to those that he expressed in his 1968 interview with Paul Cummings.

I am not trying to interpret any slogan or phrase in my painting. The visual arts are non-verbal and direct; modern education is verbal and indirect...The experience of a painter while he is painting is about the nature of the paint—this is his most direct experience—all other things, like what he is looking at outside the painting, what he remembers, what he thinks about with the left-over part of his mind, all talking to himself,

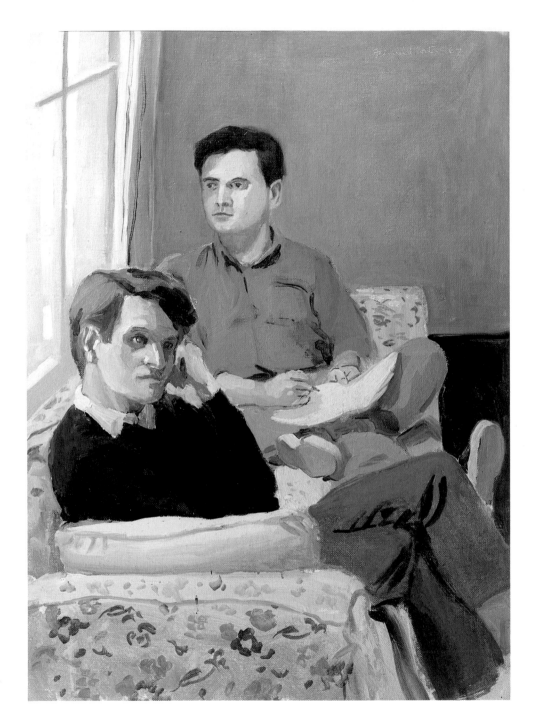

John Ashbery and James Schuyler Writing
"A Nest of Ninnies." 1967

*etc. and all translation of outside sensation, insofar as they have to do
with the painting, have to do with illusion. Therefore the realism of my
paintings is its illusory side. What illusions this evokes in the spectator is
mostly beyond my knowledge.*[3]

Porter acknowledged that it is impossible for us to know what "the left-over
part of his mind" was thinking while he was painting; by the same token, he could
not predict our response to his subjects. His views isolated him during the 1960s,
when most artists deliberately set out to predetermine their viewers' responses, or

at least to direct them onto specific tracks. Pop art trafficked in archetypes or symbols that elicited emotional responses as predictable in their way as the optical illusions in Op art. The Minimalists were fascinated by the sheer impersonality of geometry.

Porter's annual exhibition at the Tibor de Nagy Gallery, from February to March 1967, included twenty-nine paintings, many of them quite small. As always, the pictures were priced according to size. The show included two compositions on life-size square canvases: *Iced Coffee* and *Columbus Day,* both dated 1966.[4] The former was reminiscent of the "Four Ugly People" of two years earlier, save that only Jimmy Schuyler and Katie Porter were represented on the porch in Maine, posing for Porter and keeping him company at the same time. *Columbus Day,* a view of the Southampton garden, was the first and only painting in this square format that did not include any figures. *Iced Coffee* and *Columbus Day* were each priced at $9,900.

Schuyler again took the occasion to write a lengthy review of Porter's show for *Art News,* "Immediacy Is the Message." It is notable that he felt obliged to open his article with a fervent defense of Porter's work, as though his friend's reputation were under siege, which perhaps was true. He goes into detail regarding Porter's working methods and the genesis of individual works. Porter usually worked *alla prima,* directly on the canvas. Regarding one of the few exceptions, *Early Morning,* Schuyler notes, "Early Morning was perforce done from a drawing: it is an early morning view seen while lying in bed, an impractical position in which to paint."[5]

A month before their June departure for Naples, Porter found that the "excitement and anticipation" were making it hard for him to keep his mind on his work.[6] Naples was to be their home base for day excursions to Pompeii and the Amalfi Coast. After the quiet crossing on the ocean liner, Porter was unprepared for the hectic chaos of modern Naples. He took momentary refuge in a letter of 16 June to Schuyler. "Naples is as noisy as a subway station through which an express train is passing, and where the Con Ed is drilling. Our first day was exhausting and we got lost (not really, but we couldn't find our way out for a long time) . . . We took the trip in a hired car to Ravallo and Amalfi and [Liz] was in ecstasy over the orange trees, mossy trunks, paths, flowers, outlooks over the Mediterranean with antique statues; as we all were . . . I feel altogether a strange mixture of feelings, extremely moved by the beauty of a foreign city with three ladies to protect. Italian comes back to me rather fast . . . I think I wouldn't want to go to Naples again, but I can imagine living at say, Ravallo, for months and painting. The landscape is very Bonnard. Pompeii and Herculaneum were interesting; Pompeii beautiful for its setting, but we don't go so much for scavi as for the present beauty. I miss being able to paint and I hate the noise. I hope Rome is more humane . . . Tomorrow we go to Rome, and Edith [Schloss] will meet us there. Our second day we had lunch with a Duchessa cousin of Anne's, which we all liked except Lizzie who was bored . . . We plunge back and forth from ancient beauty to the present hellishness of traffic and smog."[7]

In Rome Porter had made reservations at the hotel where he had stayed with his mother forty years before, on his Grand Tour. Since it was out of the way, Edith

Orvieto. 1967

Schloss found them an apartment to rent for the second two weeks of June. Schloss had lived in Rome since separating from Rudy Burckhardt some years before. The Porters attended a papal blessing at the Vatican and saw all the sights, except the Sistine Chapel, which was unexpectedly closed. "None of us like Raphael much (as an oil painter) but do like his frescoes," Porter reported. "The ancient Romans seem to have been a very middle class lot—and scavi are not the most thrilling things to see. My Italian improves at a worm's pace—if I get plenty of sleep—but does not expand."[8]

From Rome, they went north to Orvieto, a place that Porter remembered fondly from his Berensonian wanderings with John Walker. By a string of coincidences that are now forgotten, an Italian television camera crew had somehow learned that an important American painter was visiting the town, and tracked him down, together with an interpreter. Porter agreed to be videotaped while he painted some small landscapes of the hilltop city. At the end of the segment, the crew asked Porter to pick a sprig of forsythia and to walk off into the distance, thus creating a sentimental effect that was, as Anne described it, "much more Italian than like Fairfield, it was so funny, but he did it with a sort of air of resignation."[9] The Orvieto views were the only paintings he made during this trip; he gave one of them to the nice young lady interpreter.

All the Porters fell in love with Florence, despite the heat wave, despite the tourists. Katie nearly fainted in the Medici tombs from the smothering atmosphere. The city had recovered far more than they had expected from the disastrous flood of the previous year. "We are on the Arno; it is quiet, a gentle buzz of traffic is all, and a view towards San Miniato al Monte (where we went yesterday),

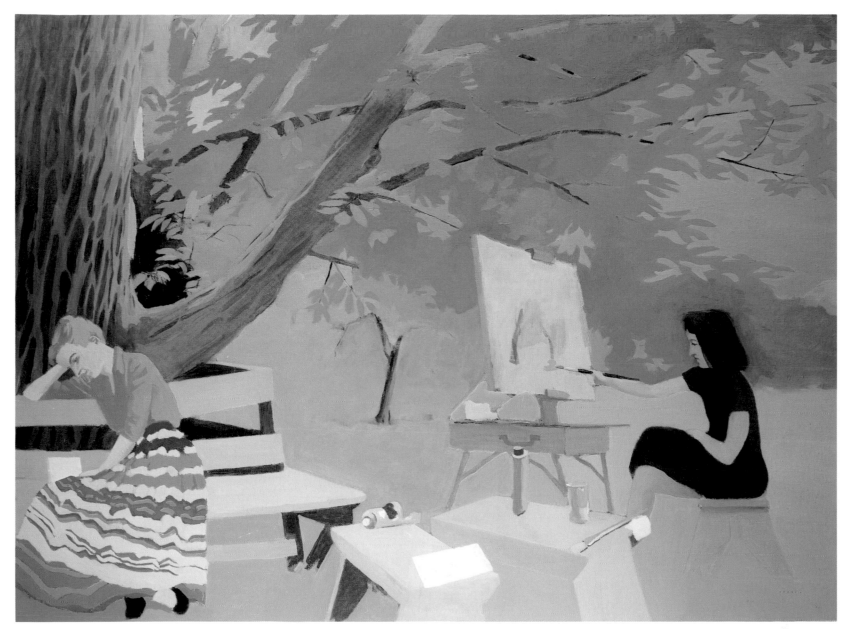

Nyack. 1966–67

which Anne and Katie preferred to all the churches in Rome."[10] They had again reserved rooms in a hotel in which Porter had stayed with his mother forty years before, overlooking a relatively quiet street along the Arno.

One sunny Sunday Edith Schloss called for them in her tiny Fiat and drove them all to the hills outside of Florence, to Rignano, where she was briefly visiting. At tea under the olives and fruit trees, the Porters sat overlooking the Arno, snaking and wandering below in the valley. "Why don't you paint *that?*" Fairfield said, itching to do it himself.[11]

By mid-July a month remained on their itinerary, including one week each in Venice, Paris, and London. Yet Porter found that the exertion and excitement of the journey were making him homesick. "I will be glad to get home and back to paint-

ing. But Italian art and architecture reduces all of the Avant Garde from Picasso on to a rather smallish bubble. Which does not in any way elevate the rear guard. There is no answer. If you know what I mean."[12]

From Paris, the Porters traveled to Wales to stay with Arthur and Judy Giardelli. The companionship and comforts of a private home were greatly welcome after so many different hotels. Porter enjoyed discussing art with Giardelli, although they were very different as artists. Encouraged by Giardelli, he added several modern-art galleries to his London rounds during the last week of the trip. From their hotel in Nottingham Road, Porter wrote a thank-you note to the Giardellis and reported on what he had seen. "At Marlborough I asked to see Adrian Stokes's paintings; they showed us two, which was all they had. They surprised me; they looked like modern art of the 30's; that is, I suppose, of my generation. [Giardelli's] panels were the strongest at Grosvenor [Gallery], and I was glad to see one slate picture, which are still my favorites. Gimpel Fils had a Collector's Choice show, with one Larry Rivers collage painting looking quite respectable, almost old-fashioned."[13]

Porter was more open about his lack of sympathy for British art in a letter to Schuyler. He was writing from Wells, where they had all gone for a respite from London and to see the cathedral that had so impressed Porter on his first trip abroad. "Modern English art is a little rear guard, somehow, except perhaps for Caro, whom I don't like, but he seems better than other sculptors, especially the American imitators. I saw some paintings by Adrian Stokes, which had a rather feeble English '30's look. I am beginning to grow frantic from so much consuming and no painting."[14]

Indeed, Porter took up his work immediately upon returning to Southampton. The picture he was working on, *Nyack*, was unusual in that he was not painting it from life, but rather based on an earlier painting, one from the early fifties, in fact. The Cleveland Museum of Art acquired the painting in 1968 and three years later Porter described its complicated evolution to the curator, Edward B. Henning.

Since you asked me to comment, I will go into the boring details. In 1954, in July, I think [it was actually in 1953], my wife and I visited Jane Freilicher and her husband Joe Hazan at a house they were renting for the summer at Nyack. On the weekend I sketched in pencil the scene of the painting Nyack. *Jane was painting, and Anne, my wife, was reading Ronald Firbank. The pencil sketch has more liveliness than the painting. It belongs to someone who lives on an island in Puget Sound, I have forgotten the name. In the winter after I made the sketch, I made a painting from the pencil sketch about one-quarter the size of your painting. I exhibited it that winter or fall at the Tibor de Nagy gallery. Later I became very dissatisfied with the painting, and put it away. Twelve years later I took it out and decided that it "had something" and I would like to make another version, and it also seemed to me that it would be better larger, and after a certain amount of thought, I hit on the size of the painting you have. It took me so long because I did it after a painting that itself was done from memory and twelve years previously. Part of the quality comes*

from the inevitable decision that if you don't remember something, you might as well make that area flat. What had dissatisfied me with the first painting was that it betrayed my memory of the flatness of the green of the ash tree leaves. The rest is almost all conceptual, reasoned, in a sense willed. There is something else in it, a memory of the yard of the first school I went to in Winnetka, Illinois, a private school run by a pleasant motherly woman with one assistant, that took children from the age of 5 to 9.[15]

To Arthur Giardelli, who had not seen the painting, Porter explained its subject as follows: "I have resumed painting on my largest painting, 7 x 9 feet, of Anne sitting reading at the left on a bench around a huge ash tree, and on the right Jane Freilicher painting, but not Anne, painting the ash trees."[16] Anne Porter remembers that she was "wilting in the summer heat," and her posture in the painting certainly suggests this.

In addition to its evocation of times and places in his life, the *Nyack* composition must have retained its interest over the years because it was based upon the motif of a painting within a painting. It is extremely helpful to have Porter's own explanation of the broad, flat areas of color in this work, since *Nyack* seems remarkably close to Alex Katz's representational style. Porter liked Katz's work, and it would not seem odd had he ever experimented with the flatness that Katz always used. In view of Porter's remarks, however, the resemblance to Katz's work must have resulted unintentionally from an analogous method of working, "conceptual, reasoned, in a sense willed." Porter did not comment, alas, on his decision to paint *Nyack* in mural-size dimensions and format, the only such example in his mature career.[17]

Porter had completed *Nyack* by 2 November 1967. "The large painting of Anne and Jane Freilicher is inconsistent, I am told, and I see that it is, but I like it. For me it works. I will have an exhibition in Chicago in March. I look forward to old family friends seeing it." Apart from *Nyack*, Porter painted very little in the autumn following his return from Europe. "I am slowed up by two months of not painting; it is a great relief to get back to it—or am I perhaps slowed up by such a large dose of masterpieces? Anyway, it doesn't bother me to be slowed up; I seem to find more to think of, to consider than ever before. At the same time I don't want to lose a sense of wholeness and become fussy."[18]

Porter wondered out loud what side effects, if any, his European "dose of masterpieces" would have upon his painting. In August, he noted, "It is too soon for me to know what I carry away from the paintings I saw. But the last ones that I would like to have learned something from are the Velázquez of *Don Carlos at the Riding School* and the *Boy Bringing Pomegranates* at the Wallace Collection."[19] But the ideas from his summer travels were clearer to him by early November: "The trip made me see all over again the qualities chiefly of light and color that I love here [Southampton] and in New York. Today I went into New York, just to draw in the streets. I should set up an easel in the streets. People probably wouldn't even notice, but I am lazy and cowardly."[20] Eventually, however, Porter did begin to work on a series of New York street scenes.

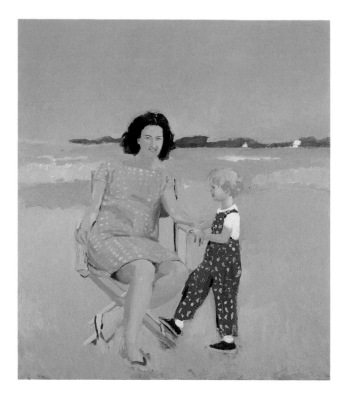

Jane and Elizabeth. 1967

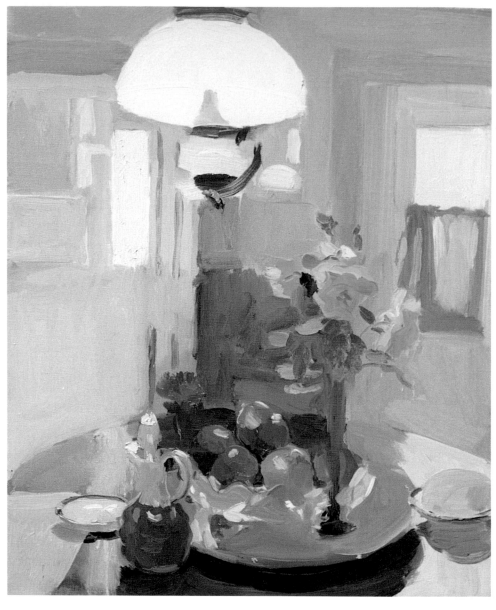

Apples and Roses. 1967

In November 1967, Fairfield and Anne acceded to Liz Porter's request for a dog; they drove to a kennel in Manorville, Long Island, to find a golden retriever puppy for her. Bruno became one of the favored subjects of the artist's last years. To begin with, though, the dog had to overcome Porter's disinclination to have a pet at all. As Anne describes it, "Fairfield didn't want him in the house. So we said, 'Oh, we'll have a pen; we won't have him in the house.' It took six months to build a pen, of course. In the meantime, the dog had to stay in the house, and then Liz grew up and went off to college at Georgetown. Fairfield ended up loving Bruno and Bruno loved him. He always went painting with him. He would lie on the grass and wait while Fairfield painted. They were very close."[21]

As in past years, Porter's annual show at Tibor de Nagy Gallery was scheduled for February and March 1968. Because he had gone to Europe instead of

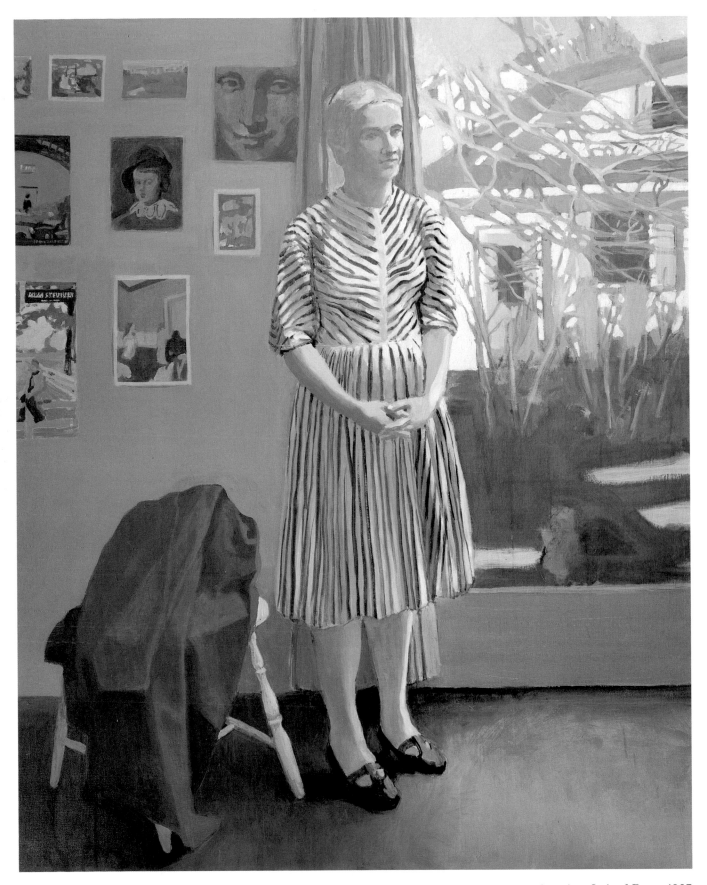

Anne in a Striped Dress. 1967

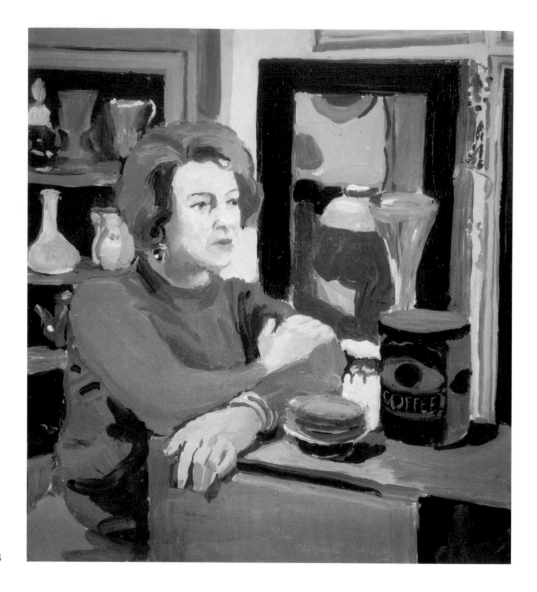

Inez MacWhinnie. 1968

Maine, he had painted far fewer pictures. He showed *Nyack,* which, at $12,000, was the major sale; it went to the Cleveland Museum of Art. An autumn interior, *Apples and Roses,* was more freely painted than usual and a notable success. The hanging lamp that seems inspired by one of Bonnard's prints had been a lucky find at a junk shop for $8.

Porter's conservationist instincts were deeply disturbed by the 1968 controversy over the construction of supersonic transport planes, which were considered by many to constitute a threat to the ozone layer of the atmosphere. He wrote letters to his congressional representative and to Senator Jacob Javits and Governor Nelson Rockefeller to apprise them of his views. In later life, Porter devoted much energy to conservationist causes, both by lending his name to action committees and by sending letters to government officials. He had early earned a local reputation for stubbornness about the environment, and had caused much inconvenience by standing in South Main Street to prevent the town from spraying his elm trees with DDT.

Cooper Square. 1968

Bruno, the golden retriever, unintentionally put a hitch in Porter's painting for the spring and some months afterward. One day in April 1968, while he was out running with Bruno on a leash, the dog suddenly swerved, and Porter fell and broke his left arm. He was hospitalized for a few days and had to wear a cast for several weeks.

Although the cast was already off in May, the elbow required daily therapy, the pain of which distracted him from his painting, even though he was right-handed. In the midst of preparations to go to Maine, Porter was visited on 6 June by Paul Cummings, who came to tape a lengthy interview with him for the Archives of American Art. This document constitutes a historical record of irreplaceable value.

The painting that summer on the island started slowly: the therapy for his arm still left him very tired. To straighten the elbow, he carried a gallon of paint with him everywhere he went. In July he reported on his non-progress to John MacWhinnie, a young painter in Southampton who had become a friend. "The raccoon trap that caught a tomcat is a parable of the way art comes out. I haven't really got into painting yet: only one painting that I like, the rest all skidding on old ice."[22] To Arthur Giardelli he wrote in August, "Otherwise the summer has been good. My brother Edward was here. There is a comfort and pleasure in all of my brothers and sister, and I have a fairly good relationship with my nieces and nephews." Kenneth Koch and his family also visited that summer, making particular use of the tennis court that was still intact fifty years after its construction by James Porter. Fairfield was reading a volume of short novels by Henry James.

Horsechestnut Tree. 1968

Self-Portrait. 1968

Schuyler was reading out loud to him a book by Marc Bloch, from which Porter took more ideas for his artistic theories.

"When I paint, I think that what would satisfy me is to express what Bonnard said Renoir told him: make everything more beautiful. This partly means that a painting should contain a mystery, but not for mystery's sake, a mystery that is essential to reality. I am reading *The Historian's Craft* by Marc Bloch, which is unfinished because of his death at the hands of the Nazis. He says in one place that . . . we in the West think knowledge is not enough without understanding. And to me it seems that understanding, or one's desire for it, inhibits one's knowledge."[25] By "understanding" Porter meant a conclusion reached to the exclusion of other

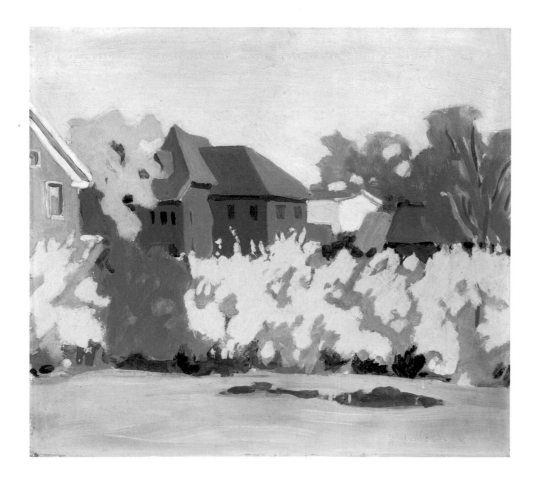

Untitled [View outside the Southampton studio]. 1968

possibilities. Single-mindedness was one of the principal faults of technological thinking, in his view.

By the third week in August, the summer's painting still had not truly taken off, and Porter's spirits were definitely low. "My painting was going depressingly badly . . . My large paintings are bland and dull. But now my little paintings at least improve. I think I was also tired of landscape. Why make it? Who cares? In a short time we will be back in Southampton. It is more beautiful *here*, in fact this is one of the beauty spots of the world. But that too, puts me off. Why reproduce this, when what matters, if it does, is just to look. How does this beauty connect with everything else? I do not imagine that ugliness is more significant, as some puritanical artists seem to believe, but I seem to have lost a certain energy or will."[24]

None of Porter's letters from this summer make mention of his inclusion in "The Figurative Tradition in Recent American Art," a strange exhibition that the United States sent to the thirty-fourth Venice Biennale, from June to October.[25] The criteria for selection were not at all clear, encompassing Leonard Baskin, Byron Burford, Robert Cremean, Richard Diebenkorn, Frank Gallo, Red Grooms, James McGarrell, Reuben Nakian, Porter, and virtually a retrospective of works by Edwin Dickinson. Most Pop artists were excluded, yet Red Grooms's raucus construction, *City of Chicago,* ended up stealing the show.

To make up for his unproductive summer, Porter painted more actively in Southampton that fall, in order to have enough good pictures for his annual show,

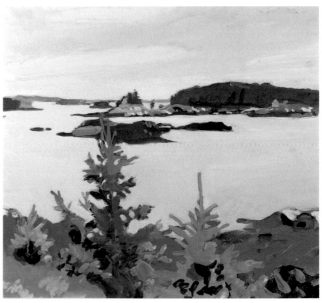

Bear Island. 1968

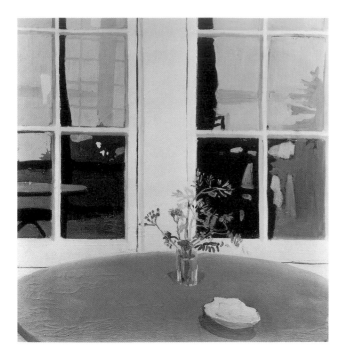

Grey Still Life. 1969

scheduled for January 1969. He painted some landscapes in the neighborhood around 49 South Main Street that are among his best Southampton landscapes. His *Horsechestnut Tree,* for example, is painted with unusual delicacy, like a postwar Constable or Corot.

Grace Glueck interviewed Porter for an article in *The New York Times* in conjunction with his new show at Tibor de Nagy. Glueck's column was not intentionally malicious, but did him no good either, treating him like a curiosity.

> *There they are* again *at the Tibor de Nagy Gallery (not exactly known as a hotbed of gentility). Idyllic, sun-kissed landscapes, drenched in green. Cozy living rooms with children perusing blocks. Homey kitchen tables bearing breakfast remains. Neither abstract nor representational [?], but existing in a light-struck zone between these beautiful, well-mannered, WASP-y records of domestic felicity make up the umpteenth one-man show of—who else but the card-carrying realist beloved by the avant garde, Fairfield Porter!*[26]

Porter's reaction to Glueck's profile is not recorded, but may be imagined. Three weeks later, Hilton Kramer reviewed the show a second time for *The New York Times,* with a thoughtful analysis of the paintings. Kramer placed Porter within a historical context, using a terminology that seems apt, an "art of conservation."

> *This art of conservation—as I prefer to call it—stands in relation to the more radical modes of artistic expression very much as our parks and gardens and surviving areas of unmolested countryside stand in relation to our overdeveloped urban centers . . . We seek in them a renewal of spirit that stands aloof from the very concept of dynamism—a spirit that nourishes itself on nuances of feeling which are, if anything, the very obverse of dynamic change and disruption . . . Of the painters who may be said to practice this art of conservation at the present moment, one of the most satisfying is Fairfield Porter . . . There is a French texture to this painting, but an American light—which converts the texture into something removed from its historical sources and makes it more responsive to the artist's own sensibility.*[27]

Porter's sensitivity to light was the mainstay of his pictorialism, as Kramer rightly emphasized. Among the comments quoted by Glueck was Porter's observation that he loved the light in New York City, which was for him, "far more beautiful than Paris or Rome." He told Glueck that he was currently working on a painting problem he found very hard, "a portrait of a Manhattan street."

"Secure in his Southampton fastness, he is busy these days preparing for a teaching stint at Queens College." This was Glueck's rosy description of Porter's main distraction in early 1969. He still felt that his uncertain finances needed the guaranteed stipends, however modest, of temporary teaching posts. He typically expended disproportionate amounts of time and energy in his preparations. Hired to teach a survey course to undergraduates at Queens College, he set out to analyze the philosophical underpinnings of contemporary art. Most of the readings on the course curriculum were philosophical, not art-historical.

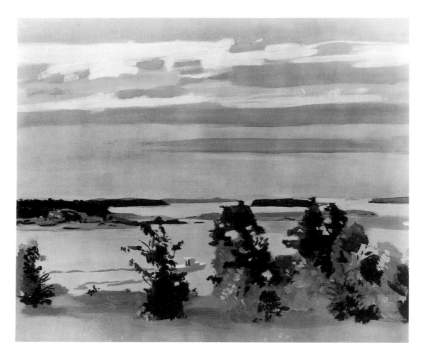

Lobster Boat. 1969

Hazel Avenue. 1969

Amherst '69. 1969

Amherst Parking Lot, No. 1. 1969

"I have started teaching at Queens College, a course that meets Thursday and Friday called 'Art since 1945.' I am desperately unprepared. I do not intend to list artists and discuss them individually, but instead be general: talk about what started the artistic explosion in New York, and afterwards elsewhere, and what it means, and what art is now, and has been, and why people are interested etc. I feel like Scherezade, that I must never end at the end of an hour, for fear that I might not be able to go on (have more to say in the) next week . . . It seems to me that if I have any idea, I could say it all in four hours, and that's all."[28]

Either Porter did not preserve his lectures or they have not as yet been identi-

Amherst Campus, No. 1. 1969

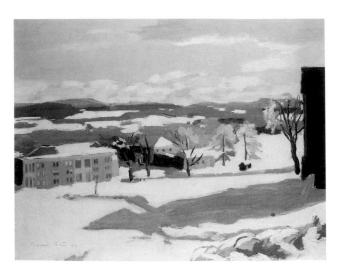

Clearing Weather. 1969

fied among his papers. It is a pity that he did not collect them for publication. (In fact, he had remarked to Glueck that he hoped someday to publish his collected criticism.) In February 1969, at the beginning of his term at Queens, he was offered and accepted a one-year visiting lectureship at Amherst College, beginning in September.

On Sunday, 12 February, Fairfield and Anne Porter set out to drive to Amherst, Massachusetts, but were trapped instead in a monstrous snowstorm that he described to Laurence Porter one week later: "Mother and I started to drive up to see a house to live in but got no farther than Bridgeport, because the road had almost disappeared in a blizzard white-out. We spent forty hours in a Howard Johnson motel, reading "A Nest of Ninnies" and watching TV. There was no food Sunday night, except what could be got from slot machines. But Monday we walked to a near-by delicatessen where there were pears and milk. Tuesday we came home by train, which in New York was just as about as adventurous as driving would have been." To Lucien Day he commented, "The Penn Station in New York was a warlike scene, crowded with refugees eager to be evacuated."[29]

Porter was invited to lecture at the University of Nebraska in early April; the "Figurative Tradition" exhibition that had been organized for the Venice Biennale was on temporary view there in the Sheldon Memorial Art Gallery. He took the opportunity to visit Laurence in East Lansing. "I had a very good time in Nebraska, which is like a foreign country. They don't make comparisons between themselves and either the East or West and seem secure in themselves."[30]

On the island that summer Porter started to work on a portrait of Laurence (in Laurence's absence), which he "spoiled" and could not bring "back to life," so he burnt it in the incinerator. He was fearless about discarding unsuccessful pictures. Kenneth Koch remembers seeing him once putting the last touches on a very big canvas. "That's a good one," Koch told Porter. "I'm going to burn it," Porter replied.[31]

Despite the hiatus of a teaching stint at Skowhegan, from 1 to 17 August, the painting season of 1969 was one of Porter's best. In September he noted, "I have from the summer four large pictures, two medium size and eight little ones. I hope to have more later."[32] Two of the large pictures were major successes: *Island Farmhouse* and *Interior with a Dress Pattern*.[33] As Hilton Kramer noted about these two pictures in *The New York Times* the following April, "They are very different in design, in the light they render, and in the emotions they evoke. There is a more knowing grasp of the problems of color in 'Island Farmhouse' than you will find in many pictures by artists who specialize in such problems and know nothing else. Both pictures are real triumphs."

At summer's end Fairfield, Anne, and Lizzie drove directly from Maine to Amherst, Massachusetts. They immediately liked everything about the town, the junior high school, and the college. "It is nice to be in a place where it isn't eccentric to paint. My students' work is often stimulating also," he wrote to Lucien Day, adding, "Your last letter reinforces my already firm commitment not to read Susan Sonntag [*sic*]." He was painting a view out of a fire door in one of the classroom buildings on the campus. "It has autumn mountains in the distance, but the leaves

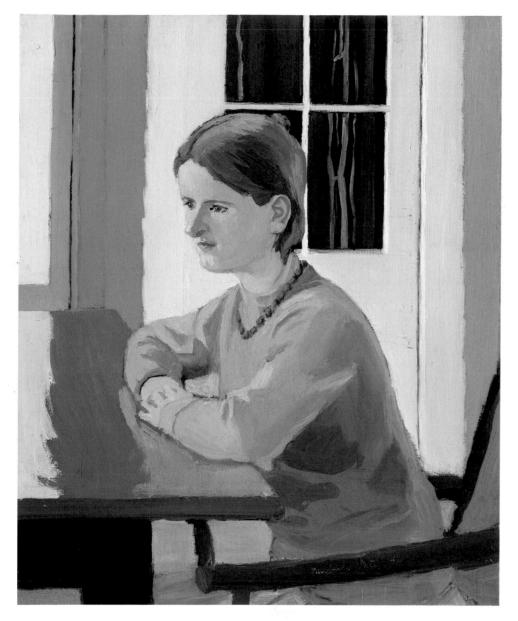

Katie. 1969

Wild Apples. 1969

have mostly fallen off. The painting gets grimmer and grimmer. Maybe I should start over on a new canvas. Some of the students watch with mild & decorous interest."[34]

Porter's year at Amherst College was one of the happiest and most productive periods of his life. Accustomed to his circle of friends and the semi-isolation of Southampton, he delighted in the informal, intellectual give-and-take of campus life. "The kids here are serious and intelligent and/or talented . . . I do paint here—in fact I am supposed to be a living demonstration of a painter, and I am enough of an exhibitionist not to mind this at all. I also very much enjoy the faculty society."[35] Porter was friendly with Benjamin De Mott in the English department. Through De Mott, he met Arnold Collery, an economics professor, who jokingly "tricked"

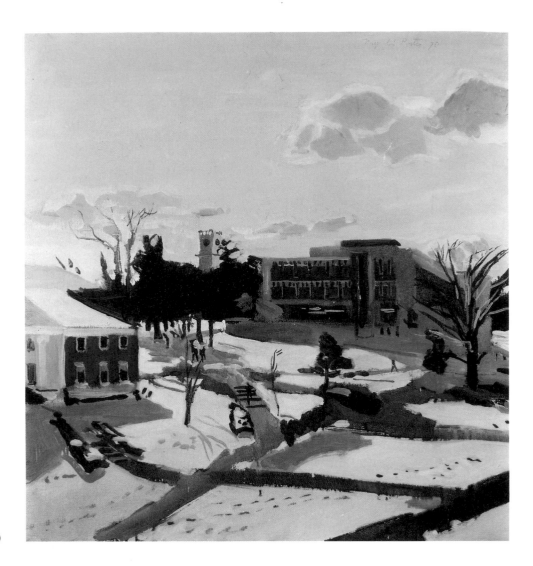

The Campus. 1970

Porter into painting his portrait for free, by offering himself as a model in exchange for the canvas.

Porter mostly painted landscapes at Amherst and nearly every painting that he made turned out well; there is an equilibrium to the brushwork and a deep-soaked resonance to the colors of this series. He enjoyed the rural and mountainous countryside, but the views that he chose to paint invariably give prominence to campus architecture and other motifs. He somehow managed to make paintings that juxtapose a forested mountain to a campus parking lot. The colors of the parked cars are as deep and as beautiful as the autumn foliage.

"The art students are in the former Physics building [called Fayerweather], along with Deans and administrators of Hampshire College, which will open to students next year . . . I have 25 students who mostly paint, according to when they can, two afternoons a week, but 10 of them have separate or semi-separate studios which I go to visit, which I like best, because they might almost be colleagues. I have an office (-studio) and I try to paint there, with some success, in spite of stu-

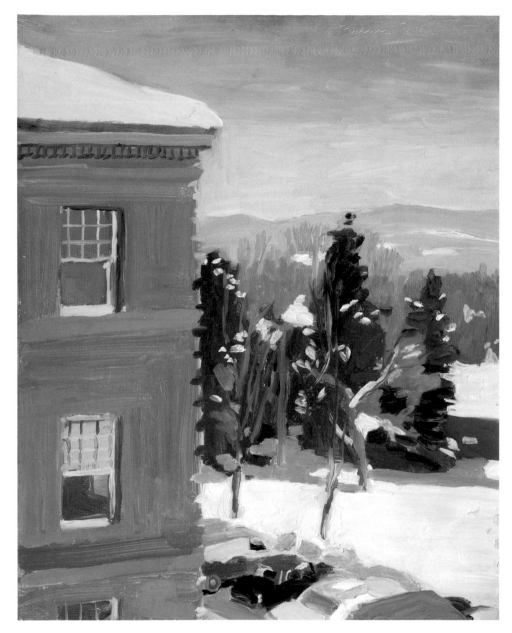

View from Fayerweather Hall. 1970

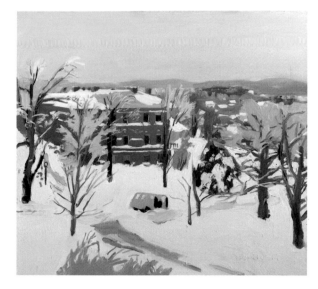

Ice Storm. 1969

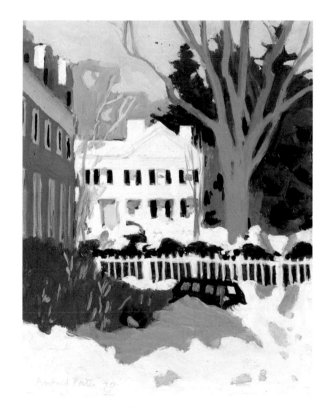

Oreton Clark House, Amherst College. 1970

dent interruptions, which might be any time. I find this much teaching exhausting . . . What I like is the ghetto of academic life, something quite new to me, after the isolation of Southampton."[36] Porter maintained ties with several of his Amherst students afterward; among them was the painter Ted Leigh, who is currently editing Porter's letters for publication.

Soon after his arrival in the fall, Porter had been asked to arrange a winter exhibition of his work. By early February, when he hung the show at the college, he had "twenty-five new paintings of which ten are really tops, the other fifteen doubtful,"[37] but as usual his opinion of himself was too severe. De Mott had bought a still life called *The Window,* which Porter considered one of his best and hoped to

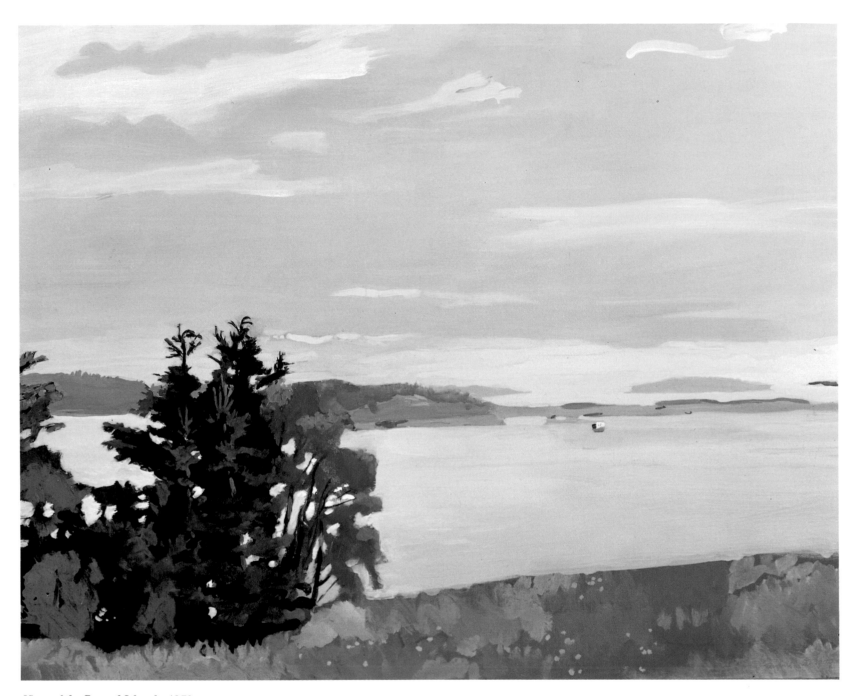

View of the Barred Islands. 1970

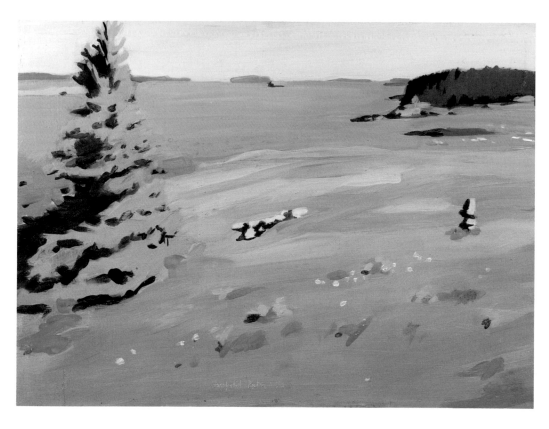

South Meadow. 1970

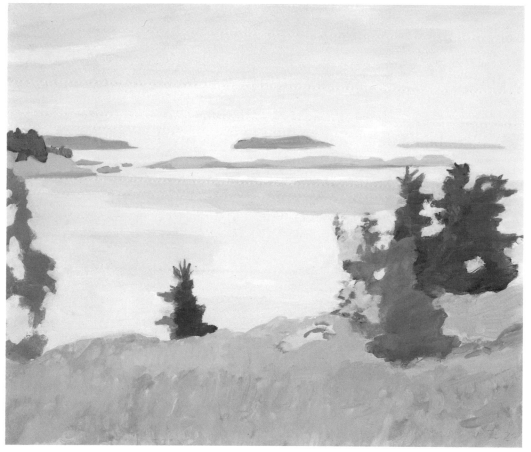

Primroses. c. 1970

South Meadow, Afternoon. 1970

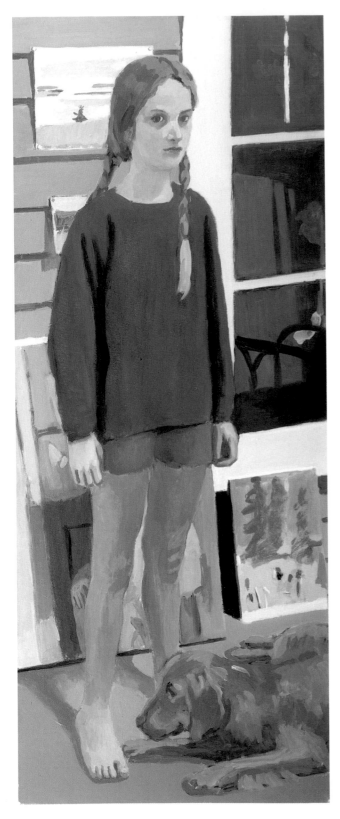

Lizzie and Bruno. 1970

be able to borrow for his next Tibor de Nagy show in April.

In the spring semester of 1970 Porter's class had grown from twenty-six students to forty-six. "Though I have more students than last semester, it is easier: I am getting used to it." Porter, who had his own perspective on political action, did not mind taking a conservative's stand against the disruptions caused by the protest actions of campus radicals. He mentioned this to Laurence. "We had a black student take-over of four buildings . . . The faculty voted its disapproval of the take-over, its sympathy with the concerns of the blacks . . . the radical students were extremely rude, arrogant, and unreasonable."[38]

A few months later, as the protest movement became nationwide, Porter commented to the poet Carl Morse, "Things are getting rather much here, by which I mean that I am for the strike's motives, but I don't go much for mass meetings, etc., which remind me of the worst aspects of radical actions in the '30's. A lot of rhetoric. For some reason art department students are in my limited experience somewhat more skeptical and a-political, which is nice. When I told my class that a strike usually meant producers stop making something or some service, and that students are not producing anything anyone wants, they laughed."[39]

Porter's April 1970 show at Tibor de Nagy Gallery included both his latest Amherst paintings and important works from the previous summer, especially *Island Farmhouse* and *Interior with a Dress Pattern,* the two works that Kramer had cited in his *Times* review. Rackstraw Downes wrote Porter a letter with praises for this show. Porter replied to Downes, asking, "Did you like the large interior, I wonder. It meant a lot to me, it has so many associations for me, particularly with my father, who was the architect of the house, and the room remains full of his personality. And I was thinking of a De Hooch in the Wallace Collection when I painted it."[40]

The 1970 show was an important one, and it was also the last he staged with his original gallery. The partnership between John Bernard Myers and Tibor de Nagy was breaking up. Rather than choose between Myers and de Nagy, both of whom had stuck with him through many slow years, Porter decided that the proper thing for him to do was to go elsewhere. He therefore accepted an offer to join Knoedler and Co., one of the largest and oldest American dealers.[41]

The contemporary-art department at Knoedler was directed by Donald Droll, who had been a friend for several years. The arrangement between the artist and dealer was set out in a letter from Droll, dated 10 June 1970. Although Knoedler would take a higher percentage of the sale price, they also agreed to relieve Porter of many time-consuming tasks and responsibilities, such as photography, publicity, and transportation. In addition, Knoedler would only take a 15 percent commission on portrait commissions that Porter received directly, whereas Porter had faithfully remitted to Tibor de Nagy a one-third commission on every sale he made, without exception. Many years later, Tibor de Nagy said of Porter's business dealings, "He was the most honest man I ever met."[42]

In June 1970, Tibor de Nagy Gallery compiled a list of its stock of Porter paintings, which were now to be delivered to Knoedler. Some unexpectedly early works were included in the group, such as a street view, *First Avenue,* from 1947, and two small sketches of Anne and Katie from 1949. The most interesting picture from the

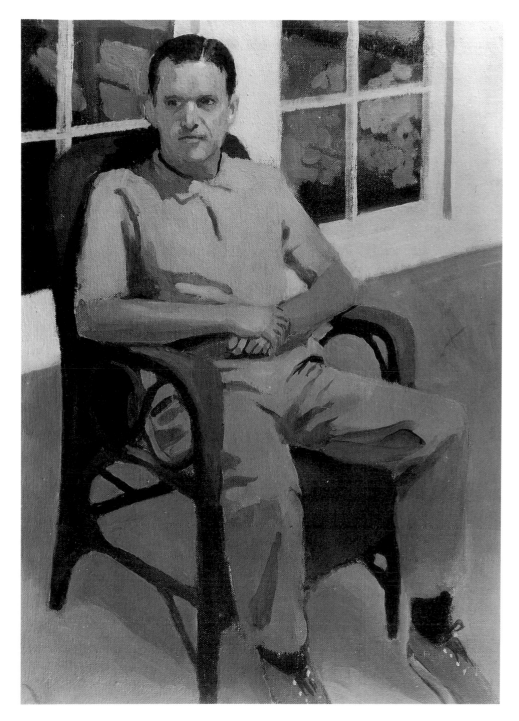

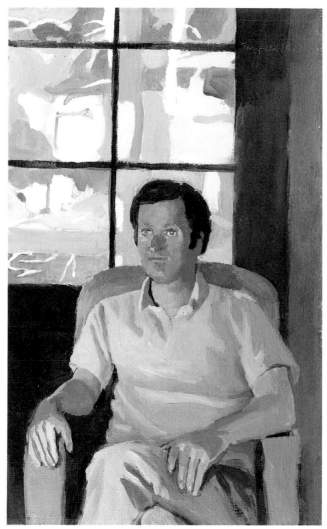

John Ashbery. 1970

Edward Porter. 1970

fifties was a 1951 portrait of Larry Rivers. The inventory listed a number of major canvases that had never sold: *Elaine de Kooning* (1957); *A Day Indoors* (1962); *A Short Walk* (1963); *Iced Coffee* (1966); *Anne in a Striped Dress* (1967). *Island Farmhouse* (1969) was also still available.

Before going to the island that summer, Porter went to Baltimore to give the commencement address at the Maryland Institute of Art and to receive an honorary degree. He spoke to the students about portraiture, a topic that was on his

Sketch for *July*. 1970. Ink, 11 x 14". Hirschl & Adler
Modern, New York

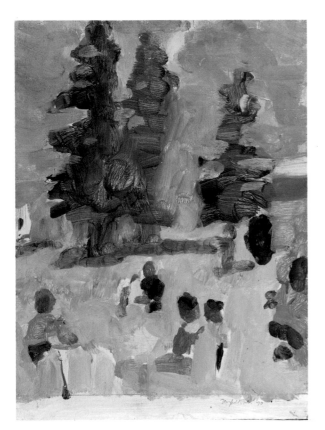

Sketch for *July*. 1970

mind because he had been asked to contribute an essay, "The Art in Portraiture,"
to the *Art News Annual* for 1970.

By the end of June the family had arrived at Great Spruce Head Island, and
Porter was already working on a portrait of the young caretaker and his wife.
Everyone was sorry that Amherst was now behind them, Liz especially, because
she had made a good friend in her school. Porter had discovered that he also liked
"academic life from the inside; to be more concrete, I liked having lunch with the
faculty."[43] At more than one of these daily lunches with the Amherst faculty,
Porter's views on ecology and his opposition to nuclear power had led to impas-
sioned arguments with members of the science department. But he had always
found some supporters, too.

The good form of his Amherst year carried over into the Maine paintings of
1970. An upright portrait, *Lizzie and Bruno,* makes it seem easy to paint a canvas
shaped like a narrow box. The whole composition is an undisguised play of verti-
cals and horizontals, without contrivance. Liz and Bruno form a kind of "L" in
front of a typical background of paintings and windows. On the floor of the porch,
one can see a sketch for Porter's most ambitious painting of the summer, titled
simply *July*.

This painting represents a familiar sight on the island: Porter's brother-in-law
and his sister, Michael and Nancy Straus, are seated with visitors in Adirondack
chairs on the grassy slope in front of their house. This July foursome was special to
Porter; the visiting couple were Porter's brother Edward and his wife, Audrey. The

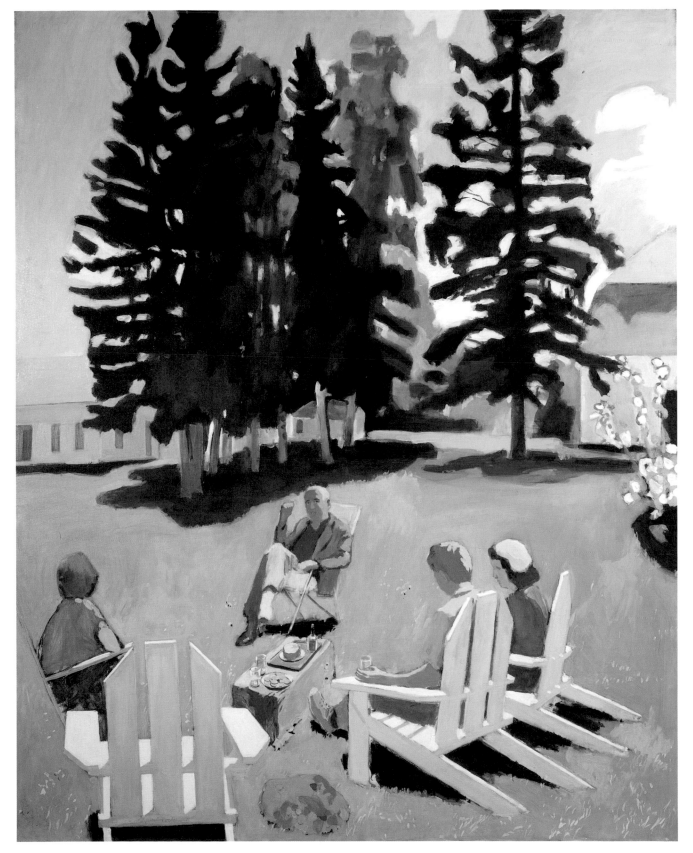

July. 1971

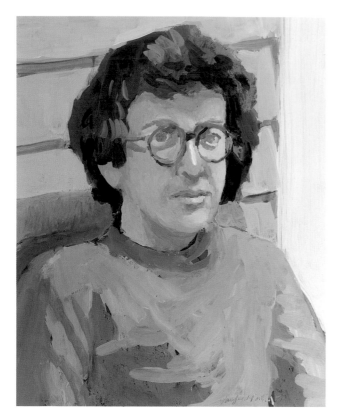

Portrait of Kenneth Koch. 1970

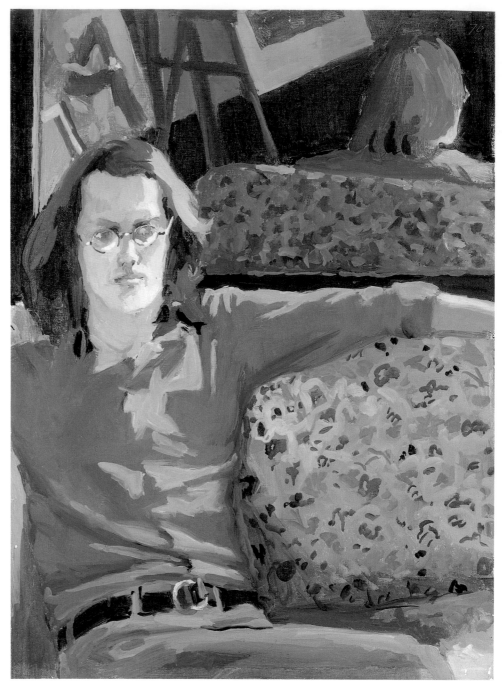

Ron Padgett. 1970

painting is as serene as the setting, though *July* became unexpectedly elegiac, when Michael Straus died that same summer.

The Porters were still on Great Spruce Head on the first of September, when Porter wrote about these events to Laurence. "I also painted a picture of four people on the lawn in front of the Strauses, which I started before Uncle Mike died (did you hear? of a heart attack on the mainland where he and Nancy had gone for a few days visit). It has Mike, Nancy, Edward and Audrey. Though not meant as a group portrait, Mike and Audrey look like themselves. It has the tall spruces

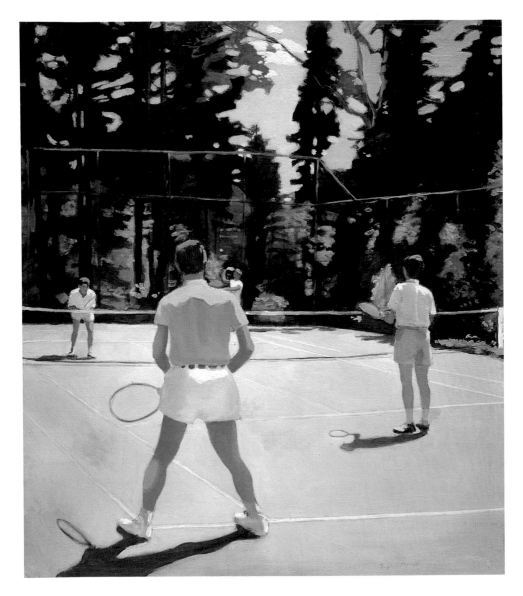

The Tennis Game. 1970

The Tennis Game. 1972

between the farmhouse and the barn behind them, and towering cumulous clouds behind the trees. I do not know if it is a good painting, but some people like it. I did it mostly from sketches. Now I have stopped painting, in order to get ready to leave."[44]

Another of Porter's projects over that summer was to "practice" his portraiture. He continued to hope that he could supplement his earnings with portrait commissions. John Ashbery and Kenneth Koch had visited the island and he had painted portraits of each of them. During the following autumn, Porter realized that he had a series-in-the-making of portraits of New York poets: Ashbery, Koch, and Schuyler.

The Gotham Book Mart on West Forty-seventh Street, a haunt of poets, responded to the idea of an exhibition of "Literary Portraits" for December. Porter added a portrait of the poet Ron Padgett, which, though small, turned out to be one of the best of the group. With loans of earlier works, such as the 1957 portrait of

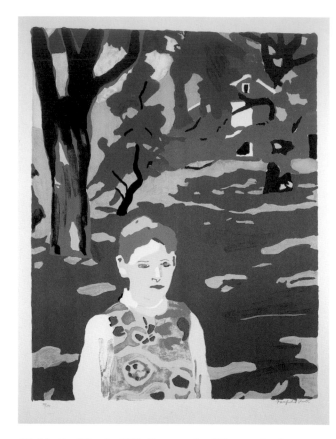

Girl in the Woods. 1971. Seven-color lithograph, sheet size: 32¼ x 24½"; image size: 28½ x 22¼". Private collection

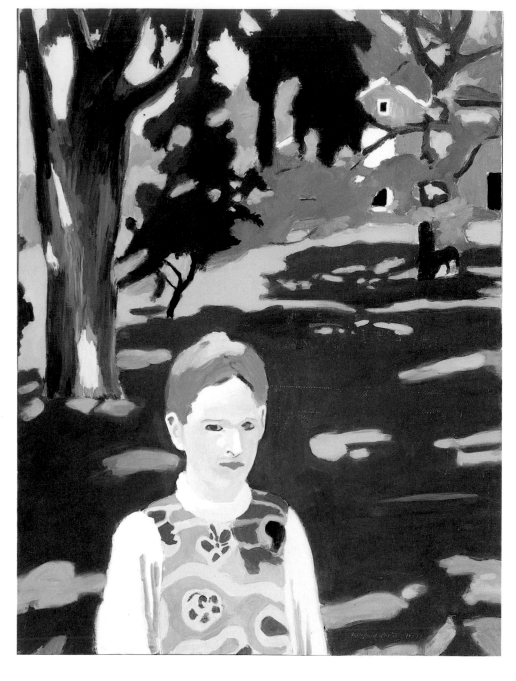

Under the Elms. 1971–72

Frank O'Hara in the studio and an early Ashbery portrait from the same year, the final number of paintings was brought to eleven. Except for Padgett's, none of the portraits had been executed with the intention of being exhibited together, and the variations within the group were more noticeable than any cohesiveness of theme. Hilton Kramer made this point in his review for *The New York Times* (9 January 1971):

> *Several of the pictures are deft but unambitious performances. A few are charged with something of Mr. Porter's real powers as a painter—particularly the portrait of Mr. Padgett in a lavender shirt, and the recent*

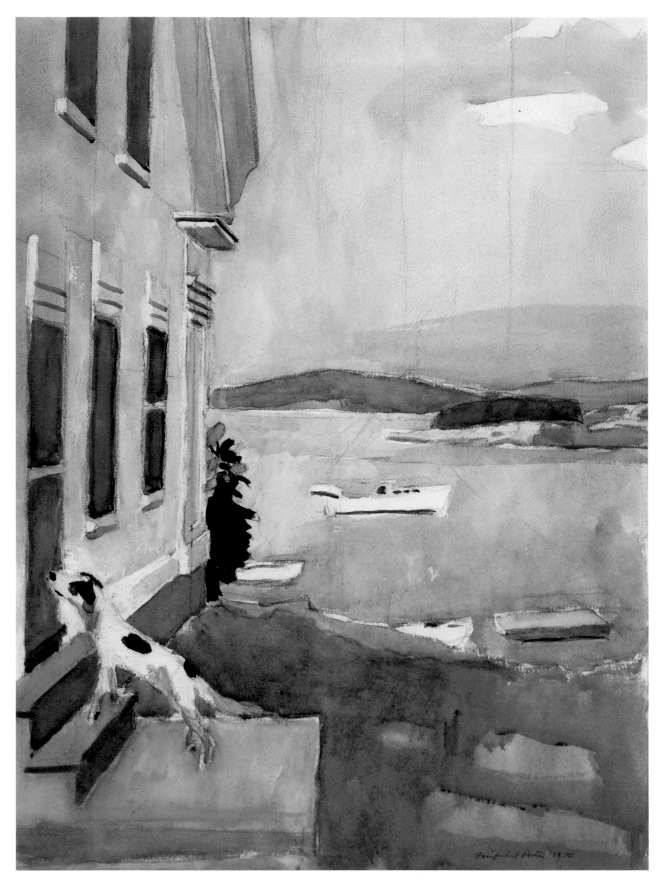

Dog at the Door. 1970

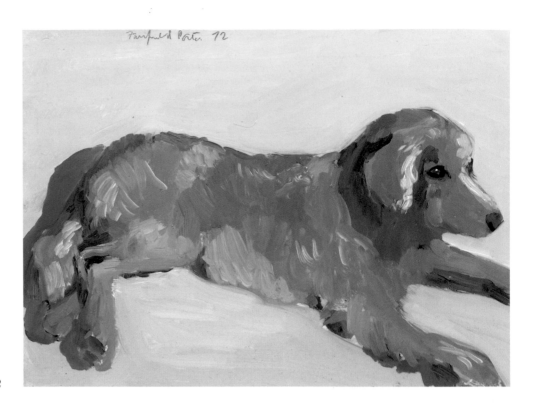

Red Puppy. 1972

Golden Retriever. 1972

portrait of Mr. Ashbery seated in front of a window. Mr. Porter is always at his best where the design of his pictures calls for complicated effects of light and these are not always to be found in some of the more routine work here.

John Ashbery wrote a review of "Literary Portraits" for *Art News* that adroitly balanced informative commentary with his insider's perspective on the undertaking. He praised the "undramatic intensity" of the portrayals. His comment that some of the paintings were more like "parts of pictures rather than portraits" is another way of saying that Porter's best pictures integrate portraits into a setting.

Porter was disappointed when none of the paintings in the Gotham show were sold, because he was not certain when he could count on having his first show at Knoedler. Part of the delay at Knoedler had been due to the arrival of a new director, Xavier Fourcade, who needed some time to settle in before drawing up a schedule of exhibitions. In the meantime Porter was very pleased with the gallery because Fourcade had agreed to pay his expenses at the Bank Street Atelier, a fine-art lithography workshop.

Porter had worked in various print mediums at different times in the course of his career, but he never seriously took up graphic art as an independent artistic expression until the winter of 1970–71. In all, he made twelve lithographs during the last four years of his life; the challenges that the unfamiliar medium posed and the successes that he enjoyed with it constitute one of the central aspects of his late career.

The original plan was for Porter to make five lithographs at Bank Street. The first four were finished by March 1971, after months of travel to and from New York two or three times a week.[45] Although afterward he often felt exhausted, he very much enjoyed working at the atelier. The printers, most of whom were French, genuinely liked him, and the rapport was deepened by his efforts to speak in French with them. Around March Porter wrote to Steve Porter, Eliot's son and an accomplished sculptor in his own right, saying that he was making sketches for a lithograph of a New York landscape.

Porter's fifth lithograph was finished by May. By this point he had become involved in creative improvisations in the printing process. "It was a view looking up Sixth Avenue from Bleeker Street at noon. I finally made two versions, one with the sky at the bottom purplish, and one with it gray green, fading into blue. The first was most popular with everyone, but as I couldn't make up my mind, I printed a small edition of each."[46] Later he commented, "The printers at the Bank Street Atelier like it, I think, best of all my lithographs; and several workers there to whom I need not give copies asked for one. They all but one chose the purple sky version. The one was Chip, the Hippy young man whose job at the Atelier is to cut the prints, inspect them, and edit out the imperfect ones. He said the green sky version was a 'sleeper.'"[47]

Porter went to Maine at the end of June, with the idea in mind that he would have to learn painting all over again, after doing so much lithography. He calculated that each of his lithographs had required a full month's work, but he felt that the results had justified the effort. His first exhibition at Knoedler was now sched-

Aline by the Screen Door. 1971

Single Peonies. 1972

Study for *Jimmy with Lamp.* 1971

uled for the following March; in the meantime, a July show was quickly organized at the Parrish Art Museum in Southampton; it contained twenty-six paintings from the Porter inventory that Knoedler had taken over from the Tibor de Nagy Gallery, together with Porter's five new lithographs.

Fairfield and Anne were alone in the big house at the beginning of the summer, "which was restful until the news about Jimmy, which required trips to Deer Isle to telephone and make no decisions, for what decisions can one make?" James Schuyler had had to be hospitalized in Islip State Hospital, after suffering a nervous collapse.[48] This calamity had been completely unexpected, because his work had been going so well of late, as Porter told Laurence. "When you wrote of Apollinaire's shattering blow to his self-esteem in 1912, I could not help comparing it to Jimmy's breakdowns, of which this is the second. He has been writing very good poetry this winter, the best he has ever done; and some were accepted by The New Yorker, and another, his best poem ever, a long one, somewhat Whitmany, which John Ashbery and Kenneth and I consider his best poem, and on his own account, excellent, he sent to the Paris Review. The New Yorker rejected it only because of its length. He has also been getting recognition beyond what he has ever had."[49] Schuyler was out of the hospital by early September and recuperating in Southampton with the Porters.[50]

Meanwhile, Porter's move to M. Knoedler and Co. was not working out as planned. During the fall of 1971 the gallery went through a crisis and was on the verge of closing down; both Donald Droll and Xavier Fourcade tendered their resignations, and Porter felt he had no option but to find another gallery. At the last moment, however, it was taken over by the financier and collector Armand Hammer and most of the employees, including Droll and Fourcade, returned. Porter's inaugural show at the new Knoedler was rescheduled for May 1972, "which is great with me. I could have more paintings then. As of now [January 1972] I have about 26—two years work, including several very large ones." In Porter's view, the most important painting that he would show was the large one, *July*.[51]

But Knoedler disappointed him just a month later, in early February, when Porter was told that his show would not be in May after all.[52] Porter was just then spending a lot of time in the city, working on a commission from Brooke Alexander to make two new lithographs.[53] By now his patience with Knoedler was completely exhausted, and his finances considerably strained. It had been two years since his last show at Tibor de Nagy. Although Knoedler had sold several of his paintings from inventory, it seemed obvious that the gallery was not concerned with supporting his needs. Three blocks away from Knoedler on the Upper East Side was Hirschl & Adler Galleries, like Knoedler a leading dealer in American art, but without experience in contemporary art. Nevertheless, Norman Hirschl and Stuart Feld, the directors, immediately took Porter into the gallery and in record time organized his next one-man show.

"Recent Work by Fairfield Porter" opened at Hirschl & Adler Galleries on 11 April 1972. The exhibition catalogue, despite some telltale signs of the haste with which it was prepared, was the most extensive treatment that any of Porter's shows had ever received. A foreword had been commissioned from the critic Peter

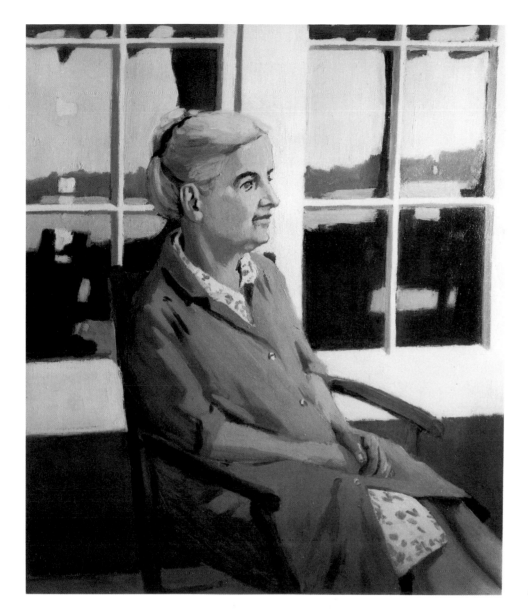

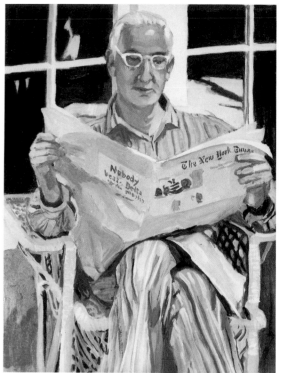

Portrait of Arthur Bullowa. 1971

Anne. 1971

Schjeldahl and ten paintings were illustrated. Porter's first show with Hirschl & Adler was also his largest to date; it comprised thirty-three paintings, nine water colors and drawings, and six lithographs. The tersely titled canvases *July* and *View* were two of the major landscapes. In addition to some of the portraits of his poet friends, Porter included a recent portrait, *John MacWhinnie*, looking nautical and handsome in his navy pea coat, seated amid paintings of Penobscot Bay. Porter was elated with the sales from this show: by June, almost twenty paintings had been sold. The largest canvas sold was a Maine landscape from 1969, *Lobster Boat*, which was priced at $5,200, of which Porter's share was $3,466.

Porter went up to Maine that summer in a mood to work, greatly contented that Hirschl & Adler had delivered him from Knoedler. Before leaving for the island, he finished an important Maine composition in his Southampton studio:

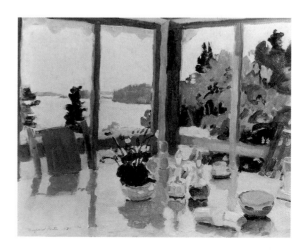

The Table on the Porch. 1971

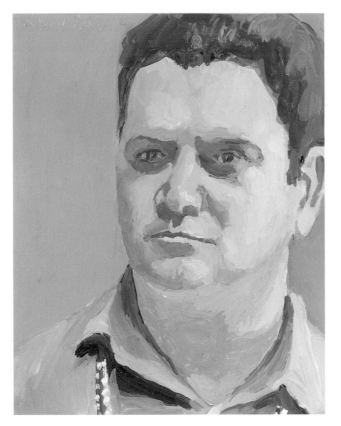

Jimmy. 1972

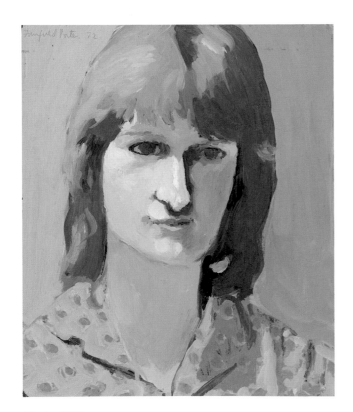

Katie. 1972

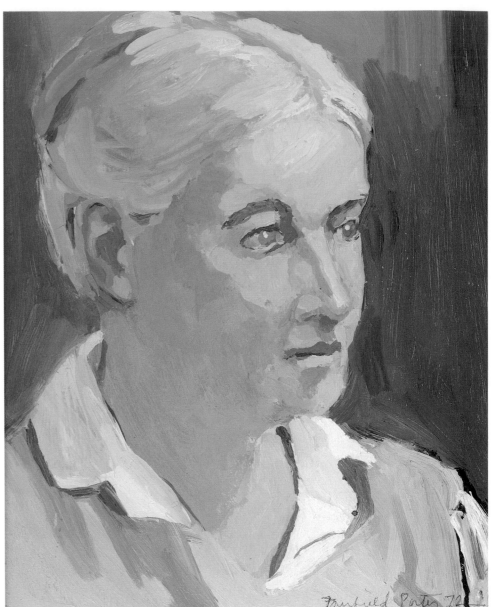

Anne. 1972

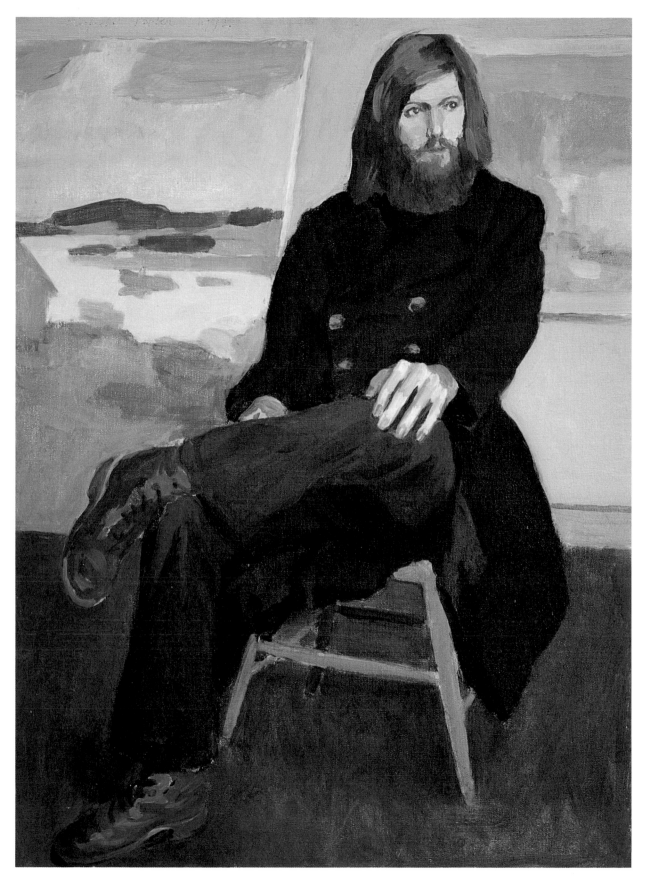

John MacWhinnie. 1972

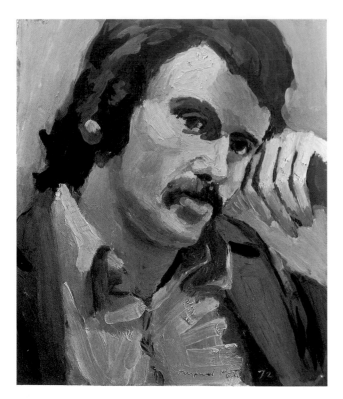

Peter Ackroyd. 1972

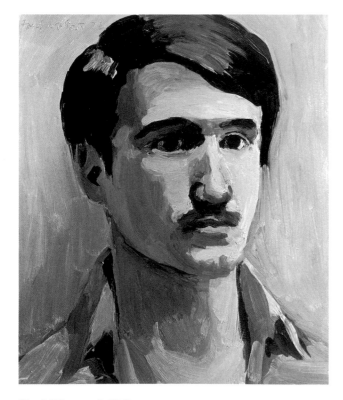

David Kermani. 1972

The Tennis Game, one of the last life-size canvases of his career. He had painted some sketches for the picture two years earlier, and also worked from some photographs of the tennis court,[54] but he only now felt ambitious enough to undertake it in full scale. The tennis court on Great Spruce Head Island had been designed by his father to withstand the rigors of the Maine climate, and during his lifetime James Porter had advocated tennis for physical fitness. Such thoughts of his father must have been much in Porter's mind as he painted this monumental scene of the rustic island court.

"Though this was supposed to be a summer alone—just Anne and me—it didn't turn out that way. The [Paul] Georges just left. They came from Skowhegan, having left their children behind at their request. In two days he painted three paintings. They are not his best, still, I couldn't do it."[55] David and Lindsay Shapiro, a young poet and his wife, had also visited. Shapiro was a talented musician besides, and brought some music with him to the island. Porter painted a portrait of the young couple, depicting the talkative Shapiro in midsentence.

After the Porters returned to Southampton that fall, Porter painted *House with Three Chimneys,* his own house at 49 South Main Street. He thought this picture "a little different" from his others, but found it hard to say why.[56] Although the canvas is not large, his Georgian house is shown with a certain dignity, as if in recognition of its architectural good breeding. John MacWhinnie photographed Porter in his studio while *House with Three Chimneys* was in progress.

By October 1972 Porter had painted almost forty new paintings since his exhibition at Hirschl & Adler in April. He was mostly painting small pictures, in part because he liked the way his waxy Maroger's Medium took to Masonite, and Masonite boards were sold in a standard 14 x 11" format. He painted portraits of Peter Ackroyd and David Kermani that concentrated on his subjects' faces; these portrait heads proved to be a more effective format for Porter than the traditional bust-length. A nature study from 1972, *Lichens, Wild Roses and Primroses,* and a still life, *Single Peonies,* are similarly close-up studies in relatively small dimensions: they are reminiscent of Eliot Porter's nature photography, perhaps deliberately so.

Porter, who had always resented the exertions and emotional wear and tear of the holiday season, was growing more tolerant in his old age. He devoted all of January 1973 to making watercolor and ink sketches in preparation for a large canvas of Liz playing her guitar in front of the family's Christmas tree. His opinion of this painting is not recorded, but the work did not turn out successfully, simply because the picture was uncharacteristically sentimental.

Two speaking engagements of personal importance took place in that month. Porter was one of the three speakers at a memorial service for Joseph Cornell. "I hardly knew him," he wrote to Laurence Porter on the eleventh, "but he liked what I wrote about him so much that he had it as the introduction to a catalogue for a show that he had in Los Angeles. And on the 30th, I shall introduce John Ashbery at a reading before the Academy of American Poets. I was much surprised to be asked: Kenneth [Koch] said John probably asked for me."[57]

During the winter of 1973 Porter painted several canvases of the surf at

Southampton. The idea came to him in response to a request from Elaine Benson, an art dealer, for Hamptons landscapes. It was part of Porter's routine to walk along the beach with Bruno every morning. The pictures were painted from memory in the studio, yet retain an impressive specificity. In contrast, for example, to Milton Avery, who often painted sea scenes, Porter's paintings resemble portraits of individual waves. Rackstraw Downes has aptly commented about these works that Porter "paints the ocean without making any fuss about it. He doesn't say, 'This is a roaring force—look out,' the way one sometimes feels with Winslow Homer."[58]

In early spring Porter again turned his attention to lithography and resumed his frequent trips into New York. He was working with the same craftsmen, who had since moved to a different workshop. Porter was apparently fascinated by the politics of the situation, to judge from the meticulous rendition of events that he gave Laurence on 12 May:

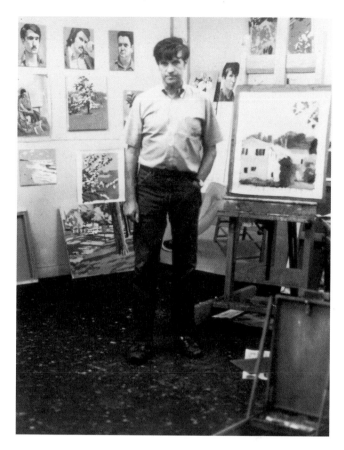

Fairfield Porter in his studio, painting *House with Three Chimneys*. 1972

> *The lithographs are being made not at the former Bank Street Atelier, which after it was bought, I didn't like any more; the atmosphere got uncomfortable and phonily commercial, while pretending to be Bohemian. My favorite French lithographer left it along with a Breton who had come to the Shorewood Atelier (which is what the Bank Street Atelier was renamed) just before I made my last lithograph there—another city one. Jean-Pierre and the Breton, Yann, and George Goodstadt, who had been manager of Bank Street, and Chip who is a hippy with a George Washington pigtail are at the new place—all people I had liked best at Bank Street. They too couldn't stand the new owner. Now Jean-Pierre, Yann and George have started a business of their own in one end of a small loft, at the other end of which is a silk-screen business that is run by very nice young Americans, and everyone gets on very well together. And it may become a success, because they have two years of work from Salvador Dali, who used to send his lithographs to Bank Street for Jean-Pierre to make; also they have Alexander Calder who turns them out like baking powder biscuits. The atmosphere is very nice, as it used to be at Bank Street.*[59]

Porter's literary friends occasionally asked him to design the jackets for their books. "I seem to be a success in this, so naturally I like doing it."[60] Part of the pleasure for him was in doing the lettering freehand. One of Porter's waves adorns the jacket of James Schuyler's 1972 volume *Crystal Lithium*. In early 1973 he made numerous watercolor studies for the jacket of Kenneth Koch's *Rose, Where Did You Get That Red?*, a book about teaching poetry to children. Porter took these illustrations as seriously as any of his works, as he wrote a few months later to the artist Joe Brainard. "I am pleased with my small success with book jackets, as a thing to do, maybe, when my paintings are no longer thought well of."[61]

In Maine that year Porter painted a series of portrait heads of children, including his grandnephew and grandniece, Scott and Lisa Fuller. Their mother, Anina Porter Fuller, was his brother John's daughter and a painter herself.[62]

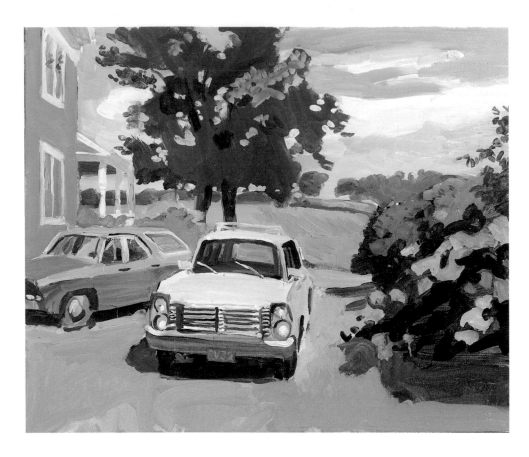

Landscape with Two Parked Cars. 1972

The Sweater. 1972

This summer I have made in paintings mostly sketches. I painted four children's heads that fill the canvas. They are a little larger than life size, which, when you only have a head, or say 90% of a head, don't look larger than life size, but exactly life-size. One, of one of my great-nephews, of whom I have a vast number, was commissioned by his mother; I hope she likes it, though I don't think it as good a likeness as some of the other children I painted the same size. I painted his younger sister first: she said, 'the painting is dripping—that's no good. You make big dark rings under my eyes.' The next rest period she thought it was better, and in the end she asked me to give the portrait to her. I said I would, but not right away; I want to exhibit it first.[63]

The major work from the summer of 1973 was also a family portrait, *Portrait of Nancy Porter Straus.* "I painted my sister Nancy, who is 73, but since I have known her for 66 years, I don't see her as if for the first time, she looks younger. Eliot says that she looks 40. She is smaller than life size, but the picture is big, 68 x 80", and there is a lot of landscape around and behind her and the flat cement porch floor with pink squares of sunlight on it."[64]

The painter Joe Brainard had asked Porter to give him details about his technique and any other advice that the older artist cared to offer. Porter's reply is valuable as an example of his thinking, artist to artist:

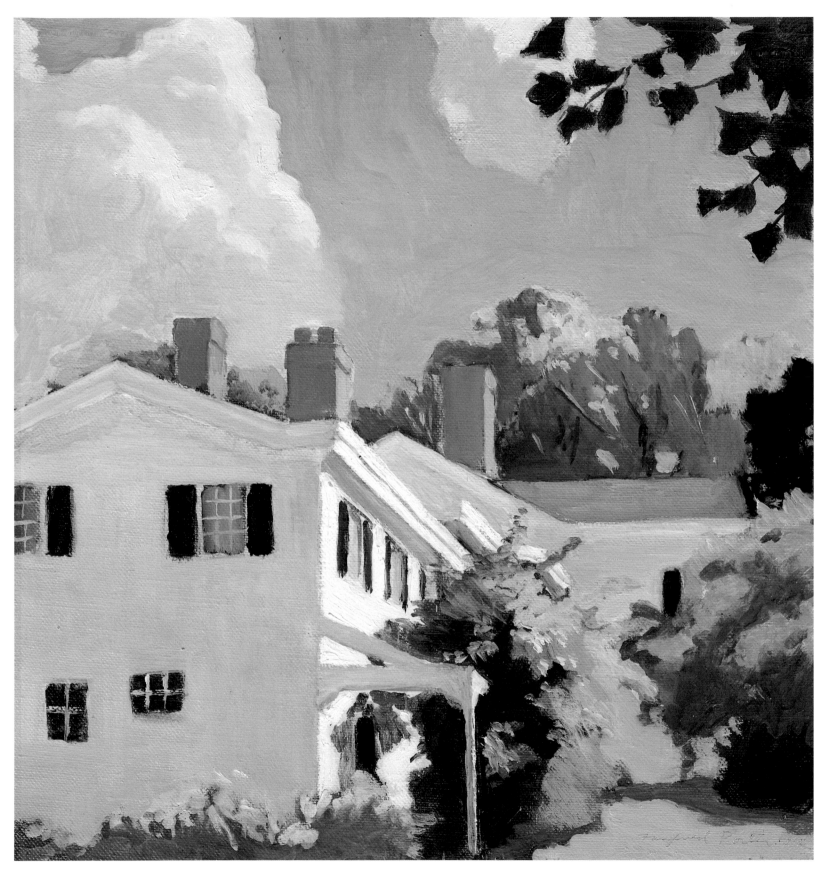

House with Three Chimneys. 1972

Book jacket illustration for *Rose, Where Did You Get That Red?: Teaching Great Poetry to Children*, by Kenneth Koch

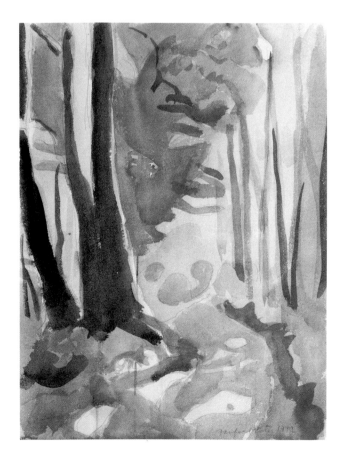

Wood Road No. 2. 1972

I have painted a couple of large landscapes (36" square) and a picture of the mailboat with Jimmy Quinn at the wheel (39 x 45") which is all naples yellow, dull purple and the blue sea, with a burst of sun coming in through the windshield to Jimmy's left. The naples yellow and dull purple are the colors of the white cabin in the shadow from the sun. My small pictures are sunrises, with a very white sun—which perhaps shouldn't be called sunrise, anymore than the sun sets at 4 in the afternoon—reflected in the water. There is a lot of sunlight in my paintings, by which I mean either the sun or its reflections in the water. I have discovered a new pigment that I use a lot now—Windsor orange, which does what neither cadmium orange nor cadmium red do. It is a favorite of Bill de Kooning; John MacWhinnie told me about it. And I use hardly at all any other green than earth green. [65]

Porter's letter to Brainard concludes with some reflections on his reputation, which he apparently felt was at its lowest ebb. "I tried to write about my paintings as you requested. I feel good about them. I hope I am not mistaken in feeling so. I think sometimes that as far as museum and patrons are concerned that I may be 'finished,' that is, that it has been decided that my work is not really any good. This partly stimulates me to be more critical, though not in the way that I think 'they' might be. I try to try harder, to learn to be continuously interested."

Porter continued to work to his fullest capacity during the last years of his life, notwithstanding various signs of declining health. He had an unsettling experience in January 1974, when he went to Chicago for a few days to be a visiting critic at the School of the Art Institute. Exhausted by a sleepless night on the train going out, he had a strange sensation of being unable to remember "anything I had just said or any recent names." [66] This loss of memory was only temporary, but the episode seemed to mark the beginning of a period of weariness and low energy

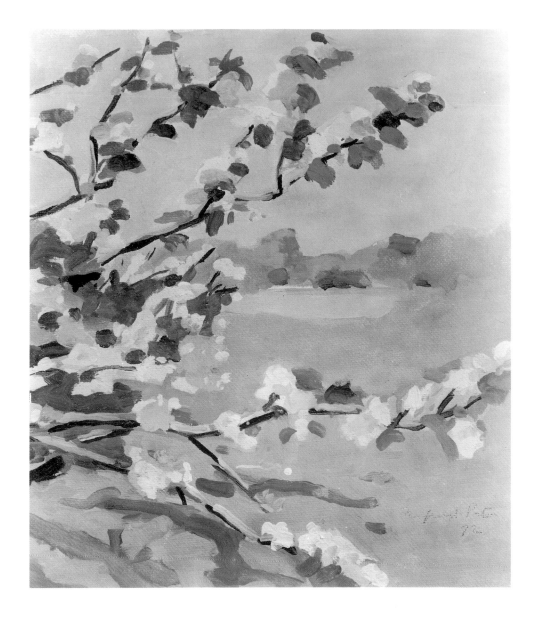

Flowering Apple. 1972

that troubled Porter during the last eighteen months of his life.

He had his second exhibition at Hirschl & Adler Galleries in March 1974. The sales from his first, hastily organized show had been good, all things considered. This time the show was a runaway success. "As of yesterday," he wrote Laurence, "they have sold 24 paintings in the last three weeks, and are extending the show for another week, of paintings that there weren't room for at first. Some of these are better than some they had hung . . . In fact, Hirschl & Adler told Aline [Porter], who was in the city with Eliot, that it was their most successful exhibition of a living artist they had ever had."[67] A month later he added, "This is not so grand as it sounds, as the Hirschl & Adler gallery has a bad taste in living artists: they make their business out of a dreary but fashionable selection of nineteenth century artists. In fact it is an impressive business enterprise, with many people working and telephoning all the time . . . And they are very nice people, the atmosphere is

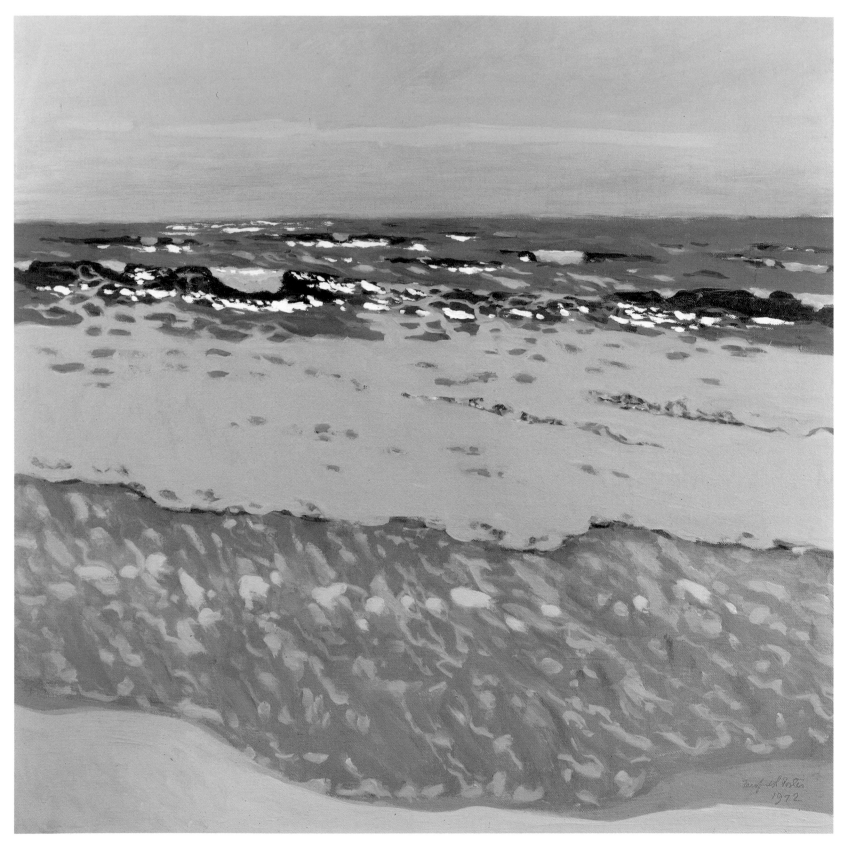

The Ocean. 1972

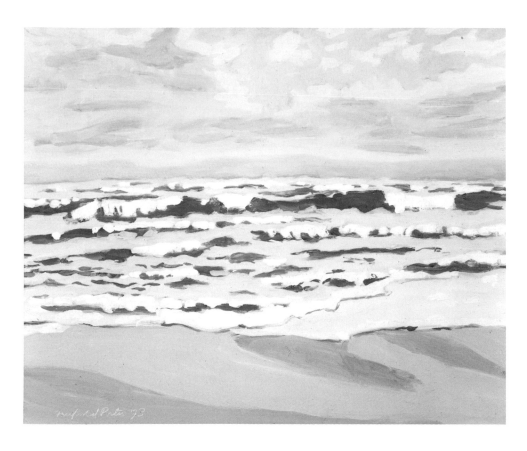

Morning after a Storm. 1973

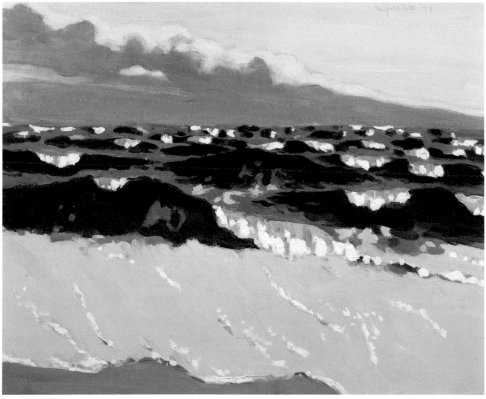

A Sudden Change of Wind. 1973

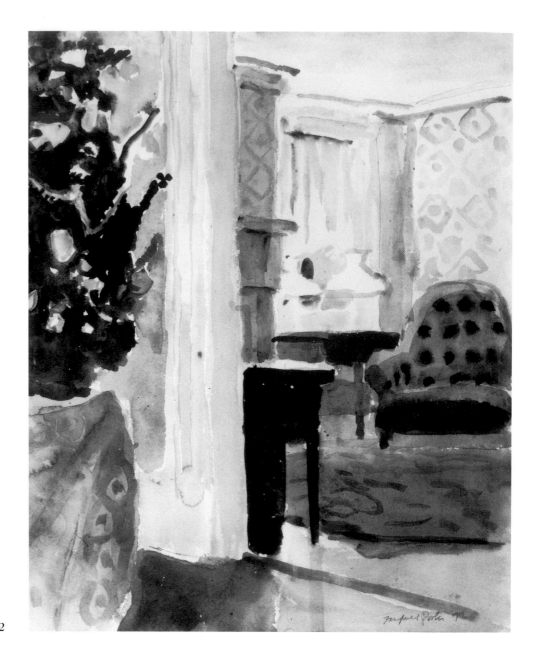

Sketch for *Lizzie and Christmas Tree*. 1972

most pleasant. They invited Anne and me and Eliot and Aline to a lunch in the gallery to celebrate the success of the show, and now they have a continuing show of Porter paintings going on the second floor, consisting of unsold and as yet unshown paintings."[68] By the end of April Porter could consider his second show at Hirschl & Adler Galleries the largest and most successful of his career: "I sold more than half (which I have done before, but this time it was more than half of about 50 paintings, instead of 25, as it was two years' work)."

Although Porter had recently expressed doubts about his reputation, Hilton Kramer continued to recommend his paintings in the highest possible terms. Kramer described in a *New York Times* review the broader, more fluid handling that is characteristic of Porter's last oils.

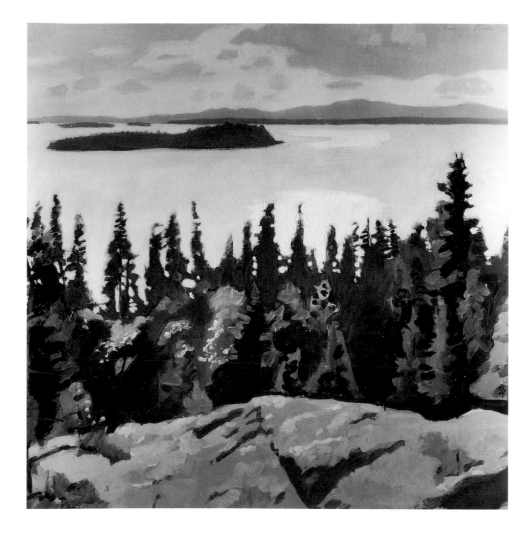

View from a Porch. c. 1973. Ink,
13⅞ x 10½", Hirschl & Adler Modern,
New York

From the Precipice. 1973

*In approximately 50 examples of Mr. Porter's recent paintings, water-
colors and drawings, there are both a new stylistic note and salutary
reminder of the artist's familiar strengths. The new note is to be found in
the somewhat looser, more expressionistic articulation of painterly form
in pictures such as "The Tender," "North Point No. 2" and "Bright Day on
the Beach". Yet so complete is Mr. Porter's authority in every pictorial
task—in capturing the effects of light and converting them into their for-
mal equivalents, especially—that he is able to assimilate this "innova-
tion" without any loss of identity.*[69]

Kramer also singled out for praise *The Beginning of the Fields,* a Southampton
landscape.

The success of his gallery show made it possible for Porter to devote more
time to conservationist campaigns, chiefly his opposition to nuclear power. He
reported in April to Laurence Porter: "I have been spending most of my emotional
energy on collecting signatures on a petition for a nuclear energy moratorium . . .
Today, for instance, I collected 13 signatures between 4 and 5:30 P.M. One was Dan

Flowering Pear. 1973. Ink, 14 x 11".
Private collection

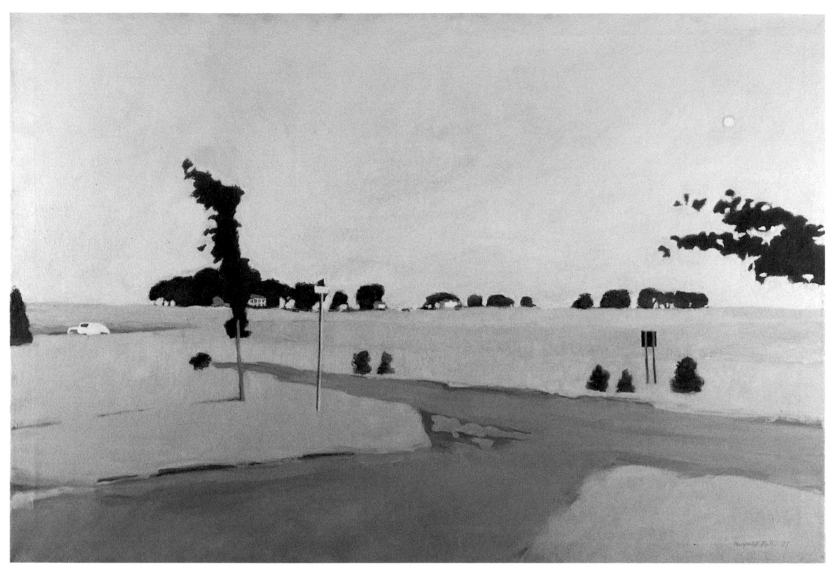

The Beginning of the Fields. 1973

Wellings, of the paper store, who told me it was in his opinion (as it is in mine) the most important issue ever to have faced people in all of history . . . And I have got helpers, one of whom is Roy Lichtenstein, the artist, and another is Patrizia Annichini the girl friend of John MacWhinnie, the talented young painter here who might be considered an unofficial 'pupil' of mine."[70]

The summer island meant an opportunity to rest for the longer hours that he now needed. Great Spruce Head Island in 1974 was still as isolated from the mainland as it had been when James Porter bought it in 1912. To this day the island has no telephone. The Porters' boats and the daily mail boat have always been the only form of communication with the rest of the world. Porter painted a view of the small harbor on the island while waiting above the dock where the mail boat landed every day. *The Harbor—Great Spruce Head* became one of his best-known paintings, after it was reproduced on the cover of the exhibition catalogue of his posthumous retrospective in 1983. At lower center the landing dock points out-

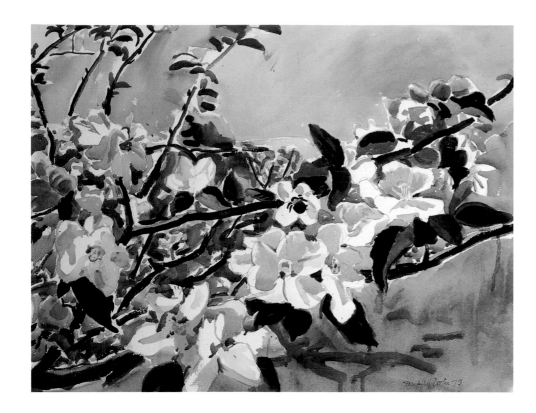

Apple Branch. 1973

ward into the bay, like a crooked finger (although in fact it is sturdy and straight).

The year 1974 was the last painting season on the island in which Porter produced major oils. By summer's end he had decided that it took too much of his energy first to set up his summer studio and then to dismantle it. The wet paintings still required a return trip to Maine each fall to be collected. "The next time I go to the island," he wrote to Laurence in October, "I think I won't paint oils, only watercolors. It is too much of a hassle transporting oils, waiting for the paintings to dry (they never quite do) and so on."[71] Notwithstanding the increasing effort they required, Porter's late paintings show no sign whatever of diminishing powers. In two hours, he caught the essence of Kristina Fuller, his four-year-old grandniece, who found it hard to sit still for her portrait. Kristina's mother, Anina, was also painting on the island that summer; once, after several silent viewings over her shoulder, Porter told her, "Your sketch had more life than the filled in painting." His point was that one must preserve the vitality and sureness of a sketch.[72]

During this same summer Porter painted *Anne in Doorway*, one of the finest works of his career. Anne stands, or leans, in the doorway of the porch, looking into the distance, on a threshold between light and shade. The door is flanked on either side by the summer's exhibition of still-wet paintings, hung up to dry. Behind her, the interior of the living room is shadowy and indistinct. There is just a glimpse of the mantelpiece, the plaster relief of the Parthenon horsemen.

Fairfield and Anne made a detour on their way home to Long Island, stopping in Lincolnville, Maine, to visit the painter Neil Welliver and his wife. "They live in a way I approve of," Porter thought, "but I suppose it is too late for me to mend my ways and do the same. They raise a lot of their own food in a way that makes the

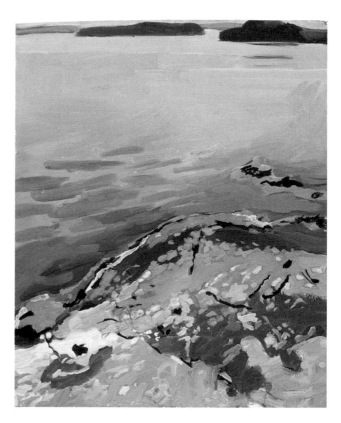

High Tide. 1973

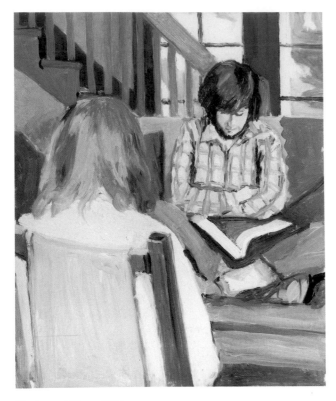

Katie and Dan. 1974

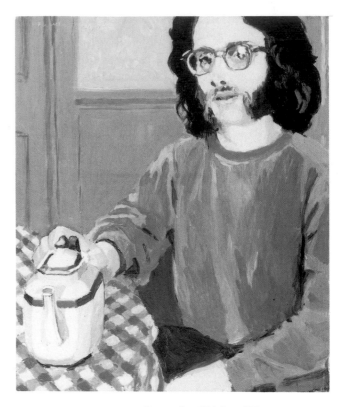

Portrait of Richard Freeman. 1974

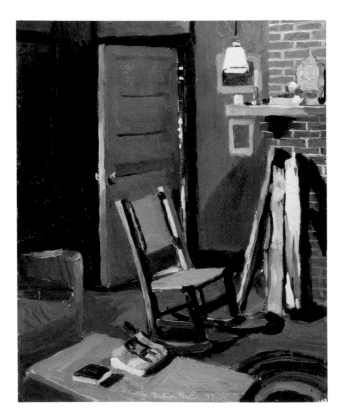

Logs and Rocking Chair. 1973

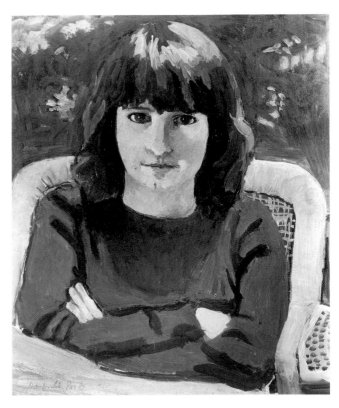

Katie. 1974

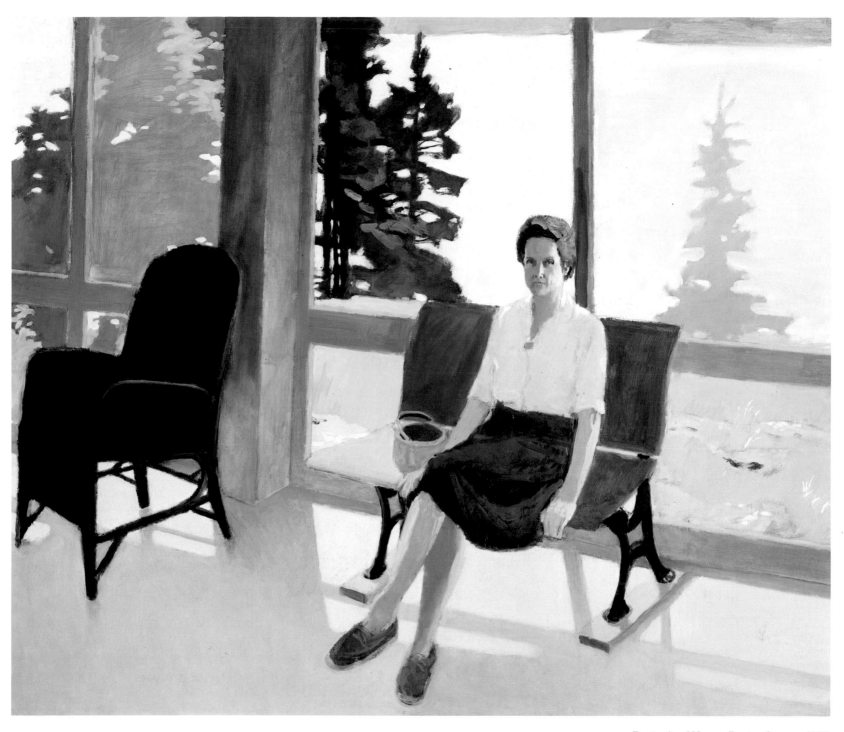

Portrait of Nancy Porter Straus. 1973

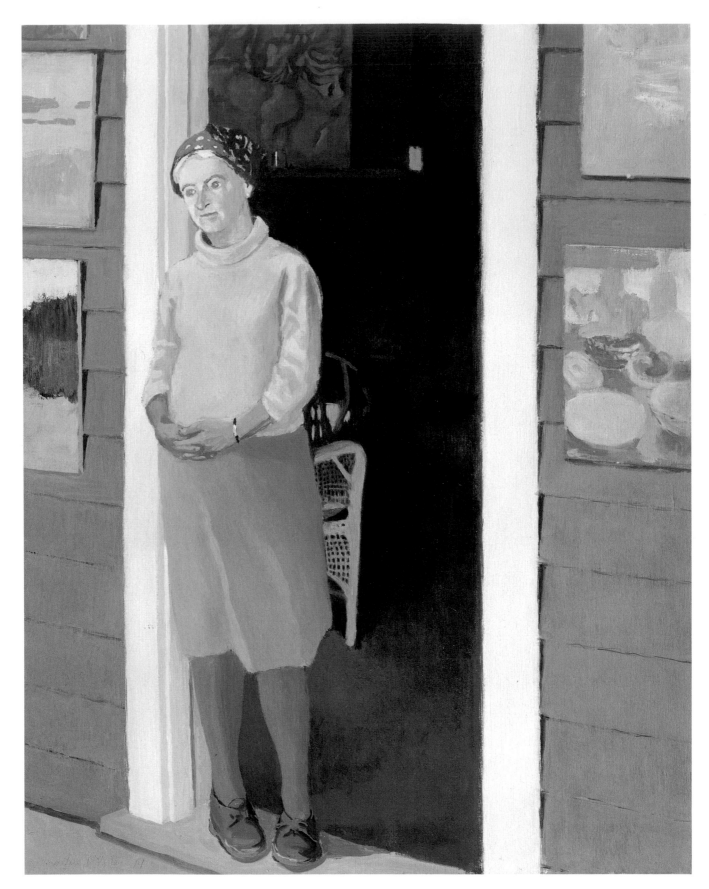

Anne in Doorway. 1974

best food . . . they also raise a lot of their own energy."[73]

For his part, Welliver always looked forward to Porter's visits. "Fairfield stopped numerous times here when coming from or going to Great Spruce Head. At the end of the day we would walk through the woods; Fairfield's 'walks' were high speed hikes. He would often try his latest revision of his theory of aesthetics on me . . . On one occasion we were walking in silence and Fairfield said suddenly, 'You know you use too much green in your painting.' I said, 'Fairfield, that's the dumbest thing I've ever heard you say. We are standing in an envelope of green! There is green above and below, left and right, in front and in back of us.' Fairfield looked all around intensely, then said, 'You're right: you probably don't use enough green.'"[74]

Porter started teaching in November at the School of Visual Arts in downtown New York City. He was hired to lead eight sessions of three hours duration every Thursday evening. He spent the mornings working on a lithograph of the cliffs of Isle au Haut, Maine, collaborating with two of the Frenchmen he had originally met at the Bank Street Atelier.

"My class at the school of Visual Arts is hard," he wrote to Laurence, "but especially the Conceptualists, who are clever, and of whom I am a little afraid, and who produce chiefly ideas. I can't somehow get across to them . . . that it is not ideas that I expect to see, but *things* they have made, and that is something I can say something about."[75] To Welliver he said, "It is a little like the challenge that might be posed in, say, a French class by a student who insisted on being taught Spanish, or perhaps baseball."[76]

The large lithograph of Isle au Haut required weeks of work and was not finished until the end of the year. Porter felt it was the best print that he had made, or at least as good as his previous favorite, *South Meadow*, "though as very often happens in lithography, or with my lithography, there is always something poignant about them caused by my invariably either settling for something that is not as good as it should be, or my finding out later that I made a wrong decision somewhere along the line. In this case there was a very good, though rather fresh young Israeli printer who had, I now believe, a better idea than I had for the color of the sky and of the foreground trees." It was typical of Porter to give his printers full credit. "The mistake partly came from the attempt to copy the original sketch, which in this case was really good. But then one can never reproduce anything, and one has to learn to look only at what you are making, and not at what it came from . . . Still, it is a good lithograph."[77]

He painted little that autumn because of his commitments to teaching and lithography; he was feeling slightly anxious over this by the end of November. "Since coming back from Maine, I still don't have enough time to do my primary work, that is painting. However, I suppose that the hiatus may even work out in my favor, because I think about painting all the time and, feeling dissatisfied with my recent work, will perhaps do all the better when I can paint again."[78] He had commented just the year before to Rackstraw Downes that he liked to think of "winter as a time for thinking, and summer for spontaneous painting. But I don't entirely follow this."[79]

The autumn of 1974 was further complicated by the need to lend a hand to a retrospective of his works that was opening in December. The show was being

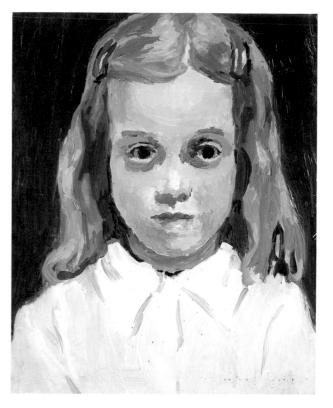

Lisa. 1973

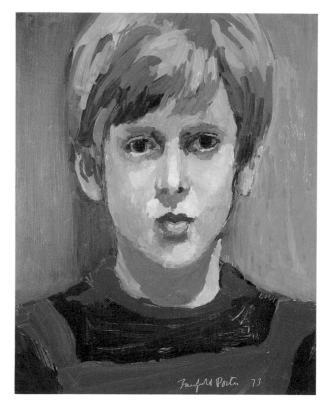

Scott. 1973

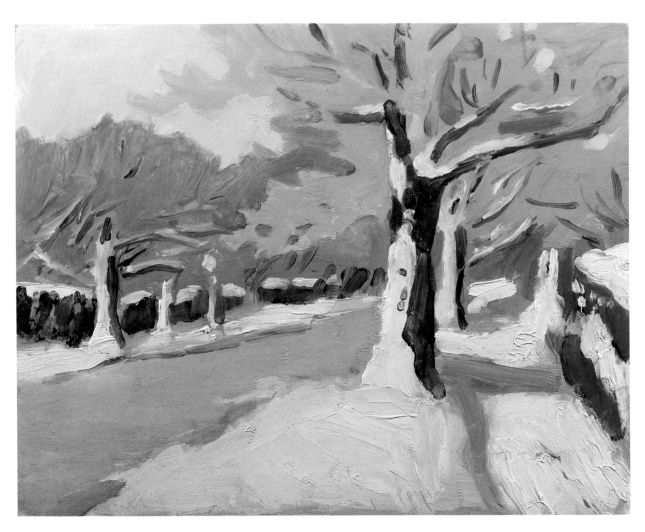

Snow on South Main Street. 1974

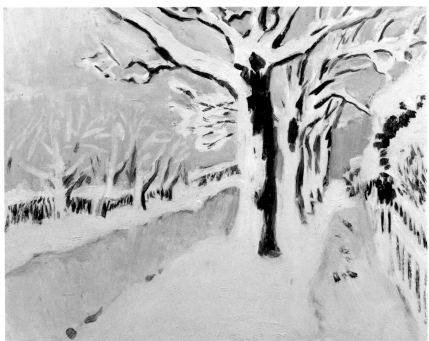

Late Afternoon—Snow. c. 1972

Dogs. 1974

shared by three regional museums, the Heckscher Museum in Huntington, Long Island, The Queens Museum in Flushing, New York, and the Montclair Art Museum in Montclair, New Jersey. A short catalogue essay was contributed by Eva Ingersoll Gatling at the Heckscher Museum, while critical tasks of coordination and organization were taken over by Prescott Schutz of Hirschl & Adler Galleries.

"Fairfield Porter Retrospective Exhibition" was a milestone, and Porter took this show much more seriously than he had the Cleveland retrospective in 1966. It was to be the largest show that he had ever had—sixty works—and the first that would include examples from every period of his career. "I am helping to get ready an exhibition in Huntington that will cover my whole painting life," he told Laurence. "It will have a watercolor I made in 1927 of the roofs of Cambridge, Mass., and the large [1954] painting of you at the piano."[80] Porter's selection for the show was important because it demonstrated that he was beginning to appreciate the whole range of his own work, instead of simply his latest paintings. Some months later he wrote to Aline Porter to compliment her on her exhibition at Betty Parsons Gallery, and commented, "Often it seems that art looks surprisingly fresh and much more interesting in a new setting. My show at Huntington looked very good: there were pictures that I don't like very much, but they looked well there. At the Queens Museum I thought they looked terrible."[81]

David Shirey reviewed the Porter retrospective for *The New York Times* on 22 December 1974. Shirey was fully aware both of the value of Porter's work and of the importance of the show as a response to the critical neglect that Porter had suffered for many years.

House in the Sun. 1974

The Harbor—Great Spruce Head. 1974

The retrospective exhibition of Fairfield Porter's art at the Heckscher Museum emphasizes that he is one of the most outstanding contemporary American artists.

Although his paintings have not always met with the establishment's approval, they are now recognized as achievements of major significance.

It takes a retrospective of this dimension— 60 works done over the last 20 years —to realize that Mr. Porter has persistently shown remarkably individual creative talent.

Porter must have been gratified by Shirey's praises, but his specific comments are not recorded. In the aftermath of this show, in May 1975, Henry Geldzahler came to Southampton to visit Porter to tell him that the Metropolitan Museum of Art was going to buy one of his paintings. Geldzahler was the curator who had omitted Porter from the Metropolitan's 1970 exhibition of postwar paintings.

The last summer of Porter's life was only partly spent on the island. He and Anne did not go to Maine until early August of 1975, because Porter did not want to interrupt the work he was doing in Southampton. He was very pleased to have received a commission to paint the portrait of Albert Gordon, the president of the Harvard Club in New York City. Apparently Mrs. Gordon, who had conducted the search for the right painter, had been amazed at how low Porter's prices were in

Dock. 1970s. Ink, 11 x 14". Hirschl & Adler Modern, New York

Bear Island—Sunset. 1974

Pea Point from the South Meadow. 1974

Yellow Sunrise. 1974

Seascape. 1974

comparison to portrait specialists. He took great care with the portrait, making frequent trips to paint the picture in Gordon's apartment on Gracie Square, over-looking the East River.[82]

To Lucien Day he wrote from the island, "I am painting only in watercolor this summer in Maine. We got here only on the 8th of August, and will leave the first week of September . . . I find I like watercolors very much—it is roughly to oil what the harpsichord is to the piano. Except I like the harpsichord better than watercolor, and oil better than the piano." Porter had painted watercolors through-out his life and had mastered the technique.[83] In his last years, he increasingly turned to watercolor as an alternative that required less exertion than oil, and much of his best work in his last years was executed in that medium; he was one of the rare artists of the postwar epoch who painted watercolors worthy of the tech-nique's distinguished American tradition.

Kristina. 1974

Sarah Porter. 1974

Broadway South of Union Square. 1975

Velasquez Study. 1974

Near Union Square—Looking Up Park Avenue. 1975

Dog in a Field. 1975

Keelin. 1975

Jerry. 1955, repainted 1975

Eliot. 1975

The Living Room. n.d.

During his last summer on the island, Porter's correspondence with his son Laurence was mostly concerned with ideas on aesthetic theory. Laurence had written about an artist who had made "an unsuccessful attempt to transport a vision of artistic beauty to everyday life." Fairfield responded with his view that any such attempt would inevitably be doomed. "The attempt will be unsuccessful if there is a vision of artistic beauty that precedes experience, and that the artist forces onto everyday life. The sense of beauty cannot be, or is not, forced. It is not something separate from or antagonistic to everyday life."[84] Porter was convinced that nature and "everyday life" offered enough beauty to occupy an artist's life-time, if he only cared to look. In this same year, shortly before his death, he sup-

From the Top. 1975

Rocks and Lichen. 1975

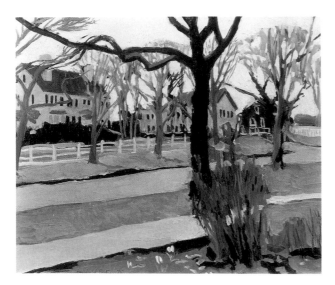

April Overcast. 1975

ported this same idea with a theological argument that was obviously influenced by the Roman Catholic faith of his wife and daughters. "What does it mean to create? Unless you hold, as I think I probably do, that man doesn't create, that only God creates, that is, make something out of nothing, then you can make at least an analogy between Creation and what the artist does."[85]

In early September Porter returned to Southampton with a very good group of watercolors from Maine and learned that he had received a commission to paint an official portrait of Cardinal Krol of Philadelphia. The idea naturally pleased him for its evocations of both Velázquez and, closer to home, Eakins. Another pending project, Porter said to Anne, was a plan he had to go to the Metropolitan Museum and paint some copies. One of Porter's last paintings was a canvas with copies of some of the heads in the background of Velázquez's *Surrender of Breda*.

Porter died suddenly on the morning of 18 September in Southampton. He had awakened early, as he habitually did, without any feeling or presentiment of distress. At 7:30 A.M. he was on his way home, after his daily walk along the beach with Bruno, when he collapsed. A passing motorist noticed a worried dog sitting alongside his stricken master and stopped his car to offer help, but Porter had died instantly of coronary arrest at the age of sixty-eight.

One of Porter's friends made a diary note about the funeral arrangements. "Anne and the children have received permission for a Requiem Mass to be said for Fairfield in the Church of the Sacred Heart of Jesus and Mary in Southampton where he will be buried in consecrated ground. A few weeks previously he was observed by his daughter, Elizabeth, reading *Revelations of Divine Love* by the Christian philosopher Julian of Norwich."[86]

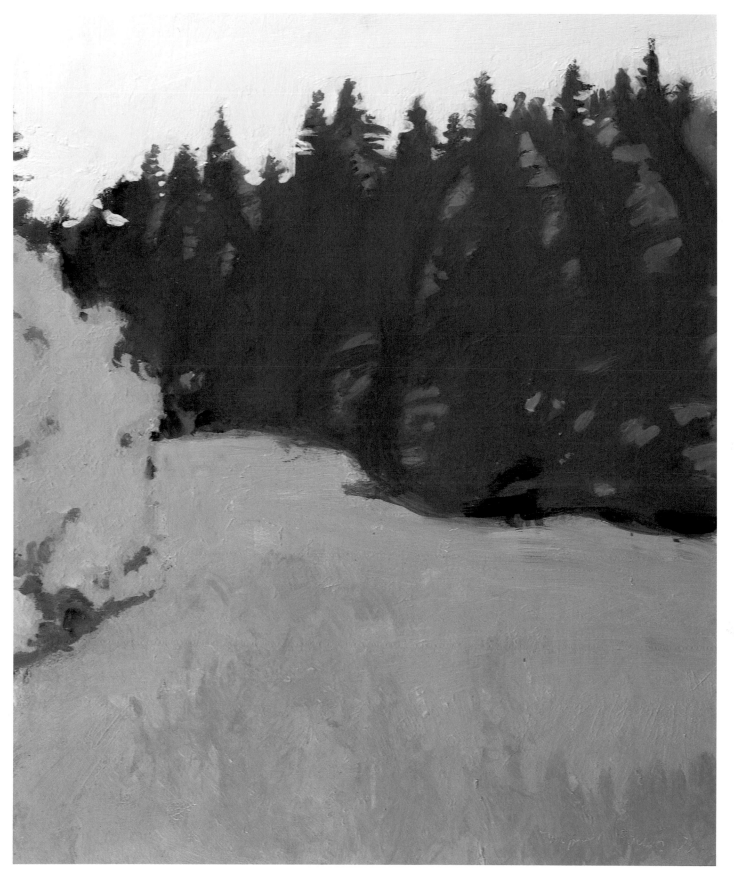

The Wall. 1974

Fairfield Porter on
Great Spruce Head
Island, painting *The
Path around the
Head*. August 1975

AFTERWORD

*When a critic suggests that something is not worth doing because it has
been done before, he is in effect urging an artist toward one of the more
exciting aspects of art, the attempt to achieve the impossible.*
—Fairfield Porter, "Perfection and Nature," *The Nation*, 1960

When Fairfield Porter died in 1975 he was as active and ambitious for his
painting as ever, but he believed that art historians had overlooked him.
His specific thoughts about his standing are not recorded: on the one hand, his
sales to private collectors were at an unprecedented peak; on the other, Ameri-
can museums showed little interest in acquiring or exhibiting his works. His
obituary in *The New York Times* listed only three major institutions as owners of
his canvases (a situation that had not changed since 1968): the Museum of Mod-
ern Art, the Whitney Museum of American Art, and the Cleveland Museum of
Art. The Modern had been given *Schwenk*, a still life, by Arthur Bullowa in 1960,
and it remains the only Porter in the collection. In contrast to the more famous

protagonists of American painting in the fifties and sixties, Porter was completely unknown in Europe (this is still true), and his paintings were sold for strikingly lower prices (also still true). The hard fact was that very few critics considered him one of the key figures of postwar painting. This debate is now engaged.

Porter did not die in obscurity, nor were his works forgotten, as he seems to have feared. His death was widely noted, and a movement to reappraise his importance began almost immediately; it is detectable even in his obituaries. "Fairfield Porter, 68, a realist in an age of Abstract Art, Dies," was the headline that appeared in *The New York Times* on Sunday, 20 September 1975. Despite its title, Grace Glueck's obituary devotes more attention to the quality of Porter's contributions than to ruminations on his isolation from contemporary trends. Indeed, Glueck seems to have credited him with a stronger reputation than that which he supposed himself to have: "Something of a late bloomer, he painted for years before his work was first shown, and did not, in fact, until the last decade get the wide recognition that knowledgeable critics and his painter friends felt he deserved." Porter's friend and editor, Thomas Hess, wrote in *New York* magazine on 22 December 1975 that Porter's status was "international," and called for a major retrospective of his paintings. In the ensuing years, Hilton Kramer used his podium at *The New York Times* to call repeatedly for a Porter exhibition, frankly challenging art historians to take up the cudgels: "So far," he wrote in 1979, "no New York curator has dared to undertake this appealing task." Porter's reputation gained considerable impetus from the publication in 1979 of *Fairfield Porter: Art in Its Own Terms; Selected Criticism, 1935–1975,* an anthology ably edited by Rackstraw Downes. Joan Ludman's catalogue raisonné of the artist's prints appeared two years later, underscoring Porter's achievements in graphic art.

In 1983, seven years after his death, the wished-for retrospective came about. "Fairfield Porter (1907–1975) Realist Painter in an Age of Abstraction" was organized by Kenworth Moffett for the Museum of Fine Arts, Boston. A smaller version of the show traveled to museums in Greenville, South Carolina, Cleveland, Pittsburgh, and New York, where it was installed at the Whitney Museum of American Art. The exhibition catalogue, very quickly out of print, was the first publication to offer many illustrations of Porter's paintings. Both the national and the specialized art press published a flood of favorable responses to the work.

The rising trajectory of Fairfield Porter's posthumous reputation is a fascinating story, comprising many more chapters—and authors—than can be cited here. To date, the high-water mark of his revival was registered in an article by Hilton Kramer, "Fairfield Porter: An American Classic," published in *The New Criterion* in 1983. Kramer concluded that Porter overtook and surpassed all his celebrated contemporaries, including de Kooning. His thesis, a gauntlet thrown down, has yet to be tested by other critics—perhaps because so much more is at stake than an individual's reputation. The fabric of existing theory will have to be torn from top to bottom, if Porter is indeed to be recognized as the foremost of his generation—an American classic. The battery of isms that has dominated postwar art criticism was drawn up without leaving space for Porter. The theoretical basis for reappraising his importance is fittingly the same fundamental but thorny standard that he himself applied to art and criticism: artistic excellence.

NOTES

Works frequently cited are referred to by author only, or by author and short title, after the first full citation. Where no author is given the work or letter cited is by Fairfield Porter.

ABBREVIATIONS

AAA — Archives of American Art, New York City. Porter documents are cited by microfilm reel number, where possible.

APL — Anne Porter Letters. Notebook containing extracts from letters sent by Anne Porter to her mother, Katharine Channing.

APL2 — Anne Porter Letters 2. Notebook containing extracts from letters sent by Anne Porter to her mother.

JTS — John T. Spike

FAMILY, EDUCATION, EUROPE 1907–1932

1. Frank Rogers, letter to his family, 1932.
2. Eliot Porter, *Summer Island: Penobscot Country* (San Francisco: Sierra Club, 1966), 42.
3. Fairfield Porter, interview with Paul Cummings, 6 June 1968. Archives of American Art, Washington, D.C. (hereafter Cummings interview, 1968).
4. Eliot Porter, interview with JTS, 24 May 1989.
5. Eliot Porter, *Eliot Porter,* foreword by Martha A. Sandweiss, exh. cat. (Boston: Little, Brown, and Fort Worth: Amon Carter Museum, 1987), 12.
6. Edith F. Wyatt, "In Memoriam: Ruth W. Furness Porter, 1896," *Bryn Mawr Alumnae Bulletin* (July 1942): 16.
7. Letter to Laurence Porter, n.d. March 1957. The poem is published in *Fairfield Porter: The Collected Poems with Selected Drawings,* ed. John Yau with David Kermani (New York: Tibor de Nagy Editions, 1985), 49.
8. Wyatt, "In Memoriam," 15. A very telling tribute was paid to Fairfield Porter's parents in an unpublished memoir written by one of their Maine neighbors, "Days that Were: The Autobiography of Gerald Warner Brace 1901–1978" (typescript, 1979), vol. 2, 48: "James was a shy, inarticulate man who had studied architecture and was good at handling any sort of practical problem. But it was his Bostonian wife, Ruth Furness Porter, who gave the island community its spirit of immense happiness and mutual affection. She had a great talent for friendship and human warmth, and loved and was loved by many people. I would nominate her without any reservation as one of that noble and beautiful company of wholly civilized and loveable men and women who represent the best of the now vanished late Victorian world. It may be that they lived a charmed life in an age of greater innocence than ours, but whatever the reason may be, and however fortunate their condition was, they succeeded in living the way all good people yearn to live— which included integrity and sustaining love. They combined the high principles of their puritan origins with a natural and romantic delight in the divinely created beauties of nature and mankind, and they always looked ahead toward some sort of human fulfillment. They never doubted the worth of their effort to attain virtue and beauty. They were mostly, of course, cultural aristocrats, and lived in comfort and security. They were the lucky ones. But the world they made for themselves was in all ways as good as any achieved by mankind."

9. Ruth Furness [Porter], *Lucy Fairfield, My Mother and My Granddaughter* (private printing, n.d.), 13–14.
10. Eliot Porter, *Eliot Porter,* 13.
11. Eliot Porter, *Eliot Porter,* 12.
12. Cummings interview, 1968.
13. Eliot Porter, *Eliot Porter,* 13.
14. Eliot Porter, *Eliot Porter,* 12.
15. Eliot Porter, *Eliot Porter,* 14–15.
16. Eliot Porter, interview with JTS, 1989.
17. Ruth Porter, letter to Field, 14 June 1923.
18. Cummings interview, 1968.
19. Cummings interview, 1968.
20. Letter to John Ashbery, n.d. [1950s].
21. Ruth Porter, letter to Nancy Porter Straus, 15 July 1924.
22. Cummings interview, 1968.
23. Ruth Porter, letter to Nancy Porter Straus, 23 August 1924.
24. John Walker, *Self-Portrait with Donors* (Boston: Little, Brown, 1974), 23.
25. Cummings interview, 1968.
26. Eliot Porter interviews with JTS, 24 May 1989 and 5 June 1989, wherein he stated that he and Fairfield were not especially friendly until the 1960s; thereafter they enjoyed each other's company on the island.
27. Letter to Ruth Porter, 12 November 1924.
28. Letter to Ruth Porter, 9 December 1924.
29. Letter to Ruth Porter, 19 March 1925.
30. Letter to Ruth Porter, 2 April 1925.
31. Cummings interview, 1968.
32. Ruth Porter, letter to Nancy Porter Straus, 11 June 1925.
33. Ruth Porter, letter to Nancy Porter Straus, 11 June 1925.
34. Ruth Porter, letter to Margaret Furness, 9 July 1925.
35. Letter to Ruth Porter, 28 October 1925.
36. Letter to Ruth Porter, 28 October 1925.
37. Letter to Ruth Porter, 13/16 November 1925.
38. Walker, *Self-Portrait,* 24.
39. Letter to Ruth Porter, 10 December 1925.
40. Letter to Ruth Porter, 10 December 1925.
41. Letter to Ruth Porter, 8/11 January 1926.
42. Walker, *Self-Portrait,* 22.
43. Letter to Ruth Porter, 8/11 January 1926.
44. Letter to Ruth Porter, n.d. March 1926.
45. Ruth Porter, letter to Nancy Porter Straus, 2 July 1926.
46. Eliot Porter, *Summer Island,* 29.

47. Ruth Porter, letter to Nancy Porter Straus, 5 July 1926.
48. Letter to Ruth Porter, 1 October 1923.
49. Ruth Porter, letter to Nancy Porter Straus, 2 July 1926.
50. Letter to Ruth Porter, n.d. March 1926.
51. Ruth Porter, letter to Nancy Porter Straus, 5 July 1926.
52. Letter to Alan Wald, 5 August 1974.
53. Letter to Ruth Porter, 15 September 1927.
54. Letter to Ruth Porter, 15 September 1927.
55. Letter to Ruth Porter, 15 September 1927.
56. Letter to Ruth Porter, 15 September 1927.
57. Fairfield Porter files, registrar, Harvard College, Cambridge, Mass.
58. Letter to Ruth Porter, 7 November 1927.
59. Letter to Ruth Porter, 27 November 1927.
60. Fairfield Porter files, registrar, Harvard College, Cambridge, Mass.
61. Cummings interview, 1968.
62. Cummings interview, 1968.
63. Cummings interview, 1968.
64. Cummings interview, 1968.
65. Cummings interview, 1968.
66. Cummings interview, 1968.
67. Cummings interview, 1968.
68. Cummings interview, 1968.
69. Letter to Ruth Porter, 12 December 1931.
70. A label on its back reads: "John Porter c/o Wesleyan University." John Porter attended Wesleyan from 1930 to 1934.
71. Anne Porter, interview with JTS, 2 July 1988.
72. Albert Christ-Janer, *Boardman Robinson* (Chicago: University of Chicago Press, 1946), 43.
73. These notes on Porter's travels with his mother are taken from Ruth Porter's travel diary, 1931, AAA, microfilm reel 2676.
74. Nicky Mariano, *Forty Years with Berenson* (New York: Alfred A. Knopf, 1967), 146.
75. Letter to Ruth Porter, n.d. [October] 1931.
76. Cummings interview, 1968.
77. Letter to Ruth Porter, n.d. [October/November] 1931.
78. Letter to Ruth Porter, 28 November 1931.
79. Letter to Ruth Porter, 12 December 1931.
80. Alan Gussow, *A Sense of Place* (San Francisco: Friends of the Earth, 1972), 145.
81. Joan Ludman, *Fairfield Porter: A Catalogue Raisonné of His Prints* (Westbury, New York: Highland House, 1981), cat. no. L.1.
82. Letter to Anne Porter, 11 February 1932.
83. Christ-Janer, *Boardman Robinson,* 60.
84. Letter to Anne Porter, n.d. 1932.
85. Letter to Anne Porter, n.d. [August/September] 1932.

THE PORTERS IN NEW YORK AND WINNETKA 1932–1949
1. Some of these drawings are preserved in the AAA files.
2. APL2, 12 December 1932.
3. APL2, 10 January 1933.
4. APL, 4 May 1933.
5. Christ-Janer, *Boardman Robinson,* 43.

6. Cummings interview, 1968.
7. APL2, 25 May 1933.
8. APL, n.d. June 1933.
9. APL, n.d. August? 1933.
10. Anne Porter, interview with JTS, 9 April 1988.
11. Ruth Porter, letter to Nancy Porter Straus, 12 October 1933.
12. APL, 30 October 1933.
13. APL, 19 November 1933.
14. APL2, n.d. 1934.
15. APL, 12 December 1933.
16. APL2, 25 January 1934.
17. APL, 1 May 1934.
18. Eliot Porter, unpublished lecture read at the Amon Carter Museum, Fort Worth, 31 October 1987.
19. John Berry, in "The Life and Films of a Political Creature," *International Herald Tribune,* 2 July 1991, back page.
20. APL, 1 May 1934.
21. APL, 8 May 1934.
22. APL, n.d. June 1934.
23. APL, 6 August 1934.
24. APL, 15 August 1934.
25. Thomas B. Hess, "Some Recent Directions," *Art News Annual* 25, 1956.
26. APL, 19 November 1934.
27. APL, n.d. 1934–35.
28. Letter to Ruth Porter, 22 January 1935.
29. Cummings interview, 6 June 1986.
30. Ruth Porter, letter to Nancy Porter Straus, 8 February 1935.
31. Cummings interview, 6 June 1986.
32. Cummings interview, 6 June 1986.
33. APL, 13 February 1935.
34. Letter to Anne Porter, n.d. 1935.
35. APL2, 6 March 1935.
36. Letter to Ruth Porter, 1935.
37. "Murals for Workers," quoted in Rackstraw Downes, ed., *Fairfield Porter: Art in Its Own Terms: Selected Criticism 1935–1975* (New York: Taplinger, 1979), 245.
38. The drawing is in the Porter material in the AAA.
39. APL2, 19 March 1936.
40. Alan M. Wald, "John Wheelwright," *Dictionary of Literary Biography,* 45, 434–35. Porter was in correspondence with Wheelwright by December 1935, but must have known him earlier, since both had been editors of *Arise* magazine.
41. Letter to Alan Wald, 5 August 1974; Cummings interview, 1968.
42. See the excellent discussion of these prints in Ludman, *Fairfield Porter,* cat. no. L.2–7.
43. Wald, "John Wheelwright," 439.
44. Letter to John Wheelwright, n.d. 1936.
45. Ludman, *Fairfield Porter,* 53.
46. Letter to John Wheelwright, n.d. 1936 [1].
47. Letter to John Wheelwright, n.d. 1936 [2].
48. APL2, 19 March 1936.
49. APL, 9 March 1936.
50. Some examples were included in the Porter Estate donations to the Parrish Art Museum, Southampton, New York.
51. Letter to John Wheelwright, n.d. 1936 [1].
52. Letter to John Wheelwright, 29 October 1936.

53. Letter to John Wheelwright, n.d. 1936 [3].

54. Letter to Katharine Channing, 13 January 1937.

55. Letter to Katharine Channing, 13 January 1937.

56. Letter to Alan Wald, 5 August 1974.

57. Letter to John Wheelwright, n.d. [1938?].

58. Letter to John Wheelwright, 13 March 1937; APL, 18 March 1937.

59. APL, 24 March 1937.

60. APL, 8 April 1937 and 19 April 1937.

61. Letter to John Wheelwright, 13 March 1937.

62. APL, 7 June 1937.

63. APL, n.d. July 1937; APL, 2 August 1937; APL, 17 August 1937; APL, 2 August 1937; APL2, 25 August 1937.

64. Ludman, *Fairfield Porter,* cat. no. L.7.

65. APL, 18 May 1937: "The League for Industrial Democracy called up and asked us to hear a member (Paul Hagen) of the German anti-nazi movement speak. So we offered our house. He says there is a little criticism and opposition just beginning to take shape in Germany, but the only possible organization is a contact between 3 or 4 in each large town."

66. Cummings interview, 1968.

67. Letter to Alan Wald, 5 August 1974.

68. Edith Schloss's unpublished memoir, "Fairfield Porter," May 1984 (hereafter Schloss memoir), is my source for this verbal portrait. I am grateful to her for making this and other Porter memorabilia available to me.

69. Letter to John Wheelwright, n.d. 1939.

70. Letter to Katharine Channing, 9 January 1938.

71. APL, 31 January 1938.

72. Fairfield Porter, lecture, "What is Art," 2 November 1964, AAA; published, with minor changes, in Downes, ed., *Art in Its Own Terms,* 260.

73. Anne Porter, interview, 2 July 1988.

74. Letter to Anne Porter, 25 March 1938.

75. APL2, n.d. Winter 1938.

76. APL2, 2 May 1938.

77. APL2, 2 May 1938; APL, 10 May 1938.

78. APL2, 2 May 1938. Anne Porter, letter to JTS, n.d. [1990]: "About Johnny: when he was small, F. spent hours and hours with him taking him to swim in Lake Michigan, etc., building him a spiral staircase in a tree because Johnny was fascinated by spiral staircases. F. got somewhat burnt out and discouraged—but though we were told by an eminent psychiatrist [in 1949] that John would 'become a vegetable,' the opposite happened. He never got 'normal,' but he grew more and more outgoing and warm as he grew older. And I think though F. never realized it, his early dedication to Johnny was one reason Johnny developed, instead of freezing up."

79. Cummings interview, 1968.

80. Cummings interview, 1968.

81. Letter to Alfred Stieglitz, 14 April 1939.

82. Eliot Porter lecture, Amon Carter Museum, Fort Worth, 1987.

83. *New York Sun,* 31 December 1938.

84. APL, 2 October 1939.

85. Letter to Paul Mattick, 20 November 1939.

86. Walter Auerbach, letter to Fairfield Porter, 26 November 1939, AAA.

87. APL, 3 October 1940.

88. APL2, 26 September 1938: "Fairfield and I had lunch with an editor of the Partisan Review and his wife from New York. I was proud because they had just heard of Fairfield as a good person to see in Chicago."

89. Letter to Paul Mattick, 20 September 1940.

90. Letter to Katharine Channing, Thanksgiving, November 1940.

91. Letter to Katharine Channing, Thanksgiving, November 1940.

92. Letter to Alfred Stieglitz, 14 April 1939.

93. Letter to Katharine Channing, November 1940.

94. Letter to Paul Mattick, 5 December 1940.

95. Letter to the editor, *Partisan Review* (January–February 1941): 77.

96. Letter to the editor, *Partisan Review* (January–February 1941): 77.

97. Downes, ed., *Art in Its Own Terms,* 239.

98. Letter to the editor, *Kenyon Review,* 9 December 1940.

99. APL2, 19 November 1945.

100. Letter to Paul Mattick, 20 December n.d. [1940].

101. Letter to Paul Mattick, 7 January n.d. [1941].

102. Letter to Paul Mattick, 31 January 1941.

103. Letter to Paul Mattick, 4 July 1941.

104. Letter to Alan Wald, 5 August 1974.

105. Letter to Paul Mattick, 4 July 1941.

106. APL, n.d. Summer 1941.

107. Rexroth is mentioned in several letters to Anne Porter, October 1941.

108. APL2, 16 December 1941.

109. Letter to Ruth Porter, 10 January 1942.

110. APL2, 12 January 1942.

111. APL2, 21 January 1942.

112. Letter to Alan Wald, 5 August 1974.

113. Walter Auerbach, letter to Fairfield Porter, 28 March 1942.

114. APL2, 2 April 1942.

115. AP letter to JTS, n.d. [1990]; APL2, 2 April 1942.

116. Letter to Anne Porter, n.d. Summer 1942.

117. Letter to Anne Porter, 25 August 1942.

118. The 1943 appraisal is in the Porter files in the AAA. Edith Schloss described the paintings owned by Porter in around 1943 in a symposium presentation at the Parrish Art Museum, Southampton, New York, on 2 June 1984: "In one room was the studio. Near Fairfield's palette stood a little pot filled with a fatty emulsion which looked like vaseline, the Maroger medium. It gave the painting surface a glossy fluid veneer. It had a special varnishy smell which pervaded the house.

Downstairs in the living room, where everyone was earnestly considering political problems, there were a wide grey couch, armchairs, a fireplace, and again the comfortable looseness of the other rooms, nothing ever too ordered. But what fascinated me, an art student, most, were all the honest to goodness pictures on the walls.

The one which then I liked best, was a social conscious Orozco of armed Mexican peasants. There was also a long painting, of some ladies in a row, a little Pompeian, a little mysterious, but curiously modern, which I later found out

was a De Kooning. A watercolor outlined within a jagged shape, of chunky islands on a rough sea, was a Marin, modern enough.

But another painting, though a little awkward, was not exactly traditional either. It showed a wide arm of land around an inlet. In it swam black and white boats on pale water against a scatter of white houses on pastured land. In the background a jagged row of blackgreen spruces were sticking their sharp tips into a blue evening sky. There was not a single person in the stillness . . . There was something stiff about it, but at the same time its straightforwardness was moving.

This was only an early version of one of Fairfield's most constant themes, the harbor of Great Spruce Head Island in Maine." Schloss memoir.

119. The inventory is on file in the AAA.
120. Schloss memoir.
121. Original documents are in the AAA.
122. APL2, 14 August 1944; APL2, 12 November 1944.
123. Schloss memoir.
124. Cummings interview, 1968.
125. This recipe for Maroger's Medium is taken from a Fairfield Porter letter to an unidentified Miss Barlow, 23 January 1969.
126. Cummings interview, 1968.
127. Cummings interview, 1968.
128. Quoted in APL2, 11 October 1945.
129. For a "Frenchman named van Hooten" who knew Degas and Renoir, see APL2, 1 November 1945; Cummings interview, 1968; and Michael Benedikt's article published in 1964 (*infra*). Porter's artist friend must have been Georges Houten, a Belgian painter born at the end of the nineteenth century. Houten exhibited nudes and landscapes at the Salon des Indépendents in Paris, beginning in 1910. Porter gave the name as "Mr. van Houten" in a letter to Katharine Channing of 6 February 1947. Anne Porter, in correspondence with the author, 1990, recalls that the artist was in fact Belgian and that he spoke of knowing Bonnard and Vuillard.

In his 1968 interview Porter gave 1939 as the date of this and several other events that apparently took place during World War II, or just afterward. Although his memories were vivid and accurate (as his surviving letters and other documents bear out), he was often only approximate in his dates. For example, Porter wrote to Alan Wald, 5 August 1974, that he had met John Wheelwright in 1937, although he had certainly known him by 1935; Porter also remembered moving to Chicago in 1939 and then back to New York in 1940, when in fact these moves took place in 1936 and 1939, respectively.
130. Cummings interview, 1968.
131. Michael Benedikt, "Fairfield Porter: Minimum of Melodrama," *Art News* (March 1964): 36.
132. Cummings interview, 1968.
133. APL2, 6 December 1945.
134. Letter to John Wheelwright, n.d. 1936 [1].
135. Letter to Katharine Channing, 8 February 1946.
136. APL2, 20 December 1945.
137. Letter to Katharine Channing, 8 February 1946.
138. APL2, 4 June 1946.
139. APL2, 12 May 1946.
140. APL2, 16 July 1946.
141. APL2, n.d. August 1946.
142. APL2, 11 November 1946.
143. Letter to Katharine Channing, 6 February 1947.
144. APL2, 3 December 1946.
145. APL2, 1 March 1947.
146. Cummings interview, 1968.
147. In his 1968 interview with Paul Cummings, and on other occasions, Porter recalled meeting other artists at Stewart's Cafeteria, on Twenty-third Street and Seventh Avenue, after the war was over; however, Edith Schloss, in her memoir of May 1984, recalls that the first time she joined Porter, de Kooning, and others at Stewart's, the war was still on.
148. Thomas B. Hess, *Willem de Kooning*. Exh. cat. (New York: Museum of Modern Art, 1968), 15.
149. Fairfield Porter, "Technology and Artistic Perception," unpublished typescript, AAA, microfilm reel 1311, 724.
150. APL2, 10 April 1947.
151. APL2, 10 May 1947.
152. APL2, 10 May 1947.
153. APL2, 28 June 1947.
154. APL2, 14 July 1947.
155. APL2, 30 March 1948.
156. APL2, 20 October 1947.
157. The film is cited in APL2, 29 February 1948, as *Black Beauty*. AP wondered in 1990 if it had not instead been Cocteau's *Beauty and the Beast*.
158. APL2, 26 May 1948, mentions a visit to the Bonnard exhibition.
159. APL2, 24 April 1949.
160. APL2, 5 August 1949.
161. APL2, n.d. September 1949.
162. APL2, 14 October 1949.

SOUTHAMPTON, *ART NEWS*, AND *THE NATION* 1949–1961

1. Anne Porter, interview, 2 July 1988.
2. Anne Porter commented in 1990 to JTS: "Fairfield thought, since Southampton is partly a resort we could afford to go to Maine by renting the house in the summer."
3. Letter to Katharine and Hal Channing, 8 January 1950.
4. Letter to Katharine and Hal Channing, 8 January 1950.
5. APL2, n.d. July 1950; APL2, n.d. August 1950.
6. Letter to Metropolitan Museum of Art, 5 January 1951, AAA.
7. Letter to Metropolitan Museum of Art, 5 January 1951. Porter pursued this theme in an article in the *The Nation*, 4 July 1959, reprinted in Downes, ed., *Art in Its Own Terms*, 164–66.
8. Its present location is unknown. The painting was included in the 1983–84 retrospective exhibition, *Fairfield Porter (1907–1975): Realist Painter in an Age of Abstraction*, and is illustrated in color in the exhibition catalogue of the same title (Boston: Museum of Fine Arts, 1983), fig. 7.
9. APL, n.d. March 1951.
10. Cummings interview, 1968; Letter to Aline Porter, 25 December 1952.
11. Letter to Aline Porter, 25 December 1952.
12. APL2, 3 September 1951.

13. Cummings interview, 1968.
14. This and following quotations from Porter's reviews are reprinted in Downes, ed., *Art in Its Own Terms,* 163, 19, 73, 178, 194, and 168, respectively.
15. Hilton Kramer, "Unexpected Linkages," *New York Times Book Review,* 3 June 1979, 13.
16. Cummings interview, 1968.
17. Downes, ed., *Art in Its Own Terms,* 187.
18. Jane Freilicher, interview with JTS, 1989.
19. Letter to Lawrence Campbell, 27 June 1952.
20. The date of this first exhibition is often cited erroneously as 1951 (cf. *Fairfield Porter,* exh. cat. 1983–84, 95).
21. John Bernard Myers in *Fairfield Porter: Realist Painter,* exh. cat., 1983, 41.
22. Letter to Aline Porter, 25 December 1952.
23. APL2, 1 October 1952.
24. "Reviews and Previews," *Art News* (October 1952).
25. James Fitzsimmons, "Fairfield Porter," *Art Digest,* 1 November 1952, 19–20.
26. Letter to Fairfield Porter, 27 October 1952.
27. Philip Evergood, letter to Fairfield Porter, 18 November 1952.
28. Schloss memoir.
29. John Ashbery, *Reported Sightings* (New York: Alfred A. Knopf, 1989), 239.
30. Letter to Aline Porter, 25 December 1952.
31. Cummings interview, 1968.
32. Cummings interview, 1968.
33. Letter to Leon Hartl, n.d. [1952?], AAA.
34. Letter to Lawrence Campbell, 14 June 1952. See also John Bernard Myers, *Tracking the Marvelous* (New York: Random House, 1983), 144: "As the dour colors in Fairfield's paintings began to lighten and move to a higher key, I asked him how this had come about. 'Looking at Jane's work,' he said. 'Her use of color has influenced my work a lot.'"
35. APL2, 28 April 1953.
36. Larry Rivers, letter to Fairfield Porter, n.d. 1953, AAA; letter to Larry Rivers, n.d. March 1953.
37. APL2, n.d. July 1953.
38. APL2, n.d. August 1953.
39. Porter summed up his feature articles to date in a letter, 25 December 1952, to Aline Porter. "I am in New York for the first two weeks of every month, reviewing, and interviewing artists for "——— Paints a Picture" articles. I have published one on Evergood and on Vasilieff, finished one on Herman Rose, am writing on Leon Hartl and [Jack] Tworkov, and slated to do Frank Wallace and Reuben Nakian. All except Evergood, the first one, were my choice and idea, especially Wallace and Hartl, whom I called to the attention of *Art News,* who either did not know of them, or had (Hartl) forgotten."
40. APL2, 31 August 1953.
41. Information about the film was kindly provided by Edith Schloss in a letter, 1991.
42. APL2, 11 September 1953.
43. APL2, 16 November 1953.
44. The Rivers portrait is illustrated in Judith E. Stein and Paul Schimmel, eds., *The Figurative Fifties: New York Figurative Expressionism.* Exh. cat. (Newport Beach, Calif.: Newport Harbor Art Museum, 1988), no. 70.
45. Letter to Frank O'Hara, n.d. 1955.
46. Anne Porter, interview, 2 May 1989.
47. APL, n.d. Summer 1954.
48. Quoted and paraphrased from Schloss memoir.
49. APL, 5 March 1955.
50. Letter to Katharine Channing, n.d. [January] 1955.
51. APL, 19 March 1955.
52. Letter to Kenneth Koch, n.d. [summer] 1956.
53. *Collected Poems,* 71–72.
54. Letter to Thomas B. Hess, 19 December 1955.
55. Abram Lerner, ed., *The Hirshhorn Museum and Sculpture Garden* (New York: Harry N. Abrams, 1974), 736, publishes comments that Porter made many years later, in 1972; his painting technique of the 1950s then seemed to him like Whistler's in its thinness: "Though I painted *Katie and Anne* seventeen years ago, I can identify with and recall the process of painting it. I think that learning to paint—which, having started, one continues all one's life—is very much a matter of having the energy to put aside almost all that one has been told, especially all that one thought important, in favor of trusting the process of watching it closely. I try to get rid of irrelevant consciousness which expresses what is outside of and unrelated to the painting in question. This one went easily, and it seemed 'finished' almost from the beginning, in a way I think Whistler meant, and it is easier to achieve an organic whole. But when I last saw it, a few years ago, I found it perhaps too thin, that is to say, unsubstantial: I hadn't trusted the materiality of the paint enough, out of a cautious desire to 'keep an easiness'. So I must also put aside what Whistler told me."
56. Letter to Kenneth Koch, 20 June 1955.
57. Letter to Frank O'Hara, 8 July 1955.
58. Letter to Frank O'Hara, 1 August 1955.
59. Letter to Frank O'Hara, 8 July 1955.
60. Letter to Frank O'Hara, 8 July 1955.
61. Downes, ed., *Art in Its Own Terms,* 204.
62. Letter to Kenneth Koch, 30 December 1955.
63. Laurence Porter, letter to JTS, 1990: "Despite Anne's modesty, one fact of her life really must be mentioned as a major event affecting all the family: her conversion to Catholicism, following twenty years of study and reflection, in early 1954 or early 1955. Lizzie was therefore a Catholic by birth, and Katie by conversion."
64. APL, n.d. November, 1955.
65. Letter to Laurence Porter, n.d. March 1956.
66. David Smith, postcard to Fairfield Porter, 27 March 1956, AAA.
67. Raphael Soyer, letter to Fairfield Porter, 1 May 1956, AAA.
68. Cummings interview, 1968.
69. Letter to Laurence Porter, n.d. March 1956.
70. Letter to Laurence Porter, 10 March 1956.
71. Letter to Laurence Porter, n.d. October 1956.
72. APL, 13 December 1956.
73. Letter to Laurence Porter, n.d. February 1957.
74. APL, n.d. April 1957. The similarities between this lost painting and the large composition of exactly a year later suggest the possibility that the date of 1957 on this extract in

APL is a misreading for 1958. The original letter is not preserved.

75. Letter to Laurence Porter, 25 July 1957.

76. Jane Wilson in *Fairfield Porter: Portraits*. Exh. cat. (Stamford, Conn.: Whitney Museum of American Art, Fairfield County, 8 June–22 August 1984).

77. Letter to Kenneth Koch, n.d. Summer 1957.

78. Letter to Laurence Porter, n.d. August 1957.

79. Porter had previously analyzed her poetry in a letter to Thomas Hess, 19 December 1955: "I think my admiration for Elizabeth Bishop's poems, aside from the fact that she has a descriptive visual mind, and aside from the fact that she has humor and is not sentimental, comes from an admiration of her relaxed line which allows each word enough space to be savored properly for what it is; and this comes from knowing when to change as well as when to repeat, how to keep such a distance that you pay attention and can go on, as you might go over the surface of a canvas, and not get stuck by boring repetitions or boring variations."

80. Letter to Arthur Giardelli, n.d. 1958.

81. Letter to Arthur Giardelli, 2 March 1958.

82. APL, 3 May 1958.

83. Letter to Arthur Giardelli, 25 May 1958.

84. APL, n.d. June 1958, describes "Katie reading at the little desk you [Katharine Channing] gave her." Katie is not reading, however, in the painting now in Nebraska; either Porter repainted this passage, or he may have worked on more than one version at the time.

85. Tibor de Nagy, interview with JTS, 20 April 1990. Cf. letter to Tibor de Nagy, 21 August 1958.

86. Anne Porter, interview, 27 December 1988.

87. Letter to Katharine Channing, n.d. 1960.

88. Sumner Winebaum, letter to Joan Ludman, 1 August 1991.

89. Letter to Katharine Channing, n.d. 1960.

90. Cummings interview, 1968.

91. Anne Porter, interview, 27 December 1988.

92. APL, n.d. 1959.

93. Hilton Kramer, "Critics of American Painting," *Arts* (October 1959): 26.

94. Lincoln Kirstein, *Nation*, 12 December 1959, 448.

95. Fairfield Porter, *Eakins*, Great American Artists series (New York: George Braziller, 1959), 26.

96. Porter, *Eakins*, 27.

97. Cummings interview, 1968.

98. Downes, ed., *Art in Its Own Terms*, 36.

99. Cummings interview, 1968.

100. Letter to Aline Porter, 8 October 1959

101. Downes, ed., *Art in Its Own Terms*, 54.

102. Frank O'Hara, postcard to Fairfield Porter, 5 October 1959, AAA.

103. Letter to Aline Porter, 8 October 1959

104. Letter to Robert Dash, n.d. May 1960.

105. Letter to Howard Griffin, 12 June 1960.

106. Letter to Tibor de Nagy, 16 July 1960.

107. Letter to Howard Griffin, 20 July 1960.

108. Letter to Robert Dash, 26 June 1960.

109. Letter to Robert Dash, n.d. June 1960.

110. Letter to Howard Griffin, 20 July 1960.

111. Letter to Robert Dash, 23 July 1960.

112. Tibor de Nagy, interview, 1990.

113. Letter to Aline Porter, 12 December 1960.

114. Letter to Howard Griffin, 28 January 1961.

115. See Ludman, *Fairfield Porter*, cat. no. L.11–16, for this lithograph series.

116. Letter to Arthur Giardelli, 15 January 1961.

117. Letter to Carl Morse, 31 January 1961.

118. Letter to Howard Griffin, 12 May 1961.

119. Letter to Howard Griffin, 3 June 1961.

120. Letter to Howard Griffin, 20 June 1961. The painter Neil Welliver, letter to JTS, 15 February 1991, recalls, "On another occasion Fairfield and I walked into John Myers's office at the Tibor de Nagy gallery. We were working on a book of New York School Poets. John had a dummy of the book and with great fanfare began taking us on an imaginary trip through the book, showing us approximately where our drawings would appear. 'Fairfield, you will be here, and John Ashbery's poems there, and Jane Freilicher's drawings there and Frank O'Hara's poems here,' finally saying, 'Isn't it marvelous?' Fairfield replied without expression, 'No.' and walked to the elevator. I followed and said as we were riding down, 'Fairfield, why in hell did you do that? John was crushed.' Fairfield replied, 'A book of poems should fit in your pocket.' 'Why didn't you say that to John?' 'He wouldn't have understood.'"

121. Letter to Howard Griffin, 20 June 1961.

THE BEST OF A VERY SMALL NUMBER 1961–1966

1. Letter to Leon Hartl, 11 July 1961.

2. Letter to Howard Griffin, 12 May 1961.

3. Anne Porter, interview, 27 December 1988.

4. Kenneth Koch, interview with JTS, August 1989.

5. Letter to Robert Dash, 27 July 1961.

6. *Fairfield Porter: Realist Painter*. Exh. cat. 1983, 41 and 46.

7. Kenneth Koch, interview with JTS, 1989.

8. Rackstraw Downes, letter to JTS, 6 November 1990.

9. Letter to Robert Dash, 27 July 1961.

10. Schloss memoir.

11. Letter to Robert Dash, 10 August 1961.

12. Letter to Robert Dash, 10 August 1961.

13. Letter to Lawrence Campbell, 25 August 1961.

14. Quoted in *The Neuberger Collection: An American Collection*. Exh. cat. (Providence: Museum of Art, Rhode Island School of Design, and Washington, D.C.: National Collection of Fine Arts, 1968), no. 407.

15. Letter to Carl Morse, 8 June 1962.

16. Letter to Carl Morse, 1 August 1962.

17. More than one hundred paintings were donated by the Porter Estate to the Parrish Art Museum, Southampton, New York, representing an endowment of unique importance. Unfortunately, none of these works is on public display.

18. Letter to John Myers and Tibor de Nagy, n.d. [1965?].

19. Porter is known to have owned two paintings by de Kooning in the 1940s, the *Three Classical Female Figures*, listed in his 1943 inventory, and a painting that Edith Schloss saw him

purchase from de Kooning only a few years later: "One day while I was visiting Rudy Burckhardt's studio on 23rd Street, Fairfield came in from his own studio next door. Bill de Kooning arrived too, unpacking a painting Fairfield wanted. I can see it now. It was shiny paint smoothed on paper. It was small. It had green in it, but mostly there was a lot of bright deep red, something then quite outrageous. There were some square shapes on it and a pod shape dancing on tentacles, a sort of bell octopus. Bill had put the painting down on the table. Fairfield put his checkbook down and made out a check for 75, maybe a 100 dollars. This was then an enormous sum. I was amazed. I was witnessing the buying of a living painter's painting." Schloss memoir.

20. Letter to Tibor de Nagy, 29 June 1962.
21. Letter to Robert Dash, 21 August 1962.
22. Letter to Carl Morse, 1 August 1962.
23. Letter to Robert Dash, 21 August 1962.
24. Letter to Carl Morse, 1 August 1962.
25. Letter to Lucien Day, 23 July 1962.
26. Letter to Robert Dash, 21 August 1962.
27. Letter to Carl Morse, 1 August 1962.
28. Letter to Lucien Day, 23 July 1962.
29. Letter to Lucien Day, 23 July 1962.
30. Letter to Robert Dash, 21 August 1962. Liquitex, a water-based, acrylic polymer emulsion paint was first manufactured by Permanent Pigments in 1956. Porter is described as using it as a temperalike substitute for casein by Brie Taylor, "Towards a Plastic Revolution," *Art News* (March 1964).
31. Letter to Robert Dash, 21 August 1962.
32. Letter to Robert Dash, 21 August 1962.
33. Letter to Carl Morse, 1 August 1962.
34. Letter to Carl Morse, 1 August 1962.
35. Letter to Robert Dash, 21 August 1962.
36. Hilton Kramer, "The Duality of Fairfield Porter," in "New York, Season's Gleanings," *Art in America* (June 1963): 134.
37. Letter to Lawrence Campbell, 27 March 1963.
38. Letter to John Myers and Tibor de Nagy, 31 January 1963.
39. Letter to John Myers and Tibor de Nagy, 15 February 1963.
40. Letter to John Myers, 27 September 1963.
41. Anne Porter, letter to JTS, 1990, comments that Porter's gross income must have surpassed the approximately $6,000 that he projected in his February 1963 letter to Myers and de Nagy, because he was paying at least $600 monthly for Johnny Porter's care in Vermont. It appears that Porter excluded this expense (and corresponding Porter Trust income) from the accounting that he sent to Myers and de Nagy. The fact remains that the Porters were obliged to count pennies during the late 1950s and early 1960s.
42. Letter to John Myers and Tibor de Nagy, 10 January 1964.
43. Anne Porter, interview, 10 April 1988.
44. Benedikt, "Fairfield Porter: Minimum," 37.
45. Elizabeth is painted in a pose, arms akimbo, with furrowed brow and jutting lip, that one often finds in Elizabethan portraits of the English monarch. Her facial expression evokes, for example, the famous portraits by Holbein and Mor.
46. Cummings interview, 1968.
47. Porter, in a letter to Allen C. Dubois, 8 April 1963, AAA, categorically ruled out a different sort of interpretation, that of "hidden faces" or other shapes in his canvases. "Moses Soyer is right that I didn't intend to paint any of the things you imagine in the picture; also I couldn't see them myself, in spite of your list."
48. FP letter, 2 December 1963.
49. Downes, ed., *Art in Its Own Terms*, 69–70.
50. Cummings interview, 1968.
51. Jerrold Lanes, "Fairfield Porter's Recent Work," *Arts* (April 1964).
52. Letter to the editor, "The Plane in Maine," *Arts* (October 1964).
53. Letter to John Myers, 18 April 1964.
54. Information regarding Porter's receipts from, and financial arrangements with, Tibor de Nagy Gallery is based on original documents, AAA.
55. Letter to Laurence Porter, 25 February 1964.
56. Downes, ed., *Art in Its Own Terms,* 259, 263. First published as "Art and Knowledge," *Art News* (February 1966).
57. "Artists and Technicians," typescript, AAA microfilm 1311, 761.
58. "What is Art," second lecture in the 1964–65 University Galleries Public Lecture Program, 2 November 1964, AAA. "Can Art Be Taught," lecture read at Southampton College, 6 April 1965, AAA.
59. Letter to Laurence Porter, 25 February 1964.
60. Anne Porter, interview.
61. Susan Shatter, letter to JTS, 26 April 1991.
62. Letter to Howard Griffin, 27 November 1965.
63. Letter to Howard Griffin, 27 November 1965.
64. The review is reprinted in Downes, ed., *Art in Its Own Terms,* 49.
65. Joseph Cornell, letter to Fairfield Porter, n.d. 1966, AAA.
66. The $1,500 price for *Flower Studies,* 40 x 50", by Freilicher was deducted from the financial statement that Tibor de Nagy Gallery sent to Porter on 25 January 1966, AAA.
67. Letter to Laurence Porter, 29 October 1965.
68. Letter to Laurence Porter, 29 October 1965.
69. Downes, ed., *Art in Its Own Terms*, 49.
70. Stein, *Figurative Fifties*, 47.
71. Hilton Kramer, "Fairfield Porter: Against the Historical Grain," *New York Times,* 20 February 1966.
72. Laurence Porter, quoted in Robin Eadie, "Fairfield Porter's *The Pump House,*" East Lansing, Michigan: Kresge Art Museum Bulletin 3 (1989): 13.
73. Edward B. Henning, introduction to "The Genre Art of Fairfield Porter." Exh. cat. (Cleveland Museum of Art, 1966).
74. Letter to Tibor de Nagy, 10 July 1966.

THE LAST YEARS 1967–1975

1. Letter to Laurence Porter, 13 December 1966.
2. Letter to Laurence Porter, n.d. October 1956.
3. Cummings interview, 1968.
4. *Columbus Day* is misdated 1968 in *Fairfield Porter: Realist Painter,* exh. cat., 1983, no. 69.
5. James Schuyler, "Immediacy Is the Message," *Art News* (March 1967).

6. Letter to Arthur Giardelli, 6 May 1967.

7. Letter to James Schuyler, 16 June 1967.

8. Letter to James Schuyler, 26 June 1967.

9. Anne Porter, interview, 27 December 1988.

10. Letter to James Schuyler, 9 July 1967.

11. Schloss memoir.

12. Letter to James Schuyler, 9 July 1967.

13. Letter to Arthur Giardelli, 2 August 1967.

14. Letter to James Schuyler, n.d. [August] 1967.

15. Letter to Edward Henning, 17 June 1971.

16. Letter to Arthur Giardelli, 16 August 1967.

17. Porter had painted various "murals for workers" during the 1930s.

18. Letter to Arthur Giardelli, 2 November 1967.

19. Letter to Arthur Giardelli, 16 August 1967.

20. Letter to Arthur Giardelli, 2 November 1967.

21. Anne Porter, interview, 27 December 1988.

22. Letter to John MacWhinnie, July 1968.

23. Letter to Arthur Giardelli, 3 August 1968.

24. Letter to Lucien Day, 20 August 1968.

25. See Norman A. Geske, *Venice 34: The Figurative Tradition in Recent American Art.* Exh. cat., United States Pavilion, Venice, 22 June–20 October 1968; National Collection of Fine Arts, Washington, D.C., 19 December 1968–2 February 1969; Sheldon Memorial Art Gallery, University of Nebraska, Lincoln, 17 March–13 April 1969.

26. Grace Glueck, "Nature with Manners," *New York Times* (Sunday), 19 January 1969.

27. Hilton Kramer, "The Art of Conservation," *New York Times,* 9 February 1969.

28. Letter to Lucien Day, 14 February 1969.

29. Letter to Laurence Porter, 19 February 1969; letter to Lucien Day, 14 February 1969.

30. Letter to John Myers and Tibor de Nagy, 18 April 1969.

31. Kenneth Koch, interview with JTS, 1989.

32. Letter to John Myers, 16 September 1989.

33. These paintings are not illustrated here because of difficulties in obtaining publication permission. Color reproductions of *Island Farmhouse* and *Interior with a Dress Pattern* are published in *Fairfield Porter: Realist Painter,* exh. cat., 1983, nos. 58 and 61, respectively.

34. Letter to Lucien Day, 22 October 1969.

35. Letter to John MacWhinnie, 30 October 1969.

36. Letter to Laurence Porter, 23 November 1969.

37. Letter to John Myers, 3 February 1970.

38. Letter to Laurence Porter, 20 February 1970.

39. Letter to Carl Morse, 5 May 1970.

40. Letter to Rackstraw Downes, 28 April 1970.

41. According to Tibor de Nagy, interview with JTS, 1990, Porter told him at the time that he wanted to remain with de Nagy Gallery, but did not want to hurt John Myers's feelings.

42. Tibor de Nagy interview.

43. Letter to Carl Morse, 5 May 1970.

44. Letter to Laurence Porter, 1 September 1970.

45. Ludman, *Fairfield Porter,* cat. L.19–22.

46. Letter to Lucien Day, 27 May 1971.

47. Letter to Laurence Porter, 8 July 1971.

48. Letter to Lucien Day, 14 August 1971.

49. Letter to Laurence Porter, 8 July 1971.

50. Letter to Lucien Day, 9 September 1971.

51. Letter to Laurence Porter, 1 January 1972.

52. Letter to Lucien Day, 6 February 1972.

53. Brooke Alexander, letter to Fairfield Porter, 14 February 1972, AAA.

54. Letter to Edith Schloss, 3 August 1972: "It was from island sketches and photographs."

55. Letter to Edith Schloss, 3 August 1972.

56. Letter to Dr. and Mrs. Harold Ludman, 22 September 1973.

57. Letter to Laurence Porter, 11 January 1973.

58. Rackstraw Downes, interview with Emmie Donadio, 28 February 1991. I am grateful to Jason Edward Kaufman for making a transcript available to me.

59. Letter to Laurence Porter, 12 May 1973.

60. Letter to Laurence Porter, 12 May 1973.

61. Letter to Joe Brainard, 17 August 1973.

62. Anina Porter Fuller, letter to JTS, recalls Porter lending her one of his Masonite boards to try.

63. Letter to Joe Brainard, 17 August 1973.

64. Letter to Joe Brainard, 17 August 1973.

65. Letter to Joe Brainard, 17 August 1973.

66. Letter to Laurence Porter, 14 January 1974.

67. Letter to Laurence Porter, 31 March 1974.

68. Letter to Laurence Porter, 29 April 1974.

69. Hilton Kramer, *New York Times,* 9 March 1974.

70. Letter to Laurence Porter, 29 April 1974.

71. Letter to Laurence Porter, 17 October 1974.

72. Anina Porter Fuller, letter to JTS, 1991.

73. Letter to Laurence Porter, 17 October 1974.

74. Neil Welliver, letter to JTS, 1991.

75. Letter to Laurence Porter, 27 November 1974.

76. Letter to Neil Welliver, 16 February 1975.

77. Letter to Laurence Porter, 1 January 1975.

78. Letter to Laurence Porter, 27 November 1974.

79. Letter to Rackstraw Downes, 8 November 1973.

80. Letter to Laurence Porter, 17 October 1974.

81. Letter to Aline Porter, 23 April 1975.

82. Letter to Laurence Porter, 5 May 1975.

83. Letter to Lucien Day, 21 August 1975; Neil Welliver recounts: "Lying on the floor in the corner of my studio was a large sheet of watercolor paper. Fairfield said, 'What is that?' 'A watercolor,' I replied. 'Why is it there?' he asked. 'I lost it,' I said. 'Watercolor can be worked over and over,' Fairfield told me. 'Oil on the other hand must be put down and left.'" Letter to JTS, 1991.

84. Letter to Laurence Porter, 8 July 1975.

85. Letter to Arthur Giardelli, 5 May 1975.

86. John Bernard Myers, in *Fairfield Porter: Realist Painter,* exh. cat., 1983, 46.

CHECKLIST OF THE PAINTINGS BY FAIRFIELD PORTER
BY JOAN LUDMAN

The checklist is arranged chronologically, and alphabetically within each year. Watercolors are on paper unless otherwise noted. Height precedes width. Works whose dates cover a period of years are listed according to the first year. Undated works appear at the end of this list, arranged alphabetically. Works whose location is unknown are not included here. The checklist is not a complete catalogue. The definitive catalogue raisonné is in preparation. —J. L.

1927

Black Sea. 1927. Oil on Masonite, 18⅛ x 24⅛". The Parrish Art Museum, Southampton, New York. Gift of the Estate of Fairfield Porter

New England Hills. 1927. Watercolor and pencil, 14⅛ x 20⅛". Christie's New York, 1985

Roofs of Cambridge. 1927. Watercolor on cardboard, 13⅞ x 20". The Parrish Art Museum, Southampton, New York. Gift of the Estate of Fairfield Porter

1928

Coast of Maine. 1928. Watercolor and pencil, 13⅞ x 20". Christie's New York, 1985

1929

Male Nude. c. 1929. Oil on Masonite, 36⅛ x 24". The Parrish Art Museum, Southampton, New York. Gift of the Estate of Fairfield Porter

Nude. c. 1929. Oil on Masonite, 36⅛ x 24⅛". The Parrish Art Museum, Southampton, New York. Gift of the Estate of Fairfield Porter

Subway. 1929. Oil on canvas mounted on Masonite, 16 x 24". Collection Mr. and Mrs. John Porter

1930

Barred Islands. c. 1930. Watercolor, 10½ x 21". Collection Mr. and Mrs. John Porter

Camden, Maine, Harbor. c. 1930. Oil on canvas board, 23½ x 30". Collection Mr. and Mrs. Harold Robbins

Overmantel (Men Cutting Trees). c. 1930–31. Canvas stretched over Masonite, 34½ x 76". The Parrish Art Museum, Southampton, New York. Gift of the Estate of Fairfield Porter

Springtime Meadow. c. 1930. Oil on Masonite, 22¾ x 34". Christie's New York, 1986

1931

Rome at Night. c. 1931. Watercolor, 17¹⁄₁₆ x 21½". The Parrish Art Museum, Southampton, New York. Gift of the Estate of Fairfield Porter

1932

Martha's Vineyard. c. 1932. Watercolor, 15⅜ x 22¹¹⁄₁₆". The Parrish Art Museum, Southampton, New York. Gift of the Estate of Fairfield Porter

Rome. 1932. Watercolor, 22¹¹⁄₁₆ x 15⅜". Collection Paton S. and Joanne K. Miller

1934

Isle Au Haut. c. 1934. Watercolor, 17⅜ x 22⅜". The Parrish Art Museum, Southampton, New York. Gift of the Estate of Fairfield Porter

1935

Schooner Dockside. c. 1935. Watercolor and ink, 17 x 22½". Collection Mr. and Mrs. John Porter

1937

Anne and Laurence. c. 1937. Tempera on canvas, 50 x 40". The Parrish Art Museum, Southampton, New York. Gift of the Estate of Fairfield Porter

1938

Allegorical Scene. 1938. Oil on panel, overmantel shape, 19½ at center, 14½ at ends, x 102". Collection Tampa Museum of Art, Florida

Seated Boy. c. 1938. Oil on Masonite, 18 x 14". The Parrish Art Museum, Southampton, New York. Gift of the Estate of Fairfield Porter

Seated Boy. c. 1938. Oil on Masonite, 33⅛ x 18⅞". The Parrish Art Museum, Southampton, New York. Gift of the Estate of Fairfield Porter

1939
Anne. c. 1939. Oil on canvas, 38¼ x 25⅜". The Parrish Art Museum, Southampton, New York. Gift of the Estate of Fairfield Porter

Portrait of Walter Auerbach. c. 1939–40. Oil on canvasboard, 24 x 18". Collection Ellen Auerbach

1940
Fairfield's Aunt Margaret Furness. c. 1940. Oil on canvas, 36 x 45". Fairfield Porter Estate

Islands—Maine. c. 1940. Watercolor, 17 x 22". Collection Mrs. Fairfield Porter

Red Cables. c. 1940. Oil on Masonite, 30½ x 23¾". The Parrish Art Museum, Southampton, New York. Gift of the Estate of Fairfield Porter

1942
Cityscape. c. 1942. Oil on canvas, 25 x 32". The Parrish Art Museum, Southampton, New York. Gift of the Estate of Fairfield Porter

Joe the Crow. c. 1942. Oil on Masonite, 12 x 16". Collection Mr. and Mrs. John Porter

Turn. c. 1942. Oil on Masonite, 24 x 30". The Parrish Art Museum, Southampton, New York. Gift of the Estate of Fairfield Porter

View toward Farmhouse with Flagpole. c. 1942. Oil on Masonite, 24 x 31½". Collection Mr. and Mrs. John Porter

1943
City Street. c. 1943. Oil on Masonite, 29¾ x 24". The Parrish Art Museum, Southampton, New York. Gift of the Estate of Fairfield Porter

Johnny in Cowboy Costume. c. 1943. Oil on canvas, 18½ x 17½". Collection Sarah Porter

Laurence. c. 1943. Oil on burlap, 50 x 40". The Parrish Art Museum, Southampton, New York. Gift of the Estate of Fairfield Porter

Second Avenue at 52nd Street. c. 1943. Oil on Masonite, 30 x 24". The Parrish Art Museum, Southampton, New York. Gift of the Estate of Fairfield Porter

Street Scene. c. 1943. Oil on Masonite, 23⅜ x 32⅛". The Parrish Art Museum, Southampton, New York. Gift of the Estate of Fairfield Porter

1944
Subway. c. 1944. Oil on canvas, 18 x 14". The Parrish Art Museum, Southampton, New York. Gift of the Estate of Fairfield Porter

1945
Cityscape. c. 1945. Oil on canvas, 25 x 30". Private collection

First Avenue. c. 1945. Oil on canvas, 31½ x 25¾". The Parrish Art Museum, Southampton, New York. Gift of the Estate of Fairfield Porter

Hennessey's Bar. c. 1945. Oil on canvas, 36 x 45". The Parrish Art Museum, Southampton, New York. Gift of the Estate of Fairfield Porter

House in Sandbrook, New Jersey. c. 1945. Oil on Masonite, 24 x 20⅛". The Parrish Art Museum, Southampton, New York. Gift of the Estate of Fairfield Porter

Islands. c. 1945. Oil on Masonite, 24¼ x 30⅛". The Parrish Art Museum, Southampton, New York. Gift of the Estate of Fairfield Porter

Laurence at Supper. c. 1945. Oil on paper, 18½ x 13". Collection Laurence and Laurel Porter

Minot/Channing Summer Home, Wareham, Massachusetts. c. 1945. Oil on Masonite, 22 x 24½". Private Collection

Parked Cars. c. 1945. Oil on burlap, 30⅛ x 25⅛". The Parrish Art Museum, Southampton, New York. Gift of the Estate of Fairfield Porter

Still Life with Flower Basket, Shells, Scissors. c. 1945–50. Oil on canvas, 21 x 15½". Collection Ellen Auerbach

Study for *Anne Reading to Laurence.* c. 1945. Oil on canvas, 51 x 40¾". The Parrish Art Museum, Southampton, New York. Gift of the Estate of Fairfield Porter

Wines and Liquors No. 1. c. 1945. Oil on canvas, 36 x 30⅛". The Parrish Art Museum, Southampton, New York. Gift of the Estate of Fairfield Porter

Wines and Liquors No. 2. c. 1945. Oil on canvas, 36 x 45". The Parrish Art Museum, Southampton, New York. Gift of the Estate of Fairfield Porter

1946
Jerry in a Wicker Chair. 1946. Oil on Masonite, 21¾ x 16⅝". The Parrish Art Museum, Southampton, New York. Gift of the Estate of Fairfield Porter

Portrait of Laurence as a Boy. 1946, repainted 1970. Oil on board, 33 x 25". Collection Laurence and Laurel Porter

1947
Anne at the Fireplace. 1947. Oil on canvas, 36 x 45". Fairfield Porter Estate

Anne at 312 E. 52nd Street. c. 1947. Oil on canvas, 36 x 44½". The Parrish Art Museum, Southampton, New York. Gift of the Estate of Fairfield Porter

Anne Reading to Laurence. 1947. Oil on Masonite, 30 x 24". The Parrish Art Museum, Southampton, New York. Gift of the Estate of Fairfield Porter

City Window. c. 1947. Oil on Masonite, 34⅛ x 20⅞". The Parrish Art Museum, Southampton, New York. Gift of the Estate of Fairfield Porter

The Dock. c. 1947. Oil on canvas, 30 x 24". The Parrish Art Museum, Southampton, New York. Gift of the Estate of Fairfield Porter

First Avenue. 1947. Oil on Masonite, 21⅞ x 27⅞". The Parrish Art Museum, Southampton, New York. Gift of the Estate of Fairfield Porter

Living Room at 312 East 52nd Street, with Laurence. c. 1947. Oil on board, 14 x 18". Collection Laurence and Laurel Porter

1948
Bedroom. c. 1948. Oil on Masonite, 16 x 12". The Parrish Art Museum, Southampton, New York. Gift of the Estate of Fairfield Porter

Big House with Hawkweed. c. 1948. Oil on Masonite, 24 x 30". The Parrish Art Museum, Southampton, New York. Gift of the Estate of Fairfield Porter

Boy at the Breakfast Table. c. 1948. Oil on Masonite, 30 x 24". The Parrish Art Museum, Southampton, New York. Gift of the Estate of Fairfield Porter

Boy in the Doorway. c. 1948. Oil on Masonite, 30⅛ x 23¼". The Parrish Art Museum, Southampton, New York. Gift of the Estate of Fairfield Porter

Boy Reading in a Garden. c. 1948. Oil on Masonite, 24 x 36". The Parrish Art Museum, Southampton, New York. Gift of the Estate of Fairfield Porter

By the Sea. c. 1948. Watercolor, 13⅜ x 21¼". Collection Mrs. Fairfield Porter

Farmhouse from the Beach. c. 1948. Oil on Masonite, 21⅛ x 31¼". The Parrish Art Museum, Southampton, New York. Gift of the Estate of Fairfield Porter

Horses. c. 1948. Watercolor, 14¾ x 20⅝". Collection Mrs. Fairfield Porter

House, Great Spruce Head Island. c. 1948. Oil on Masonite, 24 x 30". The Parrish Art Museum, Southampton, New York. Gift of the Estate of Fairfield Porter

Interior. c. 1948. Oil on Masonite, 13⅜ x 12⅛". The Parrish Art Museum, Southampton, New York. Gift of the Estate of Fairfield Porter

In the Bedroom. 1948. Oil on canvas, 45 x 36". The Parrish Art Museum, Southampton, New York. Gift of the Estate of Fairfield Porter

Landscape with Barns. c. 1948. Watercolor, 15¼ x 22½". Collection Mrs. Fairfield Porter

Living Room with Mirror. c. 1948. Oil on Masonite, 24 x 24". Weatherspoon Art Gallery, University of North Carolina, Greensboro. Gift of Mrs. Spencer Love, 1966

On the Porch. c. 1948. Oil on canvas, 30 x 24⅛". The Parrish Art Museum, Southampton, New York. Gift of the Estate of Fairfield Porter

Pasture with Islands. c. 1948. Watercolor, 14¾ x 22⅞". Collection Mrs. Fairfield Porter

Portrait of Mary Howe Straus. c. 1948. Oil on canvas, 19 x 24". Collection Mary Howe Kehler

Self-Portrait. 1948. Oil on canvas, 30 x 24". Hirschl & Adler Modern, New York

Straus Home and Boats. c. 1948. Oil on Masonite, 24 x 30⅝". The Parrish Art Museum, Southampton, New York. Gift of the Estate of Fairfield Porter

Sunset. c. 1948. Oil on Masonite, 16 x 12". The Parrish Art Museum, Southampton, New York. Gift of the Estate of Fairfield Porter

Trail. c. 1948. Oil on Masonite, 15 x 15⅛". The Parrish Art Museum, Southampton, New York. Gift of the Estate of Fairfield Porter

Wildflowers. c. 1948. Oil on Masonite, 17 x 13½". The Parrish Art Museum, Southampton, New York. Gift of the Estate of Fairfield Porter

Woman in a Field. c. 1948. Oil on Masonite, 24 x 30". The Parrish Art Museum, Southampton, New York. Gift of the Estate of Fairfield Porter

1949
Anne and Katie. 1949. Oil on Masonite, 30 x 24". The Parrish

Art Museum, Southampton, New York. Gift of the Estate of Fairfield Porter

Autumn Morning. 1949. Oil on linen, 30 x 25". The Parrish Art Museum, Southampton, New York. Gift of the Estate of Fairfield Porter

Breakfast. 1949. Watercolor, 21¾ x 30". Private collection

Chair. c. 1949. Oil on Masonite, 16 x 11⅞". The Parrish Art Museum, Southampton, New York. Gift of the Estate of Fairfield Porter

Huntley Illinois. c. 1949. Watercolor, 17¼ x 15". Collection Helen Drake Muirhead

Katie in Crib. c. 1949–50. Watercolor, 26⅜ x 20". The Parrish Art Museum, Southampton, New York. Gift of the Estate of Fairfield Porter

Maine—Jerry and Laundry. 1949. Oil on canvas, 15 x 12⅛". The Parrish Art Museum, Southampton, New York. Gift of the Estate of Fairfield Porter

Mother and Baby. 1949. Oil on Masonite, 30 x 23¾". The Parrish Art Museum, Southampton, New York. Gift of the Estate of Fairfield Porter

Painting Materials. c. 1949. Oil on canvas, 32⅛ x 25⅛". The Parrish Art Museum, Southampton, New York. Gift of the Estate of Fairfield Porter

Portrait of Woman Nursing Baby. 1949. Oil on canvas, 12 x 15". Collection Katharine Porter and Daniel Fishbein

Yard with Benches and Rocker. c. 1949. Oil on Masonite, 24¼ x 36". The Parrish Art Museum, Southampton, New York. Gift of the Estate of Fairfield Porter

1950
Apple Trees. c. 1950. Oil on canvas, 21⅛ x 18⅛". The Parrish Art Museum, Southampton, New York. Gift of the Estate of Fairfield Porter

Boathouse. c. 1950. Oil on canvas, 30¼ x 20". The Parrish Art Museum, Southampton, New York. Gift of the Estate of Fairfield Porter

Boy Seated at Table with Red Checkered Cloth. c. 1950. Oil and charcoal on canvas, 41½ x 39". The Parrish Art Museum, Southampton, New York. Gift of the Estate of Fairfield Porter

The Dining Room. 1950. Oil on canvas, 30 x 25". Collection Barbara Guest

Interior with White Rocking Chair. 1950. Oil on canvas, 30 x 24". Collection the Equitable Life Assurance Society of the United States

Isle Au Haut. c. 1950. Oil on board, 24 x 27½". Collection Marianne de Nagy

John, Richard and Laurence. c. 1950. Oil on canvas, 45¾ x 45½". The Parrish Art Museum, Southampton, New York. Gift of the Estate of Fairfield Porter

Katie's Highchair Borrowed from Dr. Mary Johnson. c. 1950. Oil on canvas, 36 x 36". The Parrish Art Museum, Southampton, New York. Gift of the Estate of Fairfield Porter

Landscape. c. 1950. Oil on Masonite, 11 x 15". Collection Mr. and Mrs. Samuel Klein

Laurence. c. 1950. Oil on canvas, 30 x 24". The Parrish Art Museum, Southampton, New York. Gift of the Estate of Fairfield Porter

The Maine House. c. 1950. Oil on canvas, 24 x 30". The Parrish Art Museum, Southampton, New York. Gift of the Estate of Fairfield Porter

Portrait of Katie. 1950. Oil on canvas, 30 x 25". Collection Katharine Porter and Daniel Fishbein

Self-Portrait in the Studio. c. 1950. Oil on canvas, 45 x 30". The Parrish Art Museum, Southampton, New York. Gift of the Estate of Fairfield Porter

Still Life. 1950. Oil on canvas, 15 x 12". Private collection

Untitled [The dining room]. 1950. Oil on canvas, 30 x 25". Hirschl & Adler Modern, New York

View of Bear Island Harbor. c. 1950. Acrylic on canvas, 23½ x 29½". Collection Leon F. Porter

1951
Interior. 1951. Oil on Masonite, 15½ x 11½". Collection David R. and Muriel K. Pokross

Katie in a Bib at Table. 1951. Oil on canvas, 40 x 30". The Parrish Art Museum, Southampton, New York. Gift of the Estate of Fairfield Porter

Katie in Front of House. c. 1951. Oil on canvas, 24¼ x 32". The Parrish Art Museum, Southampton, New York. Gift of the Estate of Fairfield Porter

Larry Rivers. 1951. Oil on canvas, 40 x 30". Collection Katherine Porter

The Living Room. 1951. Oil on board, 24 x 18". Collection Barbara Guest

Man in Blue. c. 1951. Oil on linen, 30 x 24". The Parrish Art

Museum, Southampton, New York. Gift of the Estate of Fairfield Porter

Pink Table Top. c. 1951. Oil on canvas, 29⅞ x 42⅝". The Parrish Art Museum, Southampton, New York. Gift of the Estate of Fairfield Porter

Red Car. c. 1951. Oil on Masonite, 16⅞ x 24". The Parrish Art Museum, Southampton, New York. Gift of the Estate of Fairfield Porter

Studio Interior. 1951. Oil on canvas, 35¾ x 42". Collection Mickelson Gallery, Washington, D.C.

View through the Laundry Room Window. 1951. Oil on canvas, 30 x 24". Collection Lobell Family

1952

The Cove. c. 1952. Oil on canvas, 20 x 30⅛". The Parrish Art Museum, Southampton, New York. Gift of the Estate of Fairfield Porter

House in East Hampton. 1952. Oil on canvas, 14½ x 18". Collection Roland Pease

Laundry. c. 1952. Oil on linen, 32 x 36⅛". The Parrish Art Museum, Southampton, New York. Gift of the Estate of Fairfield Porter

Laurence Typing. 1952. Oil on canvas, 40 x 30⅛". The Parrish Art Museum, Southampton, New York. Gift of the Estate of Fairfield Porter

The Lives of Kitty. c. 1952. Oil on canvas, 30⅛ x 24". The Parrish Art Museum, Southampton, New York. Gift of the Estate of Fairfield Porter

The Living Room. 1952. Oil on canvas, 48⅛ x 36". The Parrish Art Museum, Southampton, New York. Gift of the Estate of Fairfield Porter

Maine Interior with Ship Model. c. 1952. Oil on canvas, 47½ x 41⅜". Private collection

Maine Seascape. c. 1952. Oil on Masonite, 24 x 36". Collection Kenneth Koch

Penobscot Bay. c. 1952. Oil on canvas, 24 x 30¼". The Parrish Art Museum, Southampton, New York. Gift of the Estate of Fairfield Porter

The Plane Tree. 1952. Oil on canvas, 24 x 22". Private collection

The Plane Tree. 1952. Oil on canvas, 36 x 30". Private collection

Portrait of Jane Freilicher. 1952. Oil on canvas, 32¹⁄₁₆ x 24". The Parrish Art Museum, Southampton, New York. Gift of Jane Freilicher

1953

Backyard, Southampton. 1953. Oil on canvas, 42 x 43¾". The Parrish Art Museum, Southampton, New York. Gift of the Estate of Fairfield Porter

Beach and Alders. 1953. Oil on canvas, 18 x 22". Private collection

Edith Schloss. 1953. Oil on canvas, 43¾ x 39". The Parrish Art Museum, Southampton, New York. Gift of the Estate of Fairfield Porter

Frank Wallace. 1953. Oil on canvas, 40 x 30". The Parrish Art Museum, Southampton, New York. Gift of the Estate of Fairfield Porter

Interior with Oil Lamp. 1953. Oil on canvas, 44 x 30". Knoedler Gallery, New York [1970]

John Myers. 1953. Oil on canvas, 42⅞ x 38½". The Parrish Art Museum, Southampton, New York. Gift of Dr. and Mrs. Milton Gardner

Katie and Jacob in the Yard. c. 1953. Oil on canvas, 41½ x 44". Collection Katherine Koch

Katie at the Table. c. 1953. Oil on canvas, 32⅛ x 36⅛". The Parrish Art Museum, Southampton, New York. Gift of the Estate of Fairfield Porter

Laurence at the Breakfast Table No. 1. 1953. Oil on canvas board, 14 x 10". The Parrish Art Museum, Southampton, New York. Gift of the Estate of Fairfield Porter

Laurence at the Breakfast Table No. 2. 1953. Oil on canvas board, 14 x 10". The Parrish Art Museum, Southampton, New York. Gift of the Estate of Fairfield Porter

Laurence at the Breakfast Table No. 3. c. 1953. Oil on canvas, 32 x 24". The Parrish Art Museum, Southampton, New York. Gift of the Estate of Fairfield Porter

Laurence at the Breakfast Table No. 4. 1953. Oil on canvas, 40⅛ x 30". The Parrish Art Museum, Southampton, New York. Gift of the Estate of Fairfield Porter

Laurence at the Breakfast Table No. 5. 1953. Oil on canvas, 18¾ x 15¾". The Parrish Art Museum, Southampton, New York. Gift of the Estate of Fairfield Porter

Laurence at the Piano. 1953. Oil on canvas, 40 x 30". New Britain Museum of American Art, Connecticut, General Purchase Fund

Lawn Scene. 1953. Oil on canvas, 35⅝ x 38½". The Parrish Art Museum, Southampton, New York. Littlejohn Collection

Mrs. Larkin's House. c. 1953. Oil on canvas, 24⅞ x 30⅛". The

Parrish Art Museum, Southampton, New York. Gift of the Estate of Fairfield Porter

North Meadow. 1953–73. Oil on canvas, 24 x 30". The Parrish Art Museum, Southampton, New York. Gift of the Estate of Fairfield Porter

Plane Tree and House. c. 1953. Oil on canvas, 20 x 24". The Parrish Art Museum, Southampton, New York. Gift of the Estate of Fairfield Porter

Still Life with Yellow Tablecloth. 1953. Oil on canvas, 44 x 30". The Parrish Art Museum, Southampton, New York. Gift of the Estate of Fairfield Porter

Untitled [Man seated near lamp]. c. 1953. Oil on canvas, 24 x 32". The Parrish Art Museum, Southampton, New York. Gift of the Estate of Fairfield Porter

1954
The Artist's Wife. 1954. Oil on canvas, 22 x 17". Fairfield Porter Estate

Boy Reading. c. 1954. Oil on canvas, 24¼ x 30". The Parrish Art Museum, Southampton, New York. Gift of the Estate of Fairfield Porter

Breakfast in Maine. 1954. Oil on canvas, 25½ x 35". Fairfield Porter Estate

Calverton. 1954. Oil on canvas, 29⅜ x 44". The Parrish Art Museum, Southampton, New York. Gift of the Estate of Fairfield Porter

Elm Tree. 1954. Oil on Masonite, 19⅜ x 17⅛". The Parrish Art Museum, Southampton, New York. Gift of the Estate of Fairfield Porter

Farmhouse, Great Spruce Head Island. 1954. Oil on canvas, 25⅜ x 36¼". The Parrish Art Museum, Southampton, New York. Gift of the Estate of Fairfield Porter

Flowers on a Table. 1954. Oil on canvas, 29½ x 29". Alpha Gallery, Boston/Schutz & Co., New York

Frank O'Hara. 1954. Oil on canvas, 34 x 20⅛". The Parrish Art Museum, Southampton, New York. Gift of the Estate of Fairfield Porter

Frank O'Hara. 1954. Oil on canvas, 41 x 27". Private collection

Harbor Scene, Maine. 1954. Oil on canvas, 21½ x 34". Private collection

The Harbor through the Trees. 1954. Oil on canvas, 25½ x 25½". Collection The Chase Manhattan Bank

House by the Woods. 1954. Oil on canvas, 37 x 25¼". Private collection

Jane Freilicher and Anne Porter. 1954. Oil on canvas, 44 x 59". The Parrish Art Museum, Southampton, New York. Gift of the Estate of Fairfield Porter

Katie in an Armchair. 1954. Oil on canvas, 65½ x 46". Collection Katharine Porter

Laurence at the Piano. 1954. Oil on canvas, 72 x 47". The Parrish Art Museum, Southampton, New York. Gift of the Estate of Fairfield Porter

Lunch under the Elm Tree. 1954. Oil on canvas, 78 x 60¼". The Parrish Art Museum, Southampton, New York. Gift of the Estate of Fairfield Porter

Portrait of the Artist's Wife. 1954. Oil on canvas, 23 x 17". Ackland Art Museum, University of North Carolina, Chapel Hill. Anonymous gift

Robert Dash. c. 1954. Oil on canvas, 28⅛ x 22⅛". The Parrish Art Museum, Southampton, New York. Gift of the Estate of Fairfield Porter

Southampton Backyards. 1954. Oil on canvas, 25¼ x 33". Sotheby's, New York, 1989

Study for *Katie in a Chair.* 1954. Oil on canvas, 20 x 19½". Private collection

Tree. 1954. Oil on canvas, 20½ x 15". Private collection

Tree. 1954. Oil on canvas, 78 x 60". Private collection

1955
Afternoon, Maine. c. 1955. Watercolor, 24 x 19⅞". Private collection

Armchair on Porch. 1955. Oil on canvas, 37½ x 45". Collection Tibor de Nagy and Marianne de Nagy

Boy Reading. 1955. Oil on canvas, 35⅞ x 32". Private collection

Chain Links. c. 1955. Oil on canvas, 32 x 36¼". The Parrish Art Museum, Southampton, New York. Gift of the Estate of Fairfield Porter

Cityscape. c. 1955. Oil on canvas, 36 x 45". The Parrish Art Museum, Southampton, New York. Gift of the Estate of Fairfield Porter

Cityscape with Yellow Taxi. c. 1955. Oil on canvas, 32¼ x 24¼". The Parrish Art Museum, Southampton, New York. Gift of the Estate of Fairfield Porter

Flowers. 1955. Oil on canvas, 22 x 27". Fairfield Porter Estate

Flowers by the Sea I. 1955. Oil on canvas, 18 x 25". Collection Arthur M. Bullowa

Forest. 1955. Oil on canvas, 14¼ x 29¼". Private collection

The Harbor. c. 1955. Oil on burlap, 29 x 45". The Parrish Art Museum, Southampton, New York. Gift of the Estate of Fairfield Porter

Head of a Young Man. c. 1955. Oil on canvas, 23¾ x 22⅛". The Parrish Art Museum, Southampton, New York. Gift of the Estate of Fairfield Porter

Jane Freilicher. c. 1955. Pastel, 16¾ x 9". Private collection

Jerry. 1955, repainted 1975. Oil on canvas, 62 x 37". Collection Ashby McCulloch Sutherland

Katie and Anne. 1955. Oil on canvas, 80⅛ x 62⅛". Hirshhorn Museum and Sculpture Garden, Smithsonian Institution, Washington, D.C. Gift of Joseph H. Hirshhorn, 1966

Maine Coast. 1955. Oil on canvas, 20 x 36½". Collection Eleanor Lambert Berkson and Bill Berkson

Maine Landscape. 1955. Oil on canvas, 16 x 26½". Weatherspoon Art Gallery, University of North Carolina, Greensboro. Gift of Phillip Martin Droll, 1983

Maine Landscape. 1955. Oil on canvas, 26 x 37". Collection Arthur M. Bullowa

Peak Island. c. 1955. Oil on canvas, 21⅝ x 22⅛". The Parrish Art Museum, Southampton, New York. Gift of the Estate of Fairfield Porter

Portrait of a Boy. 1955. Oil on canvas, 48 x 42". Private collection

Portrait of James Schuyler. 1955. Oil on canvas, 48 x 42". Collection Ashby McCulloch Sutherland

Portrait of Jane Freilicher. 1955. Pastel, 14 x 20". Collection Lobell Family

Richard Porter. c. 1955. Oil on canvas, 35¼ x 25⅝". The Parrish Art Museum, Southampton, New York. Gift of the Estate of Fairfield Porter

Richard Porter. c. 1955. Oil on canvas, 38 x 29⅞". The Parrish Art Museum, Southampton, New York. Gift of the Estate of Fairfield Porter

Spruces and Ferns. c. 1955. Oil on canvas, 15⅛ x 12⅛". The Parrish Art Museum, Southampton, New York. Gift of the Estate of Fairfield Porter

Still Life with Casserole. 1955. Oil on canvas, 38½ x 40". National Museum of American Art, Smithsonian Institution, Washington, D.C. Bequest of Henry Ward Ranger through the National Academy of Design

1956
Artist's Wife on Studio Porch, Maine. c. 1956. Oil on board, 37 x 37". Collection Laurence and Laurel Porter

Island Landscape. 1956–57. Oil on canvas, 19¾ x 21½". Private collection

Landscape. 1956. Oil on canvas, 32½ x 38½". Private collection

1957
Bedroom. 1957. Oil on canvas, 36 x 40". Private collection

Elaine De Kooning. 1957. Oil on canvas, 62 x 41". The Metropolitan Museum of Art, New York. Gift of Mrs. Fairfield Porter, 1978

Frank O'Hara. 1957. Oil on canvas, 63⅞ x 45⅞". Toledo Museum of Art. Gift of Edward Drummond Libbey

The Grape Arbor. c. 1957. Oil on canvas, 36⅛ x 36⅛". The Parrish Art Museum, Southampton, New York. Gift of the Estate of Fairfield Porter

Jane Wilson. 1957. Oil on canvas, 57 x 32". Collection Jane Wilson

Jane Wilson in Red. 1957. Oil on canvas, 54 x 42". Extended loan from the Herbert W. Plimpton Foundation to the Rose Art Museum, Brandeis University, Waltham, Massachusetts

Jerry on a Stool. 1957. Oil on canvas, 38 x 20". Collection Arthur M. Bullowa

Jimmy and John. 1957–58. Oil on canvas, 36¼ x 45½". Collection Barbara K. Goldman

John Ashbery. 1957. Oil on canvas, 38 x 32". Private collection

Katie and Dorothy E. 1957. Oil on canvas, 16 x 20¾". Private collection

Laurence Playing Chess. 1957. Oil on canvas, 45½ x 36½". The Parrish Art Museum, Southampton, New York. Gift of the Estate of Fairfield Porter

Red House. 1957. Oil on canvas, 30¼ x 38¼". The Parrish Art Museum, Southampton, New York. Gift of the Estate of Fairfield Porter

Rhododendron on a Table. 1957. Oil on canvas, 19¾ x 17". Private collection

Two Trees. 1957. Oil on board, 15¾ x 11¾". Private collection

1958
Anne, Lizzie and Katie. 1958. Oil on canvas, 78 x 60". Nebraska

Art Association Collection, Sheldon Memorial Art Gallery, University of Nebraska, Lincoln

Chrysanthemums. 1958. Oil on canvas, 40 x 32". Wadsworth Atheneum, Hartford. The Ella Gallup Sumner and Mary Catlin Sumner Collection

Lizzie at the Table. 1958. Oil on canvas, 37 x 45". Collection Arthur M. Bullowa

Maine Coast. 1958. Oil on canvas, 18 x 34". The Metropolitan Museum of Art, New York. Gift of Stanley Posthorn, 1986

Night. 1958. Oil on canvas, 8¾ x 11⅝". Private collection

Plane Tree in October. 1958. Oil on canvas, 45 x 42". Hirschl & Adler Modern, New York

Roland Pease. 1958. Oil on canvas, 36 x 28". Collection Roland Pease

Snow. 1958. Oil on board, 11¾ x 15½". Private collection

Still Life. 1958. Oil on canvas, 39 x 30½". Collection the Equitable Life Assurance Society of the United States, New York

Still Life with Flowers. 1958. Oil on canvas, 24½ x 30". Private collection

Sunset with Tablecloths. 1958. Oil on canvas, 35½ x 41½". The Metropolitan Museum of Art, New York. Gift of Mrs. Fairfield Porter in memory of Thomas Hess, 1978

Tibor De Nagy. 1958. Oil on canvas, 40 x 30". Collection Roland Pease

Trumpet Vines. 1958. Oil on canvas, 28 x 20". Collection Arthur M. Bullowa

View from the Studio. 1958. Oil on Masonite, 17½ x 11½". Private collection

The Wheelbarrow. 1958. Oil on canvas, 32 x 42". Collection John Robertshaw

1959
A.K.J. 1959. Oil on canvas, 36 x 48". Private collection

Backyards with Wheelbarrow. 1959. Oil on canvas, 41 x 38½". The Parrish Art Museum, Southampton, New York. Gift of the Estate of Fairfield Porter

Child by a Tree. 1959. Oil on canvas, 48¼ x 43". Private collection

Children in the Backyard. 1959. Oil on canvas, 45½ x 36". The Parrish Art Museum, Southampton, New York. Gift of the Estate of Fairfield Porter

Chris, Sarah, Felicity. 1959. Oil on canvas, 48 x 48". Collection Lucien Day

The Door. 1959. Oil on wood, 9 x 12¾". Collection Alan, Robert, and Donald Blinken, Palm Beach

East 11th Street. 1959. Oil on Masonite, 12 x 16". Collection Rackstraw Downes

Farmland. c. 1959. Oil on canvas, 32⅛ x 40⅛". Hallmark Fine Art Collections, Hallmark Cards, Inc., Kansas City, Missouri

Katie on Sofa. 1959. Oil on canvas, 25¼ x 25¼". Collection Mr. and Mrs. E. W. Andrews, Jr.

Piano Duet. 1959. Oil on canvas, 26½ x 40". Collection the Equitable Life Assurance Society of the United States, New York

Schwenk. 1959. Oil on canvas, 22⅝ x 31". The Museum of Modern Art, New York. Gift of Arthur M. Bullowa

Still Life. 1959. Oil on canvas, 32 x 22". Private collection

Tree and Pond. 1959. Oil on canvas, 22½ x 32¼". Private collection

Untitled [Forest]. c. 1959. Oil on Masonite, 30 x 25½". Collection Nils A. Berglund

Wareham, Route 6. 1959. Oil on canvas, 17½ x 31". Private collection

Wildflowers. 1959. Oil on canvas, 30 x 22". Hirschl & Adler Modern, New York

Young Man in a Doorway. 1959–60. Oil on canvas, 67 x 45½". The Parrish Art Museum, Southampton, New York. Gift of the Estate of Fairfield Porter

1960
Apple Blossoms, 49 South Main Street. c. 1960. Watercolor, 17¼ x 21¼". Collection Laurence and Laurel Porter

Audrey Porter. c. 1960. Oil on Masonite, 16⅛ x 14⅛". The Parrish Art Museum, Southampton, New York. Gift of the Estate of Fairfield Porter

Autumn Bouquet. 1960. Oil on canvas, 49½ x 32½". Private collection

Back of the House. c. 1960. Oil on canvas, 32 x 38". The Parrish Art Museum, Southampton, New York. Gift of the Estate of Fairfield Porter

Children in a Field. 1960. Oil on canvas, 45 x 45". The Whitney Museum of American Art, New York. Lawrence H. Bloedel Bequest

Claire White. 1960. Oil on canvas, 45½ x 45". Private collection

The Doscher House. c. 1960. Oil on canvas, 22 x 28". The Parrish Art Museum, Southampton, New York. Gift of the Estate of Fairfield Porter

The Doscher House. c. 1960. Oil on canvas, 20 x 30⅜". The Parrish Art Museum, Southampton, New York. Gift of the Estate of Fairfield Porter

East 11th Street. c. 1960. Oil on canvas, 29⅞ x 23⅞". The Parrish Art Museum, Southampton, New York. Gift of the Estate of Fairfield Porter

The First of May. 1960. Oil on canvas, 60 x 71⅛". Hirschl & Adler Modern, New York

Garden Furniture. 1960. Oil on canvas with wood backing, 10 x 8". Collection Rebecca L. Soyer

Girl on a Swing. 1960. Oil on canvas, 35¾ x 35½". Collection William and Jane Overman

In the Middle of Summer. 1960. Oil on canvas, 48 x 48". Private collection

James Schuyler. 1960. Oil on canvas, 45 x 45". Private collection

Jimmy in a Black Rocker. 1960. Oil on canvas, 30 x 20". Fairfield Porter Estate

Jimmy Schuyler. c. 1960. Oil on canvas, 31¼ x 43¼". Collection Mrs. Fairfield Porter

Johnny. 1960. Oil on canvas, 28½ x 24½". Collection Mrs. Fairfield Porter

Katie and Forsythia. 1960. Oil on canvas, 80 x 60". Collection Mr. and Mrs. Wilfred P. Cohen

Landscape. c. 1960. Watercolor, 18 x 22¾". Fairfield Porter Estate

Lawrence Campbell. c. 1960. Oil on burlap, 35½ x 44¾". The Parrish Art Museum, Southampton, New York. Gift of the Estate of Fairfield Porter

Lizzie with Wild Roses. 1960. Oil on canvas, 30⅛ x 20⅛". The Parrish Art Museum, Southampton, New York. Gift of the Estate of Fairfield Porter

Mock Orange. 1960. Oil on canvas mounted on board, 10 x 8". Private collection

Nude. c. 1960. Oil on canvas, 46½ x 39½". The Parrish Art Museum, Southampton, New York. Gift of the Estate of Fairfield Porter

October House. 1960. Oil on canvas, 18 x 25". Private collection

Portrait of Ted Carey and Andy Warhol. 1960. Oil on canvas, 40 x 40". The Whitney Museum of American Art, New York. Gift of Andy Warhol

Potatoes. 1960. Oil on canvas, 45 x 45". The Parrish Art Museum, Southampton, New York. Gift of the Estate of Fairfield Porter

Robert Dash. 1960. Oil on canvas, 36 x 36". Collection Robert Dash

South Main Street, Spring. c. 1960. Oil on canvas, 16 x 24". Fairfield Porter Estate

Sunset and Lilies. 1960. Oil on canvas, 45 x 45". The William Benton Museum of Art, University of Connecticut, Storrs. Gift of Mrs. Fairfield Porter

Tulips and Milk Bottle No. 1. 1960. Oil on Masonite, 8 x 10". Collection Eleanor Lambert Berkson and Bill Berkson

University Place. 1960. Oil on canvas, 30 x 24". Private collection

View from Studio Window. 1960. Oil on canvas, 36¼ x 36". Collection Douglas R. and Beverly Feurring

Wheat. 1960. Oil on canvas, 33½ x 33⅜". Christie's, New York, 1989

1961
Blue Harbor. 1961. Oil on canvas, 36 x 36". Collection Roy R. Neuberger

Boathouses. 1961. Oil on canvas, 33 x 45⅛". Hirshhorn Museum and Sculpture Garden, Smithsonian Institution, Washington, D.C. The Joseph H. Hirshhorn Bequest, 1981

Boats and Peonies. 1961. Oil on canvas, 41 x 46". Collection Robert and Allison Blinken

Calm Morning. 1961. Oil on canvas, 36 x 36". Collection Arthur M. Bullowa

Cardplayers. c. 1961. Oil on canvas, 45 x 40". Private collection

Carl Morse. 1961. Oil on canvas, 28 x 22". Private collection

Chrysanthemums and Sage. 1961. Casein on canvas, 36 x 36". Private collection

Driftwood Stump. 1961. Oil on canvas, 24 x 20". Private collection

Edge in the Afternoon. 1961. Oil on canvas, 45 x 40". The Prudential Insurance Company of America

Edge in the Morning. 1961. Oil on canvas, 36 x 36". Hirshhorn

Museum and Sculpture Garden, Smithsonian Institution, Washington, D.C. Gift of Joseph H. Hirshhorn, 1966

Elizabeth in a Red Chair. 1961. Oil on canvas, 44¾ x 39¾". Heckscher Museum, Huntington, New York. Gift of the Family of Fairfield Porter

Entering Southampton. 1961. Oil on canvas, 22 x 24". Private collection

Evening Shore. 1961. Oil on canvas, 28⅟₁₆ x 38⅞". Collection The Newark Museum, New Jersey. Gift of the Anne E. C. Porter Charitable Trust, 1984

Farm Pond. 1961. Casein on canvas, 22 x 24". Private collection

Girl on a Swing. 1961. Oil on canvas, 45 x 40". Collection Alan, Robert and Donald Blinken, Palm Beach

Goldenrod in the Woods. 1961. Oil on canvas, 16 x 14". Collection Mrs. Martin E. Segal

Harbor Beach. 1961. Oil on canvas, 24 x 30". Union Carbide Corporation, Danbury, Connecticut

Hawkweed in the Woods. 1961. Oil on canvas, 36 x 36". Private collection

House by a Lake. 1961. Oil on board, 9 x 12". Collection Mac and Anita Lipkind

Island Beach. 1961. Oil on canvas, 22 x 28½". Private collection

Island Farmhouse. 1961. Oil on canvas, 30 x 24". Union Carbide Corporation, Danbury, Connecticut

Jerry against Green. 1961. Oil on canvas, 22⅝ x 18⅝". The Parrish Art Museum, Southampton, New York. Gift of the Estate of Fairfield Porter

The Long Field. 1961. Casein on canvas, 36 x 36". Private collection

Looking through the House. 1961. Oil on canvas, 20 x 18". Private collection

Maine Coast. 1961. Oil on canvas, 24 x 30". Collection William and Jane Overman

Michael W. Straus. 1961. Oil on canvas, 45¼ x 39½". Hirschl & Adler Modern, New York

Mid-day. 1961. Oil on canvas, 44¾ x 40½". Collection Mr. and Mrs. A. J. Lambert

November Moon. 1961. Casein on canvas, 36 x 36". Collection Mrs. Fairfield Porter

On the Porch. 1961. Oil on linen, 46 x 40". The Parrish Art

Museum, Southampton, New York. Gift of the Estate of Fairfield Porter

On the Trail. 1961. Oil on canvas, 36 x 36". Private collection

Queen Anne's Lace—Evening. 1961. Oil on canvas, 15 x 12". Collection Mr. and Mrs. Samuel Klein

Queen Anne's Lace—Noon. 1961. Oil on canvas, 15 x 12". Private collection

Sketch for *Portrait of Jimmy Schuyler*. 1961. Oil on canvas, 43¼ x 30". The Parrish Art Museum, Southampton, New York. Gift of the Estate of Fairfield Porter

South Meadow Spruces. 1961. Oil on canvas, 23⅜ x 27⅞". The Parrish Art Museum, Southampton, New York. Gift of the Estate of Fairfield Porter

Street in Spring. 1961. Oil on canvas, 22 x 28". Private collection

Sycamore in September. 1961. Oil on canvas, 45 x 40". Collection The Chase Manhattan Bank

Top of the Bluff. 1961. Oil on canvas, 36 x 36". Hirschl & Adler Modern, New York

The Trees. 1961. Oil on canvas, 45 x 40". Hirschl & Adler Modern, New York

Untitled [East 11th Street]. c. 1961. Oil on canvas, 20 x 12⅛". The Parrish Art Museum, Southampton, New York. Gift of the Estate of Fairfield Porter

View of Studio in Evening Snow. 1961. Oil on canvas, 33 x 36". Collection Mrs. Fairfield Porter

White Boats. 1961. Oil on canvas, 30 x 44⅞". Private collection

White Tree Stump. 1961. Oil on canvas, 24⅛ x 20". The Parrish Art Museum, Southampton, New York. Gift of the Estate of Fairfield Porter

Wild Primroses. 1961. Oil on canvas, 15 x 12". Private collection

Wild Roses. 1961. Oil on canvas, 24 x 28". Private collection

Winter Wheat. 1961. Oil on canvas, 45 x 40". Private collection

Yellow Room. 1961. Oil on canvas, 46½ x 40½". Hirschl & Adler Modern, New York

1962
April. 1962. Oil on wood, 9¼ x 11⅞". Private collection

Beach and Field. 1962. Oil on canvas, 24 x 18". Private collection

The Bicycle. 1962. Oil on canvas, 30 x 28". Private collection

Bowl of Goldenrod. 1962. Casein on canvas, 24 x 22". Private collection

Bushes. 1962. Casein on canvas, 24 x 22". Private collection

Car in Vermont. 1962. Oil on canvas, 36 x 32". Private collection

Day House in Vermont. 1962. Oil on wood, 9⅜ x 12⅛". Private collection

A Day Indoors. 1962. Acrylic on canvas, 71⅜ x 55". The Parrish Art Museum, Southampton, New York. Gift of the Estate of Fairfield Porter

The Fields in May. 1962. Oil on canvas, 28 x 22". Private collection

Flagpole. 1962. Oil on canvas, 24 x 22". Private collection

Flowering Horsechestnuts. 1962. Oil on wood, 11⅝ x 9⅝". Collection Mrs. J. Cornell Schenck

Forsythia Hedge. 1962. Oil on canvas, 36 x 36". Private collection

The Garden Road. 1962. Oil on canvas, 62 x 48". The Whitney Museum of American Art, New York. Gift of the Greylock Foundation

The Highchair. 1962. Oil on canvas, 28⅛ x 22⅛". The Parrish Art Museum, Southampton, New York. Gift of the Estate of Fairfield Porter

Interior. 1962. Oil on canvas, 24 x 20". Private collection

Jerry at the Piano. 1962. Oil on canvas, 45 x 40". Hirshhorn Museum and Sculpture Garden, Smithsonian Institution, Washington, D.C. Gift of Joseph H. Hirshhorn, 1966

The Kitchen Steps. 1962. Acrylic on canvas, 54¾ x 71¼". Private collection

The Kittiwake and the John Walton. 1962. Acrylic on canvas, 36 x 36". The Metropolitan Museum of Art, New York. Gift of the Woodward Foundation, 1976

Long Island Landscape with Red Building. c. 1962. Oil on canvas, 24⅛ x 48". Nebraska Art Association Collection, Sheldon Memorial Art Gallery, University of Nebraska, Lincoln

Low Tide. 1962. Oil on canvas, 45⅝ x 45⅝". Yale University Art Gallery, New Haven. Gift of the Woodward Foundation

Mossy Woods. 1962. Oil on canvas, 15 x 12". Private collection

Night. 1962. Acrylic on canvas, 54½ x 37". Private collection

Night. 1962. Oil on wood, 9¼ x 12¼". Private collection

Noon. 1962. Oil on canvas, 45½ x 45½". G.U.C. Collection, Chicago

The Pear Tree. 1962. Oil on canvas, 74⅞ x 60¼". Hirshhorn Museum and Sculpture Garden, Smithsonian Institution, Washington, D.C. The Joseph H. Hirshhorn Bequest, 1981

The Porch. 1962. Casein on canvas, 28 x 30". Private collection

The Porch Door. 1962. Acrylic on canvas, 24 x 22". Private collection

Portrait of Donald Schrader. 1962. Oil on canvas, 30 x 28". Collection Arthur M. Bullowa

Portrait of Penny. 1962. Oil on canvas, 45 x 40". Hirshhorn Museum and Sculpture Garden, Smithsonian Institution, Washington, D.C. Gift of Joseph H. Hirshhorn, 1966

Primroses. 1962. Oil on canvas, 24 x 22". Private collection

The Pump House. 1962. Acrylic on canvas, 36 x 30⅛". The Parrish Art Museum, Southampton, New York. Gift of the Estate of Fairfield Porter

The Rocking Horse. 1962. Oil on canvas, 36 x 36". Private collection, New York City

Scragg Island. 1962. Oil on canvas, 30⅛ x 36⅛". Collection the Equitable Life Assurance Society of the United States, New York

Southeast from Bear Island. 1962. Oil on canvas, 39 x 46½". Private collection

Summer Studio. 1962. Oil on canvas, 54½ x 37". Private collection

Under the Elm Tree. 1962. Oil on canvas, 24 x 22". Private collection

View of Studio with Elm Trunk. 1962. Oil on canvas, 24 x 22". The Parrish Art Museum, Southampton, New York. Gift of the Estate of Fairfield Porter

Water through the Trees. 1962. Oil on canvas, 15 x 12". Private collection

1963
The Barred Islands. 1963. Acrylic on canvas, 45 x 45". Private collection

Chrysanthemums. 1963. Oil on board, 8½ x 6⅛". Private collection

The Desk. 1963. Oil on canvas, 28 x 22". Sotheby's New York, 1987

Double Portrait of Mr. and Mrs. Henry B. Mayer. 1963. Oil on canvas, 50⅜ x 45". Christie's, New York, 1989

Elizabeth Thinking. 1963. Oil on canvas, 28 x 30". Collection Paul Roebling

Forest and River, Maine. 1963. Watercolor, 15 x 22". Christie's East, New York, 1990

Girl and Geranium. 1963. Oil on canvas, 45 x 30". Collection Mr. and Mrs. R. Crosby Kemper

Girl Reading Outdoors. 1963. Oil on canvas, 44⅞ x 40". Private collection

Green Landscape. 1963. Oil on canvas, 16 x 32". Private collection

Horsechestnut. 1963. Oil on canvas, 24⅛ x 22". Collection Mr. and Mrs. E. W. Andrews, Jr.

House above the Beach. 1963. Oil on wood, 12⅛ x 9¼". The Metropolitan Museum of Art, New York. Gift of Dr. Joseph I. Singer, 1979

Interior with a Doll's House. 1963. Oil on canvas, 36 x 36". Collection Ashby McCulloch Sutherland

Interior with Chess Game. 1963. Oil on canvas, 24⅛ x 22⅛". The Parrish Art Museum, Southampton, New York. Gift of the Estate of Fairfield Porter

Jimmy and Liz. 1963. Oil on canvas, 45 x 39⅞". The Pennsylvania Academy of the Fine Arts, Philadelphia. Henry D. Gilpin Fund

Laurence in Two Lights. 1963. Oil on canvas, 32 x 28". Private collection

Maine Studio with Lizzie. 1963. Acrylic on canvas, 36 x 36". Private collection

Meadow Road. 1963. Acrylic on canvas, 32 x 28". Private collection

Meadow Road II. 1963. Oil on canvas, 32 x 28". Private collection

Mildred Lamar Hooking a Rug. 1963. Acrylic on canvas, 54½ x 45½". Hirshhorn Museum and Sculpture Garden, Smithsonian Institution, Washington, D.C. The Joseph H. Hirshhorn Bequest, 1981

Milk Cartons with Zinnias. 1963. Oil on board, 17¼ x 14½". Private collection

The North Meadow. 1963. Acrylic on canvas, 36 x 36". Private collection, St. Louis

The Nubble. 1963. Oil on canvas, 36 x 36". Collection Mr. and Mrs. Harold Stein

October Interior. 1963. Oil on canvas, 56 x 72". Private collection

September Clouds. 1963. Oil on canvas, 28 x 22". Private collection

A Short Walk. 1963. Oil on canvas, 62 x 47¾". Collection Jane Richards Lane, San Francisco

South Meadow. 1963. Oil on canvas, 18 x 20". Fairfield Porter Estate

Stephen and Kathy. 1963. Acrylic on canvas, 60¼ x 48". Fairfield Porter Estate

View from the Big House. 1963. Acrylic on canvas, 36 x 36". Private collection

1964

Autumn Landscape. 1964–65. Oil on canvas, 72 x 53". Private collection

The Bay. 1964. Oil on canvas, 45 x 45". Private collection

Birches. 1964. Oil on canvas, 24 x 20". Private collection

The Bridge. 1964. Oil on canvas, 22 x 24". Private collection

The Cove. 1964. Oil on canvas, 37 x 53½". Collection Arthur M. Bullowa

Daisies. 1964. Oil on canvas, 15 x 12". Private collection

Eagle Island. 1964. Oil on canvas, 13 x 22". Private collection

East 56th Street. c. 1964. Oil on canvas, 40 x 40". The Parrish Art Museum, Southampton, New York. Gift of the Estate of Fairfield Porter

Elizabeth. c. 1964. Oil on canvas, 21 x 24". Collection Mrs. Fairfield Porter

Fairview, North Carolina. 1964. Watercolor, 10¼ x 14¼". Private collection

Fairview, North Carolina II. 1964. Watercolor, 10¼ x 14¼". Fairfield Porter Estate

Flowers in the Meadow. 1964. Watercolor, 12 x 16". Private collection

Gray Bay. c. 1964. Watercolor, 10 x 14". Private collection

Indoors. 1964. Oil on canvas, 32 x 28". Private collection

Island House. 1964. Oil on canvas, 36 x 36". Private collection

Jerry. 1964. Oil on canvas, 14½ x 14½". Portland Art Museum, Oregon Art Institute. Gift of Mrs. Fairfield Porter

July Interior. 1964. Oil on canvas, 56⅛ x 72". Hirshhorn Museum and Sculpture Garden, Smithsonian Institution, Washington, D.C. Gift of Joseph H. Hirshhorn, 1966

Katie. 1964. Oil on canvas, 15 x 14½". Permanent Collection of the Art Students League. Anonymous gift

Laurence. 1964. Oil on canvas, 24 x 22". Collection Laurence and Laurel Porter

The Living Room. 1964. Oil on canvas, 60 x 48". Collection Constance Jewett Ellis

Lizzie in a Straw Hat. 1964. Oil on canvas, 16 x 15". Private collection

The Meadow. 1964. Oil on canvas, 19¾ x 24⅛". The Parrish Art Museum, Southampton, New York. Gift of the Estate of Fairfield Porter

Meadow with Goldfinches. 1964. Oil on canvas, 36 x 36". Collection Eliot Porter

Moccasin Flower. 1964. Oil on wood, 9½ x 6½". Private collection

The Orchard. 1964. Oil on canvas, 22 x 24". Private collection

Over the Edge. c. 1964. Watercolor, 17¾ x 12". Private collection

The Path. 1964. Watercolor, 18 x 12". Private collection

The Plane Tree. 1964. Oil on canvas, 50 x 50". Collection Guild Hall Museum, East Hampton, New York. Guild Hall Purchase Fund

Portrait of a Girl. 1964–65. Oil on canvas, 72¼ x 45". Albrecht Art Museum, St. Joseph, Missouri

Primroses. 1964. Oil on board, 8½ x 5½". Private collection

Primroses in the Grass. 1964. Oil on wood, 12 x 9½". Private collection

The Screen Porch. 1964. Oil on canvas, 79½ x 79½". The Whitney Museum of American Art, New York. Lawrence H. Bloedel Bequest

Six O'Clock. 1964. Oil on canvas, 71¼ x 59½". Saint Louis Art Museum. Gift of Mr. and Mrs. Crosby R. Kemper, Jr., through the Crosby Kemper Foundation

Spruce and Birch. 1964. Oil on canvas, 22 x 24". Collection Tibor de Nagy

Still Life with Glasses. 1964. Oil on wood, 12⅛ x 9⅜". Private collection

Still Life with Standing Figure. 1964. Oil on canvas, 45 x 45". Collection Jane Norman

Trees and Water. 1964. Watercolor, 10¼ x 14⅛". Christie's, New York, 1989

White Lilacs. 1964. Oil on canvas, 15½ x 14½". Private collection

White Roses. 1964. Oil on canvas, 20 x 24". Private collection

Wild Roses. 1964. Oil on wood, 9½ x 6½". Private collection

Wildflowers. 1964. Oil on canvas, 20 x 24". Private collection

Wood Road. 1964. Oil on canvas, 24 x 30". Private collection

Woods and Rocks. 1964. Oil on canvas, 24⅛ x 22". Hirschl & Adler Modern, New York

1965

Anemone and Daffodils. 1965. Oil on board, 20 x 16¾". Collection Paul Roebling

Anne. 1965. Oil on canvas, 47 x 28". The Parrish Art Museum, Southampton, New York. Gift of the Estate of Fairfield Porter

At the Beach. c. 1965. Watercolor, 6 x 9". Fairfield Porter Estate

August Wildflowers. 1965. Oil on Masonite, 11½ x 9⅞". Private collection

The Back Porch. 1965. Watercolor, 14¼ x 10¼". Fairfield Porter Estate

Backyards, South Main Street. c. 1965. Oil on canvas, 25 x 30". The Parrish Art Museum, Southampton, New York. Gift of the Estate of Fairfield Porter

Barred Islands II. 1965. Oil on canvas, 18 x 24". Private collection

Blue Seascape. 1965. Watercolor, 8½ x 14". Private collection

Boats and Islands. 1965. Oil on canvas, 48 x 60". Private collection

Butter Island and Hardhead Island. 1965. Oil on wood, 6¼ x 8½". Private collection

Car on a Hill. 1965. Watercolor, 10¼ x 14". Private collection

Child by the Window. 1965. Oil on wood, 8¼ x 5¾". Collection Jane Norman

Chrysanthemums. 1965. Oil on canvas, 25 x 19½". Private collection

City Street. c. 1965–68. Oil on board, 14 x 9¾". Collection Mrs. Fairfield Porter

Cove Bridge. c. 1965. Watercolor, 12 x 18". Fairfield Porter Estate

Daisies and Evening Primroses. 1965. Oil on wood, 8½ x 5¾". Private collection

Daisies and Harbor Boats. 1965. Oil on Masonite, 12 x 16". Collection Mr. and Mrs. John Porter

Dinner Table. 1965. Oil on canvas, 48 x 34". Collection Paul Roebling

The Doering House. 1965. Oil on canvas, 34 x 45½". Private collection

Elizabeth. 1965. Oil on canvas, 48 x 24". Collection Mr. and Mrs. Alan Fink

Field Flowers and Berries. 1965. Oil on Masonite, 16¼ x 14". Private collection

Field in June. 1965. Oil on canvas, 28 x 32". Collection The Chase Manhattan Bank

Floral. c. 1965. Oil on canvas, 14½ x 14½". Collection Mr. and Mrs. Samuel Klein

Flowers, Blue Background. 1965. Oil on Masonite, 8 x 9⅛". Private collection

Flowers by the Sea. 1965. Oil on Masonite, 20 x 19½". The Museum of Modern Art, New York. Larry Aldrich Foundation Fund

From the Hill. 1965. Watercolor, 14 x 10¼". Private collection

From the South Meadow. 1965. Oil on Masonite, 8 x 12". Private collection

Girl in a Landscape. 1965. Oil on canvas, 45½ x 44". Collection United Missouri Bank

Great Spruce Head. c. 1965. Pastel, 11⅛ x 17⅞". Fairfield Porter Estate

Green Bottle. 1965. Oil on canvas, 28 x 15⅜". Private collection

The Hazans' Orchard. 1965. Oil on canvas, 37½ x 34". Private collection

Interior in Sunlight. 1965. Oil on canvas, 45 x 45". The Brooklyn Museum, New York. Gift of Mr. and Mrs. John Koch, 1972

In the South Meadow. 1965. Oil on Masonite, 11 x 9½". Private collection

Jimmy and Leaf Cart. c. 1965. Oil on canvas, 34 x 48". Collection Mr. and Mrs. E. W. Andrews, Jr.

Keziah Felmeth. 1965. Oil on canvas, 10⅜ x 8¾". Private collection

Lilacs. 1965. Oil on canvas, 46¼ x 36¼". Private collection

Lunch Table. 1965. Oil on canvas, 32 x 28". Collection Barbara K. Goldman

Maine Landscape. 1965. Watercolor, 10 x 14". Samuel T. Freeman & Co. Auction, Philadelphia

Maine Landscape with Boats. 1965. Watercolor, 10 x 14". Phillips Auction Galleries, New York, 1979

Meadow Flowers. 1965. Oil on Masonite, 11½ x 9¼". Private collection

Morning Landscape. 1965. Oil on canvas, 80 x 80". Private collection

Park Avenue South. 1965. Oil on Masonite, 9 x 7½". Collection Jane Norman

The Parking Lot. 1965. Oil on canvas, 14½ x 20½". Collection Rosanne Diamond Zinn

Red Tulips. 1965. Oil on Masonite, 14¼ x 15⅞". Collection Mr. and Mrs. Austin List

The Schooner II. 1965. Oil on canvas, 37 x 54½". Private collection

Self-Portrait. 1965. Oil on canvas, 17 x 16½". Private collection

Sketch for *Morning Landscape.* 1965. Oil on canvas, 20 x 19". Collection Mr. and Mrs. Austin List

South Meadow. 1965. Oil on canvas, 15 x 12". Private collection

Still Life. 1965. Oil on canvas, 19½ x 24½". Collection John Gruen and Jane Wilson

Sunset, Southampton. 1965. Oil on canvas, 17⅛ x 20⅛". The Parrish Art Museum, Southampton, New York. Gift of the Estate of Fairfield Porter

Table at Night (first version). 1965. Oil on canvas, 48 x 34". Private collection

Trees in Spring. 1965. Oil on Masonite, 9⅛ x 10½". Private collection

Tulips. 1965. Oil on Masonite, 10 x 12⅞". Private collection

View of Islands. 1965. Watercolor, 8⅜ x 14⅛". Private collection

View of the Harbor. 1965. Oil on canvas, 45 x 45". Private collection

Watermill. 1965. Oil on Masonite, 9 x 8". Collection Paul Roebling

1966

Bear Island. 1966. Oil on board, 14 x 18". Collection Elisabeth M. Nardine

Bear Island Bar. 1966. Oil on Masonite, 18⅛ x 20⅛". The Parrish Art Museum, Southampton, New York. Gift of the Estate of Fairfield Porter

Chrysanthemums at Night. 1966. Oil on canvas, 20 x 18". Private collection

Chrysanthemums under a Blue Sky. 1966. Oil on canvas, 36 x 36". The Whitney Museum of American Art, New York. Lawrence H. Bloedel Bequest

Cobb Road. 1966. Oil on Masonite, 6⅛ x 8". Private collection

Columbus Day. 1966. Oil on canvas, 80 x 80". Collection Marianne de Nagy

Crowded Table. 1966. Oil on canvas, 15 x 19". Private collection

Early Morning. 1966. Oil on canvas, 32 x 28". Collection Marianne de Nagy

Farmhouse. 1966. Oil on board, 8 x 10". Katonah Gallery, Katonah, New York

Flowers in a Saltshaker. 1966. Oil on board, 12 x 9". Private collection

Forsythia Trees in Bud. 1966. Oil on canvas, 24 x 20". Collection Ashby McCulloch Sutherland

The Grape Arbor. 1966. Oil on linen, 28 x 26". Collection Ruth Rattner

Great Spruce Head Island. 1966. Oil on board, 9 x 12". Private collection

The Harbor. 1966. Oil on board, 14½ x 15½". Private collection

Hardhack and Goldenrod. 1966. Oil on Masonite, 18 x 20". Private collection

Houses and Barns. 1966. Oil on board, 7⅞ x 9¾". Private collection

Iced Coffee. 1966. Oil on canvas, 79½ x 79½". G.U.C. Collection, Chicago

Interior by Electric Light. 1966. Oil on board, 20 x 18". Private collection

Islands and Queen Anne's Lace. 1966. Oil on Masonite, 19¾ x 20". Private collection

Islands—Maine. c. 1966. Oil on Masonite, 9 x 12". Private collection

Kenneth Koch Reading. 1966. Oil on canvas, 28 x 26". Collection Kenneth Koch

Landscape with House. 1966. Oil on wood, 8½ x 5½". Collection Katharine Porter and Daniel Fishbein

Maple Blossoms. 1966. Oil on board, 8 x 10". Private collection

The Mirror. 1966. Oil on canvas, 72 x 60". The Nelson-Atkins Museum of Art, Kansas City, Missouri. Gift of the Enid and Crosby Kemper Foundation

Morning Sunlight. 1966. Oil on board, 14 x 15". Collection Katharine Porter and Daniel Fishbein

North Sea Beach. 1966. Oil on Masonite, 13 x 11¾". Private collection

Northwest Wind. 1966. Oil on board, 14 x 18". Private collection

Nude. 1966. Oil on canvas, 38⅛ x 38⅛". The Parrish Art Museum, Southampton, New York. Gift of the Estate of Fairfield Porter

Nyack. 1966–67. Oil on canvas, 82 x 110". Contemporary Collection of the Cleveland Museum of Art

Peak Island. 1966. Oil on Masonite, 14 x 18". Private collection

Peak Island. 1966. Oil on board, 9 x 12". Private collection

Penobscot Bay with Peak Island. 1966. Oil on canvas, 48 x 59⅛". The Parrish Art Museum, Southampton, New York. Gift of the Estate of Fairfield Porter

Porch in Maine. 1966. Oil on canvas, 48½ x 60". Private collection

Porch Still Life. 1966. Oil on board, 20 x 18". Private collection

Primroses and Goldenrod. 1966. Oil on Masonite, 18 x 20". Private collection

Red House on Cobb Road. 1966. Oil on board, 10 x 14". Collection Rosanne Diamond Zinn

Rosa Rugosa. 1966. Oil on Masonite, 18 x 14". Collection Ashby McCulloch Sutherland

Still Life on a Mirror. 1966. Oil on canvas, 18½ x 20½". Private collection

Still Life with Giotto's Magdalene. 1966. Oil on board, 18 x 14". Private collection

Summer Landscape with Houses. 1966. Oil on board, 8 x 10". Sotheby's, New York, 1985

The Tan Station Wagon. 1966. Watercolor, 10 x 14". Private collection

Thanksgiving Day. 1966. Oil on canvas, 17½ x 27". Private collection

Towards Bear Island. 1966. Oil on board, 14 x 18". Collection David and Muriel Swiger

View from Upstairs. 1966. Oil on canvas, 24 x 20". Private collection

View through Reflections. 1966. Oil on canvas, 32 x 24". Private collection

View with Sailboat. 1966. Oil on board, 14 x 18". Location unknown

1967
Anne in a Striped Dress. 1967. Oil on canvas, 60 x 48". The Parrish Art Museum, Southampton, New York. Gift of the Estate of Fairfield Porter

Apples and Roses. 1967. Oil on canvas, 22 x 18". Collection Mrs. Robert H. Morris

Autumn No. 1. 1967. Oil on canvas, 19 x 18". Private collection

Autumn No. 2. 1967. Oil on canvas, 19 x 21". Collection Rosanne Diamond Zinn

December 1967. 1967. Oil on Masonite, 8 x 10". Collection of Katherine Porter

The Driveway. 1967. Oil on canvas, 20 x 15". Sotheby's, New York, 1989

Fifth Avenue: Yellow Car. 1967. Oil on canvas, 28 x 22". The Parrish Art Museum, Southampton, New York. Gift of the Estate of Fairfield Porter

House in a Thicket. 1967. Oil on board, 20¾ x 28". Private collection

Jane and Elizabeth. 1967. Oil on canvas, 55⅛ x 48⅛". The Parrish Art Museum, Southampton, New York. Gift of Jane Freilicher

John Ashbery and James Schuyler Writing "A Nest of Ninnies." 1967. Oil on canvas, 36 x 26". Fairfield Porter Estate

Johnson House—Morning. 1967. Oil on Masonite, 11 x 14". Collection David and Muriel Swiger

Katie in Green Landscape. c. 1967. Watercolor, 29 x 22". Collection Mrs. Fairfield Porter

Long Island Farmland. 1967. Oil on canvas, 14½ x 22½". G.U.C. Collection, Chicago

Maine Landscape. 1967. Watercolor, 10¼ x 14". Samuel T. Freeman & Co. Auction, Philadelphia, 1978

Maine Landscape with Cabin. 1967. Watercolor, 10 x 14". Phillips Auction Galleries, New York, 1979

Maine—Towards the Harbor. 1967. Watercolor, 11⅞ x 17⅞". Collection David and Muriel Swiger

Nude. 1967. Watercolor, 18 x 12". Collection Elizabeth Porter

Orvieto. 1967. Oil on canvas, 14 x 19". The Parrish Art Museum, Southampton, New York. Gift of the Estate of Fairfield Porter

Potato Field. 1967. Oil on board, 16½ x 12½". Private collection

Purple Mountain Landscape. 1967. Watercolor, 10¼ x 14⅛". Collection David R. and Muriel K. Pokross

Sayer House. 1967. Oil on canvas, 14 x 19". Collection Rosanne Diamond Zinn

Snow. 1967. Oil on Masonite, 10 x 8". Hirschl & Adler Modern, New York

South Meadow. 1967. Oil on canvas, 37¼ x 54½". Private collection

Spring Landscape. 1967. Oil on canvas, 18 x 19". Collection Dr. and Mrs. Ronald Abrahams

Summer. 1967. Oil on canvas, 43 x 50". Private collection

View towards the Studio. 1967. Oil on canvas, 39 x 25⅛". The Parrish Art Museum, Southampton, New York. Gift of the Estate of Fairfield Porter

The Window. 1967. Oil on canvas, 17 x 19". Private collection

Winter Clouds. 1967. Oil on canvas, 19⅜ x 17⅝". Montgomery Museum of Fine Arts Association Purchase, Alabama

1968
Adlai Stevenson. 1968. Oil on canvas, 88 x 50". Private collection

Anne Reading. 1968. Oil on canvas, 36 x 36". Private collection

Autumn Tree. c. 1968. Watercolor, 10¼ x 14". Private collection

Bear Island. 1968. Oil on canvas, 22 x 24". Private collection

Birch Trees by a Window. 1968. Oil on canvas, 36 x 36". Private collection

The Black Tree. 1968. Oil on board, 20 x 18". Collection James G. Austin, Southampton, New York

Boat Houses and Lobster Pots. 1968–72. Oil on canvas, 48 x 60". Mead Art Museum, Amherst College

Cooper Square. 1968. Oil on Masonite, 18½ x 22". Private collection

Cumulus. 1968. Oil on canvas, 20 x 24". Private collection

Double Portrait. 1968. Oil on canvas, 29 x 36". Collection Paul Roebling

Easter Morning. 1968. Oil on Masonite, 18 x 20". Private collection

East 17th Street. 1968. Oil on Masonite, 11 x 14". Private collection

Edge of the Woods. 1968. Oil on Masonite, 15 x 14". Private collection

Field Flowers. 1968. Oil on Masonite, 16 x 14". Private collection

Fifty-sixth Street. 1968–71. Oil on canvas, 36 x 29⅞". Fairfield Porter Estate

Forsythia and Pear in Bloom. 1968. Oil on canvas, 36⅛ x 29". National Museum of American Art, Smithsonian Institution, Washington, D.C. Gift of the Woodward Foundation

Friday Sun. 1968. Oil on Masonite, 11¾ x 14⅜". Private collection

Harbor Beach. 1968. Oil on canvas, 28 x 32". Private collection

Hawkweed. 1968. Oil on board, 9 x 12". Collection Lindsay and David Shapiro

Hawkweed. 1968. Oil on Masonite, 11½ x 14". Private collection

Horsechestnut Tree. 1968. Oil on Masonite, 18 x 14". Private collection

Horse in the Meadow. 1968. Oil on canvas, 24 x 41". Fairfield Porter Estate

Hyacinth. 1968. Oil on canvas, mounted on board, 14 x 11". Private collection

Inez MacWhinnie. 1968. Oil on Masonite, 20 x 18". Collection John and Virginia MacWhinnie

Islands. 1968. Oil on canvas, 28 x 32". Private collection

John MacWhinnie. 1968. Oil on canvas, 52⅛ x 37½". The Parrish Art Museum, Southampton, New York. Gift of the Estate of Fairfield Porter

Johnson House—Afternoon. 1968. Oil on board, 12 x 16". Fairfield Porter Estate

Johnson House in Snow. 1968. Oil on board, 18 x 28". Private collection

Landscape with Child and Dog. 1968. Oil on canvas, 77 x 82". Private collection

Lizzie. 1968. Oil on canvas, 60⅛ x 47¹⁵⁄₁₆". New Jersey State Museum, Trenton. Gift of Mr. and Mrs. Paul Roebling

Lunch in the Woods. 1968. Oil on canvas, 21 x 17½". Private collection

North Meadow. 1968. Oil on canvas, 20 x 24". Private collection

Path in the Woods. 1968. Oil on Masonite, 20 x 18". Private collection

Peak Island and Dirigo. 1968. Oil on Masonite, 20 x 18". Private collection

Peak Island and Lobster Boat. 1968. Oil on Masonite, 14 x 15". Private collection

Penobscot Bay with Yellow Field. 1968. Oil on canvas, 37⅛ x 54". The Parrish Art Museum, Southampton, New York. Gift of the Estate of Fairfield Porter

Scuttlehole Road. 1968. Oil on Masonite, 18 x 22". Private collection

Self-Portrait. 1968. Oil on canvas, 59 x 45⅝". Dayton Art Institute, Ohio, museum purchase with funds provided by the National Endowment for the Arts and matching funds provided by Mrs. T. Lawrence Saunders, the Hon. Jefferson Patterson and his late mother Mrs. Harrie G. Carnell, and the late Brainerd B. Thresher

Self-Portrait in the Studio. 1968. Oil on Masonite, 22 x 16". Private collection

South Meadow, Great Spruce Head Island. 1968. Oil on canvas, 48 x 59½". The Parrish Art Museum, Southampton, New York. Gift of the Estate of Fairfield Porter

Still Life with Cherries and Peaches. 1968. Oil on Masonite, 18 x 22". Collection Jane Freilicher and Joe Hazan

Still Life with Red Tablecloth. 1968. Oil on Masonite, 17¾ x 19¾". Private collection

Still Life with the New York Times. 1968. Oil on Masonite, 18 x 20". Private collection

Still Life with White Boats. 1968. Oil on canvas, 20 x 20". Private collection

Studio Interior. 1968. Oil on Masonite, 20 x 18". Private collection

Sunset in the Woods. 1968. Oil on Masonite, 21 x 17½". Private collection

Trees in Bloom. 1968. Oil on Masonite, 20 x 18". Private collection

Untitled [RKO 86]. c. 1968–71. Oil on canvas, 9½ x 11½". Private collection

Untitled [View of the Chain Links Islands, Maine]. 1968. Oil on board, 20½ x 18". Fairfield Porter Estate

Untitled [View outside the Southampton studio]. 1968. Oil on Masonite, 18 x 28¾". Collection Ron and Patricia Padgett

View from Bear Island. 1968. Oil on Masonite, 14 x 15". Private collection

View from Spruce Head. 1968–71. Oil on board, 24⅞ x 26". Private collection

View of Barred Islands from Front of House. 1968. Oil on canvas, 11¼ x 33¾". Private collection

View to the North. 1968. Oil on Masonite, 14 x 12". Private collection

View toward Blue Hill. 1968. Oil on Masonite, 18 x 20". Private collection

The Walk to the Village. 1968. Oil on Masonite, 22 x 18". Private collection

The Windows. 1968. Oil on board, 20 x 18". Collection Arthur M. Bullowa

Woods. 1968. Oil on Masonite, 20 x 18". Private collection

Young Man. 1968. Oil on Masonite, 19⅞ x 17⅞". Portland Art Museum, Oregon Art Institute. Gift of Mrs. Fairfield Porter

1969

Amherst Campus, No. 1. 1969. Oil on canvas, 62 x 46". The Parrish Art Museum, Southampton, New York. Gift of the Estate of Fairfield Porter

Amherst, Massachusetts. 1969. Watercolor and pencil, 31½ x 23". Hirschl & Adler Modern, New York

Amherst Parking Lot, No. 1. 1969. Oil on canvas. 62¼ x 46".

Honolulu Academy of Arts. Funds from the Gregg Allerton Bequest, 1989

Amherst '69. 1969. Oil on Masonite, 14 x 18". Private collection

Autumn Leaves. 1969. Oil on Masonite, 18 x 14". Private collection

Clearing Weather. 1969. Oil on canvas, 19¼ x 24". The Parrish Art Museum, Southampton, New York. Gift of the Estate of Fairfield Porter

The Fire. 1969. Oil on Masonite, 18 x 22". Collection Elizabeth Porter

Goldenrod and Wild Cherry. c. 1969. Oil on canvas, 30 x 28". Private collection

Grey Still Life. 1969. Oil on canvas, 30 x 28". Collection Benjamin and Peggy De Mott

Harry Striebel. 1969. Oil on canvas, 72 x 49¾". The Parrish Art Museum, Southampton, New York. Gift of the Estate of Fairfield Porter

Hazel Avenue. 1969. Oil on canvas, 14 x 18". Private collection

Hills to the West. 1969. Oil on panel, 14 x 18". Private collection

Ice Storm. 1969. Oil on canvas, 26 x 28". Collection Mr. and Mrs. Thomas F. O'Toole

Interior with a Dress Pattern. 1969. Oil on canvas, 62 x 46". Collection Mr. and Mrs. Austin List

Island Farmhouse. 1969. Oil on canvas, 79⅞ x 79⅞". Private collection

Island Farmhouse—Sketch. 1969. Oil on canvas, 14 x 14". Private collection

Katie. 1969. Oil on canvas, 32 x 26". The Parrish Art Museum, Southampton, New York. Gift of the Estate of Fairfield Porter

Lobster Boat. 1969. Oil on canvas, 39⅜ x 46¾". Private collection

Oak Tree. 1969. Oil on canvas, 22 x 20". Private collection

Sketch for *Dog at the Door*. 1969. Oil on Masonite, 22 x 18". Private collection

Sketch for *Island Farmhouse*. 1969. Oil on Masonite, 14 x 14". Private collection

South Meadow. 1969. Oil on Masonite, 18 x 20". Private collection

Two Parked Cars. 1969. Oil on canvas, 30⅛ x 25⅛". Private collection

Untitled [Amherst]. c. 1969. Oil on cardboard, 10⅜ x 14⅞".
The Parrish Art Museum, Southampton, New York. Gift of
the Estate of Fairfield Porter

View from the Front. c. 1969. Oil on Masonite, 12½ x 22⅞".
The Parrish Art Museum, Southampton, New York. Gift of
the Estate of Fairfield Porter

View from the South Meadow. 1969. Oil on canvas, 48 x 60".
Private collection

View toward Peak Island. 1969. Watercolor, 12 x 16". Private
collection

The Wake. 1969. Oil on board, 14 x 18". Phillips Auction
Galleries, New York, 1979

Wild Apples. 1969. Oil on board, 18 x 22". Collection Arthur
M. Bullowa

Wood Road. 1969. Oil on Masonite, 22 x 17⅞". Hirschl & Adler
Modern, New York

1970
Arnold Collery, No. 1. 1970. Oil on linen, 30½ x 28⅛". The
Parrish Art Museum, Southampton, New York. Gift of the
Estate of Fairfield Porter

The Barred Islands. 1970. Pastel, 12 x 16". Private collection

Bruno. c. 1970. Watercolor, 16 x 12". Private collection

The Campus. 1970. Oil on canvas, 30 x 28". The Parrish Art
Museum, Southampton, New York. Gift of the Estate of
Fairfield Porter

The Church. 1970. Oil on canvas, 14 x 20". Collection Charlotte
F. Rogers

City Street. c. 1970. Oil on Masonite, 17⅜ x 19¼". The Parrish
Art Museum, Southampton, New York. Gift of the Estate of
Fairfield Porter

Cover Crops on Potato Fields. 1970. Oil on Masonite,
17¾ x 23¾". Collection Katharine Porter

Dog at the Door. 1970. Watercolor, 29⅜ x 21¼". Collection
Cheryl and Joseph F. Boulos

Double Portrait. 1970. Oil on canvas, 24 x 28". Hirschl & Adler
Modern, New York

Edward Porter. 1970. Oil on canvas, 32¼ x 22½". San Antonio
Museum Association, Texas

Evening. 1970. Oil on canvas, 46¾ x 39½". Private collection

Evening Primroses. 1970. Oil on Masonite, 20⅜ x 16⅛". Private
collection

Harry Striebel in the Garden at Centasia. 1970–71. Oil on
canvas, 59½ x 48". Collection Guild Hall Museum, East
Hampton, New York (Fractional interest gift). Gift of Harry
Acton Striebel in memory of Dr. Harry McCord Scriver, Jr.

Iris. 1970. Oil on Masonite, 16 x 14". Private collection

John Ashbery. 1970. Oil on canvas, 32⅛ x 19½". G.U.C.
Collection, Chicago

July. 1970. Oil on canvas, 60 x 48". Private collection

Keelin before the Reflected View. 1970. Oil on canvas, 44½ x 45".
The Parrish Art Museum, Southampton, New York. Gift of the
Estate of Fairfield Porter

Lizzie and Bruno. 1970. Oil on canvas, 59¾ x 24½". Collection
Mr. and Mrs. Joseph Del Gaudio

Lobster Boat, Morning. 1970. Oil on canvas, 28 x 31¾". Private
collection

Lobster Pots and Boathouses. c. 1970. Oil on canvas, 40½ x 50".
Private collection

Maine Landscape. 1970. Oil on canvas, 47 x 39½". Hirschl
& Adler Modern, New York

Oreton Clark House, Amherst College. 1970. Oil on Masonite,
18 x 14". Exxon Corporation

Pam Diefenbach. c. 1970. Oil on Masonite, 21⅛ x 21⅛". The
Parrish Art Museum, Southampton, New York. Gift of the
Estate of Fairfield Porter

Peggy De Mott Sewing. 1970. Oil on canvas, 23¾ x 21¾".
Collection Benjamin and Peggy De Mott

Pelham Hills. 1970. Oil on canvas, 26 x 28". The Parrish Art
Museum, Southampton, New York. Gift of the Estate of
Fairfield Porter

Porch in Maine. 1970. Oil on canvas, 45½ x 45½". Collection
Mr. and Mrs. Austin List

Portrait of Arnold Collery. c. 1970. Oil on canvas, 27¾ x 31¾".
Private collection

Portrait of Kenneth Koch. 1970. Oil on Masonite, 20½ x 16¼".
Fairfield Porter Estate

Primroses. c. 1970. Oil on canvas, 30 x 24". The Parrish Art
Museum, Southampton, New York. Gift of the Estate of
Fairfield Porter

Ron Padgett. 1970. Oil on canvas, 31⅛ x 22¼". Collection Ron
and Patricia Padgett

Sketch for July. 1970. Oil on board, 16 x 11¾". Private collection

South Meadow. 1970. Oil on Masonite, 24 x 32". Private Collection

South Meadow, Afternoon. 1970. Oil on Masonite, 23½ x 27½". Private collection

South Meadow from the Beach. c. 1970. Oil on canvas, 33½ x 23⅝". The Parrish Art Museum, Southampton, New York. Gift of the Estate of Fairfield Porter

Spring Fog. c. 1970. Oil on canvas, 44 x 30". The Parrish Art Museum, Southampton, New York. Gift of the Estate of Fairfield Porter

Still Life with Stapler. 1970. Oil on Masonite, 24 x 16". Collection Mr. and Mrs. Samuel Klein

Study for *Portrait of Arnold Collery.* 1970. Oil on canvas, 22 x 19". Private collection

Study for *July.* 1970. Pastel, 15½ x 11½". The Spencer Museum of Art, University of Kansas, Lawrence. Gift of Mr. and Mrs. R. Crosby Kemper, Jr., through the Enid and Crosby Kemper Foundation

The Table. 1970. Watercolor, 30 x 25". Collection Elizabeth Feld

The Tennis Game. 1970. Oil on Masonite, 16 x 13⅝". Collection the Equitable Life Assurance Society of the United States, New York

Tulips. c. 1970. Oil on canvas, 22⅛ x 28⅛". The Parrish Art Museum, Southampton, New York. Gift of the Estate of Fairfield Porter

Vase of Wildflowers. 1970. Oil on Masonite, 24 x 20⅝". Hirschl & Adler Modern, New York

View from Fayerweather Hall. 1970. Oil on canvas, 24 x 19⅛". The Parrish Art Museum, Southampton, New York. Gift of the Estate of Fairfield Porter

View of the Barred Islands. 1970. Oil on canvas, 40 x 50". The Herbert W. Plimpton Foundation extended loan to the Rose Art Museum, Brandeis University, Waltham, Massachusetts

View over the Baseball Field. 1970. Oil on canvas, 30 x 28". FMC Corporation

1971
Aline. 1971. Watercolor, 22½ x 22". Tower Gallery, New York

Aline by the Screen Door. 1971. Oil on canvas, 59⅞ x 48". Collection Stephen S. Alpert, Boston

Anne. 1971. Oil on canvas, 45 x 37". Hirschl & Adler Modern, New York

Blue Table. 1971. Oil on canvas, 30 x 22". Collection Mrs. Martin E. Segal

Dog on the Steps. 1971. Oil on canvas, 66¼ x 54". Collection Rosanne Diamond Zinn

The Door to the Woods. 1971. Watercolor, 30¾ x 22⅝". Collection David and Muriel Swiger

Flowers in the Fog. 1971. Oil on Masonite, 18 x 13⅞". Fairfield Porter Estate

Jimmy with Lamp. 1971. Oil on canvas, 26½ x 35¼". Collection Mary and Norman Abrams

July. 1971. Oil on canvas, 100 x 80". The Spencer Museum of Art, University of Kansas, Lawrence. Gift of Mr. and Mrs. R. Crosby Kemper, Jr., through the Enid and Crosby Kemper Foundation

Katie Porter. 1971–73. Oil on canvas, 40 x 40". The Parrish Art Museum, Southampton, New York. Gift of the Estate of Fairfield Porter

Mackerel Sky. 1971. Oil on Masonite, 18 x 14". Collection Mrs. Martin E. Segal

Meadow, Sea and Island. 1971. Watercolor, 20½ x 29½". Hirshhorn Museum and Sculpture Garden, Smithsonian Institution, Washington, D.C. The Joseph H. Hirshhorn Bequest, 1981

Portrait of a Girl. 1971. Oil on canvas, 41¼ x 27⅜". The Parrish Art Museum, Southampton, New York. Gift of the Estate of Fairfield Porter

Portrait of Arthur Bullowa. 1971. Oil on canvas, 30⅞ x 22¼". Collection Arthur M. Bullowa

Red and Brown Interior. 1971. Oil on board, 16 x 14". Sotheby's New York, 1987

Sixth Avenue. 1971. Watercolor, 20½ x 27½". Private collection

Sketch for *Jimmy with Lamp.* 1971. Pastel, 16 x 11¼". Private collection

Sketch for *July.* 1971. Watercolor, 27¾ x 22¾". Collection David and Muriel Swiger

The South Meadow. 1971. Watercolor, 21 x 30¼". Private collection

Study for *Jimmy with Lamp.* 1971. Pastel, 15½ x 10¾". Hirschl & Adler Modern, New York

The Table on the Porch. 1971. Oil on Masonite, 19⅛ x 23⅞". Private collection

Under the Elms. 1971–72. Oil on canvas, 62⅜ x 46". The Pennsylvania Academy of the Fine Arts, Philadelphia. Gift of Mrs. Fairfield Porter

Untitled [The ocean at Southampton]. c. 1971. Watercolor, 8⅝ x 12". Collection Wayne Padgett

View. 1971. Oil on canvas, 37 x 54½". Private collection

View from the Big House, September, Great Spruce Head Island. 1971. Watercolor, 16 x 20". Collection Mrs. Fairfield Porter

View from the South Meadow, Maine. 1971. Oil on canvas, 36 x 37". Collection Laurence and Laurel Porter

View of the Barred Islands from the Big House. 1971. Oil on canvas, 36 x 36". Collection Laurence and Laurel Porter

1972

Anne. 1972. Oil on Masonite, 15 x 11⅞". The Parrish Art Museum, Southampton, New York. Gift of the Estate of Fairfield Porter

Beach at Noon. 1972. Oil on canvas, 20 x 24". The Parrish Art Museum, Southampton, New York. Gift of the Estate of Fairfield Porter

Beach Flowers No. 1. 1972. Oil on Masonite, 19 x 14⅞". Private collection

Beach Flowers No. 2. 1972. Oil on canvas, 24¼ x 20½". Private collection

The Beach in the Morning No. 1. 1972. Oil on Masonite, 12 x 14¼". Private collection

The Beach in the Morning No. 2. 1972. Oil on Masonite, 12 x 14 7⁄16". The Currier Gallery of Art, Manchester, New Hampshire. Gift of Neil Welliver, 1982

Boat off Shore. 1972. Oil on board, 16 x 14". Private collection

Buttercups. 1972. Oil on panel, 16 x 13". Collection E. E. Richards

The Christmas Tree. 1972. Oil on board, 18 x 14". Private collection

Crystal Lithium (Ocean). c. 1972. Watercolor and gouache, 20 x 26". Christie's East, New York, 1990

David and Lindsay Shapiro. 1972. Oil on canvas, 30 x 24". Collection Lindsay and David Shapiro

David Kermani. 1972. Oil on Masonite, 14½ x 12". Private collection

Door to the Woods. c. 1972. Oil on canvas, 60 x 46½". Private collection

Fallow Field. 1972. Oil on Masonite, 22⅛ x 28⅜". Private collection

Flowering Apple. 1972. Oil on canvas, 17 x 15¼". Fairfield Porter Estate

Flowering Pear. 1972. Oil on canvas, 19 x 16". Private collection

Golden Retriever. 1972. Oil on wood panel, 14 x 15⅛". The Parrish Art Museum, Southampton, New York. Gift of the Estate of Fairfield Porter

House in a Thicket. 1972. Oil on canvas, 24 x 30". Private collection

House with Three Chimneys. 1972. Oil on canvas, 22 x 21". Private collection

Islands—Morning. 1972. Oil on Masonite, 12 x 16". Private collection

Jimmy. 1972. Oil on Masonite, 14¼ x 10⅞". Fairfield Porter Estate

John MacWhinnie. 1972. Oil on linen, 31 x 22½". Collection John and Virginia MacWhinnie

Katie. 1972. Oil on Masonite, 14¼ x 12". The Parrish Art Museum, Southampton, New York. Gift of the Estate of Fairfield Porter

Keelin before the Reflected View. 1972. Oil on canvas, 60 x 62". Private collection

Landscape with Two Parked Cars. 1972. Oil on canvas, 25⅛ x 30⅛". Queens College, New York

Late Afternoon—Snow. c. 1972. Oil on paper, mounted on board, 14 x 17". Fairfield Porter Estate

Lichens, Wild Roses and Primroses. 1972. Oil on canvas, 32 x 24". Corporate Art Collection. The Reader's Digest Association, Inc.

Morning Sky. 1972. Oil on board, 14 x 16". Collection Katharine Porter and Daniel Fishbein

Morning, Southampton. 1972. Oil on canvas, 23 x 30¾". Private collection

North Point No. 1. 1972. Oil on wood, 16 x 14¼". Private collection

North Point No. 2. 1972. Oil on wood, 16 x 14". Collection Stanley M. Vickers, M.D.

The Ocean. 1972. Oil on canvas, 40 x 40". Collection Mr. and Mrs. A. J. Lambert

The Painting Table. 1972. Oil on canvas, 30⅛ x 24¼". Private collection

Parking Lot. c. 1972. Watercolor, 10¼ x 14¼". Fairfield Porter Estate

The Pear Tree—Autumn. 1972. Watercolor, 16 x 12". Fairfield Porter Estate

Peter Ackroyd. 1972. Oil on Masonite, 15 x 12". Private collection

Red Puppy. 1972. Oil on Masonite, 12 x 16". Fairfield Porter Estate

Roses No. 1. 1972. Oil on Masonite, 12 x 14⅛". Private collection

Roses No. 2. 1972. Oil on board, 14¼ x 11". Collection Katharine Porter and Daniel Fishbein

Roses No. 3. 1972. Oil on Masonite, 14¼ x 11". Collection Mrs. Fairfield Porter

Self-Portrait. 1972. Oil on board, 13½ x 10½". Collection Mr. and Mrs. Samuel Klein

Self-Portrait. 1972. Oil on Masonite, 14¼ x 10⅞". The Parrish Art Museum, Southampton, New York. Gift of the Estate of Fairfield Porter

Single Peonies. 1972. Oil on Masonite, 14⅛ x 11⅞". Fairfield Porter Estate

Sketch for *Lizzie and Christmas Tree.* 1972. Watercolor, 19¾ x 15⅝". Collection Glenn C. Janss

Snow—South Main Street. c. 1972. Oil on Masonite, 14 x 17". Fairfield Porter Estate

Southampton Landscape. 1972. Pastel, 20 x 16". Fairfield Porter Estate

South Point. 1972. Watercolor, 16 x 12". Private collection

Steep Bank Beach. 1972. Oil on board, 16 x 14". Private collection

Sun on Rough Sea. 1972. Oil on canvas, 20 x 24". Private collection

Sun on the Ocean. 1972. Oil on canvas, 32 x 35". Private collection

The Sweater. 1972. Oil on canvas, 22¾ x 31¼". Collection Mr. and Mrs. Austin List

The Tennis Game. 1972. Oil on canvas, 72½ x 62¼". Lauren Rogers Museum of Art, Laurel, Mississippi

Trail. 1972. Oil on Masonite, 16 x 12". Private collection

Tree-lined Street. 1972. Oil on board, 12 x 14". Private collection

Tree-lined Street. 1972. Oil on canvas, 25⅛ x 34⅞". Private collection

View from a High Ledge No. 1. 1972. Oil on Masonite, 15¹⁵⁄₁₆ x 11¹⁵⁄₁₆". Private collection

View from a High Ledge No. 2. 1972. Oil on canvas, 44 x 32". Private collection

View from the Camden Hills. 1972–75. Oil on canvas, 44 x 32". Collection Mrs. Robert H. Morris

The Wave. 1972. Oil on canvas, 12 x 19". Private collection

White Rocks. 1972. Oil on Masonite, 16 x 11¾". Private collection

White Rose and Peaches. 1972. Oil on Masonite, 10⅞ x 14³⁄₁₆". Collection Mr. and Mrs. Austin List

White Sky. 1972. Oil on canvas, 40⅞ x 51". Hirschl & Adler Modern, New York

Wildflowers in the Rocks. 1972. Watercolor, 16 x 12". Private collection

Wild Roses and Evening Primroses on the Rocks. 1972. Oil on canvas, 32 x 22". Private collection

Wood Road No. 1. 1972. Watercolor, 16 x 12". Hirschl & Adler Modern, New York

Wood Road No. 2. 1972. Watercolor, 16 x 12". Fairfield Porter Estate

1973

Apple Branch. 1973. Watercolor, 20 x 25". Corporate Art Collection. The Reader's Digest Association, Inc.

Beach, Southampton. 1973. Oil on board, 18 x 22". Hirschl & Adler Modern, New York

The Beginning of the Fields. 1973. Oil on canvas, 52 x 76¼". Memorial Art Gallery of the University of Rochester, New York. Marion Stratton Gould Fund

Bright Day on the Beach. 1973. Oil on Masonite, 18 x 22". Private collection

Camden Hills from the Double Beaches. 1973. Watercolor, 12 x 16". Private collection

The Clearing—North Meadow. 1973. Watercolor, 12 x 16". Private collection

Daffodils and Pear Tree. 1973. Oil on Masonite, 22 x 18". Private collection

Donald Templeton Rodbell. 1973. Oil on board, 14 x 11".
Collection Donald Rodbell

Eagle Island Roses. 1973. Oil on board, 14 x 11". Private
collection

Eagle Island Roses on a Round Table. 1973. Oil on board,
12 x 9". Private collection

East Hampton Parking Lot. 1973. Watercolor, 12¼ x 16".
Private collection

Evening Gale. 1973. Oil on Masonite, 18 x 22". Private
collection

Fir Trees with Clouds. c. 1973. Watercolor, 14 x 11". Private
collection

Fish Hawk Point. 1973. Oil on board, 22 x 18". Collection
Elizabeth Porter

From North Point. 1973. Watercolor, 14 x 11". Private
collection

From the Precipice. 1973. Oil on canvas, 36 x 36". Private
collection

The Gale. 1973. Watercolor, 20 x 25". The William Benton
Museum of Art, University of Connecticut, Storrs. Gift of the
Friends and Family of Margaret Gant

Goldenrod and Barred Islands. 1973. Watercolor, 22½ x 30".
Private collection

Harbor Full of Boats. 1973. Oil on canvas, 36 x 36". Private
collection

High Tide. 1973. Oil on board, 22 x 18". Private collection

Large Calm Sunrise. 1973. Oil on board, 30 x 24". Private
collection

Large Calm Sunset. 1973. Watercolor, 30¾ x 22½". San
Francisco Museum of Modern Art. Gift of Jane Richards Lane

Lisa. 1973. Oil on board, 14 x 11". Collection Lisa Fuller

Lizzie. 1973. Watercolor, 20 x 16". Collection Elizabeth Porter

Lizzie, Guitar and Christmas Tree No. 1. 1973. Oil on canvas,
76 x 52". The Parrish Art Museum, Southampton, New York.
Gift of the Estate of Fairfield Porter

Lizzie, Guitar and Christmas Tree No. 2. 1973. Oil on canvas,
76 x 52". The Parrish Art Museum, Southampton, New York.
Gift of the Estate of Fairfield Porter

Logs and Rocking Chair. 1973. Oil on Masonite, 22 x 18".
Private collection

The Mail Boat. 1973. Oil on canvas, 47 x 39¼". Private
collection

Maine Landscape. 1973. Watercolor, 11 x 14". Colby College
Museum of Art, Maine. Museum Purchase

Morning after a Storm. 1973. Oil on board, 18 x 22". Hirschl
& Adler Modern, New York

North Point. c. 1973–74. Watercolor, 16 x 12". Private collection

Ocean. c. 1973. Watercolor, 10½ x 13¾". Collection Mrs. Cooper
Converse

October Sunset. 1973. Oil on board, 18 x 24". G.U.C. Collection,
Chicago

Pear Tree. 1973. Oil on board, 18 x 14". Fairfield Porter Estate

Peonies. 1973. Oil on board, 21⅝ x 18". The William Benton
Museum of Art, University of Connecticut, Storrs. Louise
Crombie Beach Memorial Collection

Plane Tree—June. 1973. Oil on canvas, 24 x 24". Collection
Mrs. Martin E. Segal

Plane Tree—October. 1973. Oil on canvas, 30 x 24". Private
collection

Plane Tree—Pale Sky. 1973. Oil on board, 19⅜ x 17⅜". Fairfield
Porter Estate

Porch. c. 1973. Watercolor, 22¼ x 30". Private collection

Portrait of Howard Schneider. 1973. Oil on board, 22 x 18".
Collection Mr. and Mrs. Howard Schneider

Portrait of Nancy Porter Straus. 1973. Oil on canvas, 68 x 80".
Museum of Fine Arts, Boston. Anonymous gift

Portrait of Tami. 1973. Oil on board, 14 x 11". Private collection

The Pump House. 1973. Oil on board, 18 x 14". Collection
Kresge Art Museum, Michigan State University, East Lansing.
Gift of Professor and Mrs. Laurence Porter

Pump House and Birches. 1973. Oil on board, 22 x 18". Private
collection

Rocks on Sheep Cove. 1973. Watercolor, 22⅜ x 30⅛". Private
collection

Rocks on Sheep Cove No. 2. 1973. Watercolor, 20¼ x 30½".
Private collection

Roses, Dark Background. 1973. Oil on board, 18 x 14". Maine
Coast Artists

Scott. 1973. Oil on board, 14⅛ x 11⅛". Collection Scott Fuller

Sketch for *Lizzie*. 1973. Watercolor, 20 x 16". Private collection

Sketch for *Lizzie with Guitar and Christmas Tree*. 1973. Watercolor, 19⅜ x 13⅝". Collection Mr. and Mrs. Samuel Klein

Sketch for *Portrait*. 1973. Oil on board, 17¼ x 19¼". Private collection

Small Calm Sunrise. 1973. Oil on board, 22 x 18". Private collection

The Southwest Wind. 1973. Oil on board, 24 x 30". Private collection

Study for *The Beginning of the Fields*. 1973. Watercolor, 11 x 14". Private collection

Study: Lizzie and Guitar. 1973. Pastel, 20⅛ x 16". Fairfield Porter Estate

Study for *Rose, Where Did You Get That Red*. c. 1973. Watercolor, 17 x 21". Collection Kenneth Koch

Study for *Rose, Where Did You Get That Red*. c. 1973. Watercolor, 8¾ x 13". Collection Kenneth Koch

Study for *Rose, Where Did You Get That Red*. c. 1973. Watercolor, 8⅞ x 12¾". Collection Kenneth Koch

Study for *Rose, Where Did You Get That Red*. c. 1973. Watercolor, 14 x 17⅜". Collection Kenneth Koch

Study for *Rose, Where Did You Get That Red*. c. 1973. Watercolor, 8¾ x 12⅝". Collection Kenneth Koch

Study for *Rose, Where Did You Get That Red (2)*. c. 1973. Watercolor, 17 x 21". Collection Kenneth Koch

Subsiding Sea. 1973. Oil on board, 18 x 22". Private collection

A Sudden Change of Wind. 1973. Oil on canvas, 24 x 30". Private collection

Sunrise on South Main Street. 1973. Oil on canvas, 43 x 55". The Metropolitan Museum of Art, New York. Hugo Kastor Fund, 1976

Sunrise over the Ocean. 1973. Oil on board, 18 x 22". Private collection

Sun Rising out of the Mist. 1973. Oil on canvas, 55 x 37". Private collection

The Tender. 1973. Oil on canvas, 28 x 30". Private collection

Union Square. 1973. Oil on paper, 13¾ x 17". Gary Edwards Fine Arts, Kensington, Maryland

View in Haze. 1973. Oil on board, 22 x 18". Collection Arthur M. Bullowa

View toward Little Spruce Head. 1973. Oil on board, 18 x 22". Private collection

White Rocks. 1973. Watercolor, 16 x 12". Private collection

Windy Sunrise. 1973. Oil on board, 22 x 18". Private collection

1974

Afternoon Seascape. 1974. Watercolor, 14 x 11". Private collection

Afternoon Sun on the Bay. 1974. Watercolor, 16 x 12". Private collection

Anne in Doorway. 1974. Oil on canvas, 47 x 37". Heckscher Museum, Huntington, New York. Gift of Mrs. Fairfield Porter

Asters and Rocks. 1974. Watercolor, 16 x 20". Private collection

Barred Islands. 1974. Watercolor, 12 x 16". Private collection

Bear Island and Spruces. 1974. Oil on board, 22 x 18". Collection Mrs. Fairfield Porter

Bear Island—June. 1974. Oil on board, 18 x 22". Collection Mr. Martin E. Segal

Bear Island—Sunset. 1974. Oil on board, 18 x 22". Collection David R. and Muriel K. Pokross

Bear Island—Sunset. 1974. Watercolor, 17½ x 22½". Private collection

Bear Island with Attendant Clouds. 1974. Oil on board, 18 x 22". Collection Laurence and Laurel Porter

Birch Tree and Clouds. 1974. Oil on board, 22 x 18". Private collection

Blue Landscape. 1974. Oil on canvas, 46 x 45¾". The Parrish Art Museum, Southampton, New York. Gift of the Estate of Fairfield Porter

Blue Sunrise. 1974. Oil on board, 21½ x 17½". Collection Mr. and Mrs. Daniel Gordon

Change of Wind. 1974. Watercolor, 14 x 11". Private collection

Chrysanthemums. 1974. Watercolor, 19¾ x 21⅛". Private collection

The Cliffs of Isle Au Haut. 1974. Oil on canvas, 72 x 62". Collection Graham Gund

The Cove Bridge. 1974. Oil on board, 22 x 18". Private collection

The Dock. 1974–75. Oil on canvas, 20 x 36". William A. Farnsworth Library and Art Museum, Rockland, Maine

Dogs. 1974. Oil on Masonite, 18 x 22". Private collection

Double Beaches. 1974. Watercolor, 12 x 16". Private collection

Elaine Frater. 1974. Oil on canvas, 31⅞ x 23⅞". Collection Elaine Frater

Field Flowers, Fruit and Dishes. 1974. Oil on Masonite, 18 x 22". Collection Anina Porter Fuller

The Harbor—Great Spruce Head. c. 1974. Watercolor, 17¼ x 22". Fairfield Porter Estate

The Harbor—Great Spruce Head. 1974. Oil on canvas, 20 x 36". Private collection

Hawkweed and the Barred Islands. 1974. Oil on board, 18 x 22". Collection Mr. Martin E. Segal

House in the Sun. 1974. Oil on canvas, 30 x 25". Private collection

Isle Au Haut No. 2. c. 1974. Watercolor, 14 x 12". Private collection

James Deely. 1974. Oil on canvas, 55 x 45". The Parrish Art Museum, Southampton, New York. Gift of the Estate of Fairfield Porter

James Deely No. 2. 1974. Oil on canvas, 45½ x 45½". The Parrish Art Museum, Southampton, New York. Gift of the Estate of Fairfield Porter

Katie. 1974. Oil on board, 22 x 18". Private collection

Katie and Dan. 1974. Oil on board, 22 x 18". Private collection

Katie and Dan. 1974. Oil on canvas, 28 x 20". Private collection

Kristina. 1974. Oil on Masonite, 14 x 11". Collection Kristina Fuller

Late Afternoon—Winter. 1974. Oil on board, 18 x 22". Private collection

Leon Porter. 1974. Oil on board, 14 x 11". Collection Leon Porter

Marc Witkin. 1974. Oil on board, 22 x 18". Bowdoin College Museum of Art, Brunswick, Maine

Monument Mountain. 1974. Oil on panel, 18 x 22". Private collection

Monument Mountain No. 2—Cirrus Clouds. 1974. Oil on canvas, 32 x 36". Private collection

Monument Mountain No. 3—Cirrus Clouds. 1974–75. Oil on canvas, 32⅛ x 39¼". The Parrish Art Museum, Southampton, New York. Gift of the Estate of Fairfield Porter

Morning Fog. 1974. Watercolor, 12 x 16". Private collection

Morning from the Porch. 1974. Watercolor, 22¼ x 29⅞". Heckscher Museum, Huntington, New York. Museum Purchase

October. 1974. Oil on board, 11 x 14". Collection Darragh Park

Pea Point from the South Meadow. 1974. Oil on board, 18 x 22". Collection Arthur M. Bullowa

Portrait of James Deely. 1974. Oil on canvas, 38 x 30". The Parrish Art Museum, Southampton, New York. Gift of the Estate of Fairfield Porter

Portrait of Richard Freeman. 1974. Oil on Masonite, 22 x 18". Bowdoin College Museum of Art, Brunswick, Maine

Sarah Porter. 1974. Oil on board, 14 x 11". Collection Sarah Porter

Seascape. 1974. Watercolor, 14 x 11". Collection Robert Dash

Seascape. 1974. Watercolor, 22 x 30". Collection David and Carole Nathan Metzger

Sketch for *The Cliffs of Isle Au Haut*. 1974. Watercolor, 26 x 22". Private collection

Skokie Beach. 1974. Watercolor, 12 x 16". Collection Arthur and Carol Goldberg

Snow on South Main Street. 1974. Oil on board, 18⅛ x 22". Private collection

The South Meadow. c. 1974. Watercolor, 21¾ x 30¾". Private collection

Study for *Couple with Pears and Chrysanthemums*. 1974. Watercolor and pencil, 22¼ x 29⅞". The Parrish Art Museum, Southampton, New York. Gift of the Estate of Fairfield Porter

Study for *Eliot*. 1974. Watercolor, 30⅜ x 18¾". Private collection

Summer from the Porch. 1974. Watercolor, 22 x 30". Private collection

Summer House Interior, Great Spruce Head Island. 1974. Oil on canvas, 47 x 39¼". The Parrish Art Museum, Southampton, New York. Gift of the Estate of Fairfield Porter

Sun and Sea. 1974. Oil on Masonite, 27½ x 20". Private collection

Sun and Sea. c. 1974. Watercolor, 30 x 22". Private collection

Sun and Sea II. 1974. Watercolor, 14 x 11". Private collection

Surf on Windy Day. 1974. Oil on paper mounted on board, 11 x 14". Private collection

The Trail. 1974. Watercolor, 16 x 12". Private collection

Velasquez Study. 1974. Oil on canvas, 17⅛ x 24⅛". The Parrish Art Museum, Southampton, New York. Gift of the Estate of Fairfield Porter

View of the Islands. 1974. Watercolor, 18 x 24". Private collection

View of Islands, Maine. 1974. Watercolor, 17⅛ x 22⅛". Private collection

Violet Sky. 1974. Oil on board, 22 x 18". Private collection

The Wall. 1974. Oil on board, 22 x 18". Hirschl & Adler Modern, New York

The Waves Going By. 1974. Oil on board, 18 x 14". Collection Katharine Porter and Daniel Fishbein

Yawl in the Channel. 1974. Oil on canvas, 22 x 37". Private collection

Yellow Sunrise. 1974. Oil on canvas, 31 x 23". Collection Katharine Porter and Daniel Fishbein

1975

Afternoon Sun. 1975. Watercolor, 12 x 16". Private collection

April Overcast. 1975. Oil on board, 18 x 22". Collection Laurence and Laurel Porter

Back of the Studio. 1975. Oil on board, 18 x 22". Private collection

Backyards. 1975. Oil on board, 30 x 22". Collection Mrs. Fairfield Porter

Beach Island. 1975. Watercolor, 22 x 31". Private collection

Broadway South of Union Square. 1975. Oil on canvas, 38 x 30". Collection Mr. and Mrs. Austin List

A Cold Spring. 1975. Oil on board, 18 x 22". Courtesy Susanne Hilberry Gallery, Birmingham, Michigan

Couple with Pears and Chrysanthemums. 1975. Oil on canvas, 33 x 45". The Parrish Art Museum, Southampton, New York. Gift of the Estate of Fairfield Porter

Dawn on South Main Street. 1975. Oil on board, 18 x 22". Collection Katharine Porter and Daniel Fishbein

The Dock. 1975. Watercolor, 16 x 12". Private collection

Dog and Boats. 1975. Watercolor, 16 x 12". Private collection

Dog in a Field. 1975. Oil on Masonite, 11 x 14¼". The Parrish Art Museum, Southampton, New York. Gift of the Estate of Fairfield Porter

Eliot. 1975. Oil on canvas, 58 x 32". Collection Mrs. Fairfield Porter

Foggy Harbor. 1975. Watercolor, 12 x 16". Private collection

Fourth of July Sunrise. 1975. Oil on board, 18 x 22". Collection Mrs. Cooper Converse

From the Top. 1975. Watercolor, 12¼ x 16". Private collection

The Garden on Great Spruce Head Island. 1975. Watercolor, 22½ x 30½". Collection Heublein, Inc.

Girl in the Garden. 1975. Watercolor, 12 x 16". Private collection

Into the Meadow. 1975. Watercolor, 12 x 16". Private collection

Keelin. 1975. Watercolor, 30¼ x 22½". Private collection

Leon. 1975. Watercolor, 16 x 12". Private collection

Main Street—April. 1975. Watercolor, 12 x 16". Private collection

Marc. 1975. Watercolor, 30¼ x 22½". Collection Marc Witkin

Meadow. 1975. Watercolor, 12 x 16". Private collection

Midsummer. 1975. Oil on board, 30 x 22". Private collection

Morning Sun over the Harbor. 1975. Watercolor, 22½ x 29½". Private collection

Morning Sun over the South Meadow. 1975. Watercolor, 21½ x 30½". Private collection

Near Union Square—Looking up Park Avenue. 1975. Oil on canvas, 61¼ x 72". The Metropolitan Museum of Art, New York. Gift of Mrs. Fairfield Porter, 1978

North Point. 1975. Watercolor, 16 x 12". Private collection

The Path around the Head. 1975. Watercolor, 18 x 14". Collection Anina Porter Fuller

Persian Rose Bush. 1975. Oil on board, 30 x 22". Collection Mr. and Mrs. Austin List

Plane Tree. 1975. Oil on board, 22 x 30". Private collection

Plane Tree and House Next Door. 1975. Oil on board, 30 x 22". Private collection, Boston

Porter Home. 1975. Oil on canvas, 15 x 20½". Private collection

Portrait of Albert Gordon. 1975. Oil on canvas, 42 x 33". Collection the Harvard Club of New York City

Portrait of Paul Georges. 1975. Oil on board, 30 x 22". G.U.C. Collection, Chicago

Precipice. 1975. Watercolor, 16 x 12". Private collection

The Privet Hedge. 1975. Oil on Masonite, 18 x 22". Collection Mr. and Mrs. Alan Fink

Rocks and Lichen. 1975. Watercolor, 12 x 16". Private collection

Rocks and Shore Growth. 1975. Watercolor, 22 x 29". Private collection

Rocks on the Shore. 1975. Watercolor, 22 x 16". Private collection

Sara and Julie. 1975. Oil on canvas, 29½ x 21½". Collection Esther M. Vickers

South from the Precipice. 1975. Watercolor, 12 x 16". Private collection

Spring Fog. 1975. Oil on board, 30 x 22". Collection University of Iowa Museum of Art. Gift of Laurence M. and Laurel M. Porter

Still Life. 1975. Watercolor, 22½ x 30½". Private collection

Stone Steps in the Trail. 1975. Watercolor, 16 x 12". Private collection

Sun and Beach. 1975. Oil on board, 22 x 18". Collection Tatyana Robson, Brookline, Massachusetts

Trees in Bloom. 1975. Watercolor, 24½ x 18¼". Private collection

Trees in Bud. 1975. Oil on board, 18 x 22". Collection Elizabeth Porter

Twilight. 1975. Oil on board, 14 x 15". Fairfield Porter Estate

View from Beach Island. 1975. Watercolor, 22½ x 29". Collection Elizabeth Porter

View of Islands, Maine. 1975. Watercolor, 16 x 12". Collection Arthur and Carol Goldberg

Western View, No. 1. 1975. Watercolor, 16 x 12". Private collection

Western View, No. 2. 1975. Watercolor, 16 x 12". Private collection

UNDATED WORKS
Apples and Black-eyed Susans. n.d. Oil on board, 16 x 12". Collection Arthur M. Bullowa

Around the Bend. n.d. Watercolor, 13¾ x 20". Fairfield Porter Estate

Back of the Island Farmhouse. n.d. Watercolor, 20 x 26⅜". The Parrish Art Museum, Southampton, New York. Gift of the Estate of Fairfield Porter

Backyard. n.d. Oil on linen, 13⅞ x 23⅛". The Parrish Art Museum, Southampton, New York. Gift of the Estate of Fairfield Porter

Backyard. n.d. Pastel, 12 x 18". The Parrish Art Museum, Southampton, New York. Gift of the Estate of Fairfield Porter

Backyard. n.d. Watercolor, 22 x 30". Private collection

Beach. n.d. Oil on canvas, 13¾ x 13½". The Parrish Art Museum, Southampton, New York. Gift of the Estate of Fairfield Porter

The Boat Houses. n.d. Watercolor, 10¼ x 14⅛". Private collection

Boat Houses and Harbor, Maine. n.d. Watercolor, 11 x 14½". Collection Laurence and Laurel Porter

Boats on an Inlet. n.d. Oil on canvas, 24 x 30". Barridoff Galleries, Portland, Maine, 1991

Breakfast Table. n.d. Watercolor and pastel, 22 x 30". Private collection

Bridgehampton. n.d. Watercolor, 12 x 16". Private collection

Channing House—Interior. n.d. Watercolor, 19¾ x 15¾". Private collection

City Dining Room Still Life. n.d. Oil on canvas, 24 x 28". Collection Mrs. Fairfield Porter

Country Road. n.d. Watercolor, 10⅝ x 12". The Parrish Art Museum, Southampton, New York. Gift of the Estate of Fairfield Porter

Double Beaches. n.d. Oil on Masonite, 24¼ x 29¾". The Parrish Art Museum, Southampton, New York. Gift of the Estate of Fairfield Porter

Forty-nine South Main Street. n.d. Oil on canvas, 30 x 36½". Private collection

Great Spruce Head. n.d. Oil on board, 20 x 24". Collection United Missouri Bank

Great Spruce Head Island. n.d. Watercolor, 20 x 26¼". Fairfield Porter Estate

Great Spruce Head Island with Flag. n.d. Oil on canvas, 24 x 30¼". The Parrish Art Museum, Southampton, New York. Gift of the Estate of Fairfield Porter

Jimmy. n.d. Watercolor, 7 x 7". Collection Darragh Park

Landscape. n.d. Oil on canvas, 19¾ x 18¾". The Parrish Art Museum, Southampton, New York. Gift of the Estate of Fairfield Porter

Landscape. n.d. Oil on canvas, 24⅛ x 20⅛". The Parrish Art Museum, Southampton, New York. Gift of the Estate of Fairfield Porter

Landscape. n.d. Watercolor and pencil on paper, 17¾ x 21½". Collection the Rose Art Museum, Brandeis University, Waltham, Massachusetts. Gift of Hyman Swetzo, Boston

The Living Room. n.d. Watercolor, 26¼ x 19⅞". The Parrish Art Museum, Southampton, New York. Gift of the Estate of Fairfield Porter

Main Street. n.d. Oil on canvas, 34½ x 29½". Collection The Chase Manhattan Bank

Maine Interior. n.d. Watercolor, 12 x 12⅛". Private collection

Maine Woods with Hawkweed. n.d. Oil on board, 16½ x 22". Collection Mrs. Fairfield Porter

Morning Light. n.d. Watercolor, 18⅛ x 22⅞". The Parrish Art Museum, Southampton, New York. Gift of the Estate of Fairfield Porter

Near City Hall. n.d. Oil on canvas, 31¼ x 38". The Parrish Art Museum, Southampton, New York. Gift of the Estate of Fairfield Porter

Old House. n.d. Oil on board, 9 x 13". Collection Robert Dash

Pot Hole. n.d. Oil on canvas, 44 x 30". Collection Helen Drake Muirhead

South Meadow. n.d. Watercolor, 20 x 26⅛". The Parrish Art Museum, Southampton, New York. Gift of the Estate of Fairfield Porter

Street with Old Trees. n.d. Oil on linen, 16⅝ x 25½". The Parrish Art Museum, Southampton, New York. Gift of the Estate of Fairfield Porter

Untitled [Landscape]. n.d. Oil on asbestos flexboard, 16⅝ x 23⅞". The Parrish Art Museum, Southampton, New York. Gift of the Estate of Fairfield Porter

Untitled [Seascape]. n.d. Oil on aluminum, 24 x 30". The Parrish Art Museum, Southampton, New York. Gift of the Estate of Fairfield Porter

Untitled [Two figures—Katie or Liz]. n.d. Oil on canvas, 37 x 36¾". The Parrish Art Museum, Southampton, New York. Gift of the Estate of Fairfield Porter

View from 500 East 11th Street. n.d. Oil on board, 18 x 14". Collection Laurence and Laurel Porter

The Wall. n.d. Watercolor, 9 x 11¾". Christie's, New York, 1989

The Wood Road. n.d. Oil on canvas, 14 x 16". The Parrish Art Museum, Southampton, New York. Gift of the Estate of Fairfield Porter

ACKNOWLEDGMENTS

For their invaluable assistance in the compilation of this checklist, I wish to thank the following: Anne Porter and the Porter family; Trudy Kramer, director, the Parrish Art Museum, and Alicia Longwell and Anke Jackson; Tibor de Nagy and Andrew Arnot of the Tibor de Nagy Gallery; Stuart Feld, Donald McKinney, Betty Cuningham, and all the staff of the Hirschl & Adler Modern Gallery; Herbert Schutz and the late Prescott Schutz of Schutz & Company; Dr. John T. Spike; Ted Leigh; Ruth Peltason; the museums, galleries, corporations, and private collectors who provided information and documentation; the members of my family and many friends who helped immeasurably in countless ways; and a special debt of gratitude to Neil Ludman and Terrence King for lending their expertise in the wonders and intricacies of computerization.

JOAN LUDMAN

SELECT BIBLIOGRAPHY

A comprehensive bibliography in two parts (I. Writings by Fairfield Porter; II. Writings about Fairfield Porter) was compiled by Rackstraw Downes, assisted by Louise Hamlin, and published in *Fairfield Porter (1907–1975): Realist Painter in an Age of Abstraction* (q.v.). Most of the quotations from Porter's published writings are taken from *Fairfield Porter: Art in Its Own Terms*, an anthology edited by Rackstraw Downes (q.v.). Quotations from magazine and newspaper writings about Porter are identified at the appropriate place in the text or in the notes.

Downes, Rackstraw, ed. *Fairfield Porter: Art in Its Own Terms, Selected Criticism, 1935–1975*. New York: Taplinger, 1979.

Fairfield Porter (1907–1975): Realist Painter in an Age of Abstraction. Essays by John Ashbery and Kenworth Moffett, contributions by John Bernard Myers, Paul Cummings, Prescott D. Schutz, Rackstraw Downes, and Louise Hamlin. Exh. cat. Boston: Museum of Fine Arts, 1983.

Ludman, Joan. *Fairfield Porter: A Catalogue Raisonné of His Prints.* With appreciations by David Shapiro and Brooke Alexander and an interview with Jane Freilicher by Fred Dietzel. Westbury, New York: Highland House, 1981.

Porter, Eliot. *Eliot Porter.* Foreword by Martha A. Sandweiss. Exh. cat. Boston: Little, Brown, and Fort Worth: Amon Carter Museum, 1987.

———. *Summer Island: Penobscot Country.* Edited by David Brower. San Francisco: Sierra Club, 1966.

Porter, Fairfield. *Fairfield Porter: The Collected Poems with Selected Drawings.* Edited by John Yau with David Kermani. New York: Tibor de Nagy Editions/The Promise of Learnings, 1985.

Stein, Judith E., and Paul Schimmel, eds. *The Figurative Fifties: New York Figurative Expressionism.* Exh. cat. Newport Beach, California: Newport Harbor Art Museum, and Philadelphia: Pennsylvania Academy of the Fine Arts, 1988.

INDEX

Page numbers in *italics* refer to illustrations. All works are by Fairfield Porter unless otherwise noted.

Abstract Expressionism, 94, 95, 96, 119, 123, 143, 159, 186
Academy of American Poets, 244
Ackroyd, Peter, portrait by Porter, 244; *244*
Afternoon, Maine, 117
Alberti, Count Guglielmo degli, 39
Alexander, Brooke, 240
Aline by the Screen Door, 239
Allen, Dorothy, 59
American Abstract Artists, 68, 123
American Artists Congress, 55, 58; exhibition, 58
American Federation of Arts, 159, 186–87
American painting, 34, 36, 143
American Scene painting, 32, 34, 42, 62, 83
Amherst Campus, No. 1, 223
Amherst College, Porter at, 224–27, 230, 232
Amherst Parking Lot, No. 1, 222
Amherst '69, 222
Anne (c. 1939), 66; *69*
Anne (1965), *195*
Anne (1971), *241*
Anne (1972), *242*
Anne and Katie, 84
Anne and Laurence, 62; *63*
Anne at 312 E. 52nd Street, 83
Anne in a Striped Dress, 231; *215*
Anne in Doorway, 255; *258*
Anne, Lizzie and Katie, 135, 137; *137*
Anne Porter, 50
Anne Reading to Laurence, 80
Annichini, Patrizia, 254
Annunciation, The, 61; *61*
Anrep, Baron and Baroness, 38, 39
anti-Nazi movement, 59–60, 61
Apple Branch, 255
Apples and Roses, 216; *214*
April Overcast, 270
Archives of American Art, 217
Arise magazine, 52, 53, 54
Armchair on Porch, 120, 126; *125*
Armory Show (1913), New York City, 36
Art and Literature, 199, 202
art criticism, 67–68, 70, 119, 143, 272; *see also* Porter, Fairfield, as art critic
Art Digest, reviews of Porter's work, 103, 111
Art In America, 172, 187
Art in Embassies Project, 172
Art Institute of Chicago, 21–22, 61; exhibitions, 58, 61, 62
Art News, 75, 93–95, 98, 102–3, 111; ——Paints a Picture series, 94, 107, 110, 112, 126, 278*n;* Porter article on art and knowledge, 189, 199, 207; Porter article on Freilicher, 123, 126; Porter article on Rivers, 117; Porter article on Sargent, 120, 122, 123; Porter at, 93–95, 98, 102, 104, 106, 107, 111, 126, 128, 134, 142, 155; reviews of Porter's work, 111, 112, 135, 186, 187, 190, 209, 239; staff, 123
Art News Annual, 122, 232
Art Nouveau, 86
Art Students League, 15, 32, 33, 34, 37, 40, 41, 42, 47, 48, 82
Artists' Calendar, 61
Arts magazine, reviews of Porter's work, 134, 138, 139, 186, 187–88
Ash Can school, 34
Ashbery, John, 104, 105, 106, 107, 117, 155, 239, 244; portraits by Porter, 235, 236; *208, 231*
Ashton, Dore, 111
Atkinson, Eliot, 87
Auden, W. H., 122
Auerbach, Ellen, 60, 64, 70, 72
Auerbach, Walter, 60, 64, 65, 70, 72, 73, 93, 94, 99
Avery, Milton, 145, 245

Backyards with Wheelbarrow, 146
Bank Street Atelier, 239
Barr, Alfred H., 154
Barred Islands, 40
Baskin, Leonard, 219
Bauhaus, 61
Bay, The, 182
Baziotes, William, 96
Bear Island (1966), *201*
Bear Island (1968), *219*
Bear Island—Sunset, 264
Beginning of the Fields, The, 253; *254*
Bellows, George, 28
Benedikt, Michael, 182, 186, 187, 190
Benson, Elaine, 245
Benton, Thomas Hart, 32, 33, 37, 42, 45, 52, 53, 54; influence on Porter, 54, 62, 66, 82
Berenson, Bernard, 38–39, 42, 45–46; influence on Porter, 38–39
Berenson, Mary, 38–39, 46
Berkson, William, photograph of, *126*
Betty Parsons Gallery, 261
Big House with Hawkweed, 85
Big Studio, The, 103
Bishop, Elizabeth, 132, 279*n*
Bishop, Isabel, 79, 104
Black Sea, 31; *33*
Bloch, Marc, influence on Porter, 218; works by: *Historian's Craft, The,* 218

Blue Harbor, 165
Blue Table, 13
Bohrod, Aaron, 57
Bonnard, Pierre, 78, 205, 209, 218; exhibitions, 62, 75, 86, 96; influence on Porter, 62, 66, 75, 86–87, 103, 183, 202–3, 216; lithograph by: *Quelques aspects de la vie de Paris, 75*
Bosch, Hieronymus, works by: *Adoration of the Magi, The,* 91
Bottnall, Ronald, 47
Boy at the Breakfast Table, 86; *81*
Brach, Paul, photograph of, *126*
Braguin, Simon, 46, 112
Brainard, Joe, 245, 246, 248
Braque, Georges, 143
Braziller, George, 139
Breakfast in Maine I, 83
Bright Day on the Beach, 253
British art, Porter on, 212
Broadway South of Union Square, 266
Brooks, James, 96
Brown, Marian, 36, 48
Bryn Mawr, 16, 17, 36
Building Maintenance Employees Association, 175
Bullowa, Arthur, 138, 150, 165, 272; portrait by Porter, *241*
Burckhardt, Jacob, 110–11
Burckhardt, Rudolph, 70, 72, 75, 104, 110, 112, 114, 155, 209, 210; film by: *Day in the Life of a Cleaning Woman, A,* 110–11; photographs by, *112*
Burford, Byron, 219
Burk, Jacob, 53
Burnham & Company, 18
Burnham, Mr., 71
Button, John, 120

Calm Morning, 165; *162*
Campbell, Lawrence, 98, 102–3, 106, 164, 172
Campus, The, 226
Capitalism, 60
Carey, Ted, portrait by Porter, 150; *149*
Caro, Anthony, 212
Cedar Tavern, 96, 105, 106
Channing, Anne, Fairfield Porter and, 19, 36, 40–41, 42, 43, 45; *see also* Porter, Anne (wife)
Channing, Barbara, 36, 43
Channing family, 89, 90, 111, 152
Channing fresco, 46; studies for, *47*
Chase, George Henry, 23
Chase Manhattan Bank, 172

Chastel, Andre, 90
Chicago Society of Artists, 61
Children in a Field, 2–3, 150
Chris, Sarah, Felicity, 138
Chrysanthemums, 172; *133*
City Window, 82
Cityscape, 77
Claire White, 141
Clark, Kenneth, 39
Clearing Weather, 224
Cleveland Museum of Art, 200, 212, 216,
 272; exhibitions, 198–99, 204–5
Club, The, 82
College Art Association, 117
Collery, Arnold, 225
Color Field painting, 188
Colors of the Flag of Greece, The (poem), 17
Columbia University School of Architecture, 17
Columbus Day, 190, 209; *200*
communism, 30, 50, 54–55, 56, 58, 60
Conceptualists, 259
Constable, John, 220
Coolidge family, 32
Coolidge, Thorton, 23
Cooper Square, 217
Cornell, Joseph, 199, 202, 244
Cornell Medical School, 48, 96
Corot, Camille, 187, 220
Council Communists, 58, 60
Cove, The, 185
Creative Arts Festival, 207
Cremean, Robert, 219
Criterion, The, journal, 28
cummings, e. e., 70
Cummings, Paul, 36, 47, 58, 62–63, 72,
 184–85, 207–8, 217

Dash, Robert, 145–46, 152, 154, 161, 162,
 164, 168, 170; portrait by Porter, *142;*
 reviews of Porter's work, 134, 138
David Kermani, 244
Davies, Arthur, 37
Day Indoors, A, 231; *170*
Day, Lucien, 138, 150, 168, 224, 265
de Beauvoir, Simone, 83
de Kooning, Elaine, 122, 139, 152, 187;
 friendship with Porter, 81, 93–94, 98, 99;
 portraits by Porter, 132, 231; *88*
de Kooning, Lisa, photograph of, *126*
de Kooning, Willem, 34, 87, 119, 139, 149,
 152, 248, 273; exhibitions, 186; financial
 success, 143, 173, 279n; friendship with
 Porter, 72, 74, 81, 82, 93, 96, 98, 99, 104,
 123, 279n; influence on Porter, 74, 79,
 82–83, 96, 107, 127, 135, 165; photograph
 of, *126;* Porter reviews of, 72–73, 95,
 142–43; quoted on art, 82–83
De Mott, Benjamin, 225, 227
de Nagy, Tibor, 102, 103, 150, 154, 165, 166,
 173, 175, 176, 178, 230; portrait by Porter,
 175; *136; see also* Tibor de Nagy Gallery
de Staël, Nicolas, 91
Delacroix, Eugène, 120
Denby, Edwin, 72, 155, 171

Devree, Howard, 46–47, 111–12
di Lavriano, Count Umberto Morra, 39
Dickinson, Edwin, 219
Diebenkorn, Richard, 186, 219
Dining Room, The, 90; *91*
Dock, 263
Doering House, The, 189
Dog at the Door, 237
Dog in a Field, 268
Dogs, 261
Donkey and Elephant, 55
Dos Passos, John, 24
Dostoyevsky, Fyodor, works by: *Brothers
 Karamazov, The,* 40; *Idiot, The,* 40;
 Possessed, The, 40, 42; *42*
Dove, Arthur, 143
Downes, Rackstraw, 162, 189, 230, 245, 259, 273
Droll, Donald, 230, 240
Dubuffet, Jean, 95
Dupree, Mr., 71

Eakins, Thomas, 139, 270
Early Morning, 209; *198*
East 11th Street, 153
Edge of Morning, 165
Edith Schloss, 108
Edward Porter, 231
Eighth Street Club, 82, 96, 102, 104, 106
El Greco, 74; works by: *Burial of the Count
 Orgaz, The,* 43; *Fray Hortensio Félix
 Paravicino,* 26–27; *Saint Peter,* 43; *View
 of Toledo,* 91
Elaine de Kooning, 231; *88*
Eliot, 269
Eliot family, 16
Eliot, Henry, 29
Eliot, T. S., 16, 28, 29, 46, 57
Elizabeth, 190
Elizabeth in a Red Chair, 157
Elizabeth Thinking, 182
Elmslie, Kenward, photograph of, *126*
Ensor, James, 95
Equitable Building, New York, murals, 33
Ernst, Max, 63
Evergood, Philip, 104
Evergreen Review, The, 155
Expressionistic art, 24–25

"Fairfield Porter: An American Classic"
 (Kramer), 202, 273
*Fairfield Porter: Art in Its Own Terms;
 Selected Criticism, 1935–75,* 95, 273
"Fairfield Porter (1907–1975) Realist Painter
 in an Age of Abstraction," exhibition, 273
"Fairfield Porter Retrospective Exhibition,"
 259, 261, 263
Farmland, 144
Feld, Stuart, 240
5th Avenue at 84th Street, 83
figurative painting, 96, 119, 143, 186, 187;
 critical fashion of, 202; public attitude
 toward, 187
"Figurative Tradition in Recent American

Art, The," exhibition, 219, 224
"Figure, The," exhibition, 187, 202
"Figure in Contemporary American
 Painting, The," exhibition, 159, 186–87
Fils, Gimpel, 212
First Avenue, 230; *44*
First of May, The, 146; *146*
Fisher, Arthur, 30, 31
Fisher family, 36
Fisher, Howard, 23, 24
Fitzsimmons, James, 103
Fizdale, Mrs., portrait by Porter, 132
Fizdale, Robert, 152; photograph of, *126;*
 portrait by Porter, 132
Flagpole, 175
Flowering Apple, 249
Flowering Pear, 253
Fogg Art Museum, 27, 38
Forsythia Hedge, 166
Forsythia Trees in Bud, 199
Forty-nine South Main Street, 148
Foster family, 16
Foster, Russell, 32
"Four Ugly People" (*The Screen Porch*), 190, 209
Fourcade, Xavier, 239, 240
Francesca, Piero della, 38
Frank O'Hara, 114, 134; *130*
Frank Wallace, 105
Frankenthaler, Helen, 102, 122, 132
Frankfurter, Alfred, 93–94
Freeman, Richard, portrait by Porter, *256*
Freilicher, Jane, 90, 96, 98, 102, 104, 105,
 110, 111, 112, 120, 152, 199; influence on
 Porter, 106, 107; photograph of, *126;*
 Porter article on, 123, 126; portraits by
 Porter, 114, 212–13; *120, 211*
Fresco Painters Guild, 48
fresco technique, debate on, 48
Frick Art Reference Library, 139
Fried, Michael, 188
Friedman, Sam, 52, 54
Friend, Albert, 59, 76
From the Precipice, 253
From the Top, 270
Fuller, Anina Porter, 245, 246, 255
Fuller, Kristina, portrait by Porter, 255
Fuller, Lisa, portrait by Porter, 245–46
Fuller, Scott, portrait by Porter, 245–46
Furness family, 16
Furness, Laura (aunt), 24, 26
Furness, Rebecca (aunt), 24, 26
Furness, William Eliot (grandfather), 16, 24

Gallo, Frank, 219
Garden Road, The, 168, 205; *173, 174*
Gatling, Eva Ingersoll, 261
Geldzahler, Henry, 202, 263
"Genre Art of Fairfield Porter, The,"
 exhibition, 205
Georges, Paul, 244
Gerhart, Dorsey, 36
Ghirlandaio, Domenico, 38
Giardelli, Arthur, 40, 45, 132, 134, 135, 155,
 212, 213, 217

Giardelli, Judy, 212
Gide, André, 28
Gilbert, Creighton, 117
Gilmour, Leonie, 28–29
Giorgione, *Apollo and Daphne,* 37
Giotto frescoes, 37
Girl in a Landscape, 193
Girl in the Woods, 236
Glueck, Grace, 220, 224, 273
Gogh, Vincent van, 143
Gold, Arthur, 152; photograph of, *126;* portrait by Porter, 132
Goldberg, Michael, 155
Golden Retriever, 238
Golden Rod, 154
Goodman, Paul, 71
Goodnough, Robert, 102
Gordon, Albert, portrait by Porter, 263, 265
Gordon, Mrs. Albert, 263, 265
Gorky, Arshile, 93–94, 119
Gotham Book Mart, 235–36
Gottlieb, Adolph, 96, 119
Grand Central Galleries, 53
Great American Artists Series, 139
Great Spruce Head Island, described, 19–20, 112, 114, 254; guests at, 112, 114, 120, 164, 171, 217, 244; houses on, 19–20, 62; photograph of, *21;* tennis court, 29, 217, 244
Greenberg, Clement, 67, 68, 71, 72, 95, 102, 119, 126
Greenleaf family, 16
Gregory, Horace, 54
Grey Still Life, 220
Griffin, Howard, 149, 152, 155, 159, 196, 198
Grooms, Red, 219; works by: *City of Chicago,* 219
Gropper, William, 53, 56
Gruen, John, 127; book by: *Party's Over Now, The,* 126
Guston, Philip, 96, 154

Haberstroh, Alex, 36, 43, 51, 52, 53, 54, 55, 61, 67
Hagen, Paul, 59
Hallmark International, 138
Hammer, Armand, 240
Harbor—Great Spruce Head, The, 254–55; *263*
Harbor Scene, Maine, 117
Hart, Betsy, 152
Hartigan, Grace, 102, 155
Hartl, Leon, 106, 159
Hartley, Marsden, 79
Harvard Lampoon, 32
Harvard University, art department, 23, 24–25, 26–28; Dramatic Club, 24; William Eliot Furness at, 16; Eliot Porter at, 23–24; Fairfield Porter at, 22, 23, 24–25, 26–28, 29–30, 31–32, 82; James Porter at, 17; Laurence Porter at, 122
Hatch, Robert, 142
Hazan, Joseph, 111, 112, 120, 152, 212; photograph of, *126*
Hazel Avenue, 221
Head of a Young Man, 122

Heckscher Museum, Huntington, Long Island, 261; exhibitions, 32
Heller, Ben, 165, 166, 168
Henning, Edward, 205, 212
Henri, Robert, 28
Henssler, Fritz, 60
Hess, Thomas, 52, 93–94, 119, 122, 134, 139, 143, 273
High Tide, 255
Hirschl & Adler Galleries, 261; Porter exhibitions at, 240, 249, 252–53
Hirschl, Norman, 240
Hirshhorn, Joseph, 165, 188
Hofmann, Hans, 96, 119
Hokusai, Katsuhika, 78
Holbein, Hans, 25
Homer, Winslow, 245
Hooch, Pieter de, influence on Porter, 230
Horsechestnut Tree, 220; 218
Hound and Horn journal, 28
House, Great Spruce Head Island, 85
House in the Sun, 262
House with Three Chimneys, 244; 245, 247
Houten, Georges van, 78–79, 277*n;* influence on Porter, 82, 182

Ice Storm, 227
Iced Coffee, 17, 190, 209, 231; *197*
Ickes, Harold, 51
Impressionism, 143, 183, 202
In the Middle of Summer, 154
Inez MacWhinnie, 216
Interior, 97, 171; study for, *97*
Interior with a Doll's House, 178
Interior with a Dress Pattern, 224, 230
Interior with Bust, 155; *152*
Interior with White Rocking Chair, 93
Irish Harp, 59
Island Farmhouse, 190, 224, 230, 231
Isle Au Haut (c. 1934), *51*
Isle Au Haut (c. 1950), *94*

Jackson, Harry, 102
James, Henry, 112
Jane and Elizabeth, 214
Jane Freilicher, 120
Jane Freilicher and Anne Porter, 114
Jane Wilson in Red, 129
Javits, Jacob, 216
Jefferson, George, portrait by Porter, 81
Jerry (1955, repainted 1975), *268*
Jerry (1964), *187*
Jerry in a Wicker Chair, 80; *80*
Jerry on a Stool, 132
Jimmy (1972), *242*
Jimmy and John, 131
Jimmy and Leaf Cart, 194
Jimmy in a Black Rocker, 149
Jimmy with Lamp, study for, *240*
John Ashbery, 231
John Ashbery and James Schuyler Writing "A Nest of Ninnies," 208
John MacWhinnie, 241; *243*

John Myers, 104
John Reed Club, 52
Johns, Jasper, 194, 195
Judd, Donald, 194
Julian of Norwich, *Revelations of Divine Love,* 270
July, 232, 234, 240, 241; *233;* sketches for, *232*
July Interior, 179, 185–86, 188, 190; *180*

Kacere, John, photograph of, *126*
Kafka, Franz, 66–67
Kahn, Wolf, 122
Kandinsky, Vassily, 143
Katie (1954), *113*
Katie (1964), *186*
Katie (1969), *225*
Katie (1972), *242*
Katie (1974), *256*
Katie and Anne, 120, 126, 205, 278*n; 121*
Katie and Dan, 256
Katie and Dorothy E., 128
Katie in an Armchair, 112; *113*
Katie in Crib, 93
Katie on Sofa, 144
Katy, 103
Katz, Alex, 145–46, 171, 187, 194, 195; influence on Porter, 213
Keelin, 268
Kelly, Ellsworth, 194, 195
Kennedy, Jacqueline, 154
Kent, Rockwell, 27; influence on Porter, 25, 27–28, 51; Porter essay on, 27–28; reputation, 28
Kent State University, 207
Kenyon Review, The, 67–68, 70, 72, 73
Kermani, David, portrait by Porter, 244; *244*
Kirstein, Lincoln, 28, 142; reviews of Porter's work, 139
Klee, Paul, 63
Kligman, Ruth, 152
Kline, Franz, 119, 143
Knoedler and Co., 230, 239, 240, 241
Koch, Janice, 205
Koch, Katherine, 205
Koch, Kenneth, 104, 105, 106, 117, 122, 155, 162, 205, 217, 224, 244; photograph of, *126;* Porter sestina to, 118; portraits by Porter, 235; *234;* works by: *Rose, Where Did You Get That Red?,* 245, 248
Kornblee Gallery, 187
Kramer, Hilton, 95, 172, 200, 202, 205, 220, 224, 230, 236, 239, 252–53, 273; works by: "Fairfield Porter: An American Classic," 202, 273
Krasner, Lee, 89
Kreymbourg, Alfred, 47
Kristina, 266
Krol, Cardinal, 270
Kroll, Jack, 172
Kuniyoshi, Yasuo, 123

Landscape, 154
Landscape by the Lake, 61

Landscape with Two Parked Cars, 246
Lanes, Jerrold, 186, 187–88
Laning, Edward, 53, 59, 77, 79, 103–4; works
 by: *History of Printing*, 51
Larry Rivers, 96; *99*
Late Afternoon—Snow, 260
Laurence at the Breakfast Table No. 4, *101*
Laurence at the Piano (1953), 106; *100*
Laurence at the Piano (1954), 114; *115*
Laurence Playing Chess, *131*
Le Brun, Mr. and Mrs., 48
Leigh, Ted, 96, 227
Leonardo da Vinci, works by: *Last Supper*,
 37; *Virgin of the Rocks*, 22
Leslie, Alfred, 102, 155
Lewis, Wyndham, 68, 70, 72
Lichens, Wild Roses and Primroses, 244
Lichtenstein, Roy, 254
Lieberman, William, 138
Lindner, Richard, 95
Lippold, Richard, 154
Liquitex medium, 168, 169, 170
Lisa, *259*
"Literary Portraits," exhibition, 235–36, 239
Living Marxism journal, 67, 71
Living Room, The, 195, 205; *97*, *269*
Lizzie and Bruno, 232; *230*
Lizzie and Christmas Tree, sketch for, *252*
Lizzie at the Table, 137, 138, 187; *135*
Lizzie with Wild Roses, *156*
Lobster Boat, 241; *221*
Logs and Rocking Chair, 256
Long Island Landscape with Red Building, *177*
Longview Foundation, 143
Louis, Morris, 188
Low Tide, 172; *176*
Ludman, Joan, 273
Lunch under the Elm Tree, *116*

MacDonald, Dwight, 65–66, 71, 72
McGarrell, James, 219
Machiz, Herbert, photograph of, *126*
MacLeish, Archibald, 59
MacLeish, Norman, 59
MacWhinnie, Inez, portrait by Porter, *216*
MacWhinnie, John, 217, 244, 248, 254;
 portrait by Porter, 241; *243*
Madrid street scene, from Porter's sketch-
 book, *43*
Maine House, The, 95
Maine Interior with Ship Models, *127*
Maizell, Sylvia, photograph of, *126*
Male Nude (c. 1929), *35*
Male Nude [Frank O'Hara], *111*
Mallarmé, Stéphane, 106, 111
Mantegna frescos, 37
Mariano, Nicky, 38, 39
Marin, John, 36, 54, 63, 66; exhibitions, 61;
 influence on Porter, 51–52; works by:
 Movement—Cape Split, Maine, 74
Maroger, Jacques, 25, 77, 79
Maroger's Medium, 80, 83, 131, 244;
 formula, 77–78
Marquet, Albert, 165

Marsh, Reginald, 123
Martini, Simone, 39
Maryland Institute of Art, 231–32
Masses, The, 36
Matisse, Henri, exhibitions, 96
Mattick, Paul, 58, 60, 64, 66–67, 70, 71;
 portrait by Porter, 64
Maurice Porter Memorial (hospital), 16
Mayer, Mr. and Mrs. Henry, portrait by
 Porter, 175
Metropolitan Museum of Art, New York, 78,
 263, 270; exhibitions, 202; restorations at,
 90–91
Mettler, Barbara, 42, 53, 56
Mexican muralists, 62, 66
Michael W. Straus, *160*
Michelangelo, 40, 143
Mid-day, *166*
Miere, Hildreth, 53
Miller, Dorothy, 154
Miller, Richard, 155
Milton Academy, 21, 23, 29
Minimalists, 209
Mirror, The, 203–4, 205; *204*
Mitchell, Joan, 102, 155
Moffett, Kenworth, 273
Moholy-Nagy, László, 61, 95
Monet, Claude, 27, 183
Montclair Art Museum, N.J., exhibitions, 261
Moore, Marianne, 47
Morandi, Giorgio, 202
Morning after a Storm, 251
Morning Landscape, 190, 200, 205
Morris, George L. K., 67, 68, 71
Morse, Carl, 155, 168, 171, 230
Mother and Baby, *84*
Motherwell, Robert, 119
Mower, Mr., 27
Müller, Jan, 186
mural painting, American, 33, 45, 46, 51, 52,
 53, 58, 59; debate on, 48; Mexican, 62, 66
murals for workers article, 45, 52, 53
Museum of Fine Arts, Boston, 26, 27, 28,
 120, 273
Museum of Modern Art, New York, 79, 83,
 138, 150, 154, 272; exhibitions, 64, 66, 86,
 96, 186, 187
Myers, John Bernard, 90, 98, 102, 103, 104,
 150, 161, 165, 173, 175, 176, 178, 188, 230;
 photograph of, *126*; portrait by Porter, *104*

Nakian, Reuben, 219
Nation, The, 29, 54; Porter article on Ameri-
 can nonobjective painting, 143; Porter
 at, 94, 142, 155, 159; Porter review of de
 Kooning, 142–43; Porter review of Eliot
 Porter exhibition, 145; reviews of Porter's
 work, 139
National Academy of Design, 96
National Gallery of Art, Washington, D.C.,
 65, 154
Nazism, 59–60, 61
*Near Union Square—Looking Up Park
 Avenue*, 267

Neeren, Hans van, 36
Neuberger, Roy, 165
New Criterion, The, 202, 273
"New Images of Man," exhibition, 186
New Masses, The, 36
New Republic, The, 29, 54, 159
New School for Social Research, murals, 33
New Trier Township High School, 21, 61
New York City Kitchen, *46*
New York Herald Tribune, 126
New York magazine, 273
New York Painting and Sculpture: 1940–70,
 exhibition, 202
New York Public Library, murals, 51
New York School (artists), 202
New York school (poets), 104
New York Sun, reviews of Eliot Porter's
 work, 63–64
New York Times, illustrations of Porter's
 work, 126, 154, 188; Porter letter to, 57–58;
 Porter obituary, 272, 273; reviews of
 Porter's work (1933), 46; reviews of
 Porter's work (1950–60), 103, 111–12, 154;
 reviews of Porter's work (1961–66), 165,
 186, 190, 200, 202; reviews of Porter's
 work (1967–75), 220, 224, 230, 236, 239,
 252–53, 261, 263, 273
Newman, Barnett, 96, 119
Newsweek magazine, 172, 188, 202
Night, 168; *169*
Noguchi, Isamu, 29
Noguchi, Yone, 28
Noland, Kenneth, 195
nonobjective painting, 143
North Point No. 2, 253
Northwestern University, 17
Nottingham, Elizabeth, 40, 53
Novak, Alvin, photograph of, *126*
nuclear power, 232, 253–54
Nude (c. 1960), *149*
Nyack, 111, 212–13, 216; *211*

Ocean, The, 250
October Interior, 179, 186, 188, 190, 199; *179*
O'Doherty, Brian, 186
O'Hara, Frank, 102, 104, 106, 107, 111, 114,
 117, 120, 122, 123, 139, 143, 155; nude
 study by Porter, 111; photograph of, *126*;
 portraits by Porter, 114, 132, 134, 236; *111*,
 130; reviews of Porter's work, 111, 112, 135
oil medium, 57, 82, 94
O'Keeffe, Georgia, 54
Old Masters techniques, 25
Op art, 209
Oreton Clark House, Amherst College, 227
Orozco, José Clemente, 52, 55, 58; influence
 on Porter, 53; works by: *Fire*, 66; *Vigil*, 74
Orvieto, *210*

Padgett, Ron, portrait by Porter, 235; *234*
Painting Materials, 90
painting restoration, 91
painting style, American, 32, 34, 36, 42, 62,
 83, 143

Palazzo Pitti, 40
Parrish Art Museum, Southampton, 34, 59, 149, 240
Parsons, Betty, 154
Parsons School of Design, 77
Partisan Review, 64, 65, 67, 71, 72, 119
Path around the Head, The, 272
Pea Point from the South Meadow, 264
Pear Tree, The, 165, 166, 168
Pearlstein, Philip, 186, 194, 195
Pease, Roland, portrait by Porter, 138; *137*
Pennsylvania Academy of the Fine Arts, 48
Penobscot Bay, 103
Perry, Eleanor, photograph of, *126*
Perry, Frank, photograph of, *126*
Persian Rose Bush, 10
perspective, artistic, 42
Pesellino, 40, 74
Peter Ackroyd, 244
Piano Duet, 145
"Picasso: Forty Years of His Art," exhibition, 64–65
Picasso, Pablo, 71, 143; article about, 68; influence on Porter, 22; retrospectives, 64; works by: *Guernica,* 64–65
Pierre Matisse Gallery, 96
Piot, René, 46
Plane Tree, 138
Poems for a Dime magazine, 55, 56–57, 59; *55*
Poems for 2 Bits magazine, 55
Poetry magazine, 57, 117
Pollack, Reginald, 155
Pollock, Jackson, 34, 89, 96, 119, 139, 186, 187
pop art, 202, 209, 219
Pope, Arthur Upham, 23, 24, 25, 27, 28, 47, 91
Porter, Aline (sister-in-law), 99, 106, 143, 249, 252, 261
Porter, Anina, 161
Porter, Anne (wife), 112, 154, 159, 161, 163, 168, 175, 189, 240, 252; illnesses, 178, 179, 185; photograph of, *126;* political views and activities, 50; on Porter as an art critic, 94; on Porter's artistic progress, 46, 48, 51, 52, 56, 71, 74, 82, 87; on Porter's exhibitions, 102, 134–35; on Porter's models, 59; on Porter's poetry success, 117; on Porter's political views, 51, 61; on Porter's sensitivity, 80; portraits by Porter (1933–49), 46, 47, 52, 59, 61, 62, 83, 87, 90; *50, 63, 69, 80, 84;* portraits by Porter (1950–60), 92, 114, 120, 135, 137, 205; *109, 121, 137;* portraits by Porter (1961–66), 168; *195;* portraits by Porter (1967–75), 212–13, 231, 255; *211, 215, 241, 242, 258;* reading aloud to family, 17, 59; relationship with Porter, 71, 74; Roman Catholicism of, 18, 122, 270, 278*n;* script by: *Day in the Life of a Cleaning Woman, A,* 110–11; on size of family, 122; trip to Europe (1967), 207, 209–12; writing career, 48, 61, 64, 106, 110–111
Porter, Arthur Kingsley, 25
Porter, Audrey (sister-in-law), 232, 234
Porter, Betsy (daughter-in-law), 164, 205;

portrait by Porter, 168
Porter, Charles (nephew), 48
Porter, Ebby, 161
Porter, Edward (brother), 16, 19, 30, 217, 232, 234; photographs of, *20, 26;* portrait by Porter, *231*
Porter, Eliot (brother), 16, 17, 18, 36, 51, 246, 249, 252; birth, 18; childhood, 16, 19–22; decision to become photographer, 19; divorce from Marian Brown, 48; exhibitions: at An American Place, 63–64; of *The Seasons,* 145; on Great Spruce Head Island (1925), 25, 26; at Harvard, 23–24; influence on Fairfield, 63, 244; influenced by James Porter, 19; marriage, 30; photographs of, *20, 26;* political views, 53; portraits by Porter, 54; *269;* recollections of Fairfield, 21; relationship with Fairfield, 24; religious views, 17–18; reviews of work, 63–64; Stieglitz and, 49–50, 63; works by: *Seasons, The,* 145; *Summer Island: Penobscot Country,* 16, 21
Porter, Eliot, Jr. (nephew), 48
Porter, Elizabeth (daughter), 134, 205, 232, 270; birth, 126; pets of, 214; portraits by Porter (1950–60), 135, 137, 138; *135, 137, 156;* portraits by Porter (1961–66), 168, 182, 203–4, 205; *157, 190, 204;* portraits by Porter (1967–75), 232, 244; *230;* Roman Catholicism of, 18; trip to Europe (1967), 207, 209–12
Porter, Fairfield
adolescent years, 21–26
aesthetic theory, 199, 269
anatomy lessons, 47–48, 96–97
art collection, 63, 74, 276–77*n,* 279–80*n,* 199
art commercialism and, 165, 166, 168
as art critic, 53–54, 72–73, 92, 159, 199; approach to, 67–68, 70, 143, 199; for *Art in America,* 187; for *Art and Literature,* 199, 202; for *Art News,* 93–95, 98, 102, 104, 106, 107, 111, 117, 120, 122, 123, 126, 128; 134, 142, 155, 278*n;* for *Art News Annual,* 232; art in portraiture article, 232; for *Evergreen Review,* 155; impartiality as, 68; poets and painters in collaboration article, 155; Recent Painting USA review, 187; for *The Nation,* 94, 142–43, 145, 155, 159
art education, 15, 21–22, 26, 37–43, 82; confusion caused by, 23, 47; with Maroger, 77, 78; with van Houten, 78–79, 82; *see also* Porter, Fairfield, at Art Students League; Porter, Fairfield, at Harvard
at Art Students League, 15, 32, 33–34, 37, 47, 48, 82
artistic development, 15, 24–25, 38–43, 62, 81–82, 86–87, 91, 106, 137, 138; *see also* Porter, Fairfield, influenced by
artistic expression of, 220
artistic style, 82, 91, 103, 120, 252–53, 278*n;* abstraction in, 46–47; academic influence, 187; American Scene painting, 32, 42, 62, 83; anatomical accuracy,

97; brushwork, 90, 111, 226; color, 25, 90, 106, 137, 187, 226, 239, 248; composition, 47, 90, 152, 188, 213, 232; described, 91; format, 190; highlighting, 187; independence in, 202; light in paintings, 79, 220; mature style, 90, 106; Mexican muralist style, 62; modernist tendencies, 32, 34; naturalism of, 66; painterly phase, 111; of portraits, 96; texture, 66; tone, 90; transitional paintings, 83
artistic theories, 189, 218–19
artistic vision, 145
Bauhaus theory and, 61
birth, 18
book jackets by, 245
books by, on Eakins, 139, 142
books read by, 24, 29, 58, 60, 74, 79, 90, 122, 217–18, 224, 270
car accidents, 45, 71, 196, 198
caricatures by, 48
cartoons by, 31–32
Anne Channing and, 19, 37, 40–41, 42, 43
character, honesty, 154, 230
child rearing views, 66–67, 71
childhood, 19–22
cityscapes, 61, 75, 83, 90, 213, 220; *76, 77, 82, 153, 217, 266, 267*
collaborations: with Paul Rosenfeld, 70; with John Wheelwright, 55
collectors of work: Arthur Bullowa, 138, 165, 272; Ben Heller, 165, 166, 168; Joseph Hirshhorn, 165, 188; Roy Neuberger, 165; Rockefeller family, 126–27, 154; Paul Roebling, 199; Donald Schrader, 114
commissions: for Cardinal Krol portrait, 270; for Channing mural, 46; from Brooke Alexander, 240; from Mrs. Albert Gordon, 263, 265; from Rebel Arts, 52; from Socialist Party, 51, 53; from Straus family, 59; from Tibor de Nagy Gallery, 102; percent received, 230; portrait commissions, 81, 138, 150, 159, 175, 230, 235, 263, 265, 270; unsuccessful attempts at, 58
communism views on, 30, 50, 54–55, 56, 58
compared to: Avery, 245; Bonnard, 185; Constable, 220; Corot, 220; Homer, 245; Marquet, 165; Morandi, 202
conservationist causes, 216, 253–54
contribution to American painting, 187, 273
correspondence: with Clement Greenberg, 119; with *Kenyon Review,* 67–68, 70; with Jerrold Lanes, 188; with Dwight MacDonald, 65–66; with Metropolitan Museum of Art, 90–91; with *Partisan Review,* 67; with poet friends, 117–18; with Tibor de Nagy Gallery, 173, 176, 178; *see also Notes* section of this book
critical dismissal of, 67, 194–95, 203, 205
death, 270, 273
destroying of unsatisfactory paintings, 32, 83, 224

development of interest in art, 21–22, 25–26

dissatisfaction with his work, 46, 55, 74, 83, 164, 188, 199, 219, 227, 259

donation of paintings, 165

drawings, for Channing fresco, 46

early artistic interests, 21–22

early work of, 27, 36, 42, 45

education, high school, 21, 23; *see also* Porter, Fairfield, art education

Eliot, T. S., and, 16, 46

exhibition catalogues, 205, 240–41, 254, 261, 273

exhibitions (1933–49), 53; at Art Institute of Chicago, 58, 61, 62; at Grand Central Galleries, 53; at New Trier Township High School, 61; at Pennsylvania Academy of the Fine Arts, 48; at Theodore A. Kohn & Son, New York City, 46, 112; at Winnetka Community House, 62; lack of, 53, 83; of murals, 53

exhibitions (1950–60), 186–87; at Artists' Gallery, 90; at Rhode Island School of Design, 138; at Tibor de Nagy, 93, 98–99, 103, 111–12, 114, 119, 122–23, 126, 128, 134, 138, 147, 149, 150, 152, 154; by American Federation of Artists, 159

exhibitions (1961–66), at Cleveland Museum of Art, 198–99, 200, 204–5; at Kornblee Gallery, 187; at Reed College, 199; at Tibor de Nagy, 165, 172, 176, 178–79, 182, 186, 190, 195, 199–200, 202; at university galleries, 199; at Whitney Museum Annual, 165, 168

exhibitions (1967–75), at Amherst College, 227, 230; at Gotham Book Mart, 235–36, 239; at Heckscher Museum, 32, 261; at Hirschl & Adler Galleries, 240–41, 249, 252–53; at Montclair Art Museum, 261; at Parrish Art Museum, 240; at Queens Museum, 261; at Tibor de Nagy, 209, 214, 216, 220, 230; at Venice Biennale, 168, 219, 224; exclusion from, 202; retrospectives, 32, 259, 261, 263

exhibitions (1983), retrospective, 273

family background, 16–22

family inheritance, 16, 45, 58, 126, 138, 173, 176

family life, 17, 56, 83, 86, 87

in film, 110

financial difficulties, 58, 117, 126, 138, 139, 173, 240, 280n

financial success, 155, 195, 199

first paintings seen by, 18, 20, 21–23

fresco painting by, 45, 46, 48

friends of, 82, 95–96, 104–5, 107, 110, 117–18, 154; *see also* names of individuals

Hampton summer artists' colony and, 127–28

at Harvard, 22, 23, 24–25, 26–28, 29–30, 31–32, 47, 82; courses, 23, 25; Dos Passos poster, 24; essays on artists, 26–28; graduation, 32; social activities, 24, 32

health, 126, 171, 205, 248–49

honors received, as art critic, 117, 143

illustrations: for book jackets, 245; *248;* for *Poems for a Dime,* 55, 56–57, 59; *55;* for *Poems for 2 Bits,* 55; for *The Possessed,* 40, 42; *42*

importance as artist, 187, 273

influenced by: Benton, 34, 54, 62, 66, 82; Berenson, 38–39; Marc Bloch, 218; Bonnard, 62, 66, 75, 86–87, 92, 103, 202–3, 216; Burckhardt, 70; de Kooning, 79, 82–83, 96, 127, 135, 165; European masterpieces, 213; Freilicher, 106, 107, 111; de Hooch, 230; van Houten, 79, 82, 182; Impressionism, 183; Katz, 213; Kent, 25, 27–28, 36, 51; Marin, 51–52; Maroger, 77–78, 79, 80, 83; Matisse, 96; Mexican muralists, 66; Old Masters, 37, 47; Orozco, 53; Picasso, 22; Eliot Porter, 63, 244; James Porter, 19, 20, 21; Ruth Porter, 19, 21; Renoir, 66; Herman Rose, 106; Sargent, 120; Velázquez, 182, 190, 194, 204, 213; Vuillard, 62, 66, 75, 83, 86–87, 92, 96, 103, 111, 120, 135, 138, 155, 202–3; Whistler, 278n; Whitehead, 29–30

interviewed by: Paul Cummings, 36, 47, 58, 62–63, 72, 184–85, 207–8, 217; Jack Kroll, 172

isolation as artist, 67, 194–95, 203, 205

Japanese prints and, 25, 28–29

Knoedler and Co. and, 230, 239, 240, 241

landscape painting, 51, 111, 220, 226, 245

latihan meditation and, 152

lectures: at Creative Arts Festival, 207; at Maryland Institute of Art, 231–32; at University of Alabama at Tuscaloosa, 188; at University of Nebraska, 224; at University of Wisconsin at Milwaukee, 188–89

library of, 74

lifestyle, 52, 255, 259

linoleum cuts by, 55, 59, 61; *55, 60, 61*

linotypes by, 59

literary interests, 16, 29, 40, 104–6

lithographs by, 40, 154–55, 239–40, 245, 259; *152, 236*

marriage, 45

material wealth and, 60, 176

May Day parade and, 61

meaning in his art, 183–86, 190, 207–8, 209, 220, 280n

memory loss, 248–49

Metropolitan Museum of Art purchase, 263

models, 59, 91–92, 127

mural paintings, 45, 46, 51, 52, 53, 59; mural-sized paintings, 213; murals for workers article, 45, 52, 53

museum collections: Cleveland Museum of Art, 212, 216, 272; Museum of Modern Art, 150, 154, 272; Parrish Art Museum, 149; Wadsworth Atheneum, 172; Whitney Museum of American Art, 272

museum copies in his house, 74

museum copy painting, 38, 39–40, 78, 270

named for grandmother, 16

Nazism views, 59–60, 61

nonconformity with art fashion, 67, 194–95, 203, 205

nuclear power and, 232, 253–54

nude bathing by, 51, 152

nude paintings by, 75, 111, 149

obituaries, 273

omission from art books, 203

personality: frankness, 161, 279n; impatience with chitchat, 161–62, 279n; optimism, 176; sensitivity, 80; shyness, 21

philosophical background, 60

photograph collection, 74

photographs of, *16, 19, 20, 26, 112, 126, 173, 245, 272*

physical appearance, 25, 51

physical energy, 171–72

pivotal years, 92–93

poetry by: 106, 118; homage to his mother, 17; published, 117; sestina by, 118

poetry reviews by, 155

political views and activities, 50–51, 52, 55–56, 57–58, 59–60, 61, 172, 216, 230

Pollock, Jackson, and, 89

portraits by: of Peter Ackroyd, 244; *244;* anatomical accuracy of, 97; of John Ashbery, 235, 236; *208, 231;* of Arthur Bullowa, *241;* of Ted Carey, 150; *149;* of Robert Dash, *142;* of Lucien Day's children, 138; of Elaine de Kooning, 132, 231; *88;* of Tibor de Nagy, 175; *136;* expressions of sitters, 190, 194; of Mrs. Fizdale, 132; of Robert Fizdale, 132; of Richard Freeman, *256;* of Jane Freilicher, 114, 212–13; *120, 211;* of friends, 128; of Kristina Fuller, 255; of Lisa Fuller, 245–46; of Scott Fuller, 245–46; of Arthur Gold, 132; of Albert Gordon, 263, 265; of George Jefferson, 81; of David Kermani, 244; *244;* of Kenneth Koch, 235; *234;* of Inez MacWhinnie, *216;* of John MacWhinnie, 241; *243;* of Paul Mattick, 64; of Mr. and Mrs. Mayer, 175; of John Myers, *104;* of Frank O'Hara, 111, 114, 132, 134, 236; *111, 130;* of Ron Padgett, 235; *234;* of Roland Pease, 138; *137;* of Anne Porter (1933–49), 46, 47, 52, 59, 61, 62, 83, 87, 90; *50, 63, 69, 80, 84;* of Anne Porter (1950–60), 92, 114, 120, 135, 137, 205; *109, 121, 137;* of Anne Porter (1961–66), 168; *195;* of Anne Porter (1967–75), 212–13, 231, 255; *211, 215, 241, 242, 258;* of Betsy Porter, 168; of Edward Porter, *231;* of Eliot Porter, 54; *269;* of Henry Porter, 54; of Jerry Porter, 80, 126–27; *80, 132, 187, 268;* of Kathy Porter, 179; of Katie Porter (1949), *84;* of Katie Porter (1950–60), 90, 91–92, 120, 135, 137, 149–50, 205; *93, 121, 128, 137, 144;* of Katie Porter (1961–66), 168, 175, 186; *186, 225, 242, 256;* of Laurence Porter, 62, 106, 114, 168, 224; *63, 80, 100, 101, 115, 131;* of Liz Porter (1950–60),

135, 137, 138; *135, 137, 156;* of Liz Porter (1961–66), 168, 182, 203–4, 205; *157, 190, 204;* of Liz Porter (1967–75), 232, 244; *230;* of Sarah Porter, *266;* of Stephen Porter, 179; of Larry Rivers, 96, 231; *99;* of Edith Schloss, *108;* of Donald Schrader, 175; *178;* of James Schuyler, 120, 168, 235; *124, 208;* self-portraits, 203–4, 204, 205; *81, 96, 204, 206, 218;* of Jimmy Straus, 81; of Michael Straus, *160;* of Nancy Straus, 246; *257;* of Frank Wallace, *105;* of Andy Warhol, 150; *149;* of Claire White, *141;* of Jane Wilson, 127, 128, 131, 134; *129*

posthumous reputation, 273

prices for his work: 273; prices for his work (1950–60), 102, 114, 138–39, 154; prices for his work (1961–66), 165, 166, 168, 173, 175–76, 188, 195; prices for his work (1967–75), 209, 216, 241, 263, 265

quoted on: American painting, 36, 143; Amherst College, 226–27, 230; anatomical accuracy, 97; art commercialism, 165, 166, 168, 172; art criticism, 67–68, 94, 95, 119, 272; art education, 91; Art Students League, 34; artistic beauty, 218, 219, 269; artistic intensity, 143; artistic perception, 190; artistic theory, 189, 218–19; artistic vision, 145; beauty in art, 218, 219, 269; Thomas Hart Benton, 34, 54; Bernard Berenson, 39; British art, 212; child discipline, 66–67; color, 259; communism, 30, 54–55; composition, 47; criticism of his work, 188; Thomas Eakins, 139; figurative painting, 182, 187, 246; *First of May, The,* 146, 149; first show at Tibor de Nagy, 98–99, 102; framing, 176, 178; God, 270; Great Spruce Head Island, 155, 156, 159, 162–63, 164; Clement Greenberg, 67; Marsden Hartley, 79; Harvard fine arts courses, 23, 24–25, 26–27, 82; Thomas Hess, 134; Hirschl & Adler Galleries, 249, 252; his art criticism, 94, 95; his artistic development, 62, 63, 79, 82, 106–7, 168, 230; his lifestyle, 57, 132, 134, 255, 259; his reputation, 248; his work, 168, 230; van Houten, 78; influences on his art, 106–7; *July,* 234–35; Rockwell Kent, 28; light in painting, 79; Liquitex medium, 169–70; lithography, 245, 259; John Marin, 63; master/pupil distinction, 42, 91; meaning in art, 70, 119, 184–85, 207–8; modern art, 24–25, 202, 207–8, 212; *Morning Landscape,* 200; George L. K. Morris, 67; murals for workers, 45; nuclear power, 253–54; nude painting, 75; *Nyack,* 212–13; oil medium, 57, 94, 281*n;* painters, 123, 126; painting from life, 25; painting restoration, 91; party with Gruens', 127–28; photography, 145; "Poets and Painters," 155; political views and activities, 30, 52, 54–55, 56, 58, 60, 230; Eliot Porter, 63; portrait

painting, 182, 187, 246; promotional schemes,172; realist painters, 123; retrospective exhibition, 261; Boardman Robinson, 34; Denman Ross, 27; Russian visitors at Museum of Modern Art, 154; John Singer Sargent, 122; satisfaction with his work, 63, 90; James Schuyler, 240; showing his paintings, 98; snowstorm, 224; Socialist Party views, 54–55, 56; Alfred Stieglitz, 54; *Summer Studio,* 168; teaching, 259; techniques, 131–32, 248; watercolors, 265, 281*n;* John Wheelwright, 54–55; writers, 123, 126; *Yellow Room,* 161

Rebel Arts and, 52, 53

recollections of: by Rackstraw Downes, 162; by Jane Freilicher, 98; by John Bernard Myers, 98, 161; by Anne Porter, 36; by Eliot Porter, 21; by Frank Rogers, 15; by Edith Schloss, 104; by Neil Welliver, 259; by Jane Wilson, 128, 131

relationships: with Jane Freilicher, 123; with Clement Greenberg, 67, 119; with his children, 79–80, 83, 86; with Frank O'Hara, 111; with Anne Porter, 71, 74; with Eliot Porter, 24; with James Porter, 52–53; with Jerry Porter, 79; with Johnny Porter, 59, 61–62, 79, 132, 276*n;* with Johnny Porter's teacher, 71; with Katie Porter, 87; with Ruth Porter, 17, 19, 21; with James Schuyler, 161

religious views, 18, 29, 38, 122, 269–70

reputation, 186, 205, 248, 252, 272–73

reviews of work: 126, 199, 205; by John Ashbery, 239; by Dore Ashton, 111; by Michael Benedikt, 186, 187; by Lawrence Campbell, 102–3; by Robert Dash, 134, 138; by Willem de Kooning, 98; by Howard Devree, 46, 111–12; by Philip Evergood, 104; by James Fitzsimmons, 103; by Grace Glueck, 220; by Thomas Hess, 122; by Hilton Kramer, 139, 172, 200, 202, 205, 220, 224, 230, 236, 239, 252–53, 273; by Jerrold Lanes, 186, 187–88; by Brian O'Doherty, 186; by Frank O'Hara, 111, 112, 135; by Stuart Preston, 103, 154, 165, 190; by James Schuyler, 135, 190, 209; by David Shirey, 261, 263; by John Wheelwright, 57

Russian writer meeting at Museum of Modern Art, 154

sales of work (1950–60), 114, 126, 135, 138–39, 154; sales of work (1961–66), 165, 166, 168, 172–73, 175–76, 188, 195, 199; sales of work (1967–75), 216, 227, 239, 241, 249, 252

satisfaction with his work, 64, 134, 168, 188, 227, 248

sentimentality in art and, 179, 182

Socialist views, 50–51, 54–55, 56, 57–58

Spain sketchbook, 43; *43*

as speaker, at Joseph Cornell memorial, 244; introduced John Ashbery, 244

student protest movement and, 230

studios and houses: fire in, 127; on Great Spruce Head Island (1925–32), 19, 25, 43; on Great Spruce Head Island (1933–49), 47, 51, 71, 79–80, 83, 86, 87; on Great Spruce Head Island (1950–60), 90, 112, 114, 120, 126; on Great Spruce Head Island (1961–66), 155–56, 159, 161, 162–64, 171, 189–90, 205; on Great Spruce Head Island (1967–75), 217–18, 219, 224, 232, 234–35, 239–40, 241, 244, 254–55, 265; in New York City, 32, 45, 74, 75, 134; in Southampton, 86, 87, 89–92, 107, 110, 127, 128; in Winnetka, 57

teaching: at Amherst College, 224–27, 230, 232; at Queens College, 220, 222, 224; at Rebel Arts, 52, 53; at School of Visual Arts, 259; at Skowhegan, 224; at Southampton College, 199; private students, 53, 132

techniques: 66, 71, 103, 120, 134, 182, 209, 213, 246, 248, 278*n;* casein paint, 90; density of medium, 137, 138; Liquetex medium, 168, 169, 170; Maroger's Medium, 77–78, 80, 83, 131, 244; Masonite, 244; oil medium, 255, 281*n;* painterly phase, 111; speed of painting, 82, 131–32; type of paint, 152; watercolor medium, 265, 281*n*

travels (1922), with family, 22–23; to Athens, 22; to Europe, 22–23; travels (1927), to France, 30; to Russia, 30–31; travels (1931–32), to Austria, 40–42; to Europe, 15, 37–43; to Germany, 40–42; to Italy, 36–38, 39, 40, 42; to see art collections, 38–43; to South, 45; to Spain, 42–43; travels (1938–41), to California, 64, 71–72; to New York City, 61; to visit John Marin, 66; travels (1950–60), to the Catskills, 110; to Massachusetts, 152; to Nyack, 110, 111; travels (1961–66) to Carbondale, Illinois, 189; travels (1967), to England, 212; to Europe, 205, 207, 209–12; to Italy, 209–11; to Wales, 212

treatise on artistic theory, 189

Trotsky sketch, 30

watercolors, 17, 61, 75, 255, 265

working habits, 114

in World War II, 72, 73, 75, 76–77

writings of: Joseph Cornell article, 199, 202; Eakins book, 139, 142; *see also* Porter family (Fairfield)

Porter family, 16

Porter family (Fairfield), in Croton-on-Hudson, New York, 54, 65, 71–72; on Great Spruce Head Island (1933–49), 71, 79–80; on Great Spruce Head Island (1950–60), 90, 112, 114, 120; on Great Spruce Head Island (1961–66), 189–90; on Great Spruce Head Island (1967–75), 232, 234–35, 239–40; in Hubbard Woods, 18, 56; in New York City, 45, 48, 74, 86; in Peekskill, New York, 64; in Sayville, Long Island, 76; in Southampton, 86, 87, 89–92, 107, 110

Porter family (James), on Great Spruce Head Island, 19–21, 28–29, 51; in Hubbard Woods, 18–19; religious discussions, 29; vacations, 19
Porter Family Trust, 16, 45, 58, 126, 138, 173, 176
Porter, Henry (cousin), portrait of, 53
Porter, James (father), 16, 25, 122, 254; as architect, 18; atheism of, 17–18; career, 17, 18; death, 64; education, 17; on Porter's artistic talent, 21; Porter's political activities and, 52–53; family background, 16; Great Spruce Head Island house design, 18, 19–20; Alex Haberstroh and, 43; Hubbard Woods house design, 18; lifestyle, 274n; marriage, 17; nature interests, 19; personality, 17–18, 20–21; self reliance, 20–21; tennis interest, 29, 217, 244; travels, 17
Porter, Jerry (son), 86, 120, 122, 134; birth, 70; personality, 123; photographs of, 126; portraits by Porter, 80, 126–27; 80, 132, 187, 268; relationship with Porter, 79; in Southampton, 89
Porter, John (brother), 16, 19, 26, 51, 62, 161; photographs of, 20, 26; portraits by Porter, 48; 49
Porter, Johnny (son), 61, 64, 65, 71; birth, 48; at Devereaux school, 79; handicap of, 59, 61–62, 66, 74, 79, 132, 276n; in Vermont, 89–90
Porter, Julia Foster (grandmother), 16; death, 56; house of, 18; photograph of, 16
Porter, Katherine (daughter), 110, 134, 171, 205; birth, 74, 87; photographs of, 126; as Porter's model, 91–92, 127; portraits by Porter (1949), 84; portraits by Porter (1950–60), 90, 91–92, 120, 135, 137, 149–50, 205; 93, 113, 121, 128, 137, 144; portraits by Porter (1961–66), 168, 175, 186; 186, 225, 242, 256; Roman Catholicism of, 18; in Southampton, 89; trip to Europe (1967), 207, 209–12
Porter, Kathy, portrait by Porter, 179
Porter, Kenneth, 56
Porter, Kingsley, 32
Porter, Mrs. Kingsley, 32
Porter, Laurence (son), 61, 64, 65, 71, 74, 79, 86, 90, 110, 122, 123, 126, 127, 132, 164, 171, 199–200, 203, 205, 207, 224, 230, 234, 240, 244, 245, 249, 253–54, 255, 259, 261, 269; birth, 56; marriage, 152; in Michigan, 188; portraits by Porter, 62, 106, 114, 168, 224; 63, 80, 100, 101, 115, 131; relationship with Johnny, 66; in Southampton, 89
Porter, Nancy (sister), 16, 18, 22; photograph of, 20
Porter, Ruth (mother), 16, 17, 29, 48, 53, 64; death, 74; education, 16–17; T. S. Eliot and, 46; Porter's career and, 62; family background, 16; influence on Porter, 19, 21; liberal views of, 16, 17; lifestyle, 274n; marriage, 17; personality, 17; photograph

of, 17; on Porter's appearance, 25; on Porter's early enthusiasm for travel, 22; on Porter's friendships, 23; reading aloud to family, 17, 19, 21, 28; religious views, 17; travel to Italy with Porter, 36–38
Porter, Sarah, portrait by Porter, 266
Porter, Stephen (nephew), 239; portrait by Porter, 179
Porter, Trudy (sister-in-law), 51, 62, 161
portrait painting, unpopularity in 1950s, 96, 119
Portrait of a Girl, 192
Portrait of Arthur Bullowa, 241
Portrait of Donald Schrader, 178
Portrait of James Schuyler, 124
Portrait of John Porter, 49
Portrait of Kenneth Koch, 234
Portrait of Nancy Porter Straus, 246; 257
Portrait of Richard Freeman, 256
Portrait of Ted Carey and Andy Warhol, 149
Portrait of the Artist's Wife, 109
Portraits Inc., 138
Pound, Ezra, 28
Preston, Stuart, 103, 154, 165, 190
Primroses, 229

Queens College, 220, 222, 224
Queens Museum, Flushing, New York, exhibitions, 261

Raphael, works by, La Donna Gravida, 38
Rauschenberg, Robert, 122, 146
Reality (arts group), 123
Rebel Arts, 52, 53
"Recent Painting USA: The Figure," exhibition, 187
"Recent Work by Fairfield Porter," exhibition, 240–41
Red Cables, 73
Red Car, 102
Red Puppy, 238
Red Wheelbarrow, 199
Reed College, 199
Reimann, Guenther, 71
Renoir, Pierre Auguste, 63, 218; influence on Porter, 66; work by: Mme. Charpentier and Her Children, 126
Rewald, John, 75
Rexroth, Kenneth, 72
Reynolds, Wendell, 36
Rhode Island School of Design, Porter exhibition at, 138
Ripley, Dwight, 102
Rivera, Diego, 53, 58
Rivers, Clarice, photograph of, 126
Rivers, Larry, 90, 122, 152, 155; artistic style, 120, 127, 212; exhibitions, 187; friendship with Porter, 96, 98, 102, 104, 107, 110, 111; photograph of, 126; portraits by Porter, 96, 231; 99
Rivers, Stephen, photograph of, 126
Robert Dash, 142
Robinson, Boardman, 15, 32, 33, 36, 37, 40, 47; on perspective, 42; work by: History of

Commerce, The, 33
Rockefeller, David, 154
Rockefeller family, 154
Rockefeller, Mrs. John D., 126–27
Rockefeller, Mrs. John D., III, 154
Rockefeller, Nelson, 216
Rocking Horse, The, 170
Rocks and Lichen, 270
Roebling, Paul, 199
Roger-Marx, Claude, 90
Rogers, Frank, 15, 33, 41
Roland Pease, 137
Rome, 41
Ron Padgett, 234
Roofs of Cambridge, 32; 37
Rosa Rugosa, 196
Rose, Dr., 25
Rose, Herman, influence on Porter, 106
Rosenberg Gallery, 75
Rosenberg, Harold, 95, 119, 126, 143
Rosenfeld, Paul, 47, 48, 61, 66, 68, 70, 80
Ross, Denman, 27
Rothko, Mark, 34, 96, 119, 152, 154
Rubens, Peter Paul, 42, 120
Rubenstein, Louis, 48
Ruins, 55

Sachs, Paul, 27, 38
Sarah Porter, 266
Sargent, John Singer, Porter articles on, 120, 122, 123; works by: Daughters of Edward D. Boit, The, 120
Schjeldahl, Peter, 240–41
Schloss, Edith, 104, 110, 112, 114, 209, 210, 211; portrait by Porter, 108
School of Visual Arts, New York City, 259
Schooner Dockside, 62; 65
Schrader, Donald, 114; portrait by Porter, 175; 178
Schuber, David, 71
Schutz, Prescott, 261
Schuyler, James, 117, 123, 212; as poet, 104, 106, 155; at Porters', 120, 159, 161, 164, 171, 189–90, 218, 240; portraits by Porter, 120, 168, 235; 124, 208; reviews of Porter's work, 135, 190, 195, 209; work by: Crystal Lithium, 245
Schwab, Arthur, 45
Schwab, Edna, 45
Schwenk, 150, 154, 272
Scott, 259
Scragg Island, 171; 177
Screen Porch, The, 190, 195; 181
Seascape, 265
Seated Boy, 66; 68
Segal, George, 186, 194
Self-Portrait (1948), 205; 81
Self-Portrait (1968), 218
Self-Portrait (1972), 206
Self-Portrait in the Studio, 96
sestinas, 117, 118
Shahn, Ben, 154
Shapiro, David, portrait by Porter, 244
Shapiro, Lindsay, portrait by Porter, 244

Shapiro, Miriam, photograph of, *126*
Shatter, Susan, 190
Sheldon Art Gallery, 224
Shepard, Rose Ann, 168
Sherman, Jules, 155
Shirey, David, 261, 263
Short Walk, A, 231; *167*
Signorelli, Luca, 39
Single Peonies, 244; *240*
Siqueiros, David Alfaro, 53
Skowhegan School of Painting and
 Sculpture, 190, 224
Sloan, John, 15, 32
Smith, David, 123
Snow on South Main Street, 260
Sontag, Susan, 224
South Main Street, Spring, 148
South Meadow, 259; *229*
South Meadow, Afternoon, 229
Southampton, 119
Southampton College, 199
Southern Illinois University, 189
Soyer, Raphael, 123
Spaulding, John T., 28
Spruce and Birch, 184
Stankiewicz, Richard, 120
Stein, Judith E., 202
Stephen and Kathy, 179, 188; *171*
Stevens, Wallace, 57
Stewart's Cafeteria, 82, 277n
Stieglitz, Alfred, 46, 48, 63, 66, 74; gallery,
 34, 36, 50, 61, 63; personality, 48, 50
Still, Clyfford, 96, 119
Still Life, 139
Still Life in a Mirror, 196
Still Life with Yellow Tablecloth, 105
Stokes, Adrian, 212
Straus, Jimmy, portrait by Porter, 81
Straus, Mary Howe, 59
Straus, Michael, 22, 51, 161, 232, 234;
 portrait by Porter, *160*
Straus, Nancy (sister), 25, 29, 51, 53, 161,
 232, 234; portraits by Porter, 246; *257*
Street Corner, 60
Street Scene, 75; *76*
student protest movement, 230
Studio 35, 82
Studio Interior, 91, 103; *92*
Subway, 34; *14*
Sudden Change of Wind, A, 251
Summer Studio, 168
Sunset and Lilies, 152
supersonic transport planes, 216
Sweater, The, 246
Sycamore in September, 172
Synchromism, 34

Table, The, 6
Table at Night (first version), *191*
Table at Night, 200
Table on the Porch, The, 241
Tamayo, Rufino, works by, *Pretty Girl,* 66
Teague, Walter Dorwin, 76
Tender, The, 253

Tennis Game, The (1970), *235*
Tennis Game, The (1972), 241, 244; *235*
That First Night in Mower Hall, 32; *31*
Theodore A. Kohn & Son, 46
Thiebaud, Wayne, 186
Thomson, Virgil, 36
Three Archers, 55
Tiber Press, 155
Tibor de Nagy, 136
Tibor de Nagy Gallery, 90, 98–99, 102, 172,
 230, 240; poetry at, 104–6, 155; Porter at,
 92–93; Porter exhibitions at (1950–60),
 103, 111–12, 119, 122–23, 126, 128, 134,
 138, 147, 149, 150, 152, 154; Porter
 exhibitions at (1961–66), 165, 172, 176,
 178–79, 182, 186, 190, 195, 199–200, 202;
 Porter exhibitions at (1967–75), 209, 214,
 216, 220, 230; sales of Porter's paintings,
 114, 126–27
Tiepolo, Giambattista, 78
Time magazine, 202; reviews of Porter's
 work, 186
Titian, 22
Tobey, Mark, 119
Tommaney, Jim, photograph of, *126*
Torricini, Angelo, photograph of, *126*
Towards Bear Island, 201
Trotsky, Leon, 30, 57–58; sketch by Porter,
 30; works by: *Dictatorship vs. Democracy,*
 58, 60; *In Defense of Terrorism,* 60
Trumpet Vines, 140
Turn, 70
Turn Imperialist War into Civil War, 51
Turner, Joseph Mallord, 22
"Twenty Centuries of Mexican Art,"
 exhibition, 66
Tworkov, Jack, 123

Under the Elm Tree, 166
Under the Elms, 236
University of Alabama at Tuscaloosa, 188
University of Nebraska, 224
University of Wisconsin at Milwaukee,
 188–89
Untitled (view outside studio), *219*

Vasilieff, Mrs., 110, 111
Vasilieff, Nicholas, 110, 111
Velasquez Study, 266
Velázquez, Diego, 270; influence on Porter,
 182, 190, 194, 204, 213; works by: *Boy
 Bringing Pomegranates,* 213; *Don Carlos
 at the Riding School,* 213; *Las Meninas,*
 120, 182, 190, 194, 204; *Surrender of
 Breda,* 270
Venice Biennale, exhibition, 168, 202, 219, 224
Veronese, Paolo, 22
Verrocchio, Andrea del, works by,
 Bartolomeo Colleoni, 122
View, 241
View from a Porch, 253
View from Fayerweather Hall, 227
View from Upstairs, 203

View magazine, 102
View of Studio with Elm Trunk, 172
View of the Barred Islands, 228
Vuillard, Edouard, 78, 90, 205; exhibitions,
 62, 75; influence on Porter, 62, 66, 75, 83,
 86–87, 96, 103, 111, 120, 135, 138, 155,
 202–3; Nabi, 92

Wadsworth Atheneum, 172
Wadsworth family, 16
Wadsworth, Lucy Fairfield (grandmother),
 16, 17
Waldorf Cafeteria, 82
Walker, John, 23, 27, 28, 38–39, 40, 42, 47,
 65, 154, 210
Wall, The, 271
Wallace Collection, 213, 230
Wallace, Frank, portrait by Porter, *105*
Ward, Joan, photograph of, *126*
Ward, Nancy, photograph of, *126*
Warhol, Andy, 194; portrait by Porter, 150; *149*
Weil, Gertrude, 52
Weinstein, Arnold, 123
Weinstein, Arthur, 132
Weinstein, Naomi, 122
Welliver, Neil, 255, 259
Weyhe Gallery, 75
Wheat, 152, 154; *151*
Wheelwright, John Brooks, 52, 54–57, 58,
 59, 60, 67, 79; books by: *Rock and Shell,*
 54; death, 65; poems by: *Masque with
 Clowns,* 55; *Mirrors of Venus,* 55
Whelan, Kenneth, poem by, *Murder at
 Pottsville,* 55
Whistler, James, influence on Porter, 278n
White Boats, 163
White, Claire, 89; portrait by Porter, *141*
White Tree Stump, 165
Whitehead, Alfred North, 41; books by:
 Science and the Modern World, 29–30
Whitney Museum of American Art, 272, 273;
 exhibitions, 93–94, 138, 165, 168, 273
Wild Apples, 225
Wilson, Jane, 127; photograph of, *126;*
 portraits by Porter, 127, 128, 131, 134; *129*
Window, The, 227
Winebaum, Sumner, 138
Wines and Liquors, 77
Winnetka Community House, 62
Wood, Grant, 79
Wood Road No. 2, 248
Woodberry, Mr., 26
Woods and Rocks, 183
WPA program, 58, 96
Wyeth, Andrew, 172

Yeats, W. B., 28
Yellow Room, 161, 165; *158*
Yellow Sunrise, 264
Young Man in a Doorway, 147

PHOTO CREDITS